CHARDIN

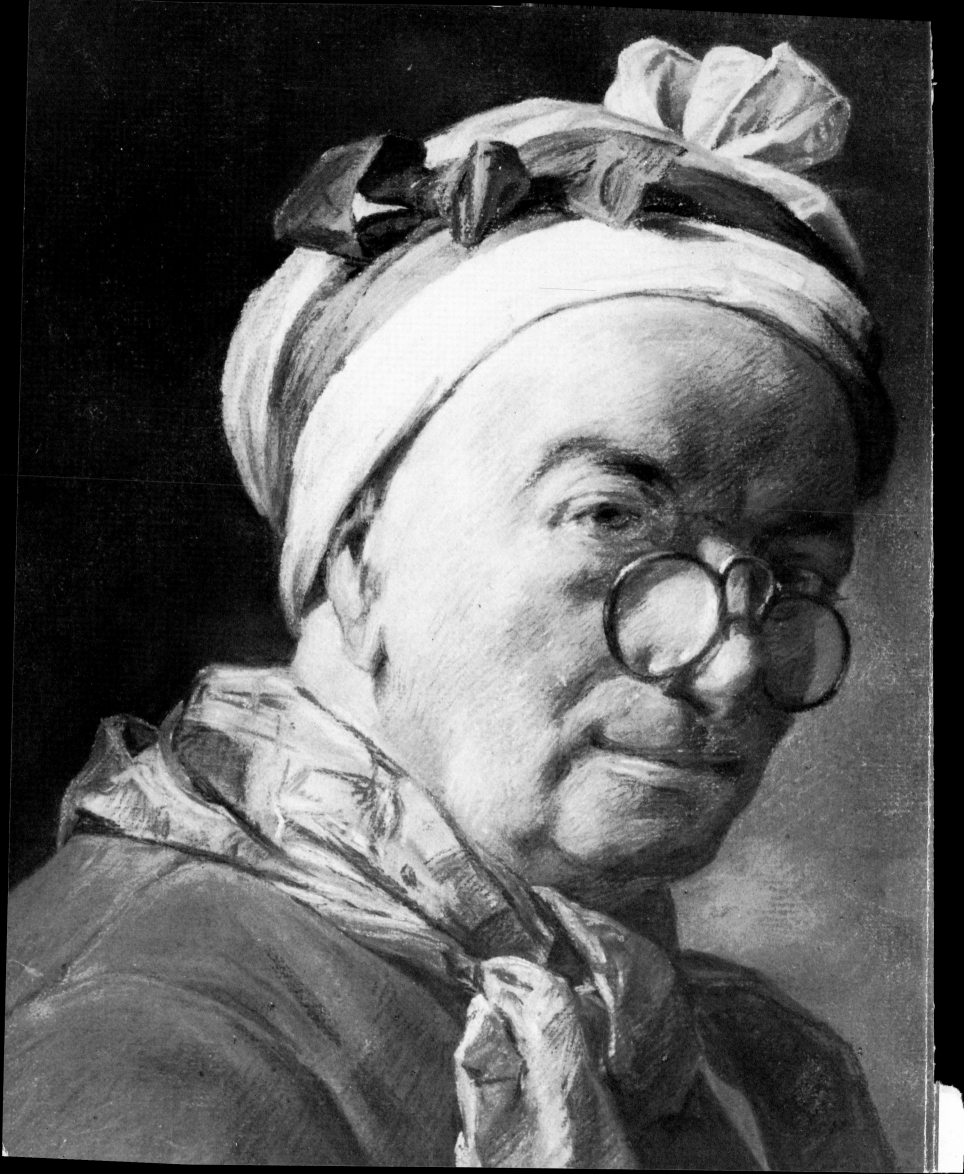

CHARDIN

Philip Conisbee

Lewisburg
BUCKNELL UNIVERSITY PRESS

© 1985 by Phaidon Press Limited

First American edition published 1986
by Associated University Presses, 440 Forsgate Drive, Cranbury, NJ 08512.

Library of Congress Cataloging in Publication Data

Conisbee, Philip.
 Chardin.

 Bibliography: p
 Includes index.
 1. Chardin, Jean Baptiste Siméon, 1699–1779.
I. Title
ND553.C4C66 1985 759.4 84–23259
ISBN 0–8387–5091–5

Printed in Spain

Frontispiece. *Self-portrait with spectacles.* 1771. Pastel 18⅛ × 14¾ in. (46 × 37.5 cm.). Paris, Musée du Louvre, Cabinet des Dessins.

Contents

	Preface	9
1	The Great Magician	11
2	Academic Ideals	35
3	A Natural Alternative	53
4	A Talent for Animals and Fruit	69
5	Little Pieces of Common Life	106
6	Modern Moral Subjects	133
7	Women and Children	169
8	Back to Nature	184
9	The Bold, Assured Hand	210
	Notes	229
	Select Bibliography	232
	List of Plates	234
	Index	237

Lesley's book

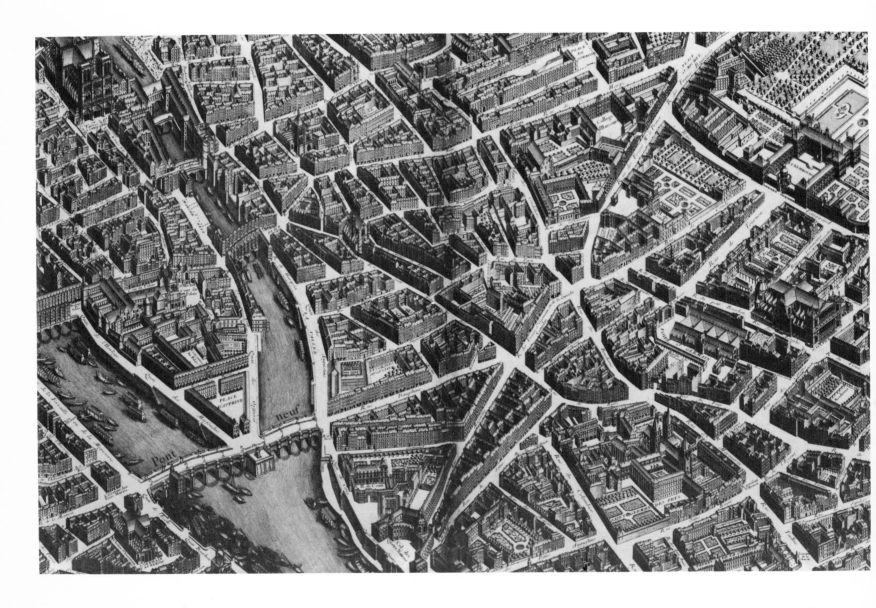

1. Detail of the 'bird's-eye' plan of Paris drawn by Louis Bretez between 1734 and 1739 and printed in 1739 in twenty engraved sections. It is known as the *Turgot Plan*, after Michel Etienne Turgot, Provost of the Merchants of Paris, who commissioned it.

The detail shows Chardin's Paris. At the top left is the church of Notre-Dame, while at the lower point of the island, just above the Pont-Neuf, is the Place Dauphine, where the Exposition de la Jeunesse was held. Below this, on the Quai Bourbon, a corner of the royal palace of the Louvre can just be seen, where Chardin had lodgings and a studio from 1757. On the other side of the river, behind the Collège des Quatre Nations, runs the Rue de Seine, where Chardin was born. Turning right at the top of the Rue de Seine, the Rue de Bussi leads to a junction which includes the Rue du Four; following this street, the Rue Princesse is first on the left. Chardin lived in a house on this corner from his childhood until the mid-1740s; by 1747, he had moved around the corner into a house owned by his second wife, in the Rue Princesse. In 1757 they moved to the Louvre. For most of his life, Chardin's parish church was Saint-Sulpice, just above and to the right of the Rue Princesse. He was buried at Saint Germain l'Auxerrois, just above the Louvre, where he died.

Preface

Oblivion overtook the name and the art of Jean-Siméon Chardin after his death in December 1779. Incompatible with the established academic ideals in the 1770s and the following decades, his art furnished no exemplars, and his reputation was never perpetuated through academic discourse. In the market-place, the names of a number of good if prosaic painters of still life superseded that of Chardin in this speciality, which he had made popular in the middle decades of the century. He himself had already abandoned his everyday figure subjects for the best part of thirty years, leaving the field of narrative genre painting open for Greuze and his followers. In contrast with Greuze, Chardin's art remained highly personal and essentially inimitable.

Chardin's posthumous reputation was to grow simultaneously from two concerns arising in the 1840s out of Romantic historicism: a reassessment of French painting of the eighteenth century, and the belief that art should express a direct commitment to the contemporary world. The sale in March 1845 of the collection of the Marquis de Cypierre, which contained versions of several important figure-pieces by Chardin, had a catalogue written by the great realist critic Théophile Thoré, including a virtual 'manifesto' in favour of the then neglected French School of the eighteenth century. In the same year, rooms were opened at the Louvre to display French eighteenth-century works, including *Saying Grace* (Plate 151) and *The industrious mother* (Plate 150) – the first time they had been seen in public since their exhibition at the Salon of 1740 and, it appears, the first time they had been given any proper attention since they had effectively gone into storage in about 1760. These two works were extolled in a review by another realist critic, Jules Champfleury; in December 1846, Pierre Hédouin published the first scholarly articles on Chardin. Other scholars and collectors were soon busy documenting Chardin's career and rescuing his works from barrows and storerooms. Already in 1840 Thoré himself had come across two of Chardin's finest still lifes of his earlier period, *The fast-day meal* and *The meat-day meal* (Plates 86 and 87), in a provincial town, and purchased them for next to nothing; by 1852 they had entered the Louvre, where they remain among his best-loved still lifes. Thoré, who is now remembered mainly as the principal agent of the 'rediscovery' of Vermeer in the nineteenth century, was later (especially on the occasion of an exhibition of French art in 1860) to write eloquently about Chardin, not only as a realist somewhat in the manner of the Dutch seventeenth-century masters the critic admired so much, but also as a brave rebel, who dared to paint against the pervasive 'frivolous' taste for rococo painting of his day.

The revival of interest in French painting of the eighteenth century coincided

with the development in the 1840s of a realist and anti-classical aesthetic, in opposition to the old but still potent academic tradition. Some of the same critics, such as Champfleury and Thoré, were to give this new tendency an articulate theoretical voice. Among the painters, it was not so much the giants who emerged from this movement, Courbet and Millet, for whom Chardin would be a luminary, but the lesser masters, such as François Bonvin (1817–87), Théodule Ribot (1823–91) and Antoine Vollon (1833–1900), to name but three.

Chardin's reputation was officially sanctioned, so to speak, during the 1850s and the 1860s, when the Louvre made its principal acquisitions of his works, which to this day give that museum the greatest single collection of them. In 1863 and 1864, Edmond and Jules de Goncourt published important scholarly articles on Chardin, which form the basis of their chapter on him in *L'art du XVIIIe siècle* (1880–4), the most frequently reprinted account of his life and works. Several recent scholars have documented the 'Chardin revival' of the nineteenth century, and it is not proposed to develop the theme here.

In the last hundred years a substantial literature on Chardin has accumulated, and his life and art are well documented. The literature is too vast to review here; it must suffice to mention the basic works: Emile Bocher's catalogue of the engravings after his works (1876); the indispensable monograph by Georges Wildenstein (1933), which reprints the majority of contemporary references to Chardin and his works, and contains an impressive catalogue; the revised editions by Daniel Wildenstein of this last catalogue, in French (1963) and in English (1969), with a handy essay, but, alas, without the documents published in 1933. Above all, however, we must pay tribute to one of the most memorable exhibitions of our time, organized by Pierre Rosenberg and held in Paris in 1979 and subsequently in slightly reduced form in the United States. Here, well over one hundred of Chardin's prime paintings could be studied together – giving us a great advantage even over the artist's contemporaries – and with the benefit of M. Rosenberg's remarkable catalogue. This catalogue contains a mass of new or revised documents, brings to light a number of works unknown to the Wildensteins, contains much important new research on matters of provenance, and carefully establishes a convincing chronology. Rosenberg's chronology is followed in this book, with a few exceptions; some of his own revisions in *Tout l'oeuvre peint de Chardin* (1983) are noted in my Plate captions.

It is not easy to find verbal equivalents for this great painterly painter, although writers of genius, such as Diderot and Proust, have done so. The intention of the present book is more humbly to give an account of Chardin's career in the context of eighteenth-century French painting, and to examine the contemporary response to his work. It is hoped that the endeavour will go some way towards introducing to an English-speaking public a great painter who will, however, never reveal all of his secrets. Above all, of course, it is essential to see and experience Chardin's paintings; alas, the 1979 exhibition will not be repeated in our lifetimes. As often as possible, I have drawn attention to works in public collections, at the expense of relatively inaccessible works in the art trade or in private collections. I am pleased to acknowledge the financial assistance of the Research Board at Leicester University and The British Academy, who have enabled me to travel for research and to see works by Chardin. Pierre Rosenberg has been characteristically helpful in the matter of obtaining permission to reproduce some works in private collections. My friends and my children have been extraordinarily patient during the writing of this book. I would also like to thank my tactful and efficient editor, Diana Davies.

Leicester, August 1984 P.C.

I The Great Magician

So there you are again, great magician, with your silent compositions! How eloquently they speak to the artist! How much they tell him about the imitation of nature, the science of colour, and of harmony! How the air circulates around these objects!

Denis Diderot (1713–84), by far the most perceptive and articulate art critic of Chardin's time, always took pleasure in discovering his works in the mêlée of the Salon exhibitions at the Louvre, as he did in 1765. Typical, at the Salon that year, was *A basket of grapes* (Plate 2): not a very promising subject, continued Diderot, but look at the way it is painted!

Scatter around the basket a few separate grapes, a macaroon, a pear, and two or three lady-apples; you will agree that individual grapes, a macaroon, some isolated lady-apples, are hardly given to form or colour; but look at the painting by Chardin.

Even our black and white illustration conveys the sheer quality of craftsmanship, perception and intellect that combine to produce such a vivid work: incomparable in the control of its tonal harmony; in the glimmering light and shade of its almost palpable ambience, out of which the artist conjures fruits and basket; in the reflections of light on the various fruits, the different surfaces of their skins; in the vitality of the paint, scumbled and dabbed and dragged, now assuming representational form, now present in its own right. As Diderot further observed:

Chardin's handling is all his own. It is an abrupt manner; close to, you know not what it is, and the further you move away, the object assumes form and ends by being that of nature. Sometimes it will please you equally as much near to, as from a distance.

The public arena of Chardin's art was the exhibition, known as the Salon, which had been mounted by the Académie Royale de Peinture et de Sculpture for its members in the Salon Carré of the Louvre every year or two since 1737. Gabriel de Saint-Aubin (1724–80) made a drawing of the installation of the Salon of 1765 (Plate 3), where to the left of the far wall we can just make out the eight large canvases Chardin exhibited that year (including our Plates 202 and 203). His smaller works, such as *A basket of grapes*, are not visible in Saint-Aubin's drawing. Although we can see quite a few small cabinet pictures by Chardin's colleagues – rows of portraits to the left and below Chardin's works, for example, or rows of mythologies, pastorals and oil sketches to the right – the room is dominated by the two upper ranks of very large figure paintings, stirring narratives from the Bible

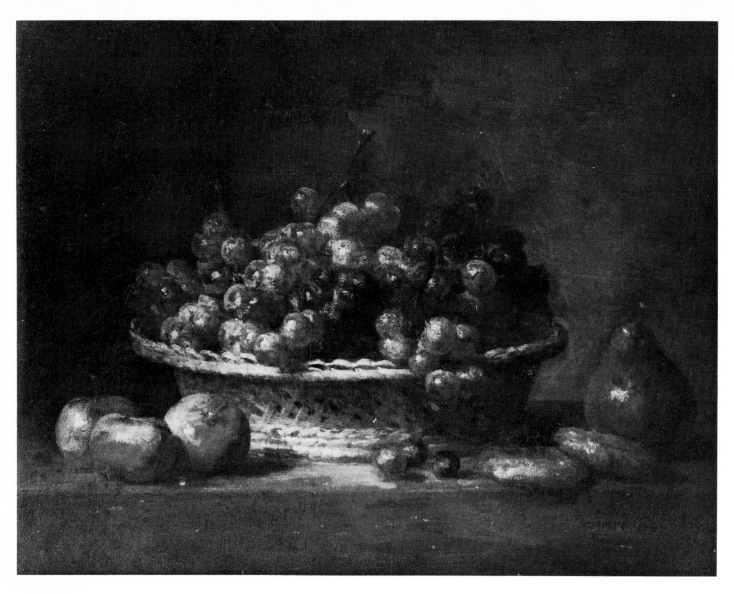

and ancient history. In scale and subject-matter, Chardin's art could hardly have been more modest; but, it was acknowledged, the force of his art made his paintings dangerous neighbours in an exhibition. More than one observer remarked that for all the lack of pretension in Chardin's choice of subject, he could teach even the most elevated history painter a thing or two about pictorial effect.

Only once in his own work did Chardin make reference to the portentous and elevated class of painting, and even then it was with characteristic reticence. On a dim back wall in *The bird-song organ* (Plate 173), a refined but modest domestic interior, hangs *Thalia ejected by Painting* (Plate 4), engraved after an allegorical work by Charles Coypel (1694–1752). *The bird-song organ* was to mark the tardy beginning of Chardin's official recognition, at the age of fifty-two, for the commission for this work came from the office of the Directeur des Bâtiments du Roi (effectively, Minister of Fine Arts), and had been facilitated by Coypel, who held the esteemed and influential position of Premier Peintre du Roi, First Painter to the King. The inclusion of this picture within a picture was an acknowledgement and a tribute to Chardin's friend and colleague. Coypel's work alludes to his own choice, in the 1720s, to abandon his career as a dramatic poet and devote the rest of his life to the art of painting. The publication of the engraving in 1733 was almost certainly inspired by Coypel's appointment as Professor at the Académie that year. Thalia, the Muse of Poetry, leaves the scene with her young genii, who gather up as many of Coypel's numerous literary works as they can manage. The allegorical figure of Painting, backed by some of Coypel's own paintings and two exemplary antique statues, waves the literary Muse away.

2. *A basket of grapes*. 1764. Oil on canvas, 12⅝ × 15¾ in. (32 × 40 cm.). Angers, Musée des Beaux-Arts. An almost identical version of this painting exists, dated 1765 (Amiens, Musée de Picardie); we cannot be sure which one was shown at the Salon of 1765, no.49.

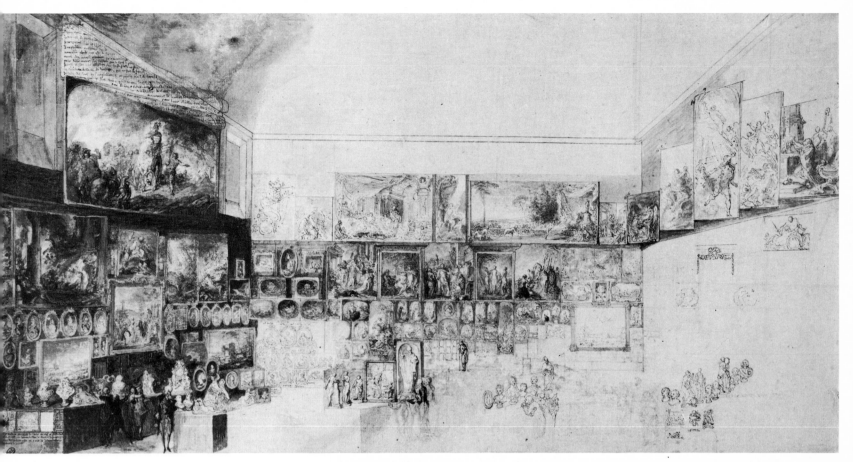

3. Gabriel de Saint-Aubin. *The Salon of
1765*. Watercolour over black chalk,
9½ × 18¾ in. (24 × 46.7 cm.). Paris,
Musée du Louvre, Cabinet des Dessins. A
general view of the Salon Carré of the Louvre,
as hung by Chardin for the exhibition of
1765. Sculptures are displayed on tables, and
the smaller cabinet pictures hung at the
lower levels. Among the major history
paintings are Fragonard's *Coresus and
Callirhoe* (Paris, Louvre) at the left, and above
it Lépicié's huge *William the Conqueror
landing in England* (Caen, Lycée Malherbe).
The far wall is dominated by Challe's *Hector
and Paris* (lost) and Hallé's *Hippomenes and
Atalanta* (Paris, Louvre), a tapestry cartoon
for the Gobelins works; below are major
history paintings executed for the royal
Château de Choisy (see pages 202–5); in the
left corner eight works by Chardin can be
seen (Plate 199, detail). The right wall is
dominated by altarpieces.

4. *Thalia ejected by Painting.* 1733. Engraving
by F.-B. Lépicié after Charles Coypel's
painting of 1732. The painting is now in the
Chrysler Museum, Norfolk, Virginia.

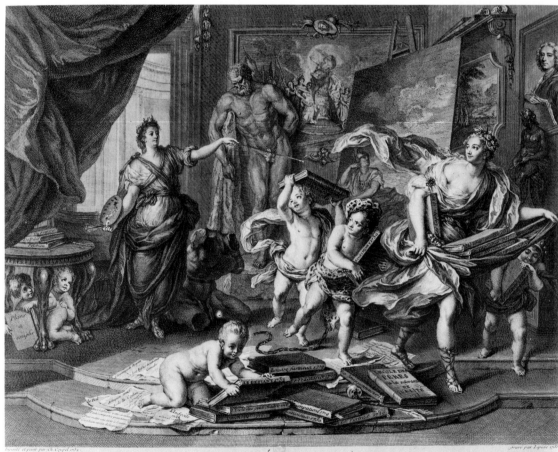

THALIE CHASSÉE PAR LA PEINTURE.
Cette Allegorie a eté imaginée au sujet d'une personne, qui a sacrifié à l'etude
de la Peinture, le goût qu'elle avoit a composer des pieces de Théatre.

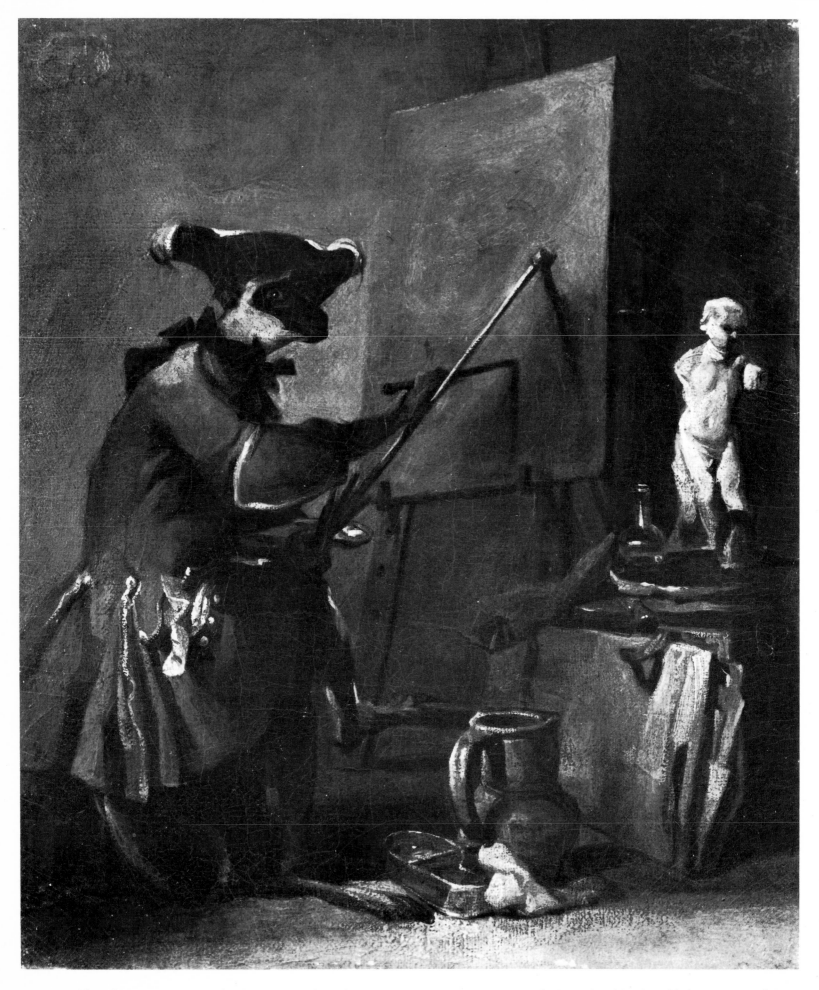

5. *The monkey as painter. c.* 1735–40. Oil on canvas, 11¼ × 9¼ in. (28.5 × 23.5 cm.). Chartres, Musée des Beaux-Arts. Together with the necessary equipment for his profession, the monkey-painter has a plaster cast after a *putto* by Nicolas Coustou (1658–1733), a studio prop very similar to one still employed by Cézanne at the end of the nineteenth century.

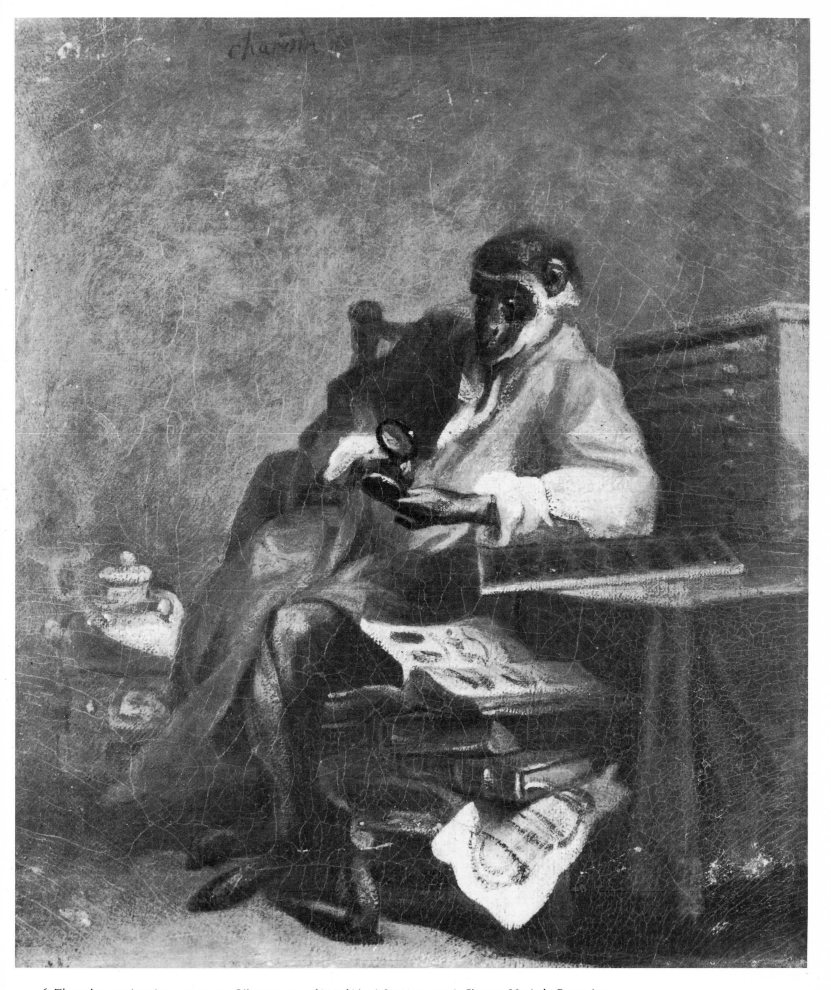

6. *The monkey as antiquarian. c.* 1735–40. Oil on canvas, 11¼ × 9¼ in. (28.5 × 23.5 cm.). Chartres, Musée des Beaux-Arts.

For all that its baroque rhetoric is far removed from his own approach to painting, Chardin himself would have endorsed its meaning. A man of few words, his art spoke for him. Indeed, he only very rarely spoke for his art. In an age of eloquent and literary painting, Chardin was the least literary of its painters. He might well have argued the implications of the Coypel print much further. Coypel was the archetypal history painter of their day: taking his subject-matter from some literary or historical text, and depending for success on his own powers of imaginative invention, it is the *narrative*, read through the actions, gestures and expressions of his characters, which assumes primary importance. In still life, Chardin's first and last love in the art, it is the *paint* that is made to count, considered in direct relation to the thing seen.

Chardin's art has none of the rhetoric found in the work of many of his contemporaries. He offers us no angels to sing a Magnificat in the heavens, no Hercules to transport us to Olympus, no ancient Roman hero to inspire us by his courage or his clemency; he is not given to the affected grace of gallant flirtation, nor to the knowing frolics and artful serpentine rhythms of decorative mythology. His works are concerned with the here and now, and they have a direct, though reserved and never sensational, visual appeal. They require, and repay, prolonged contemplation. Himself a slow and painstaking worker, Chardin asks a commensurate patience from his spectator. His painting is invested with intensity, and confers on the lowly nature of its subject-matter a privileged splendour.

More than once, contemporary critics drew an analogy between Chardin's powers of imitation and the story told by the ancient writer Pliny the Elder of some grapes so naturalistically painted by Zeuxis that the birds were fooled into pecking at them. But, remarked Diderot, animals are bad judges of painting. In his own commentaries on Chardin's still lifes, Diderot makes constant play on the duality of their apparent realism and their existence as paintings. All the reader need do, he says in 1765, is to make an arrangement of the objects the critic describes, and he will know what the pictures look like. Another form of flattering conceit employed by Diderot is to say that the paintings of Chardin require the same response as nature itself – just as, in his review of the Salon of 1767, he invites the spectator to take a walk through the landscapes of Joseph Vernet. Of Chardin he wrote in 1763: 'O Chardin! It is not white, red or black pigment that you mix on your palette: it is the very substance of objects, it is air and light that you take on the tip of your brush and place on the canvas.'

Chardin satirized the merely mimetic idea of painting in *The monkey as painter* (Plate 5): from a contemporary engraving after this work, it is clear that the monkey is painting an image of himself. He is a rather successful ape, with feathered hat and braided coat; but it is only monkeys, or monkey-like painters, who mimic, who merely imitate – and animals are bad judges of painting. The pendant is *The monkey as antiquarian* (Plate 6), where the verses appended to the contemporary engraving after it stress the simian foolishness of studying only the past – instead of scrutinizing his ancient coins, this antiquarian would do better to devote his energies to the study and encouragement of modern art.

Contemporary admiration for Chardin's still life was almost always expressed in terms of his realism, his powers of imitation. Thus, when he had completed a pair of such works for Abbé Trublet in 1759, *A basket of plums and a glass* (Plate 7) and *A basket of peaches, glass and cooler* (Plate 8), a keen admirer published the following short notice:

M. Chardin, Professor of the Académie Royale de Peinture, has just completed two paintings of fruit, 18 inches wide and approximately 15 inches high. One of

7. *A basket of plums and a glass*. 1759. Oil on canvas, 14⅛ × 17¾ in. (36 × 45 cm.). Winterthur, Oskar Reinhart Collection.

8. *A basket of peaches, glass and cooler*. 1759. Oil on canvas, 14⅝ × 18⅛ in. (37 × 46 cm.). Winterthur, Oskar Reinhart Collection. Autograph replicas of this painting and its pendant are in Rennes, Musée des Beaux-Arts, and it is not absolutely certain which pair belonged to Abbé Trublet and was sent to the Salon of 1759.

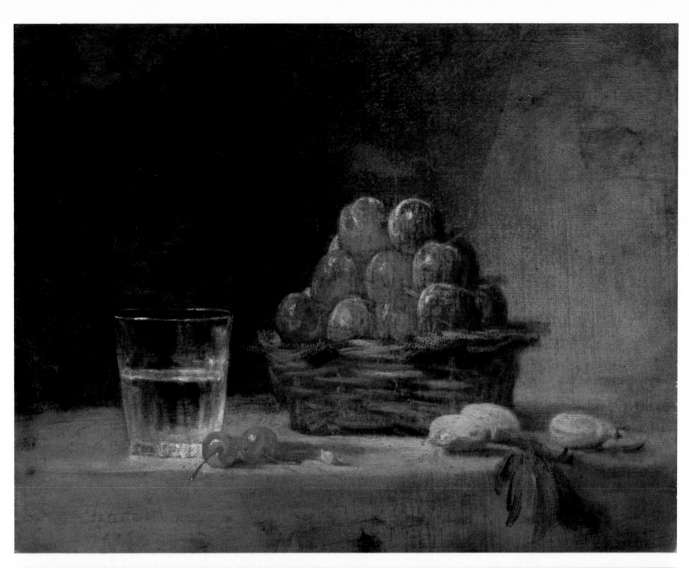

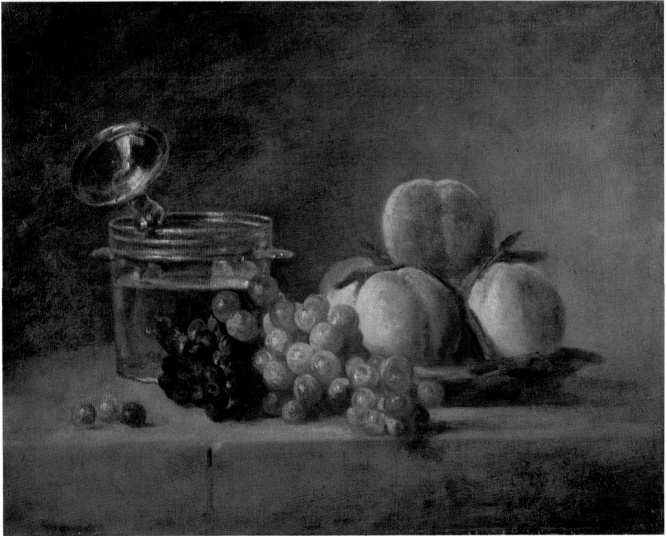

these paintings represents a basket of plums on a table; next to the basket there is a glass half filled with water which creates two kinds of transparencies, perfectly rendered. On the front part of the table are two cherries, a cherry-stone, and two almonds in the shell. The companion piece is a basket of peaches with red and white muscat grapes; a crystal bucket full of water, and a glass inverted in this bucket, offer light effects which deceive the eye . . .

The author of this notice was almost certainly the man of letters, bookseller, art-lover, and compiler of the successful *Dictionnaire portatif des beaux-arts* in 1752, Jacques Lacombe. While his account of Trublet's two pictures is a typical period response to Chardin's ability to create an effective illusion, he had also, in a thoughtful review of the Salon of 1753, attempted a description of Chardin's technique in the black and white terms he understood best:

The touch and the tints of these pieces are most singular. It is a manner of working which only produces its full effect at a certain distance; close to, the picture only offers a sort of vapour, which envelops all the objects. You could compare this technique with mezzotint in engraving, composed, as you know, of a fine grain which is worn down and polished to a greater or lesser degree, following the shadows and lights.

Here, Lacombe is trying to convey to his reader, who may never have seen a painting by Chardin, the broken, textured, impasted character of his surface, and the importance of tone in his works. Generally speaking, the surface is that of all great 'painterly' painting from the time of Giorgione onwards – paint with a life of its own, as it were, when seen close to, but assuming descriptive form as the spectator draws back. In the paintings admired by Lacombe in 1759, it is also the subtle variety in Chardin's touch that makes both the objects he represents and the paint itself so vivid. He has a different application for the cloudy bloom on dark plums, the firm velvety skin of almonds, the shine of cherries, the downy softness of peaches, the translucency and reflection of white and black grapes, the fall of light on and through glass, crystal and water.

The effect of Chardin's art is as difficult to put into words in our day as it was in his own. His contemporaries were particularly aware of the distinctive character of his handling, so different, for example, from the carefully polished finish of an Oudry (see Plates 68 and 182), or from the way the smooth brush of Boucher licks a surface into being (see Plates 30 and 172). This is where Chardin's secret lies; but secret is the operative word. He was regularly called a magician – and how he achieved his effects, he was not prepared to reveal. We have no record of his working methods. Even Diderot, who picked the brains of artist friends such as Chardin, in order to learn for himself some of the technical tricks of painting, was not a party to his studio procedures:

It is said that he has a technique all his own, and that he uses his thumb as much as his brush. I do not know what it is; what is certain, is that I have never known anyone who has seen him working. Whatever it is, his compositions appeal equally to the ignorant and to the connoisseur.

But even if we had a full account of Chardin painting, say, *A basket of grapes* (Plate 2), the peculiar power and beauty of that accumulation of brushmarks on a canvas that was once blank would remain mysterious. Year after year, Diderot tried to discover and define the secret:

This magic defies understanding. It is thick layers of colour applied one on top of the other and beneath which an effect breathes out. At other times, you could say

it is a vapour that has been breathed onto the canvas; elsewhere, a delicate foam that has descended upon it . . . Approach the painting, and everything comes together in a jumble, flattens out, and vanishes; move away, and everything creates itself and reappears.

Nevertheless, Diderot felt the power of Chardin's art, and indeed defined three of its basic elements in three words from our opening quotation: nature, colour, harmony. These Chardin fused together into a wonderful unity of effect. In spite of the common opinion that by 1769 the great critic was losing interest in the art of painting, in his review of the Salon that year he still made some simple but penetrating observations, whose lack of further development, however, we might regret:

> Take the smallest picture by this artist, a peach, a grape, a pear, a nut, a cup, a saucer, a rabbit, a partridge, and there you will find the great, the profound colourist . . . He is the master of all, when it comes to harmony, that rare part [of the art] of which everyone talks but which very few know.

And in the same review Diderot reports one of the master's lively repartees – the type of bold and unexpected expression of opinion Cochin tells us was characteristic:

> Chardin was right, when he said to one of his colleagues, a mediocre painter,
> – Do you paint with colours?
> – With what else, then?
> – With what else? With feeling . . .
> It is feeling which perceives the ripple of light and reflections on surfaces; it is feeling which captures and renders, I know not how, their wonderful confusion.

(Cochin gives a variant of Chardin's reply: 'We *use* colours, but we *paint* with feeling'.)

Chardin's own words are at once precise and enigmatic – what exactly did he mean by feeling (*sentiment*)? If in general terms he was stressing the subjective element in artistic creation, to the well-informed Diderot clearly on one level it denoted a sensitive and penetrating visual perception. But rendering, painting, was a matter of feeling too. The power of Chardin's art lies in its total visual effect, the matchless harmony between his colour, his design and his subject-matter. Much of this harmony, however, comes from his deployment of chiaroscuro, light and shadow, by which he could control and render more impressive the general effect of the whole of a work, and give emphasis to the parts – and this chiaroscuro, this play of light and darkness, was the chief vehicle of his feeling. Chardin was passionately attached to the thing seen – he could not paint without a model before him – so that in his work perception and pictorial design become one. His was a rare sensibility for the mass, the volume and the surface of the humblest of objects, for their physical presence, for the light which brings them out of their mysterious penumbra, and for the very air which envelops and caresses them. He combined a sense of intimacy, learned from Dutch and Flemish art of the seventeenth century, with a sense of decoration and resonant colour comparable with the great Venetians, although more immediately allied with the fine decorative painters of his own time and place. He had the colourist's special feeling for the perfect concord of his tones and the harmony between colour and subject-matter. For him, the act of representation was a discovery of unity.

Chardin's figure paintings share similar qualities of design and execution with the still lifes, and indeed the earliest critical comment we have on his art is an attempt to come to terms with his highly personal manner in one of these, *The*

draughtsman (Plate 10). It was among his most admired works in his own day, and one of the designs he repeated most often. Seated on a studio floor with his back to the spectator, on his knees a portfolio supporting a large sheet of paper, the young man is busily at work, copying the academic life-drawing pinned to the wall – such diligence was to be a favourite theme with our artist. On the floor lies a knife for sharpening his crayon, while to the right two canvases lean against the wall, a blank one facing out, the other facing the wall, to reveal its wooden stretcher. The basic colour harmony is of beiges and creams, but the drawing on the wall is a soft brick-red sanguine, and the lining of the grey-brown coat shows light red at the student's left leg, between the tails, and through the small rip on his shoulder.

Chardin has considered the almost square format of this small panel, and incorporated it, as it were, into the rectangular shapes underlying the design itself.

9. *The embroiderer. c.* 1734–7. Oil on panel, 7⅛ × 6⅛ in. (18 × 15.5 cm.). Stockholm, Nationalmuseum. This picture and its pendant (opposite) are both reproduced in approximately the original size.

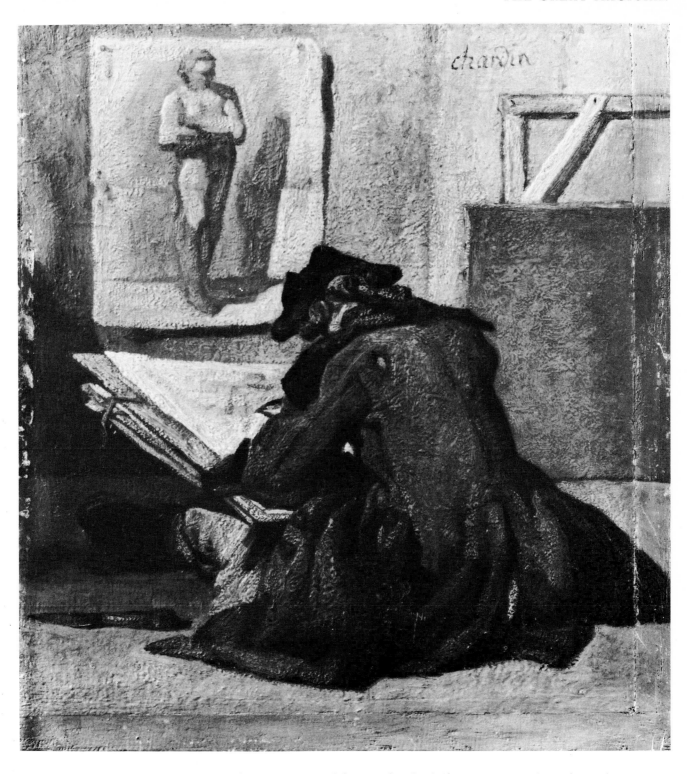

10. *The draughtsman. c.* 1734–7. Oil on panel, 7⅝ × 6⅞ in. (19.5 × 17.5 cm.). Stockholm, Nationalmuseum. One of Chardin's most popular figure-pieces, many versions of which are recorded in eighteenth- and nineteenth-century picture sales. The most recent autograph replica to appear, in 1982, is now in the Kimbell Art Museum, Fort Worth.

But any hardness is relieved by the bold, dark silhouette of the bent figure, the broad shape of his open coat-tails repeated in the diminishing echoes of the collar and the tricorne hat. The mood is of intense concentration on the task in hand – a concentration imposed on the spectator too, by the compressed energy of the design, focused close in and low. Were he not hunched over his work, the student would burst out of the pictorial space which contains him. His bulk is powerfully modelled, with deep shadows and thick paint. Indeed, the whole surface is deeply impasted, although with an almost palpable softness in the movements of the brush. Baffled, admiring, Chardin's first commentator, Chevalier Neufville de Brunaubois-Montador, saw the present work at the Salon of 1738:

His manner of painting is all his own. It is not a case of finished outlines, nor of a

11. Casper Netscher. *The embroiderer.* c. 1670. Oil on panel, 10⅞ × 9¼ in. (27.5 × 23.5 cm.). Dresden, Gemäldegalerie.

fluid touch; on the contrary, it is brutal and rugged. It seems as if the strokes of his brush are exaggerated, and yet his figures are of a striking realism, and the singularity of his manner only makes them more natural and spirited.

As Diderot was to observe of a version of this little panel exhibited with its pendant (see Plate 9) at the Salon of 1759: 'His touch is as broad in his little figures as if they had plenty of room. The breadth of handling is independent of the extent of the canvas (*sic*) and the size of the objects.' Ironically, although the irony may not have been lost on Chardin himself, the exemplary academic drawing which the student is copying is perforce rendered by Chardin in paint – as boldly modelled a chiaroscuro sketch, it is tempting to remark, as any executed by the young Matisse around 1900. But the history painters of Chardin's day made compositional oil sketches in just such a broad manner, with a few bold strokes of the brush, as did Chardin in his own oil sketches (Plates 161 and 178). However, it would be fascinating to know whether Chardin, who rarely made a drawing, ever painted individual figure studies like the one his young draughtsman is set to copy!

The companion picture, *The embroiderer* (Plate 9), shows a young woman seated in a low chair with her work on her knee. She has just selected a ball of blue wool from

her open work-basket, while beside her she has an ell (a cloth-measure) and a box of pins on the table. The colours of the room are again beiges, but she is more contrasted in her black and white, and there is more positive colour in the large red area of the tablecloth and the red and blue wools. In this picture, accents of blue correspond to the accents of red in *The draughtsman*. She too forms a massy pyramidal volume, within the tiny, constrained rectangle of her picture-space. The two figures, and the various objects in their separate rooms, are carefully balanced and related.

For a moment, the girl seems to pause in reflection, lost in her own thoughts, giving the image a mood of wistful tenderness, which is a counterpart to the more engaged absorption in the companion painting. Chardin was often to borrow his subject-matter from Dutch and Flemish art of the previous century, and the theme of *The embroiderer*, for example, can be matched in a work by Caspar Netscher (1635/6–84; Plate 11). But the ambiguously distracted air of Chardin's young woman, and the gently enveloping atmosphere created by the soft, caressing brushstrokes, make the earlier work seem detached, merely descriptive and prosaic in comparison, and give the eighteenth-century work a quite different, more poetic, but indefinable mood.

These latter qualities are normally associated with those scenes of amorous flirtation and dalliance, usually in sophisticated parkland settings, and known as *fêtes galantes*, which were the highly personal creations of Antoine Watteau (1684–1721) during the first two decades of the century. On one occasion he made a small painting of a domestic interior – now lost, but known through an engraving of 1731 (Plate 12) – which shows the varied occupations of women of different ages: two girls playing mischievously with a cat and a dog, a pensive old woman spinning, and a young woman working at embroidery. The theme is essentially

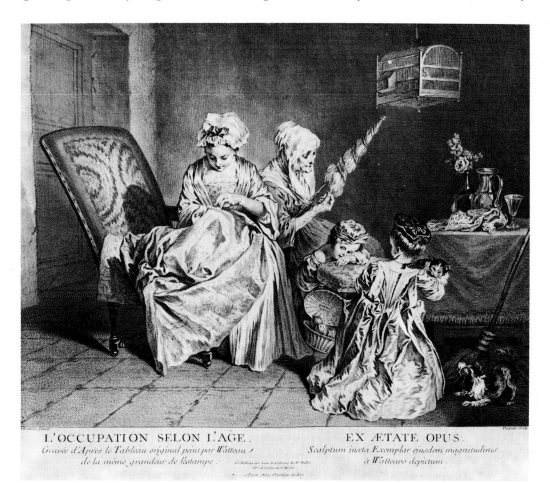

12. *Occupation according to age.* 1731. Engraving by C. Dupuis after Antoine Watteau's lost painting of *c.* 1718. Already at the beginning of the eighteenth century, Watteau was exploring the moralizing potential of everyday figure subjects in the manner of Dutch and Flemish artists of the previous century, providing a temporal and perhaps even a specific link between their approach and that of Chardin.

L'OCCUPATION SELON L'AGE.
Gravée d'Après le Tableau original peint par Watteau de la même grandeur de l'estampe.

EX ÆTATE OPUS.
Sculptum juxta Exemplar ejusdem magnitudinis à Watteavo depictum.

'The Three Ages of Woman', a speculation on the passing of time, and of life, from childhood to old age and beyond. It was not an uncommon theme in Northern European art – later we shall discuss a seventeenth-century French variation on it by Le Nain (Plate 31) – but Watteau's painting, which was in Parisian collections during Chardin's lifetime, was an especially delicate and poignant interpretation. Chardin's young embroiderer seems imbued with a decidedly Watteauesque air.

For all the singularity of his own art – a singularity that was universally recognized, if not always understood, by his contemporaries – Chardin pursued a successful career, with an international reputation, and was a highly respected figure in the Parisian art world of his day. He was devoted to the Académie, of which he was a member and office-holder for most of his working life, assiduously attending the official meetings. The Académie in the eighteenth century dominated artistic life in Paris, to a degree difficult for us to imagine in the post-Romantic era. It played a major part in the training of artists, in the maintenance of a very high standard of competence, gave them financial and intellectual encouragement, and looked after their interests in as many ways as possible. Not least, it provided opportunities for them to exhibit in public at the Salon.

From the mid-1750s until near the end of his life, Chardin was in charge of organizing and hanging these complex exhibitions. The drawing by Saint-Aubin reproduced above (Plate 3) shows the Salon Carré of the Louvre as Chardin hung it in 1765. He was sometimes cunning in the way he juxtaposed works at the Salon, to test a mediocre talent against a better one, or to bring out a contrast between two painters. In 1757 he hung his own works near those of the up-and-coming Jean-Baptiste Greuze (1725–1805), which gave rise to some interesting critical comments on their relative merits. His hanging of the work of Jacques-Charles Oudry *fils* (1720–78) in 1761 brought a vociferous protest from this painter, who as a result was suspended from the Académie for a while until he offered apologies. Chardin was also Treasurer of the Académie from 1755, meticulously attending to its accounts, and successfully managing to make a substantial improvement in its ailing finances.

Chardin was born in Paris in 1699, and was to lead a quiet, respectable and comfortable life there. Apart from one working visit to Fontainebleau in 1731, as far as we know he never left his native city (Plates 1 and 13) and its immediate environs. From the artistic point of view he might have argued that there was no need to travel further afield. The range of European art, from the north and from south of the Alps, could be studied in Paris – in the great royal collections, housed at the Louvre, the Palais du Luxembourg and nearby Versailles, in the equally impressive collection of the Duc d'Orléans at the Palais-Royal, and in the numerous superb private collections in the city.

Like many artists of the period, Chardin was the son of a successful skilled artisan, a master cabinet-maker; and the witnesses to his first marriage contract in 1723 were from a similar background and also included musicians and merchants. His young fiancée, Marguerite Saintard (1709–35), came from a more well-to-do background of administrators, lawyers and government officials. They were finally married in 1731. Later that year they had a son, Jean-Pierre, Chardin's only child to survive infancy, who was to die, probably by his own hand, between 1767 and 1769. Marguerite died in 1735. An inventory of her estate drawn up in 1737 lists a fair number of household goods and other items, many of which can be identified in Chardin's paintings. Whenever possible, these items are indicated in the relevant captions to the illustrations in the present book, where reference is also made to the 1779 inventory of Chardin's own estate.

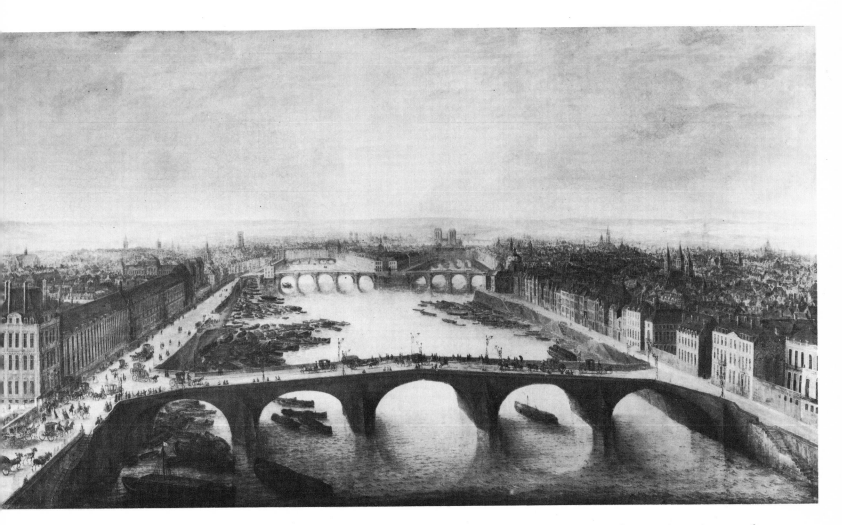

13. Charles-Leopold van Grevenbroeck. *Paris from above the Pont-Royal. c.* 1738. Oil on canvas. Paris, Musée Carnavalet. Grevenbroeck was a marine, landscape and topographical painter of Flemish origins, who exhibited a variety of such works at the Paris Salon between 1738 and 1743. This view of Chardin's Paris has the Pont-Royal in the foreground; to the left is the palace of the Louvre; at the tip of the island in the distance, where the two parts of the Pont-Neuf meet, is the Place Dauphine (see Plate 59); to the lower right are the three spires of the monastery of Saint-Germain-des-Prés, and further right the two towers of Chardin's parish church, Saint-Sulpice.

In 1744 Chardin was married again, to a wealthy widow with an income from investments and rents, Françoise Marguerite Pouget (1707–91). The couple soon set up home in a house belonging to her. Born and brought up in the Rue de Seine, then moving with his parents to the Rue du Four where he lived until his second marriage, and subsequently living literally round the corner in Françoise Pouget's house in the Rue Princesse, Chardin inhabited the same area of Paris around Saint-Germain-des-Prés and Saint-Sulpice for over fifty years (Plate 1). By the time of his second marriage Chardin's reputation was well established, and the couple must have lived in a comfortable manner. It is tempting to see this gradual improvement in circumstances as reflected in the subject-matter of his paintings from the later 1740s onwards. In 1757 he was granted living-quarters in the Louvre, which marked his full and official acceptance into the artistic establishment of his day. The little portrait drawing (Plate 14) by Cochin was made around this time.

Coming from an artisan background, albeit a fairly prosperous one, Chardin would certainly have been seen by his family as having 'gone up in the world'. Painting was a liberal art, elevated by its intellectual and imaginative dimension and dignified by the protection of the Académie Royale. Not only was Chardin an office-holder of that august body, but residence in the royal palace would have been an impressive symbol of the protection he enjoyed. His own circle of friends seems to have remained fairly modest. Within the Académie his closest friends were Charles-Nicolas Cochin *fils* (1715–90; Plate 15), son of the engraver of the same name (1688–1754) who reproduced a number of Chardin's works, and the portrait painter Joseph Aved (1702–66). The marine painter Joseph Vernet (1714–89) and the sculptor Jean-Baptiste Pigalle (1714–85) were of this same circle. The younger

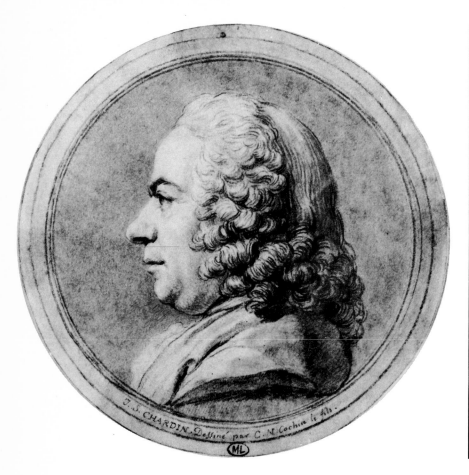

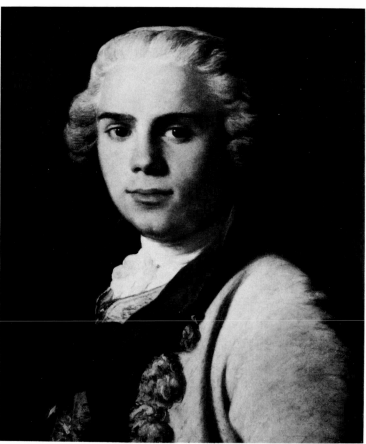

Cochin became Secretary to the Académie in 1755, and in his other influential official capacity as artistic adviser to the Directeur des Bâtiments was often to try to promote his friend's interests. His obituary of Chardin is the best and most personal contemporary biography of the artist, and a primary source for our knowledge of the man and his art.

A typical friend of Chardin and his second wife was Aignan-Thomas Desfriches (Plate 16), a talented draughtsman and collector, who was obliged to give up an artistic career to look after his prosperous family business in Orléans. Some warm and amiable correspondence between Desfriches and the Chardins exists — the letters normally written by Madame Chardin. Desfriches made regular visits to Paris to see the Salon, and purchased modest works by his contemporaries and by Dutch and Flemish masters. He owned a number of works by Chardin, including *A pheasant and game-bag* (Plate 186) and *A hare with onions and a pot of stocks* (Plate 187). Chardin seems to have sold some of his works to his friends at a discount; Desfriches, for instance, paid 48 livres for one of these pictures although he valued it at 72 livres.

Jean-Jacques Lenoir, a prosperous furniture-dealer and cabinet-maker — '*Négociant, Bourgeois de Paris*' as he was described when witnessing Chardin's second marriage — was another friend, whose wife and children Chardin portrayed (Plates 140, 141 and 146). He also painted portraits of the children of the jeweller and banker Charles Godefroy (d. 1748). These portraits (Plates 103 and 149) are discussed below in their place, but some idea of the cultivated aspirations of this household can be gained from the drawing of the boys (with a tutor or a friend?) by Jean-Baptiste Massé (Plate 148). Chardin himself was described as a '*bon bourgeois*', and although that may mean simply 'an upright citizen' it also implied a comfortable existence financially and socially above manual work or petty trade, but

14. (*left*) Charles-Nicolas Cochin. *Portrait of Jean-Siméon Chardin. c.* 1755. Pencil on Vellum, diameter 4½ in. (11.5 cm.). Paris, Musée du Louvre, Cabinet des Dessins. This portrait by Cochin of his friend was engraved by L. Cars in 1755. It is reproduced here in the original size.

15. Unknown painter. *Portrait of Charles-Nicolas Cochin. c.* 1745. Oil on canvas, 17¾ × 15 in. (45 × 38 cm.). Amiens, Musée de Picardie. This fresh and direct portrait dates from the mid-1740s, when Cochin would have been about thirty. An old attribution to Louis Tocqué is no longer accepted.

below the glittering world of financiers with their vast fortunes. It is appropriate that the Académie should have put Chardin, always prudent in his own affairs, in charge of its finances.

A number of Chardin's contemporaries remarked on a close affinity between the character of his work and the character of the man himself: 'One is struck by the naïvety which forms his character and which governs his work', wrote one, while another extolled 'an admirable simplicity, which makes him such a faithful imitator of nature'. An obituarist in 1780 saw 'noble simplicity' not only in his art but also in 'the character of his mind'; and this anonymous admirer continued: 'Honest in his morality as in his pictures, of a strict probity, but modest, compassionate and kind in company . . . he was a good son, a good husband, a good father and above all a good citizen.' While these epithets conform to the encomiastic conventions of the eighteenth-century obituary, nevertheless they provide some insight into the social integration of the artist in Chardin's day, and are far from the Romantic myth of the 'artistic temperament' at odds with the world.

Chardin had other friends among contemporary artists, several of them neighbours in the studios and apartments of the Louvre after his own move there in 1757, and he was generally liked and admired both as a loyal fellow-Academician and as a painter. A number of his colleagues had works by him in their collections: Aved, who was also a dealer, the sculptor Philippe Caffiéri (1714–74), the engravers Jacques-Philippe Le Bas (1707–83) and Georg Wille (1715–1808). The engraver and draughtsman Jacques-Augustin de Sylvestre (1719–1809) was a keen collector, and his name often appears in the Salon catalogues after 1759 as lending works by Chardin; he was the first owner of the pastel portraits of the artist (Frontispiece) and his second wife (Plate 223).

Socially and financially elevated above the immediate circle of the artist's friends and colleagues, a fond Parisian collector of Chardin's works was Ange-Laurent de La Live de Jully (1725–79). Inheritor in 1751 of a huge fortune from his financier father, he began avidly to collect works of art, and by the time he compiled and published the catalogue of his collection in 1764, it was one of the most celebrated in Paris. An interesting feature of this collection is La Live's attempt to display a representative range of works of the French School. He explains this in his catalogue:

> The taste which I always had for painting . . . gave me many an opportunity to go and admire the fine collections of pictures assembled in the various cabinets of Paris. I was astonished to see that the taste of French art lovers had led them to make collections of foreign pictures, above all of the Flemish School, and that French pictures hardly had any place in their cabinets, or found themselves placed only in the last row, so that [the collectors] would, so to speak, have something of everything.

In fact La Live had an impressive collection of Dutch and Flemish works, but also some two dozen important French pictures of the seventeenth century. At pains above all to encourage contemporary artists, he played an important role in promoting the reputation of the young Greuze, purchasing around ten of his works, including the sensationally successful work of his Salon début, *The Bible-reading* (Plate 209). He was especially keen on the lesser genres, and acquired many portraits, about a score of still lifes by various painters, animal pieces by Oudry, and scenes from modern life by Greuze and Chardin. Among his Chardins were the versions of *The drawing lesson* and *The good education* (the former perhaps Plate 17; see Plates 170 and 171) shown at the Salon of 1753, and imposing still lifes such as *The kitchen table* (Plate 191) and *The butler's table* (Plate 192), lent by the owner to the Salon of 1757.

Chardin showed his commitment to the art of his own century by sometimes

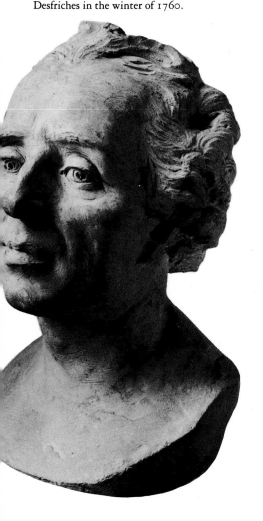

16. Jean-Baptiste Pigalle. *Portrait of Aignan-Thomas Desfriches*. 1760. Terracotta, height 20⅛ in. (51 cm.). Orléans, Musée des Beaux-Arts. This lively bust was executed while Pigalle was staying with his friend Desfriches in the winter of 1760.

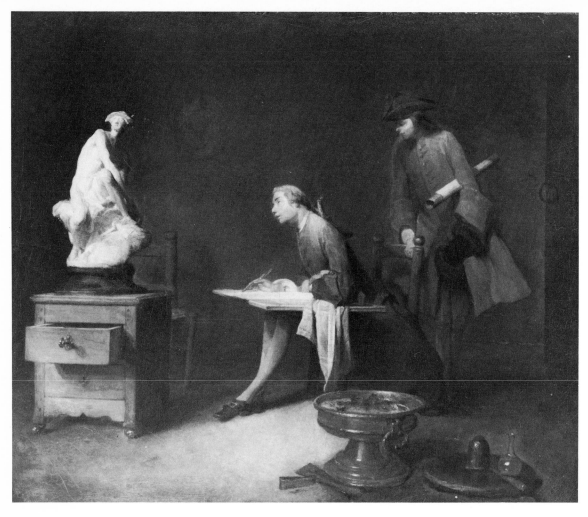

17. *The drawing lesson.* 1748–53. Oil on canvas, 16 × 18½ in. (41 × 47 cm.). Artemis Group. Chardin painted two versions of this work, one in 1748 for Luise Ulrike of Sweden (Salon of 1748) and one with slight variations for the Parisian collector La Live de Jully (Salon of 1753). If the engraving reproduced as our Plate 170 was indeed after the Queen of Sweden's picture, then the present painting, differing in some details, is probably the one sent by La Live de Jully to the Salon of 1753. Thus the Queen of Sweden's painting (and its pendant) await rediscovery; or perhaps new documentary evidence will clear up the confusion. Chardin's own plaster cast of the *Mercury* is listed in the 1779 inventory of his estate. Our illustration shows the painting after cleaning in 1983. Some contemporary critics did not appreciate the refined handling of this work, see page 176.

18. Jean-Baptiste Pigalle. *Mercury attaching his wings.* 1744. Marble, height 20⅛ in. (51 cm.). Paris, Musée du Louvre.

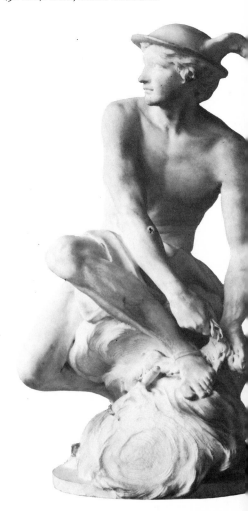

paying tribute to contemporary works in his paintings. For example, in another representation of an artist at work, known as *The drawing lesson* (Plate 17), we see a student busy making a drawing after a plaster cast of the celebrated *Mercury attaching his wings* by Jean-Baptiste Pigalle. A marble version of the *Mercury* (Plate 18) was presented by the young sculptor as his reception-piece for membership of the Académie in 1744, and it established his reputation as the rising star of modern sculpture. Chardin owned a plaster cast of this famous work – no doubt the one that appears in the painting – while Pigalle, at the time of his death in 1785, owned no fewer than six paintings by Chardin. Abbé Gougenot (an enthusiastic admirer of Chardin's art), in a commentary on the Salon of 1748 where a version of *The drawing lesson* was shown, saw the inclusion of Pigalle's *Mercury* as something of a manifesto, carrying the message that modern French art could provide a model for artistic endeavour, just as well as, and even in place of, the Antique: 'The figure being copied is M. Pigalle's *Mercury*. Through this choice, the author is letting it be known that our own School can furnish drawing with the purest models of correctness.'

During the next few years there was to be a protracted public outcry when Louis XV decided to make a gift of a larger marble version of the *Mercury* and a companion piece to Frederick II of Prussia, to mark the Peace of Aix-la-Chapelle in 1748. In his *Observations sur les arts* of that year, Charles Léoffroy de Saint-Yves wrote:

To talk any longer about these pieces would be to augment the regrets of the public, which sighs to see them depart. Soon they will leave our sight to carry to the North the glory of M. Pigalle and his art, there to form the foundations of a School. Such is the lot of France: she produces great artists only for the benefit of the foreigner.

Frenchmen were indeed proud that Paris was the artistic hub of Northern Europe in the eighteenth century – but it also upset them to see many of their finest productions shipped off to distant places ranging from St Petersburg to London. Chardin himself had been aware of this issue just a couple of years before – executing a pair of domestic interior scenes on commission for the Swedish court in 1746, he insisted, in spite of the protestations of his impatient patron, on keeping the works in Paris until they were engraved for reproduction, 'since France will be losing these two paintings, and since one owes something to one's nation'.

Chardin was to pay tribute to Pigalle once more, when he included the plaster *Mercury* in *The attributes of the arts*, a large work commissioned by Catherine II in 1766 as an overdoor decoration for a room in the St Petersburg Academy. He painted a replica for Pigalle, most likely the painting now in Minneapolis (Plate 19). *The attributes of the arts* is also the tribute of a great painter to the art of sculpture – sculpture dominates the design, even over the loaded palette and brushes of the painter. Pigalle had worked hard to raise the status of modern sculpture, which had long been a poor relation to painting in French eyes; for

19. *The attributes of the arts.* 1766. Oil on canvas, 44½ × 55⅛ in. (113 × 140 cm.). Minneapolis, The Minneapolis Institute of Arts.

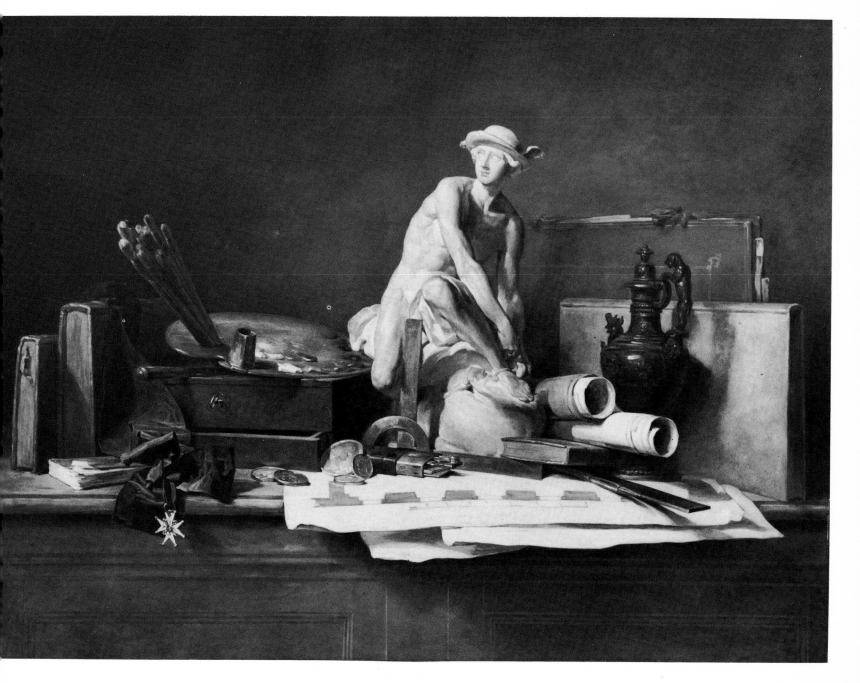

example, one of the highest honours for a painter was to be appointed Premier Peintre du Roi – but there was no post of Premier Sculpteur. Pigalle, however, was to be the first sculptor (jointly with Jacques Saly, 1717–76) to receive the royal decoration of the Ordre de Saint-Michel in 1769. The award had apparently been proposed by Louis XV in 1765 (the year before Chardin's painting), to show his pleasure and satisfaction at seeing Pigalle's monument to him in the Place Royale at Rheims. The Order on its black riband dangles prominently over the ledge at the left of the picture. At about this time Pigalle had his portrait (Plate 20) drawn in pastel by Marie-Suzanne Roslin (1734–72), and it was exhibited at the Salon of 1771. He is proudly dressed as a knight of the Ordre de Saint-Michel, in black silk and with a cape lined in blue moiré, the medal near his hand, and a model of the Rheims monument in the background. Once we understand the full context, Chardin's painting of *The attributes of the arts* can be seen as something more than just a still life. Indeed, it embodies the kinds of meaning we might rather expect of an allegorical history painting. After admiring the confident dispositions of form, space, colour, tone and light in this work, one commentator expressed the wish that contemporary history paintings should share its perfection of form and effect: 'Who would not be pleased to do a history painting as true, as decisive, as this Mercury and these attributes of the arts, which at every moment of the day, even in the evening, keeps its effect . . . ?'

It is indeed formally a complex work, successfully organized with the greatest clarity. The colours of the painting are found ranged on the palette within it, dominated by the primaries, yellow, red and blue. The portfolio at the right, with its blue ribbons, is bound in bright red leather, while the two books at the left have red page-edges; one of these has a blue place-marker, while below rests a volume bound in blue paper. There are other small accents of red and blue, while the large tome at the right is bound in yellow parchment. For all that this work is a tribute to sculpture, it was generally recognized at the Salon of 1769 as being a masterpiece of Chardin's own art.

The interest in sculpture of this most painterly of eighteenth-century painters is worth remarking. On several occasions, but especially towards the end of his career, Chardin enjoyed making monochrome paintings after well-known sculpted reliefs, such as the *Autumn* (Plate 21), based on a plaster cast taken from one of the Four Seasons on the celebrated fountain in the Rue de Grenelle (Plate 22, engraving) designed by Edme Bouchardon (1698–1762). Commissioned in 1739, this was one of the major public monuments erected in Paris during Chardin's lifetime. If the overall effect of the fountain was found to be, and remains, somewhat disappointing, the lively reliefs of the Four Seasons have always been admired. Bouchardon exhibited plaster casts of them at the Salon of 1741. Chardin's *Autumn* was painted in 1770, but he had already paid a posthumous tribute to the great classical sculptor by including the allegorical statue of the City of Paris from the fountain in a decorative overdoor painted for the Château de Choisy in 1765 (Plate 202).

Chardin's paintings of reliefs were well received at the Salons. One critic wrote, in terms which will be familiar to the reader by now:

> It is not only the degree of illusion he has attained, which makes his pictures worthy of the highest esteem; they are even more so because of the manner, spirited, bold and broad, in which they are painted. The character of this artist is to paint with a strength of harmonious magic, which astonishes even the most talented painters.

The *Autumn* relief is in itself a sensuous subject, with plump, naked children feeding off abundant bunches of grapes and playing with a boisterous goat; they

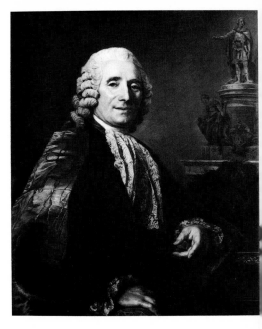

20. Marie-Suzanne Roslin. *Portrait of Jean-Baptiste Pigalle.* 1770. Pastel, 35⅝ × 28¾ in. (91 × 73 cm.). Paris, Musée du Louvre, Cabinet des Dessins. Following convention, this portrait of a member of the Académie (together with the portrait of another academician, the history painter Jacques Dumont le Romain) formed the reception-piece for Madame Roslin's admission to that institution as a portraitist in 1770.

21. *Autumn.* 1770. Oil on canvas, 20⅛ × 32½ in. (51 × 82.5 cm.). Moscow, State Pushkin Museum of the Fine Arts. One of Chardin's very last works in oil, when it was exhibited at the Salon of 1771 it aroused less interest than his newly developed studies of heads in pastel.

22. The Fountain of the Rue de Grenelle. 1752. Engraving by Babel in J.-J. Blondel, *Architecture française*, Vol. I, after Edme Bouchardon's fountain commissioned in 1739. The reliefs of the Four Seasons are under the niches containing statues; Autumn is second from the right. Chardin was also to depict the allegorical figure of Paris (Plate 202) seated in the centre between reclining figures of the rivers Seine and Marne.

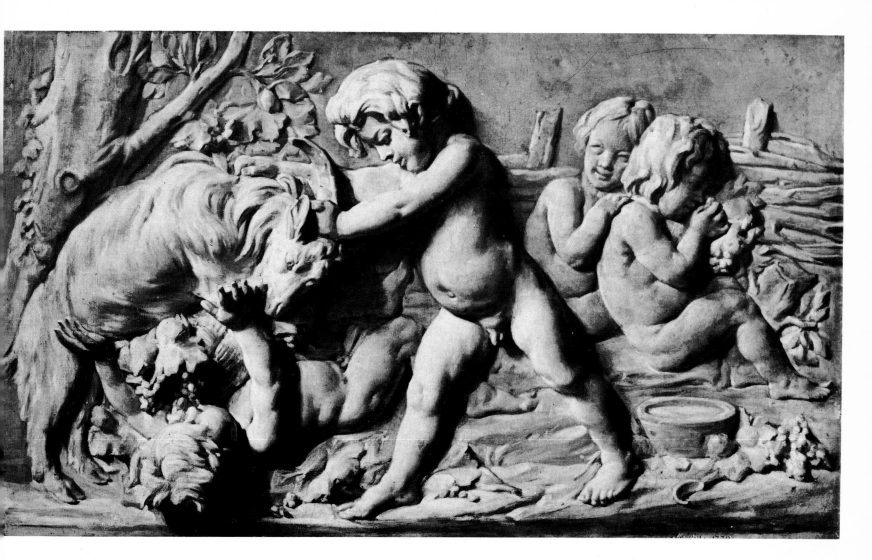

ÉLÉVATION GÉOMÉTRÀLE ET DÉVELOPPÉE DE LA FONTAINE ERIGÉE RUË DE GRENELLE, FAUBOURG S.ᵗ GERMAIN
Par les soins et pendant la 5.ᵉ Prevôté de MONSIEUR TURGOT, Conseiller d'Etat, Prevost des Marchands, &c &c.
Sur les desseins et sous la conduite du Sieur Edme Bouchardon, Sculpteur du Roy.

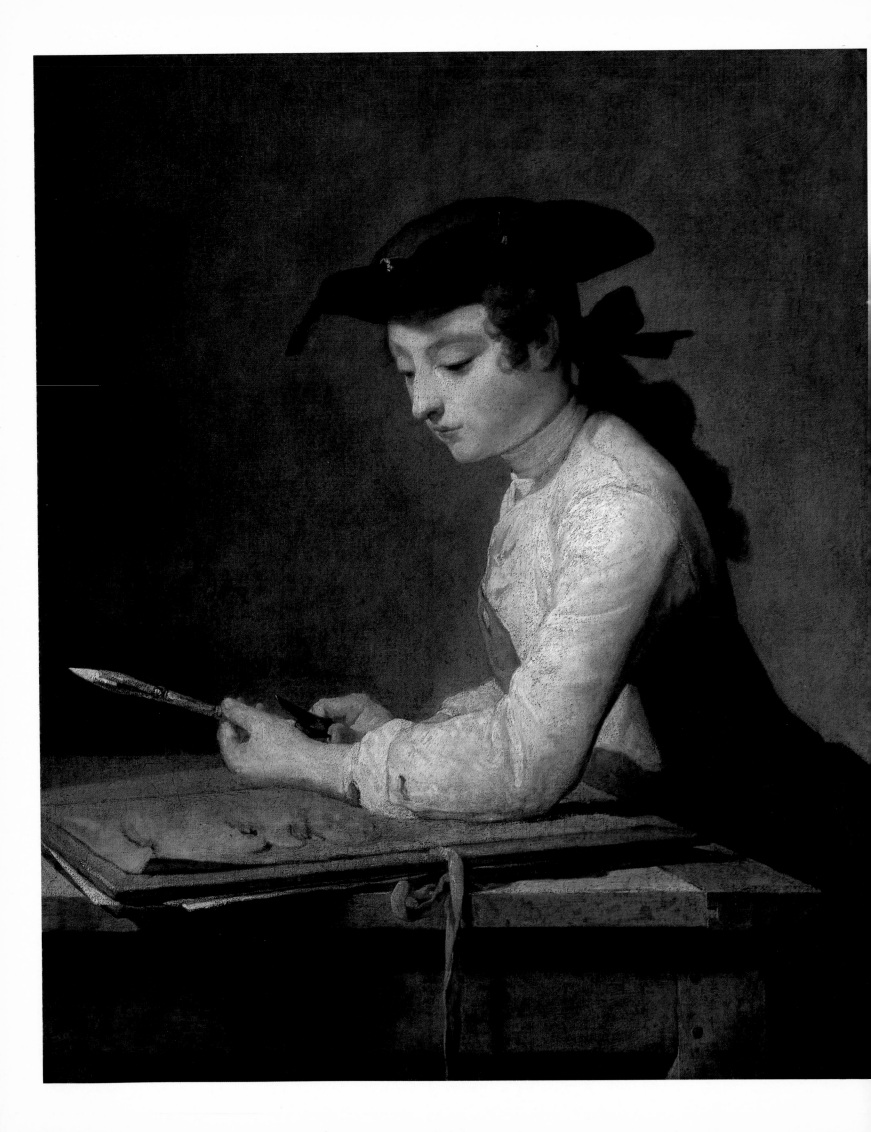

23. *The young draughtsman*. 1737. Oil on canvas, 31½ × 25⅝ in. (80 × 65 cm.). Paris, Musée du Louvre. One of the earliest Chardins to come to England, where it was engraved in 1740 (Plate 25), and where it remained until the 1830s. The original pendant, showing a girl pausing over her needlework, awaits rediscovery. An autograph version is in Berlin, acquired by Frederick II of Prussia in 1747.

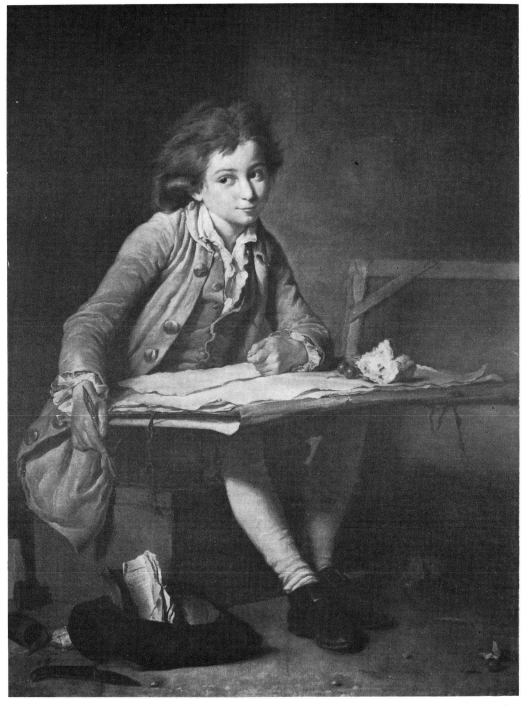

24. Nicolas-Bernard Lépicié. *The young draughtsman. c.* 1770. Oil on canvas, 46 × 36 in. (117 × 91.5 cm.). Private Collection. Son of François-Bernard Lépicié, the engraver of Chardin, Nicolas-Bernard, born 1735, was a history painter (one of his history paintings can be seen in Saint-Aubin's view of the Salon of 1765, Plate 3); but from the early 1770s until his death in 1784 he turned rather to anecdotal and sentimental genre paintings influenced by Greuze.

seem like descendants of Donatello's vigorous infants of the Renaissance. Chardin endows them with the softest modulations of light and shade, tremulous in the half-lights. Perhaps he is playing a mild game with the spectator – paintings which look like sculptures, paintings of sculptures, painterly sculptures – and proving at the same time the greater imitative power of painting. Perhaps also he felt that the power of his art was being tested to the limit, in infusing a sensuous vitality, a warmth (one is tempted to say – of colour!), into the hard matt surface of plaster. It was in discussing such paintings of monochrome reliefs that Diderot was prompted to reiterate Chardin's rare comment on the role of feeling in the art, adding that 'It is feeling which perceives the ripple of light and reflections on surfaces . . . which captures and renders, I know not how, their wonderful confusion.'

The sensitive, understated and subjective nature of Chardin's art is epitomized in *The young draughtsman* (Plate 23); and is all the more apparent when contrasted with Nicolas-Bernard Lépicié's cheeky *Young draughtsman* (Plate 24) of *c.* 1770, who

hectors, who insists on our attention, who engages us in anecdotal narrative by flicking cherry-stones out of the picture. The contentment of Chardin's youth and his self-containment are expressed not only through his expression of quiet absorption in the task in hand, but in the perfect equilibrium of the design, the subtle adjustment of impasted paints from rough to smooth, the delicate control of tonal values, the muted harmony of the palette, receding from the red ribbon dangling before our eyes from his portfolio. The student is sharpening the black crayon in his twin crayon-holder, intent upon returning to his drawing of a grotesque old man's head. It has been suggested that this painting may be a critique of the dull system of contemporary academic art education, which Chardin did criticize elsewhere. But this notion is hardly supported by the contented absorption of this boy. He might equally be attempting an essay in Leonardesque fantasy and invention, fired, perhaps, by the series of grotesque heads recently engraved by the Comte de Caylus in 1730. Moreover, the moralizing verses emanating from the decidedly anti-academic Hogarth circle, which are appended to John Faber's lovely English mezzotint of 1740 after this very work (Plate 25), are a gentle exhortation to study: to study nature, it is true – and Chardin would not have argued with that – but there is no suggestion that this 'happy youth' is intent on anything else. Paradoxically, he engages us by his very reserve. The invitation to contemplate his form, his meaning, is tacit. Like all of Chardin's subjects, he refuses to yield up any secrets; he conceals more than he chooses to reveal.

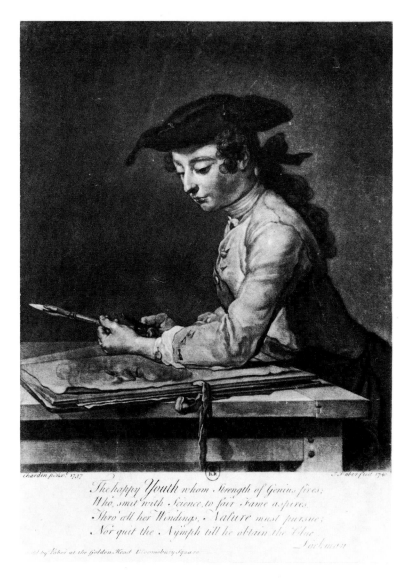

25. *The happy youth* . . . 1740. Mezzotint by J. Faber after Chardin's painting of 1737 (Plate 23). This fine print is evidence of contemporary British interest in Chardin's art. John Lockman (1698–1771), who wrote the verses, was a minor writer and a noted translator of contemporary French literature.

2 *Academic Ideals*

In our own day, Chardin is probably the best-loved French painter of the eighteenth century, admired without reservation. Indeed, he is almost a hero of modern art. In still life or domestic interior, the integrity of his art seems as hard-won a struggle against the intractability of the world as that of Cézanne. Original in its application and assertive in its physical presence, the exquisite substance of his paint takes on a life of its own. The simple objects of everyday life, artefacts and foodstuffs, or the habitual movements of the daily round, seem sanctioned by his tender regard. He denies the rhetoric of his peers. The equivocal, at times even hostile, reaction of some contemporary critics – sensitive and artistically informed men – may puzzle us by its apparent incomprehension of his art, while it increases our estimation of his single-mindedness, his heroism. Should we simply dismiss such critics as blinkered by received ideas, which only go to prove the worthless pedantry of the old academic values? For these were the standards by which Chardin was often judged.

Following the humanistic ideals expressed in Renaissance artistic theory – and most perfectly, in practice, in the works of Raphael – the Académie since its foundation in the mid-seventeenth century encouraged its artists to promote a noble and heroic image of mankind. History painting – that is, subjects taken from the Bible, history and literature, with a theme of serious moral import – was seen as the highest aspiration of the artist, and the great bulk of academic theory and all of its practical teaching were designed to promote this genre. If the dual aim of art was to please and to instruct the spectator, then it was on history painting above all that the burden of instruction fell. In an influential lecture given in 1667, André Félibien, the Secretary of the Académie, codified a hierarchy among the different genres of painting. History painting was at the top of this hierarchy, representing man in his ideal aspect, in some morally or historically important role; next came portraiture, showing man more 'as he is' than 'as he ought to be' in some ideal scheme of things; then came what we call 'genre' painting, still concerned with human experience, but in a lowly, everyday, and usually merely picturesque way; below this came landscape, animal painting and still life, showing nature at its most basic, amoral level. In 1728 Chardin was to be received into the Académie as a painter of 'animals and fruit'.

Not very long after his reception, however, Chardin began to paint figure subjects. As long as he confined his efforts to the lowly class of still-life painting, Chardin's art was perfectly acceptable to those commentators who were interested enough to write about it. But to turn to the human figure was to invite evaluation in terms of a great and time-honoured tradition. A hierarchical and compartmen-

talized way of thinking about art conditioned the responses of nearly all informed spectators in the eighteenth century. Thus, one of the earliest commentators on Chardin's figure painting, a Parisian correspondent of the Marquis de Caumont reporting on the Salon of 1737, carefully qualified his own observations about *A girl with a shuttlecock* (Plate 135) in the light of this habit of mind:

> When you speak of truth in painting, it is there that you should look, if you wish to be sure of finding it. I know the distinction one should make between such limited subjects and others which demand much more imagination; but I also mean only to tell you which gave me the greatest pleasure.

While to some eighteenth-century spectators Chardin simply took his place low down in the academic hierarchy of the genres, to others the power of his art brought into question the validity of that hierarchy. His challenge to accepted values came not only from the fact that his works gave more pleasure than history paintings in the acuteness of their observation and the sheer visual delight of their paint surface, but also because they implicitly carried as much meaning as many a work with more apparent pretensions. But his contemporaries seem usually to have missed this meaning. Chardin's admirers praised the realism of his art in a conventional way, although occasionally we come across a sympathetic and understanding commentator, like the one who in 1742 recalled a visit to Chardin's studio by Saïd Pasha, ambassador extraordinary of the Sultan, who was in Paris in December 1741:

> The Ambassador was also taken to see Chardin, known for that admirable simplicity, which renders him such a faithful Imitator of Nature . . . Do you not agree with me, Sir, that seeing those masterpieces, recognizable as such, his Excellency would have felt all the value of that simplicity and truth, which are so rare, so difficult to grasp in a century when art of every kind is so close to mannerism and affectation?

So at least some of his spectators were aware of Chardin's fundamental seriousness of purpose, even if unable to define or explain it. It is only in quite recent years that the subject-matter of his figure-pieces has been studied with a view to understanding its full significance.

Art criticism as a literary genre did not develop until the 1740s, stimulated by the institution of regular exhibitions at the Salon in 1737. Chardin's career as a figure painter came to fruition during these years, and so his works were assimilated into the critical debate. It was only in 1747 – well into Chardin's career – that the serious discussion on the condition of contemporary French painting was opened by La Font de Saint-Yenne in his celebrated essay, *Réflexions sur quelques causes de l'état présent de la peinture en France*. La Font used the occasion of the Salon exhibition of the preceding year as an opportunity to express his views, which we can take to exemplify the classic/academic standpoint. Broadly speaking, his argument is that the stylistic development of interior decoration in early eighteenth-century France, with its employment of elaborately carved wooden panelling and the extensive introduction of large mirrors, had diminished the opportunities of the painter to execute large-scale history paintings or tapestry cartoons. Nor was history painting any longer encouraged by official patronage, as it had been in the reign of Louis XIV. As a result, modern painters, including the very best talents, fell too readily to the execution of merely decorative works, which played a subordinate role in an overall scheme, or to cabinet pictures on a small scale. Moreover, painters were forgetting and neglecting the time-honoured traditions of grand design handed down from the sixteenth and seventeenth centuries and no longer looking to the elevated moral paradigms of history and literature for their subject-matter.

La Font continues to elaborate his ideas in his discussion of various painters exhibiting at the 1746 Salon. Jean-Baptiste-Marie Pierre (1713–89) especially interested him: here was a highly competent young history painter, trained in model fashion through the Académie in Paris and its branch in Rome, who demonstrated his abilities in large and dramatic historical compositions such as *The punishment of Herod* and *Medea*. After a eulogistic description of Pierre's expressive powers in the former work (which is now lost), La Font adds: 'The French School can hope to recover its earlier vigour in History through Pierre, author of this picture, who is taking giant strides in his career.' This was an accurate perception of Pierre's potential, for he was indeed to succeed Boucher in 1770 as Premier Peintre du Roi, and was to be one of the leaders of artistic reform in the reign of Louis XVI.

But La Font also expressed dismay that a painter of such apparently elevated aspirations could equally happily turn his hand to cabinet pictures showing merely picturesque scenes of low life. Pierre had been exhibiting such works since his Salon début in 1741, and when he did not specify the subject he usually called them *'bambochades'*, after the low-life works of the Dutch artist Pieter van Laer (*c.* 1592–1642), who worked in Rome in the seventeenth century and was known locally, and subsequently, as Bamboccio. It may be significant that Pierre was to cease exhibiting such works after 1748, the year when he reached the status of Professor

26. Jean-Baptiste-Marie Pierre. *The schoolmistress. c.* 1741. Oil on canvas, 51¼ × 37¾ in. (130 × 96 cm.). Auxerre, Musée des Beaux-Arts. When Pierre, as Premier Peintre du Roi and Director of the Académie in the 1770s, attacked Chardin as a genre painter, he conveniently forgot his own early essays in this type of work.

at the Académie; his lively interest in the everyday life around him had been aroused during his own time as a student in Rome from 1735 to 1740, as his graphic work especially shows. La Font wrote:

> The public would strongly advise him to abandon his mediocre talent for *Bambochades*, which are unworthy of a man whose genius is sufficiently elevated to conceive and execute the picture of Herod; it is Scapin's bag as opposed to the *Misanthrope*, it is as if the author of the *Cid* and of *Rodogune* put out fair-ground entertainments.

In short, the painter of genius should pay no attention to such 'subalternate tastes'; and it is no excuse to say that such paintings are 'the left-overs of great works'. La Font continues by saying that success in any class of painting, high or low, depends on constant application and study, and that the history painter will only waste his time on genre: 'Without thoughtful study and much practice, he will fall into that vile multitude of painters of this type, who flood the bourgeois cabinets of our petty art-lovers, whose delight they are.' Any spare time the history painter may have should be devoted to the more useful activities of reading the great poets and historians and studying the old masters.

La Font's *Réflexions* is of course a polemical work, which expresses a somewhat uncompromising academic point of view. The genre scenes of Pierre were generally admired by other critics, along with his history paintings. *The schoolmistress* (Plate 26), for example, was 'viewed with pleasure' by one anonymous critic at the Salon of 1741:

> The subject is treated appropriately. The gravity of the pedagogue, the embarrassment, the apprehensive respect of the schoolgirls, all this is well characterized. Their clothing, though of simple stuffs and not very dressy, only conforms to their age and standing.

While Pierre's *bambochades* of the 1740s do have a down-to-earth quality he had absorbed as a student in Rome in the previous decade, the decision to adopt this sober and realistic mode of painting could well have been inspired by the example of Chardin, whose reputation was rising just at the moment when Pierre began his own Parisian career. But while Chardin would be unaffected by La Font's remarks on genre in general – and by his ambivalent attitude to Chardin's paintings in particular – very likely the critic's strictures combined with Pierre's academic ambitions to turn this painter into the doctrinaire classicist, and enemy of Chardin, which he was to become.

La Font's challenging book opened up a lively debate. His ideas were to be forcefully answered by Abbé Gougenot, a much more empirical and less high-minded critic, whose aesthetic viewpoint was more naturalistic. In a review of the Salon of 1748, Gougenot turns to the works submitted by Pierre that year:

> Among many small works of happy composition and a pleasing and vigorous touch, we were delighted to see that he has not abandoned his talent for *bambochades*. If he had deferred in this to the feelings of the author of the *Réflexions sur la peinture*, we would have been deprived this year of many works in this genre *of an original and seductive variety*. Whatever M. La Font says, a history painter can sometimes, *without dishonour to his genius*, amuse himself with this sort of task; just as the mind cannot always be extended and occupied with great and elevated ideas, these little compositions are so many useful amusements which, in giving the imagination a needed rest, are new proof of its range and fecundity.

For Gougenot, Pierre's genre scenes do have some interest and value within their

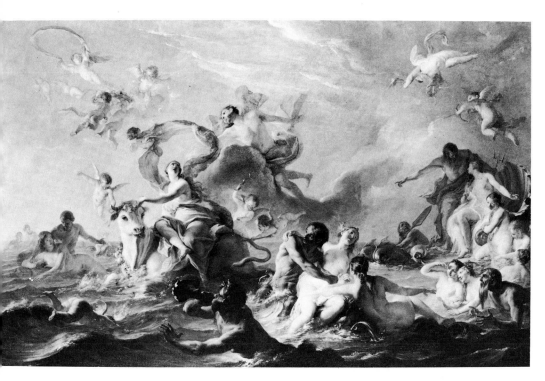

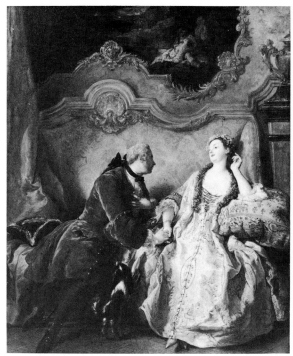

27. Noël-Nicolas Coypel. *The Rape of Europa*. 1727. Oil on canvas, 51 × 76⅜ in. (129.5 × 194 cm.). The Philadelphia Museum of Art (Gift of John Cadwalder). A masterpiece of rococo decoration from one of Chardin's first teachers, it was Coypel's entry for an official competition in 1727 to encourage history painting.

28. Jean-François de Troy. *The declaration of love. c.* 1725. Oil on canvas, 25 × 20¾ in. (63.5 × 52.7 cm.). Mr and Mrs Charles B. Wrightsman Collection. The excitement of the dog underlines the eager desire of the young man, whose real intention is perhaps reflected in the decorative painting within the painting.

class of painting, even if they are only 'amusements' in relation to history.

Both La Font and Gougenot were opposed to the decorative rococo type of art which they felt had dominated French painting for too long. This art is typified in *The Rape of Europa* (Plate 27) by Noël-Nicolas Coypel (1690–1734), one of Chardin's first masters. A silvery-pink Europa is carried out to an azure sea by a beautiful white bull, and Zephyr blows them on their way, puffing Europa's garment into a fluttering loop whose serpentine shape is an echo of the flowing movements of the design as a whole. Frolicsome *amorini* swoop and dive in the clear air, while plump nymphs sport with muscular Tritons in the curling waves. The colour is brighter, clearer and more transparent than nature would ever allow, a perfect complement to the graceful mannerism of Coypel's design.

On a more domestic scale, and in contemporary settings, this light-hearted decorative approach to painting found expression in the gallant scenes executed in the 1720s by Jean-François de Troy (1679–1752). *The declaration of love* (Plate 28) can be compared with Coypel's work in its gay colours, its love of surface, and its sinuous rococo rhythms. Indeed, there is a sense in which *The Rape of Europa* could replace the ornamental painting set into the wall behind De Troy's amorous couple, where we see an even less decorous advance. De Troy's painting owes a good deal to the *fêtes galantes* of Watteau in its interest in the flirtatious aspect of human affairs, although it is more prosaic in its recognizably contemporary interior setting and costumes. This type of painting understandably enjoyed a considerable public success throughout the first two-thirds of the century.

The survival of the more intimate type of rococo painting into the 1740s can be seen in Nicolas Lancret's *A family taking coffee* (Plate 29). This family group, a charming combination of solicitude and humour, has none of the amatory implications of the dallying couples in Watteau's *fêtes galantes* (a genre which his pupil Lancret also continued), but the scale and type of the figures, their setting in a somewhat artificial park, and the dainty way the whole is painted, are strongly reminiscent of the master. Lancret (1690–1743) was a leading decorative painter in the 1720s and 1730s, and this carries over into the fluid and graceful rhythms of his easel-pictures. The fanciful scale and perspective of the fountain and pool at the

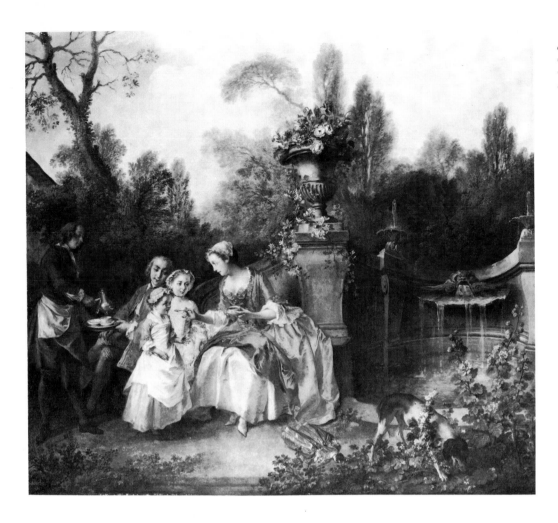

29. Nicolas Lancret. *A family taking coffee.* c. 1742. Oil on canvas, 35 × 38½ in. (88.9 × 97.8 cm.). London, National Gallery. This delightful family group was exhibited by Lancret at the Salon of 1742.

right matter less than their sweeping curves and imaginative forms as elements in the design as a whole.

The domestic and familial concerns which we shall meet in Chardin's art of the late 1730s are given a rococo turn in 'Le déjeuner' (Plate 30) by François Boucher (1703–70). Boucher's characters are never usefully employed, and his children interrupt their games only to take a drink of chocolate. His name is almost synonymous with rococo decorative painting from the 1730s to the 1750s; in 'Le déjeuner' the scale is reduced to comply with the popular taste for small Northern cabinet pictures. The artist takes pleasure in representing a well-appointed rococo interior, with its ornate asymmetrical clock and candelabra, its fancy furniture and woodwork, and its pretty women in their finery. The superb craftsmanship of his technique matches the material quality of the world he represents, just as the gracefully flowing rhythm of his design corresponds to its elegance. The type of art represented by the three paintings just discussed would have been exactly what the anonymous commentator in the early 1740s mentioned above (page 36) castigated for 'mannerism and affectation'.

The late 1740s and early 1750s were crucial years for aesthetic debate, revolving around an awareness of the classical tradition and a less ambitious, more naturalistic approach. For all of La Font's polemic, he also tacitly admits that the finest painters of the day were those who attached themselves to nature and made themselves masters of lesser, less idealist genres – the marine and landscape painter Joseph Vernet: 'a great painter, a natural philosopher, able scrutineer of nature'; Jean-Baptiste Oudry (1686–1755): 'nature conceals her charms from the regard of others to display them to his. There she reveals herself in a naïve and rural beauty, a thousand times more enchanting and analogous to our natural tastes, than those of

30. François Boucher. *'Le déjeuner'*. 1739. Oil on canvas, 31⅞ × 25⅜ in. (81 × 65 cm.). Paris, Musée du Louvre. For all its fashionable rococo elegance, Boucher's cosy domestic scene is his response to the contemporary interest in Dutch genre painting of the previous century.

the palaces of kings'; and Chardin. These painters at least offered a sober and naturalistic alternative to the decorative rococo art of a De Troy, a Lancret, or a Boucher, fine painters in their own ways, but who misapplied their talents.

A critic like Abbé Gougenot, on the other hand, took a much less ambivalent and more positive naturalistic and liberal-minded approach. In landscape painting, for example, he advocated attention to the changing effects of nature and so anticipated the attitudes of the Romantic period; and at a time when Watteau's work was increasingly neglected – and even attacked by the influential and classically minded Comte de Caylus in a discourse to the Académie in 1748 – Gougenot regretted that Watteau had had no pupils or followers, since the death of Lancret in 1743, to continue the light-hearted genre of the *fête galante* which he had perfected. The neglect of the *fête galante* was also regretted by the painter Massé (1687–1767) in a lecture delivered at the Académie in 1750, where he boldly asserted that the hierarchy of the genres mattered less than the perfection an artist might achieve in his work, regardless of whether it aspired to a high ideal or represented lowly nature: 'There is more glory in representing well a simple bunch of flowers, which can encompass all the precepts and the charms of art, than in giving birth to historical works which are insipid.' We should note that Massé's words, so subversive of that traditional academic hierarchy in painting, echo a similar statement, that flowers were as demanding to paint as figures, attributed to Caravaggio, whose own approach to painting had already challenged those academic values in early seventeenth-century Italy.

But during the 1750s it was to be the orthodox classic/academic aesthetic which came to dominate French artistic life. Traditional academic values were deeply ingrained and so institutionalized that, with renewed official support for the

Académie and the aesthetic values it embodied, the naturalistic tradition remained a marginal one.

It is interesting to see the reactions of La Font de Saint-Yenne and Gougenot to the genre scenes of Chardin. In the case of La Font, there is equivocation behind his words; he suggests that Chardin might well be discussed among the history painters – his are, we are told later, 'an original talent and an inventive brush'; although La Font thinks that his subject-matter has no interest or significance beyond itself, there is yet something to be said for the penetrating truth and singular naïvety of his vision:

> I should have spoken of M. Chardin in the class of inventive and original painters. We admire in him the talent of rendering with a truth that is all his own, and singularly naïve, certain moments in the business of life, without the least interest, which in themselves merit no attention, and some of which are not worthy of the author's choice, nor the beauties which are admired in them.

It is as if the force and beauty of Chardin's observation transcend what La Font can only know as inadequate subject-matter. La Font's hierarchical preconceptions are challenged by the powerful and authentic unity of Chardin's perception and execution, so that the critic rather backs away from the issue. The discussion is taken up by Gougenot in his brochure of 1748, brief though his comments are. He takes to task those critics who simply dismiss Chardin as 'the French Teniers', and continues to find him 'more correct in his drawing, finer and more delicate in his expressions'. Comparisons between Chardin and the seventeenth-century Flemish genre painter David Teniers (1610–90) were common, but meant little more than that Chardin was a worthy painter of low-life subjects. The problem with painters who work in the lesser genres, says Gougenot, is that their work does not offer much scope for the commentator – but he acknowledges, 'The one among them whose genre approaches closest to history is M. Chardin.'

A similar ambivalence towards Chardin is betrayed in the biography written in 1749 by Pierre-Jean Mariette, who was very much a partisan of the Italianate grand manner in painting. After discussing the considerable success Chardin's works found with the public which visited the Salons, Mariette goes on to condemn this taste as reflected in the engravings published after them, and to mete out rather grudging praise. He compares Chardin not only with Teniers, but also with the seventeenth-century French painters of rustic genre, the Le Nain brothers:

> The prints that have been engraved after M. Chardin's pictures . . . have become fashionable, which, with those of Teniers, Wouvermans and Lancret, have succeeded in giving the final blow to the serious prints of Le Brun, Poussin, Le Sueur and even Coypel. The vulgar public takes pleasure in seeing again the activities which take place every day under their eyes at home, and without hesitation gives them the preference over more elevated subjects, whose appreciation demands an element of study. I do not wish to examine whether this contributes to the detriment of good taste; I am content to remark that, to understand it properly, the talent of M. Chardin is but a renewal of that of the Le Nain brothers. Like them, he chooses the simplest and most naïve subjects and, to speak the truth, his choice is even better. He seizes attitudes and character very well, and he is not lacking in expression. I believe this is even what has contributed most until now to encourage the vogue for his pictures, and to merit them a place beside Teniers and the other Flemish painters, who worked more or less in the same genre as he, whatever the distance between their works and his.

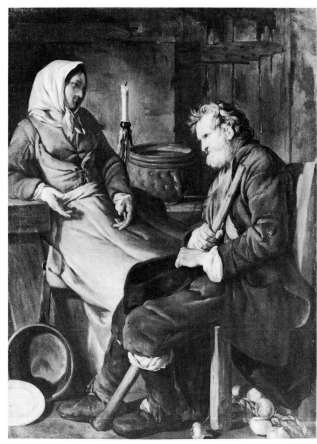

31. Le Nain. *Peasants in an interior. c.* 1640. Oil on canvas, 21⅞ × 25½ in. (55.6 × 64.7 cm.). Washington, D.C., National Gallery of Art, Samuel H. Kress Collection. The painting was engraved in the mid-eighteenth century by E. Cousinet with the title *'Le bénédicité flamand'*, and with moralizing verses to the effect that more prosperous diners all too readily forgot their Divine benefactor. The several painters of the Le Nain family still remain to be distinguished one from another.

32. Jean-Baptiste-Marie Pierre. *An old man and a young woman. c.* 1745. Oil on canvas, 51⅛ × 38⅛ in. (130 × 97 cm.). Leningrad, Hermitage. A meditation on youth, age and death in a remarkably rustic setting for a Salon painting of the mid-1740s.

In passing, we might note that one of the very few works by the Le Nain brothers known in the Paris of Chardin and Mariette was *Peasants in an interior* (Plate 31), which shows folk in much humbler circumstances than any of Chardin's subjects. This particular painting, which is a meditation on the Ages of Man and the passing of time (with different ages represented, and a spinner, traditional figure emblematic of the passing of time), seems to have provided the model for an equally static and expressionless meditative *vanitas* image exhibited by Pierre at the Salon of 1745, *An old man and a young woman* (Plate 32), where the figures are in a poor, rustic kitchen interior. Mariette is, however, sensitive to the greater charm of Chardin's vision compared with that of the Le Nain or Flemish seventeenth-century painters: both in his subjects, with which his public could more readily identify – events which happen daily under their eyes and in their homes – and in the greater psychological interest of his work – 'his choice is even better. He seizes attitudes and characters very well, and is not lacking in expression.' We have to understand this last remark in the light of the almost complete lack of action and expression in the works of the Le Nain. However, as we shall see below, Mariette found Chardin's manner of painting heavy and laborious, and rated him beneath Teniers and other Flemish artists in ease and fluency of execution, which in his opinion demonstrated the artistic confidence of a true master.

While critics like Mariette and La Font were not speaking in any official capacity, their views do reflect orthodox attitudes to the hierarchy of the genres in academic circles. Their lively and committed criticism of much in contemporary art played its part in a broader artistic debate, which forms the background to Chardin's career. Increasingly, efforts were being made in official circles to stimulate 'serious' painting, such as the competition organized in 1747 by the Direction des Bâtiments to encourage the history painters of the day (a similar competition had been organized in 1727). Works by eleven leading history painters of the Académie

were to be exhibited in the Galerie d'Apollon of the Louvre, as a sort of annexe to the Salon of that year. The exhibited works, each to be typical of the contesting painters (in the final event only nine, as the aged Louis Galloche and Pierre-Jacques Cazes had not completed theirs in time), were the object of long descriptions and commentaries by Abbé Le Blanc in his Salon review, *Lettre sur l'exposition des ouvrages de peinture, sculpture, &c. de l'année 1747*. The two works he admired most were *Alexander and his doctor* (Amiens, Musée de Picardie) by Jean Restout (1692–1768) and *Mucius Scaevola at the camp of Porsenna* (Plate 33) by Jacques Dumont le Romain (1701–81), which do indeed bear the closest relation to elevated French history painting of the sixteenth and seventeenth centuries; Le Blanc was able to compare Restout's picture favourably with the works of Eustache Le Sueur (1616/17–55), a leading classicizing painter of the previous century. But as we might expect of such a conservative critic, whose views were close to those of La Font, for example, he has little to say for Chardin, save that he has 'a manner which belongs to himself alone and which is full of truth', and that he could treat 'familiar subjects without being base'.

The academic ideals of the time are rather well expressed in a drawing made in

33. Jacques Dumont le Romain. *Mucius Scaevola at the camp of Porsenna*. 1747. Oil on canvas, 65 × 75⅞ in. (165 × 192 cm.). Besançon, Musée des Beaux-Arts. Only two years younger than Chardin, Dumont followed a conventional academic career, although this work has an idiosyncratic power, which sets it apart from the average history paintings of the period.

1746 by Charles-Joseph Natoire (1700–77), one of Chardin's contemporaries who followed a more official career. It shows *An ideal drawing academy* (Plate 34), where students are being instructed in how to draw from a posed group of two nude life-models; the students, however, are literally surrounded by the exemplars of the past: the *Farnese Hercules*, the *Laokoön* group, the *Medici Venus* and the *Gladiator* representing the sculpture of antiquity, while the paintings on the walls are by the great French masters of the previous century, Charles Le Brun (*Alexander at the tent of Darius*), Jean Jouvenet (*The Descent from the Cross*), Eustache Le Sueur and Nicolas Poussin.

While there can be no doubt about Chardin's loyalty to the Académie as an institution, one of his very few recorded observations on art is severely critical of its system of education. Diderot quotes his remarks in the preface of his *Salon de 1765*, and goes on to develop further the implications of an essentially naturalistic aesthetic in his *Essais sur la peinture* written in the same year. Chardin argues that the years spent by the young student drawing examples of anatomy from engravings and then working from selected examples of antique statuary neither prepare him for coping with nature at first hand, nor teach him how to invent more imaginative

34. Charles-Joseph Natoire. *An ideal drawing academy*. 1746. Watercolour over black chalk, 17⅞ × 12⅝ in. (45.3 × 32.2 cm.). London, Courtauld Institute Galleries, Witt Collection. Rather like the following illustration by Cochin, Natoire shows us an imaginary academy to convey the idea of the ideal artistic education. Possibly the drawing was originally intended for engraving.

45

35. Charles-Nicolas Cochin. *The drawing academy*. Engraving for the *Encyclopédie*, 1763. Here, one of Chardin's closest friends provides an illustration for the article *'Dessein'* ('Drawing') in the great compendium of Enlightenment thinking.

works. This system is well illustrated in the little didactic engraving by Cochin, *The drawing academy* (Plate 35), where the different stages of drawing instruction are shown. For Chardin, it was boring, it deadened real talent, blunted perception, and severed the student from the vital source of art, life itself:

At the age of seven or eight a crayon is set in our hand. We begin to draw from a pattern, eyes, mouths, noses, ears, then feet and hands. For a long time we have had our backs bent over the portfolio, when we are placed before the *Hercules* or the *Torso*; you have not witnessed the tears that this *Satyr*, this *Gladiator*, this *Medici Venus*, this *Antinoüs* have caused to flow. You can be sure that these masterpieces of the Greek artists would no longer excite the jealousy of the teachers, if they had been left to the spite of the pupils. Having used up days and passed nights by the lamp before an immobile and inanimate nature, we are presented with living nature; and at a blow the work of all the preceding years seems reduced to nothing; we were no more inhibited the first time we took up a pencil. The eye must be taught to look at nature, and how many have never seen it and never will! It is the torment of our life. We are kept for five or six years before the model, before we are left to our own genius, if we have any. Talent is not determined in a moment. It is not with the first essay that we have the right to avow our incapacity. How many attempts, now happy, now unhappy! Precious years have passed by before the day of distaste, lassitude and boredom comes. The pupil is aged nineteen or twenty before the brush and palette drop from his hands, he remains without station, without resources and without character. For it is not possible to be young and wise and have nature in the raw continuously before your eyes. What to do, what will become of you? You have to cast yourself into one of those lower conditions where the door stands open to misery, or else die of hunger. You take the first course; and with the exception of twenty or so who come here [i.e. to the Salon] every two years to exhibit themselves to the animals, the others, unknown but perhaps less unhappy, have a breast-plate on their chest in a guard-room, or a musket on their shoulder in a regiment, or a theatrical costume on the boards . . . What you see is the fruit of the travails of a small number of those who have struggled more or less successfully. He who has not felt the difficulty of art, does nothing worthwhile; he who feels it too soon . . . does nothing at all. And believe me, the greater number of elevated positions in society would be empty, if you were only admitted there after an examination as severe as that to which we artists are submitted.

It is very likely that Chardin's attack on academic training reflects his own difficulty, or wilful refusal – or a combination of the two – before the rigours of this system. Similarly, his lack of grasp, or his deliberate rejection – depending on how one looks at it – of the standard repertoire of rhetorical gesture and expression would date back to his own, not altogether happy, early experience of academic training.

The systematization of facial expression for academic artists had been initiated by Charles Le Brun in a lecture delivered in 1668 and subsequently published in various forms. This aspect of the academic ideal is amusingly (to us) illustrated in an engraving (Plate 36) after a painting by Chardin's close contemporary and eminent colleague Charles Coypel. The print shows selected expressive heads taken from a monumental *Ecce Homo* (since destroyed), completed in 1729 at the Parisian church of the Oratoire. Not only do the heads represent a range of stylized expressions such as can be found in Le Brun's treatise, but here many are also shown as independent sculptures, reminding us of the antique sculptural ideal to which elevated painters were expected to aspire. Just as he did not conform to the

36. *Principal heads from the picture at the Oratoire. c.* 1729. Engraving by F. Joullain after Charles Coypel's *Ecce Homo* (destroyed), completed in 1729 in the Parisian church of the Oratoire.

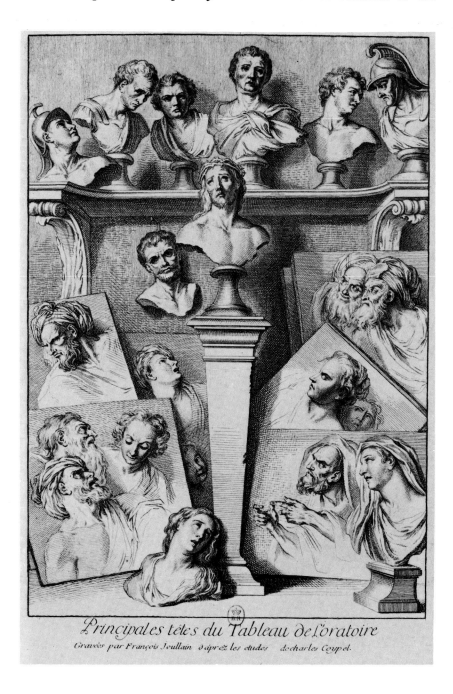

47

conventional rhetoric of the human figure, just as he opted for a contemplative inwardness of expression rather than standardized academic mouthing, so too Chardin was to reject this sculptural ideal – in paintings which assert, before all else, their paint.

Chardin first encountered this academic tradition when, in about 1718, his father placed the aspiring young painter in the studio of Pierre-Jacques Cazes, a highly respected history painter born in 1676. Cazes in his turn had been a pupil of Bon Boullongne (1649–1717) and followed the conventional training of the day. He was above all a painter of works for the church, such as *St Peter raising Tabitha* (Plate 37), and of decorative mythologies, which are perhaps more successful in their relatively modest way. *The swing* (Plate 38) is typical of these works, and was executed as part of the decoration of the Petits Appartements at Versailles. Cazes is one of many history painters with careers spanning the late seventeenth and early eighteenth centuries, famous in their day, whose works are rarely sympathetic to modern tastes, and are hence almost forgotten. Before entering the Louvre at the time of the Revolution, *St Peter raising Tabitha* hung in the sacristy of the church of Saint-Germain-des-Prés, and is a small-scale replica of a very much larger votive picture Cazes had executed for the same church. It is a typical academic history painting of the time, treating an elevated theme from the New Testament in a noble design derived from the masters of the Franco-Italian tradition that runs from Raphael to Poussin and Le Sueur. The figures are set in a clear architectural space, and through their gestures and expressions the spectator can read the narrative of the miraculous event and the reactions of the witnesses. By the highest standards, the compositions of Cazes lack substance and his figures sometimes look mannered in pose and type; these features suit his smaller-scale decorative works better than

37. Pierre-Jacques Cazes. *St Peter raising Tabitha*. Oil on canvas, 36¼ × 28¾ in. (92 × 73 cm.). Paris, Musée du Louvre.

38. Pierre-Jacques Cazes. *The swing*. 1732. Oil on canvas, oval, 38¼ × 34⅝ in. (97 × 88 cm.). Paris, Musée du Louvre. There is a pendant, *The village dance*, also in the Louvre; the two pictures formed part of a decorative scheme to which other contemporary painters contributed works.

39. Pierre-Jacques Cazes. *Academic nude: seated man. c.* 1727. Black and white chalk, 22⅞ × 16¾ in. (58 × 42.7 cm.). Paris, Ecole des Beaux-Arts. This is the type of drawing from life advocated in the drawing by Natoire (Plate 34) and the print after Cochin (Plate 35).

40. *Study of a man. c.* 1722. Black chalk, 11¼ × 16 in. (28.7 × 40.6 cm.). Stockholm, Nationalmuseum. This drawing is on the *verso* of that reproduced as Plate 46.

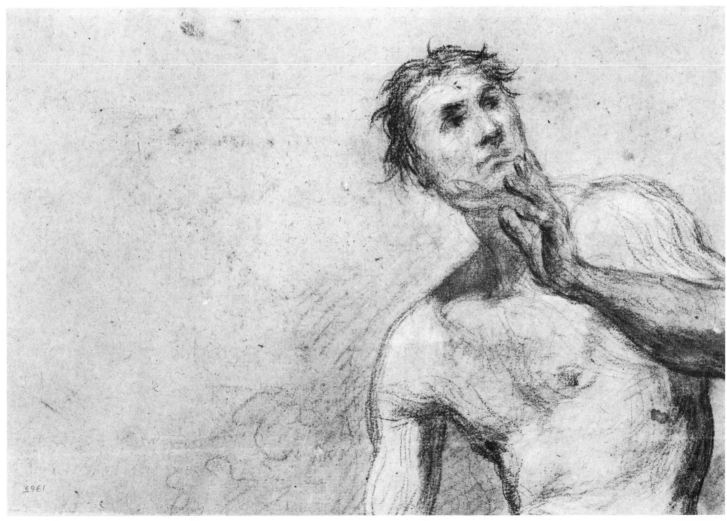

those in the grand manner. But with these reservations, *St Peter raising Tabitha* is very much the type of picture which official art education was designed to encourage. If we follow Chardin's first biographers, this would have been the goal to which the young painter aspired. But, as Mariette tells us, for all Chardin's desire 'to succeed in the genre of history', he did not do so 'as much as he would have liked'.

In common with other history painters of the day, Cazes instructed his pupils in drawing from the life-model. A group of his own *académies*, one of them dated 1727, survives at the Ecole des Beaux-Arts and on the basis of these (e.g., Plate 39) it has recently been possible to identify an *académie* from Chardin's hand (Plate 40). It is on the reverse of another very early drawing by Chardin, which will be discussed below. The two illustrated drawings by Cazes and Chardin share a sketchy lack of determination in outline, hesitant hatching for some of the shading, and use of the stump for the denser shadows. Chardin's treatment of the trunk of the body and especially the shoulders is clumsy, less academically proficient than that of his more experienced master: but a good deal of 'academic proficiency' was a matter of drawing to precept, and Chardin's multiple outlines might rather be his naïve attempt to capture exactly what was there. There is nothing in Cazes's *académies* to suggest that he might have trained great draughtsmen, although these drawings do have a distinctive character and charm of their own. His composition drawings for large-scale works are hesitant and insubstantial. Chardin's friend and biographer Cochin, writing at a time (1780) when 'correct' academic standards were still very much a matter of debate, was critical of Chardin's first teacher:

> The school of M. Cazes was not really right for the formation of pupils; one did not paint from the life there at all; one made do with copying the master's pictures and drawing at the Académie in the evenings. M. Cazes could not afford to pay any models. He did his finest pictures purely by routine and by means of a small number of studies he had made in his youth and the figures he drew at the Académie. There he drew, to speak the truth, in a way superior from many points of view, but nevertheless in too mannered a manner.

That Chardin had a high regard for drawing we have seen from his attachment to the young draughtsman as a pictorial theme (Plates 10, 17 and 23). A print (Plate 41) by Jean-Jacques Flipart (1719–82) probably reproduces a version of *The draughtsman* sent by Chardin to the Salon of 1759, where the student is busy copying another academic nude; a further engraving of this subject published in Chardin's lifetime was given the title '*Le principe des arts*'. In this and in other respects, Chardin certainly took seriously the theoretical and institutional bases of the Académie and indeed encouraged his own son to pursue his artistic career along that avenue. But only the merest handful of drawings can be attributed to Chardin today, while in the eighteenth century mention is made of only a dozen or so more. No doubt he produced more drawings than we know, but it does seem unlikely that he was at all prolific in this medium. We can hardly blame Cazes; but the remarks of Cochin in this respect are noteworthy, as is the evidence of Cazes's own graphic work. In a sense it all hardly matters, for Chardin nevertheless made some of the most beautiful paintings of the eighteenth century, developing his own magical way with brushes and paint that rendered conventional drawing superfluous; he saw and rendered, not with the eye of a draughtsman, but with the eye of a painter, understanding perfectly the difference between the graphic and the painterly ways of representation.

It is significant that Chardin chose to avoid those artistic occasions which might have presented an opportunity to demonstrate the solid virtues of academic

41. *The draughtsman*. 1757. Engraving by J.-J. Flipart after a lost painting by Chardin, which was a later version of the painting reproduced in Plate 10.

draughtsmanship. With one juvenile exception, there are no large-scale figure compositions, and above all he avoided depicting the nude. His difficulty with human anatomy mattered not at all – he learned to cope with hands, heads and faces; for the rest, those hollows and bumps and countless foreshortenings, those twists and turns of flesh, tissue, muscle and bone frame, he concealed and covered with a cut and fall of fabric all his own. Chardin had a brilliant sense of design, with a personal manner that never lapsed into mannerism, and a subtle grace that he seems to have absorbed from the decorative works of Cazes and his second teacher for a brief time, Noël-Nicolas Coypel. The lack of interest in nature of both Cazes and the much younger Coypel was a deficiency Chardin was soon and thoroughly to remedy. But their refinement of figure type, as for example in *The swing* (Plate 38) or Coypel's brilliant *Rape of Europa* (Plate 27), sometimes a certain appealing sweetness of demeanour, and above all a feeling for delicately rhythmical design both in the posing of figures and in their shapes in the abstract sense, these he adapted from their rococo decorative works. Further, the irregular curling and curving rhythms which we encounter in many rococo works of the 1720s by the decorative artists we have discussed are a deliberate aesthetic device. They show a wilful pictorial variety, with asymmetrical and dynamically off-centre compositions, which went under the name of '*genre pittoresque*'. It was a manner of composing and arranging a picture that was to be discreetly absorbed by Chardin in his still lifes of the mid and later 1720s.

Before we leave Cazes altogether, something can be learned of the merits and deficiencies of the French academic system if we compare his career with that of a close contemporary, Michel-Ange Houasse (1680–1730), who managed to escape – the word is scarcely too strong – to a freer environment and develop more of his native talent. Houasse trained as a history painter in a manner very similar to Cazes, and it is likely that Cazes was a student in Rome in the early 1700s with Houasse and the latter's father, who was Director of the French Academy there. Their history paintings share a somewhat thin-blooded classical manner. In the second decade of the century, however, Houasse went to Madrid to work in an official capacity as a portraitist and religious painter for the Bourbon rulers, who had recently been established on the Spanish throne. They had an inherited admiration for French culture, and even came to found an Academy along French lines in 1752. But Madrid was a long way from Paris.

During the decade before his untimely death in 1730, Houasse developed in a

42. Michel-Ange Houasse. *The barber's shop.* c. 1725. Oil on canvas, 20½ × 24¾ in. (52 × 63 cm.). Madrid, Palacio Real. A good knowledge of Dutch seventeenth-century painting seems to inform the careful treatment of light and the precise detail of this amused French observer's painting of the bustle of a Spanish barber's premises.

43. Michel-Ange Houasse. *The drawing academy.* c. 1725. Oil on canvas, 24 × 28½ in. (61 × 72.5 cm.). Madrid, Palacio Real. A drawing of this composition in the Louvre, Cabinet des Dessins, may have been intended for engraving; see Plates 34 and 35.

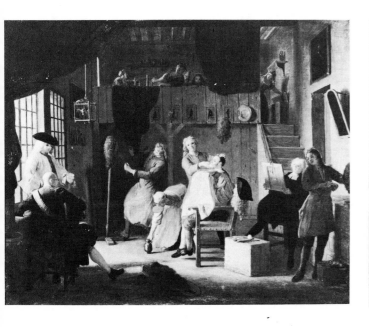

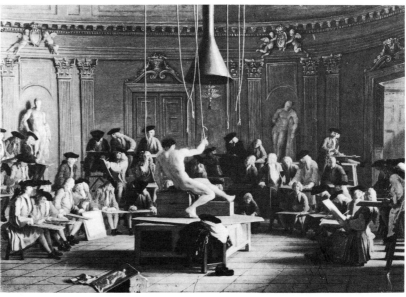

remarkable way, exploring a range of subject-matter which one could not imagine him attempting had he simply continued a Parisian academic career: subjects in a Watteau-like manner, humorous scenes of country life with a sharp eye for realistic detail, fresh landscape views and down-to-earth amusing genre scenes, such as *The barber's shop* (Plate 42). He had a good eye for expressions, as if he had adapted his Academy training under Le Brun in this aspect of art to the more lively context of everyday life. Such variety and humour of expression was something which Chardin did not, could not, attempt. In these works Houasse comes close to European contemporaries like William Hogarth (1697–1764) in London or Pietro Longhi (1702–85) in Venice, both of them painters who were gratefully free of academic constraint. He continued to paint mythologies and religious works, but Madrid offered a more liberal artistic climate than Paris, and a painter could freely develop his own creative impulses. Of course, there was in Spanish art a native strain of naturalistic observation, and Flemish realism had always been favourably received. An element of the French classical tradition does linger even in the genre works of Houasse, however, in their clear design, careful construction and precise execution. He almost certainly ran a drawing school in Madrid, and this may be illustrated in his delightful painting of *The drawing academy* (Plate 43). Its design perhaps consciously echoes Raphael's *School of Athens* which he had copied as a student in Rome. It is this type of knowledge which enabled Houasse so beautifully to organize such a complex figure composition – the subject, after all, was one dear to Chardin too, but we could not imagine him controlling such an ambitious pictorial idea.

French history painting of the eighteenth century is permeated by a sense of strain, as one recent commentator has put it, a sense of striving after a great ideal sanctioned by history, which yet seems to remain just out of reach. It is indeed arguable that the thoroughness of the French system of art education effectively hampered those very talents it set out to cultivate. Was it so mechanical and dogmatic, and were history painters so self-conscious in their deference to the revered models of the past, that the personal observation, the original invention, the animating passion, the creative imagination itself were simply atrophied by neglect?

Chardin betrayed a rare courage in his single-minded, uncompromising and passionate commitment to the thing seen. This approach to art, however, had its own history, its own tradition. Chardin attached himself to this more modest tradition of Northern European art, which was ignored by the academic system of his day. We could say that he turned his own academic disability to his advantage. His alternative commitment to nature once established, he studied the tradition which could lend it most meaning and moral content. He was well placed to do so, in the Paris of the 1720s and 1730s, for his own career was developing just at the time of a tremendous vogue among French collectors for Dutch and Flemish 'little' masters. His attitude to the past was academically exemplary – he adapted and incorporated it into his own vision, and made of it something new. But Chardin saw – remarkably, as few of his contemporaries did – that the Northern, naturalistic tradition to which he belonged had not only surface, but depth too. There could be more to the picture than met the eye. For whatever reasons – whether a personal inability to cope with the rigours of the conventional academic training which he rejected, or a conscious realization that the rhetoric of classic academic art was becoming a redundant means of expression – a subtle employment of the emblematic tradition inherent in much of this Northern art was to be his way of raising a mean genre to the intellectual level of high art, of investing genre with the seriousness of history painting.

3 A Natural Alternative

We are told by Cochin that on leaving the studio of Cazes, Chardin worked with Noël-Nicolas Coypel. One of a distinguished family of painters, Noël-Nicolas was perhaps most successful in his mythological works, such as the highly sophisticated *The Rape of Europa* (Plate 27). This painting was Coypel's contribution to the competition organized in 1727 by the Direction des Bâtiments, to give official encouragement to history painting in the grand manner, which for a combination of reasons financial and aesthetic had enjoyed little patronage in the earlier decades of the century. That this well-intentioned event was of little consequence for elevated painting might be expected from the character of Coypel's picture in itself, and is demonstrated by the fact that it was considered necessary to hold another such competition in 1747. Cochin refers to this state of affairs in his essay on Chardin, pointing out that the only major works commissioned during the early part of the century were some huge canvases for the choir of Notre-Dame, and for the church of Saint-Germain-des-Prés – to which scheme we have seen the contribution of Cazes (Plate 37).

Chardin was with Coypel in about 1720–1, and we may assume that during this time he would have come to a fuller understanding of the decorative possibilities of painting that he had first observed under Cazes. However, Cochin tells the story that Coypel set his young assistant to paint 'with exactitude', in the correct lighting, and from the object itself, a musket in a portrait the master was making of a man in hunting attire. Chardin was struck by the care Coypel demanded even for such a detail, and by the difficulty of capturing the colour, light effects and reflections as seen in nature. The experience was revelatory, for Cazes had taught him that the painter must invent out of his own head, and that recourse to nature was but a last resort for those without genius. Whether the story is literally true or not, the significance lies in its meaning: that Chardin found his true way by the first-hand study of nature. This important discovery perhaps confirmed in him a feeling that he was not cut out to be a painter of the elevated, conceptual type. Cochin tells us that Chardin was regretfully aware that he was lacking in that formal education (i.e., in history, literature and the classics) which would form the intellectual basis for the concepts and inventions of the history painter. Indeed, so far as we know, Chardin's earliest independent efforts in painting were to be realist in tendency, as if he had made a conscious decision not to attempt the grand manner.

He was apparently asked to paint a signboard for a surgeon, a friend of his father. This fascinating picture, some 4.4 metres in length, has been lost since 1783, when it was in the sale of effects belonging to the engraver Jacques-Philippe Le Bas

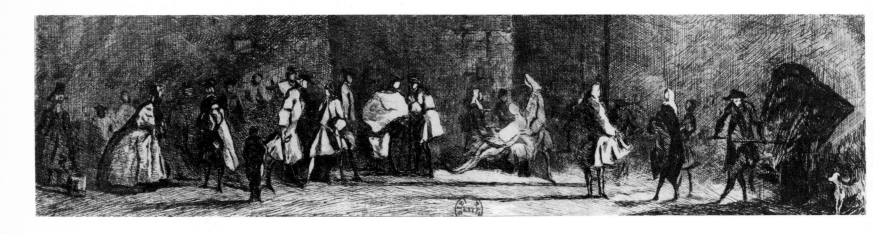

(1707–83). Chardin's oil sketch for it, which remained in his own possession until his death, was destroyed in 1871, but fortunately Jules de Goncourt had made an etching after it (Plate 44). A man who has received a sword-wound has been brought off the street into a surgeon's house, where he is attended, while some passers-by are drawn to the scene and others simply continue on their way. The long horizontal format of the picture, the distribution of the figures across it, and the fact that it represented a contemporary street scene, must put us in mind of Watteau's celebrated sign (Plate 45), painted for the shop on the Pont Notre-Dame of his friend, the art-dealer Gersaint, at the end of 1720. This work by Watteau apparently caused something of a sensation in the Paris art world of the day. Chardin seems to look to *Gersaint's shop-sign*, with which he would certainly have been familiar, as offering an alternative, more realistic aesthetic, to that of the

44. Sketch for *The surgeon's sign* of *c.* 1722. Etching of *c.* 1867 by J. de Goncourt after Chardin's oil sketch, destroyed in 1871. A lively and precious record of what must have been a surprisingly ambitious design for a young and inexperienced painter.

45. Antoine Watteau. *Gersaint's shop-sign*. 1721. Oil on canvas, 71⅞ × 118⅞ in. (182 × 307 cm.). Berlin, Staatliche Museen Preussischer Kulturbesitz, Schloss Charlottenburg. Chardin, an aspiring young painter when this celebrated work was completed, certainly knew and almost certainly drew inspiration from it.

46. *A two-wheeled sedan. c.* 1722. Black chalk heightened with white. 11¼ × 16 in. (28.7 × 40.6 cm.). Stockholm, Nationalmuseum.

47. Claude Gillot. *The quarrel of the cabmen. c.* 1707. Oil on canvas, 50 × 63 in. (127 × 160 cm.). Paris, Musée du Louvre. Chardin's art would be very different from this, but early on he understood the 'theatrical' alternative to the more elevated genre of history painting.

orthodox Academicians who had been his teachers. The technique would have had nothing of Watteau's exquisite refinement, and would have been no more subtle than that of *The billiard party* (Plate 49), discussed below. There is a drawing (Plate 46) for the two-wheeled sedan and its porter on the right of Goncourt's reversed engraving; it was acquired in Paris, *c.* 1739–41, by Count Carl Gustav Tessin (1695–1770), a collector with a profound love and understanding of Chardin, and is now universally accepted as one of the master's rare drawings. Its sketchy but bold and assured style, and the use of black and white chalk on a tinted paper, is generally consistent with the manner of older contemporaries, such as Jean Restout, and forms a contrast with the much more hesitant and puzzled academic study we have seen on the reverse (Plate 40).

A two-wheeled sedan is reminiscent of the theatrical painting of *The quarrel of the cabmen* (Plate 47) by Claude Gillot (1673–1722; a teacher of Watteau), a fact that not only indicates Chardin's espousal of a non-idealist tradition, but also draws our attention to the theatricality of Chardin's own picture. An anonymous obituarist of Chardin, who knew *The surgeon's sign* in the collection of Le Bas, tells us of Chardin making studies of a number of friends (a Watteau-like procedure!) and then uniting them on the final canvas, 'using for scale the paving-slabs of the street where the scene took place'. This grid of lines does not appear on the Goncourt print (which in any case is after the preliminary oil sketch, not the final painting), but the account

55

is interesting, with its sense of a somewhat naïvely deliberated approach, which suggests an artist not easily conversant with the construction of a large populated space, and consciously adopting the perspective device of the rare urban scenes of Watteau and Gillot. In discussing *The surgeon's sign*, it is difficult to resist an analogy with William Hogarth in England, another painter who was to pursue rigorously a naturalistic aesthetic, who began his career in the early 1720s as a sign-painter (for example, his *Paviour's sign*; Yale Center for British Art, New Haven), and whose heavy-handed juvenilia anticipate nothing of his later technical refinement.

It is almost certainly to over-intellectualize Chardin's approach to art to say that he seems to have been the only painter of the early 1720s to have been tempted to take up the radical implications of Watteau's late, more realist style. However, Watteau's more immediate followers – Jean-Baptiste Pater (1695–1736) and Nicolas Lancret, to name the most talented – were content to repeat the successful formula of his *fêtes galantes*, but only in the outward form, with none of the personal poetry. While we know that *Gersaint's shop-sign* was immediately recognized as a great work of art, *The surgeon's sign* was to remain all but unsung in the eighteenth century; only Jacques Lacombe (see page 18) wrote admiringly in 1759 of the animation of its action and the variety of its expression.

Chardin's homage to Watteau was both practical and a matter of intuition, only to be fully developed at a later date, when he considered the full implications of Watteau's late masterpiece. But at the start of his career, intimidated by the demands made on those who aspired to the highest ranks of art, and unable (or

48. Study for *The billiard party. c.* 1723. Black and red chalk, heightened with white, 9¾ × 14⅝ in. (24.7 × 37 cm.). Stockholm, Nationalmuseum.

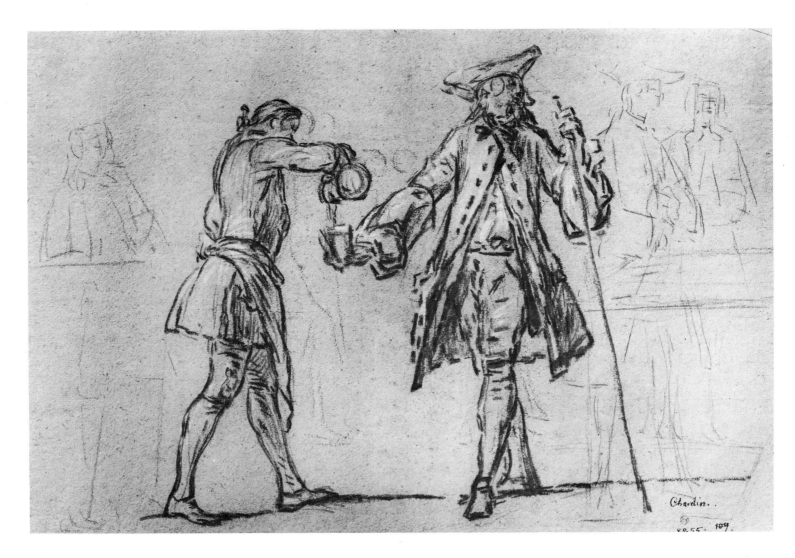

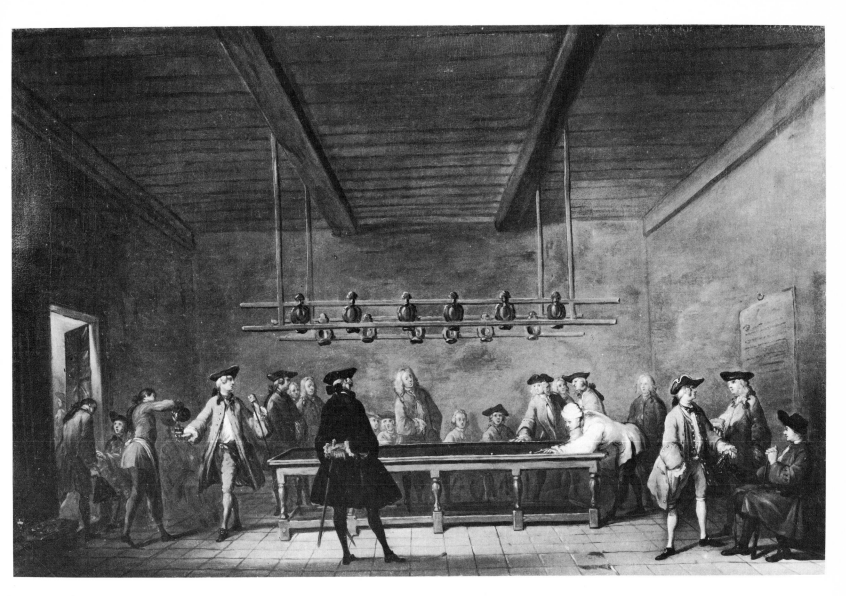

49. *The billiard party. c.* 1723. Oil on canvas, 21⅝ × 32½ in. (55 × 82.5 cm.). Paris, Musée Carnavalet. Compared with Houasse (Plates 42 and 43), Chardin's conception of the human figure and sense of space are naïve, but his keen interest in contemporary manners points to his later development as a genre painter.

unwilling) to benefit from his eminent academic teachers, Chardin settled for a more modest lot. The normal expectation of a talented pupil of Cazes or Coypel would be to proceed through the official educational channels of the Académie, even if in a lowly genre. Thwarted in what may have been his initial ambition, Chardin followed a relatively obscure path, until he received his letters as Master-Painter at the Académie de Saint-Luc in 1724. This was the ancient guild of painters, a rival of the state-controlled Académie Royale, which was finally to assert its supremacy in 1777 when the former was suppressed by the Government. However, once Chardin himself had been made a full member of the official body, he renounced his allegiance to the Académie de Saint-Luc in 1729.

The work which has found general acceptance as Chardin's earliest surviving painting is *The billiard party* (Plate 49). Its everyday theme and the design of figures strung out across the picture relate it to *The surgeon's sign*, as does the style of a preparatory drawing for two figures at the left (Plate 48), which again comes from the Tessin collection in the eighteenth century, and bears comparison with the drawing of *A two-wheeled sedan* for the latter painting. However, the present drawing employs sanguine, as well as black and white chalk, which gives it a character reminiscent of the drawings of Charles de la Fosse (1636–1716) and the circle of Watteau, where the use of the three colours was especially favoured. It is tempting to see more than a merely coincidental connection between *The billiard party* and the fact that Chardin's father was a cabinet-maker who specialized in

producing billiard tables. The picture is a fascinating document of an aspect of Parisian life in the eighteenth century, showing the interior of a public billiard-hall, the police regulations affixed to the wall at the right, and a framework above bearing candles and metal reflectors to illuminate the table when necessary. Nothing in this work announces the personal style which Chardin was to find within a few years; indeed, it has variously been attributed in the past to Etienne Jeaurat (1699–1789), the circle of Hubert Gravelot (1699–1773), and the British School. It is only the preparatory drawing and the analogies with *The surgeon's sign* that point to Chardin's authorship, while the slightly mannered type and stance of the figures recall his master Cazes. While the figures betray a certain naïvety of conception, their execution is quite fluid, as is the design as a whole. The artist has some understanding of the play of light and shade, and the dark-coated figure in the foreground makes for a bold *repoussoir* effect.

The surgeon's sign and *The billiard party* show us a hesitant young artist, who has abandoned the high aspiration of history painting in favour of the depiction of the contemporary everyday world. But did he still feel the lack of that inventive imagination which is still necessary for what are, after all, quite complex and ambitious figure compositions? We have seen how the classical training of a painter like Houasse, for example, in his delightful *Drawing academy* (Plate 43), gives him the resources with which to deal with the problems of perspective, spacing, grouping and harmonious design. It is curious that Chardin did not attempt (so far as we know) more restricted figure subjects at this time, as, for example, Lancret and De Troy were doing in the same decade. If the story of his revelatory exercise of painting a gun from nature for Coypel contains an element of truth, then very likely his first still lifes date from these same years, the early 1720s.

Cochin and Mariette tell us that Chardin was given either a rabbit or a hare, which he painted with the greatest care and attention. So successful was this work that, according to Mariette, Chardin was asked to paint a pendant representing a duck. It is worth dwelling for a moment on the fact that the first two still lifes mentioned by Mariette were representations, respectively, of fur and feathers. It was only some three years after Mariette compiled his notes that Jean-Baptiste Oudry, on 2 December 1752, read to the Académie (Chardin was present) a discourse on the practice of painting, in which he discusses the contrasting techniques required in painting fur and feathers. The nature of his subject-matter means that the painter must paint '*au premier coup*' – that is, rapidly and directly, without a long process of drawing and underpainting. The details of fur, for example, must be worked lightly and thinly over a base of thick, dry impasto which describes the main masses; feathers, on the other hand, must be much more fluidly rendered, with the use of extremely fine glazes, to capture a glossy effect.

Oudry, in this lecture of 1752 and an earlier one delivered in 1749, makes continual and respectful reference to his own training under Nicolas de Largillierre (1656–1746) from *c*. 1707 to *c*. 1712, frequently citing the types of practical exercise his master gave him. The different approaches to painting fur and feathers are exactly the kinds of exercise Largillierre encouraged (Oudry also specifically cites exercises in painting white flowers, the human head, and the use of backgrounds of various colours and different effects of light), and it is reasonable to infer from Oudry's experience that Chardin's first steps in still life may have followed a comparable pattern some ten years later. Valuable as Mariette understands these exercises in painting directly from a model to be, later in his biography he comes to see Chardin's perennial need for the presence of a model from which to paint as a fundamental deficiency, demonstrating a lamentable absence of inventive imagination. We have seen in the preceding chapter the essentially idealist aesthetic of

Mariette, which informs all his writings with a particular pedagogical bias. Against this, we can set the more sympathetic attitude of Cochin.

Cochin gives the fullest account of Chardin's discovery of still life, and his text deserves close study, for not only did he, broadly speaking, share Chardin's naturalistic aesthetic, but he had also been a long-time intimate friend, so that his knowledge of the early career may well have come directly from the artist. Thus Cochin stresses the positive advantages of working from the model, and no doubt the lines he wrote would have evoked a sympathetic response from Oudry and Largillierre, could they have read them:

> The first lessons which M. Chardin had received from nature induced him to follow this study assiduously. One of the first things he did was a rabbit. This object would appear to be of little importance; but the manner in which he wished to do it made it a serious study. He wanted to render it with the greatest veracity in all respects, and yet with taste, without any appearance of servitude which would make the handling dry and cold. He had not yet attempted to depict fur. He well knew that he should not think of counting it or rendering it in detail. 'Here is an object', he said to himself, 'which it is a question of depicting. To be concerned only with rendering it truly, it is necessary that I forget everything I have seen, even so far as the manner in which these things have been treated by others. I must place it at such a distance that I can no longer see the details. I ought to occupy myself above all with imitating the general masses well and with the greatest truth – those shades of colour, the volume, the effects of light and shade.' Thus he revealed and discovered the beginnings of that taste and that magic handling, which have ever since characterized the talents which distinguish him.

This paragraph makes clear Chardin's fundamentally naturalistic aesthetic, at least as it was understood by his friend Cochin, and is consistent with what else we know of Chardin's practice and his views on painting. The principle of working from nature once discovered and established, Chardin never abandoned it. Indeed, Diderot in 1769 recalled an occasion when the necessity of painting from nature was at odds with Chardin's notorious slowness as a worker:

> Chardin is such a rigorous imitator of nature, a judge so severe with himself, that I have seen a painting of *Game* that he never finished, because the small rabbits after which he was working had become rotten, and he despaired of attaining with others the harmony he was seeking. All those brought to him were either too brown or too pale.

Conscious that a purely descriptive painting was an impossibility – and in any case, the attempt to number the hairs on a rabbit's fur would lead to a dry, cold finish – Chardin yet wanted to avoid the pictorial formulae which his predecessors in the genre had evolved. He was after a pictorial resolution that was all his own. Placing the rabbit at a distance was his first solution to the problem presented by his desire to reconcile a multiplicity of particular detail with a more generalized effect. Soon he must have realized the importance of technique, the application of the impasto, the tiny gestures of the brush on the canvas, in the creation of the ideal pictorial form he was seeking. After all, he wanted to work 'with taste, without any appearance of servitude'. His intention was to create a general effect of harmony and unity, not of descriptive detail; nevertheless he had to respect the integrity and appearance of the objects before him. Rather than by placing the subject at a distance, it was when he came to terms with the descriptive limitations of paint

that he found his ideal: at the point of reconciliation between representation and the self-evident reality of the paint.

Chardin's ideal, unlike that of the history painters who were his contemporaries, was not an abstract, intellectual concept, a kind of Platonic ideal which could never be perceived by mortal eye, but only suggested by an inadequate visual approximation, whose lustre came from the reflected glories of the past. And far from merely repeating what had been done by others in his own genre, his productions showed an original cast of mind and were the result of genuine study, whose consequence was a novelty of style in their mode of execution. The move from academically approved 'invention' to an art of observation, demanded such a shift from conception to execution. Chardin was concerned with the here and now, and his creative imagination, his invention, was invested in the evolution of a unique and subtle vehicle of expression, a way with paint that could make the magical transposition into pictorial form of the thing seen, where the act of representation became the discovery of an ideal unity.

Mariette's account of Chardin's first essays in still life is the necessary complement to that of Cochin:

> Someone had made him the gift of a hare. He found it beautiful, and made an attempt to paint it. Some friends to whom he showed this first product of his brush saw great promise in it, and encouraged him as best they could. The canvas which he had used, one which had come into his hands by chance, was not nearly filled by the hare, so he was therefore able to add some kitchen utensils, and his painting became a composition, which in no time found an owner. But this was only on condition that it would have a pendant, with a duck for its subject.

These first paintings from the life have never been identified, and we must expect of them even less confidence than is shown in some of his earliest known works in still life, discussed in the next chapter.

Although it might conform to Mariette's very generalized description of Chardin's first picture of a hare, the beautiful *Rabbit and a copper pot* (Plate 50), in Stockholm, is hardly acceptable as such an early work, as some have proposed. In spite of a disturbing ambiguity in the placing of the pot (see Plate 70) and in its proportion and position relative to the hanging rabbit, the confident execution points to the later 1730s. The work comes from the collection of Count Tessin, who was in Paris from 1739 to 1742. It was dispatched to Sweden in August 1741, and the present writer would incline to see it as perhaps Chardin's unique still life of the period between 1736 and *c.* 1747 – when he temporarily abandoned this genre for figure paintings – a work executed especially for this sympathetic patron. The brilliant and even audacious colours of the copper pot, red-brown chestnuts, yellow quince and the smears of blood from the rabbit's nose against the greyish scumble of the stone wall and ledge, and the bold monumentality of the design, all point to the period of *The kitchen-maid* (Plate 116) and *The turnip-scraper* (Plate 120) of 1738 and 1739.

A more plausible candidate, already suggested by others before now, for the duck mentioned by Mariette is *A green-neck duck and an orange* (Plate 51). It has some of the informal appearance we might expect of an early essay in painting from nature, although we might also notice the arrangement of the duck itself, its artful positioning on the canvas, and the calculated placing of the bright Seville orange to complete the pattern of the orange feet and bill. But it nevertheless comes closer than any other work by Chardin to the preparatory oil studies from nature we know by his contemporaries. Indeed, the duck in this picture was used in a larger

50. *A rabbit and a copper pot. c.* 1739. Oil on canvas, 26¾ × 22 in. (69 × 56 cm.). Stockholm, Nationalmuseum.

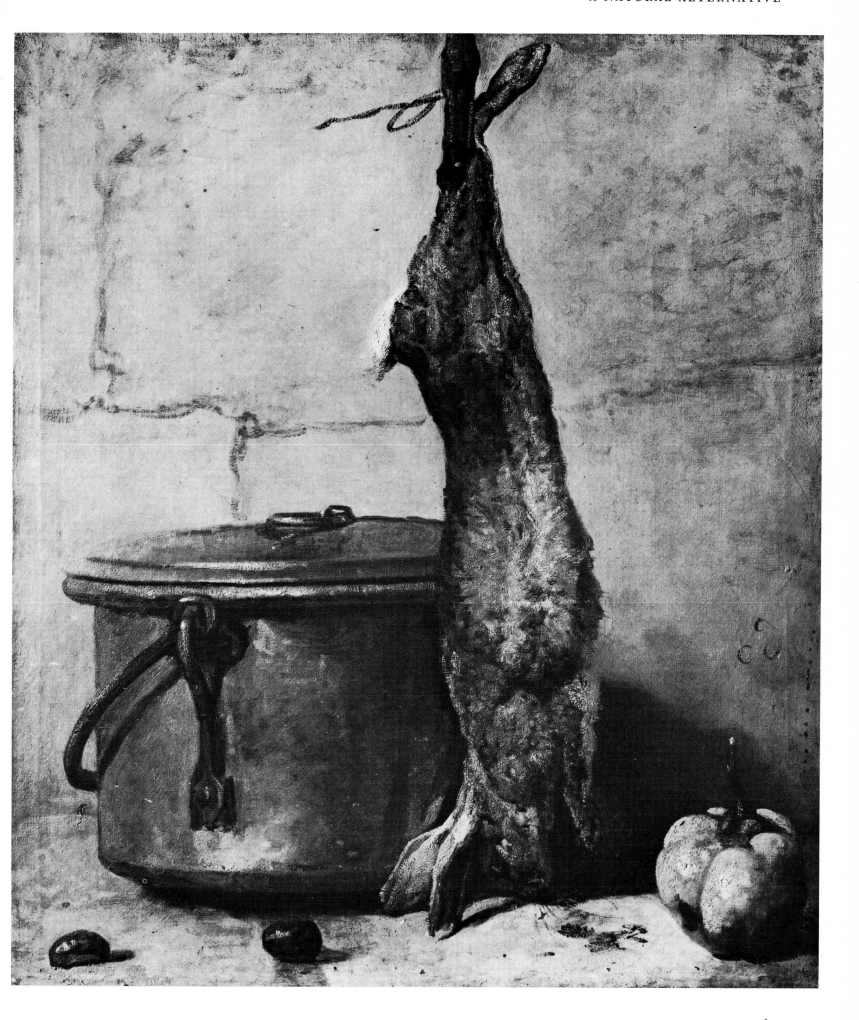

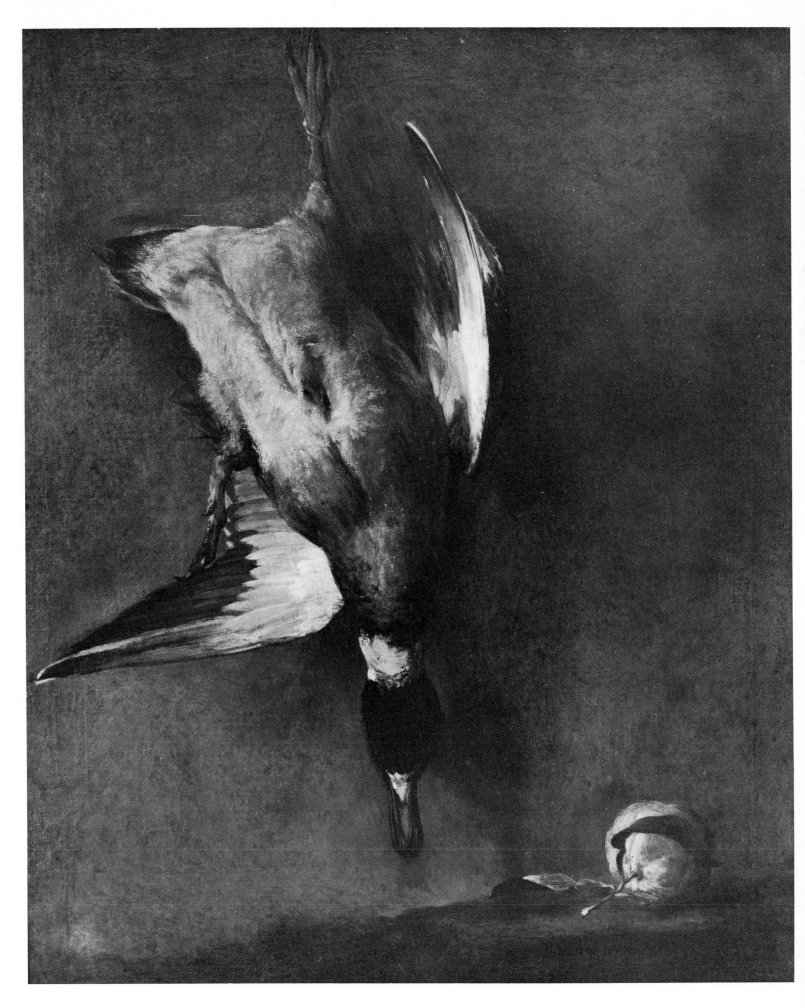

52. Jean-Baptiste-Marie Pierre. *Academic nude as Bacchus*. 1735? Oil on canvas, 57½ × 39¾ in. (146 × 101 cm.). Karlsruhe, Staatliche Kunsthalle. Acquired by the Margravine of Baden with a pendant, *Academic nude as Prometheus*, from the artist, through the engraver J.-G. Wille. The two paintings had been in the collection of the Comte de Vence for a time, but he failed to pay for them; while in the Vence collection, they were engraved by P. Chenu, with the indication that they had been painted in Rome.

51. *A green-neck duck and an orange*. 1728–30. Oil on canvas, 31¾ × 25⅜ in. (80.5 × 64.5 cm.). Paris, Musée de la Chasse et de la Nature.

53. Pierre Subleyras. *Female nude. c.* 1735. Oil on canvas, 29⅛ × 53½ in. (74 × 136 cm.). Rome, Galleria Nazionale d'Arte Antica, Palazzo Corsini. Such frank, direct, and unaffected studies of the female nude are rare in eighteenth-century art.

painting of the hunting-trophy type which Chardin signed and dated in 1730 (Private Collection).

In our own time there is nothing remarkable in Chardin's insistence on working from the life, in painting from nature. But in his day this was considered at best to be a useful exercise, and only an exercise. The practice of painting from nature never gained full academic recognition. Because the Académie placed the greatest importance on the elevated humanistic ideals which were supposedly embodied in history painting, working from nature could have only a limited role. For obvious practical reasons, a history painting could not be painted entirely from the life; and in any case, as a matter of principle, the artist was endeavouring to show man not as he is, but as 'he ought to be'. At best, history painters (and indeed portraitists, genre painters, and painters of landscape) painted only certain details from nature, in the form of studies (*études*) as part of the preparation of a more complete studio work. The low regard in which such direct studies of nature were generally held is reflected in the fact that they are hardly ever discussed in French artistic literature of the seventeenth and eighteenth centuries – and that Oudry, for example, in his lectures on these matters to the Académie in 1749 and 1752, was apologetic for introducing discussion of such basic painterly practice. Even if we allow that questions of studio practice were not normally deemed worthy of public debate or academic discourse, the relative rarity of painted studies (as opposed to drawings; or even painted sketches, *esquisses*, to explore the imaginative invention of a composition as a whole) is an indication of the neglect of this aspect of artistic training, and of this stage in the preparation of a larger work.

The Académie made a limited acknowledgement of the value of painting from nature in its requirement that *pensionnaires* studying at its school in Rome should send to Paris a nude figure painted from the life, to demonstrate their developing powers. Since the late seventeenth century these students and their Director in Rome had been rather lax and at best sporadic in the submission of such works. Only with the reforms of the Academy in Rome by Vien during the 1770s did this become a more routine practice. The tendency was to cast these figures in some nominal historical or literary role, as for example in Pierre's *Academic nude as Bacchus* (Plate 52), which is perhaps the figure referred to in 1735 by the Director in Rome as 'a large figure painted from nature which is good'. Pierre especially plays off the creamy flesh against the fur of the leopard-skin on which the nude is seated. But only Pierre Subleyras (1699–1749), a painter as remarkable and independent as Chardin himself (and his exact contemporary), could paint a stunning nude study

54. Nicolas Vleughels. *Studies of a Man*. 1727. Oil over black chalk on prepared paper, 10⅛ (including addition, top right) × 10 in. (25.7 × 25.5 cm.). Paris, Musée du Louvre, Cabinet des Dessins. Vleughels used this study in the finished painting of 1727, *Christ in the House of Simon* (Bayreuth, Neues Schloss).

for itself, without any literary overtones (Plate 53). For all that he owed some of his training to the Académie, and found his way to Rome under its auspices, Subleyras managed to develop an independent career in Italy – and this independence must to some extent account for the unconventional, that is to say refreshingly 'un-academic', character of much of his work. Nevertheless, it is possible to understand why Chardin could never conceive nor execute even naturalistic nudes of this type, lacking as he did the thorough official background and training of a Pierre or a Subleyras. Both Subleyras and Pierre were deeply affected as students by contact with Nicolas Vleughels (1668–1737), an artist of Flemish origin who was Director of the French Academy in Rome from 1725 to 1737. While in this post, Vleughels at least by the early 1730s had his students, on his own initiative, painting studies of heads and variously draped figures from the life, the only way, as he saw it, 'to master reality, which is the soul of our business'. Vleughels himself made quantities of painted studies from the life (Plate 54), many of which can be identified as preparations for his history paintings. This often gives a lively sense of observation to these more conceptual works. His influence lies behind the naturalism of a painter such as Subleyras, for example in the beautifully observed figure of the porter lifting an exquisitely painted basketful of still-life objects in the foreground of *St Camillo de Lellis in the flood of 1598* (Plate 55). It is this sense of patient

naturalistic observation that sets Subleyras somewhat apart from the other history painters of his day, and saves him from their rhetoric. His deep, but reserved and quietly expressed emotion and the careful deliberation with which he applied his paint bring him close in spirit to Chardin.

Painting from nature seems to have been a predilection especially among artists with a Flemish background in the early part of the century. Largillierre, for example, who in the second decade was to encourage Oudry to paint still life from nature, himself painted some remarkable studies of hands and arms for use in his portraits (Plate 56); and Alexandre-François Desportes (1661–1743), who has been greatly admired in our own time for his fresh and spontaneous oil studies of landscapes made around 1700, also painted a large number of studies of all manner of animals and still-life objects for use in his larger, imaginative, decorative works. In oil studies such as his *Demoiselle cranes* (Plate 57), for example, Desportes was probably influenced by the Antwerp artist Pieter Boel (1622–74), who worked in Paris from 1668 until his death, and whose studio contents of many drawings and oil studies are now divided between the Louvre and various French provincial museums. Among many complex contributory factors, it was the absence of academies and classical academic dogma which allowed Flemish and Dutch artists of the seventeenth century to follow nature more closely than their southern counterparts. Their example was directly transmitted, through background or training, to certain French painters such as Largillierre, Vleughels, Desportes and

55. Pierre Subleyras. *St Camillo de Lellis in the flood of 1598*. 1746. Oil on canvas, 70¾ × 81⅞ in. (205 × 280 cm.). Rome, Museo di Roma. Commissioned by the Order of Camillans for Pope Benedict XIV. A fine example of the reform of Roman painting in the 1740s, by reference back to nature, in the work of Subleyras, Pompeo Batoni (1708–87), and others.

56. Nicolas de Largillierre. *Studies of hands and arms. c.* 1700. Oil on canvas, 26 × 20⅞ in. (66 × 53 cm.). Paris, Musée du Louvre. These studies were for use in different portraits, some of which have been identified.

57. Alexandre-François Desportes. *Studies of Demoiselle cranes. c.* 1700. Oil on prepared paper, 13⅝ × 20⅛ in. (34.5 × 51 cm.). Paris, Musée de la Chasse et de la Nature. Hundreds of oil studies painted from nature, the contents of Desportes's studio, were acquired from his descendants by Louis XVI in 1784, above all landscapes, plants, animals and birds. They are now distributed among several French museums. Desportes made such studies throughout his life, and these birds were used by him in two of the *New Indies* tapestry cartoons he designed in 1739 and 1740.

58. *The teapot*. 1764. Oil on canvas. 12⅝ × 15¾ in. (32 × 40 cm.). Boston, Museum of Fine Arts. There is a replica in Algiers (Musée Nationale des Beaux-Arts d'Alger).

Oudry, and it is to this tradition, if that is not too grand a concept, of vital attachment to the thing seen, that Chardin belongs.

Chardin was admired in his own century as a colourist, and the notion of colour (*colore*, in Renaissance art theory), as opposed to the more privileged and supposedly 'intellectual' drawing (*disegno*), had long been intimately related to the imitation of the thing seen. Because of this traditional and prejudicial theory, the study of colour was no more a part of the academic curriculum than the direct study of nature in any medium (with the exception of the conventionally posed and drawn life model). In the lectures referred to above, Oudry too had specifically linked the study of colour to the study of nature at first hand, but arguing positively that the only way to reach a true understanding of colour – or, feeling ('*sentiment fin*') for colour, as he stated it – was by the constant observation of this feature in nature itself. If through his academic lectures Oudry was trying to gain for the dual study of colour and of nature the sanction and the status of

official precept, from Chardin we have the solid testimony of his works, and the one cryptic remark about colour and feeling reported by Cochin: 'We *use* colours, but we *paint* with feeling.'

Whether he was painting still life or figure subjects, Chardin's early biographers tell us that he painted from the model. A few of his earliest still lifes, such as *The green-neck duck*, do have the casual air of painted *études*; but normally his works have a feeling of absolute completeness in themselves, and of a perfect reconciliation between conception and perception. In a sense he was to elevate painting from nature to an ideal status. The close identity between invention and observation in one of his pictures was established at the very beginning of work, in the careful arrangement of his subject. In *The teapot* (Plate 58; the same date and same size as *A basket of grapes*, Plate 2) he has assembled the teapot, the two chestnuts, the grapes and the pear with the greatest attention to their relative sizes, shapes, volumes, surfaces and colour-values. The lighting is of prime importance, and as Chardin's career develops he seems to adjust it with even greater care and subtlety. In a relatively late work such as *The teapot*, a masterpiece of his maturity, the lighting is fairly dim, which is characteristic of his approach at this period – a contrast with his *Rabbit and a copper pot* (Plate 50), for example. The teapot is a large light area, with the brightest lights of the painting in the strokes which render its highlights and in some of the dabs on the grapes; the shadows on the pot, and the more absorbent colours and textures of the fruits provide passages of half-tone; but most of the picture is dark and shadowy.

The reader need only arrange a Chardin-like still life like that represented in *The teapot* to appreciate the dim and selective lighting he employed. Had Chardin not been so secretive about his working methods, we might know whether he used artificial light, which seems very likely in such a work. This was not especially unusual in his day – life-classes, the most common form of working from nature, were normally conducted by artificial light (see Plate 35), because unlike the more diffuse natural light it could be held constant and controlled, particularly to enhance the shadows that define forms. Since Impressionism especially, we expect a painter's studio to be as open, bright, and evenly lit with daylight as possible; but eighteenth-century painters did not strive to capture 'open-air' lighting. Chardin, above all, was a man to eschew the transient, the variable, and a man in whose artistic world control was essential and absolute.

4 A Talent for Animals and Fruit

Chardin's development as a still-life painter before 1728 is difficult to assess since none of his works before that year is dated. After 1728, there are enough dated works to establish a reasonable chronology. The three known dated works of 1728 are *The buffet* (Plate 60), *Two rabbits and an orange* (Plate 77), and a painting in a private collection in Switzerland showing a thieving cat. Some other works can be dated by comparison with these, and we know that *The ray-fish* (Plate 72) was completed by 1728, when it was exhibited at the Exposition de la Jeunesse in June (Plate 59). These annual open-air exhibitions, inaugurated in the seventeenth century, were held in the Place Dauphine and on the Pont-Neuf, weather permitting, usually on Corpus Christi Day. Until more or less regular exhibitions were established by the Académie in 1737, with rare exceptions the Exposition de la Jeunesse was the only opportunity for painters to show their work in public. We know little of these exhibitions before 1722, when the *Mercure* (later, *Mercure de France*) began to report them. From 1724 the *Mercure de France* was edited by Chevalier Antoine de la Roque, a passionate art collector and admirer of Watteau soon to become a supporter and collector of Chardin. It was no accident that Chardin had a special mention in the journal's accounts of the exhibitions to which he contributed in 1728 (where *The ray-fish* is singled out), 1732 and 1734. Most painters who exhibited there are now forgotten, but some of Chardin's eminent contemporaries also showed small works in the minor genres, including Boucher, N.-N. Coypel, J.-F. de Troy, Favanne, Lancret, Lemoyne, Nattier, Oudry, Restout and Rigaud.

The ray-fish and *The buffet* were Chardin's most substantial and impressive works to date – the former almost a personal statement of his own development so far, the latter a more sober recognition of time-honoured tradition. In the years either side of this important point in his artistic career, we witness Chardin both coming to terms with traditional ways of approaching this type of subject-matter, and developing his own expressive language, which was to be his unique and essentially inimitable contribution to the art. When he presented himself for his reception into the Académie in September 1728 – being exceptionally made an Associate (*Agréé*) and a full Academician at the same meeting, and classified as a painter with a 'talent for animals and fruit' – he offered the assembled academic judges a choice of several works (one source says ten or twelve) for his official reception-pieces. *The ray-fish* and *The buffet* were selected; not surprisingly, as they are easily his most ambitious and monumental works in these years.

In more than one sense, *The buffet* is a set-piece, unusually large in scale for Chardin, and grand in its overall conception. No doubt he was doing all he could to

Vue Pittoresque de l'Exposition des tableaux et desseins dans la Place D'Auphine le jour de la petitte feste de Dieu.

59. Gaspard Duché de Vancy. *The Exposition de la Jeunesse in the Place Dauphine*. 1780. 8⅜ × 10⅞ in. (21.3 × 27.5 cm.). Paris, Musée Carnavalet. Although executed in the year after Chardin's death, this unique drawing gives us a good idea of the appearance of this annual open-air exhibition, which would have changed little since Chardin exhibited there some fifty years earlier. The artists' works are attached to temporary hangings ranged around the square.

impress his future colleagues at the Académie with this work. In it he comes his closest to the lavish displays of still life popular in the Netherlands in the seventeenth century. He would have known works such as *The butcher's table* (Plate 62) and *Fruit and vegetables* (Plate 63) by Pieter van Boucle, a Flemish painter who settled in Paris, where he died in 1673. This pair of paintings entered the French royal collections sometime towards the end of the reign of Louis XIV. Chardin adopts devices typical of this school of painting, such as the folded tablecloth and the projecting knife-handle, or the dramatic interest created by the presence of live animals such as cats and dogs. In *The buffet*, a dog is taunted by a blue macaw, while in *The ray-fish* the cat on the oysters is reminiscent of the one pawing the meat in Van Boucle's picture.

Van Boucle was one of a number of Flemish still-life and animal painters – Pieter Boel was another – who settled in Paris in the mid-seventeenth century around the Antwerp master Nicasius Bernaerts (1620–78), and who were frequently employed by the Crown, notably providing designs for the Gobelins tapestry works. Not surprisingly, these artists had their effect on native talent. Alexandre-François Desportes was apprenticed to the aged Bernaerts, and completely absorbed this Northern tradition. From the time of his reception into the Académie in 1699 (with the splendid *Self-portrait as a hunter* in the Louvre), Desportes was the official painter of still life, hunting-trophies, royal hunting-hounds, and so on, until the early 1740s. A sumptuous pair of still lifes of dinner-tables by Desportes now in Munich (Alte Pinakothek) show respectively a dog sniffing the aroma of a magnificent ham, and a greedy cat reaching for some oysters. *The buffet* is a homage to Desportes, a point to which we shall return in a moment. But when Chardin was seeking advice from Largillierre on his reception into the Académie, the old painter initially mistook *The buffet* and *The ray-fish* for works of the Flemish school! Or so Cochin's story goes; it is the kind of story that no doubt improved over the years.

Chardin has also absorbed the lessons of Dutch still-life painting – the curl of

60. *The buffet*. 1728. Oil on canvas, 76⅜ × 50¾ in. (194 × 129 cm.). Paris, Musée du Louvre. This work is unusually large and grand in scale for Chardin's still lifes, but it was probably intended to impress as a reception-piece for the Académie.

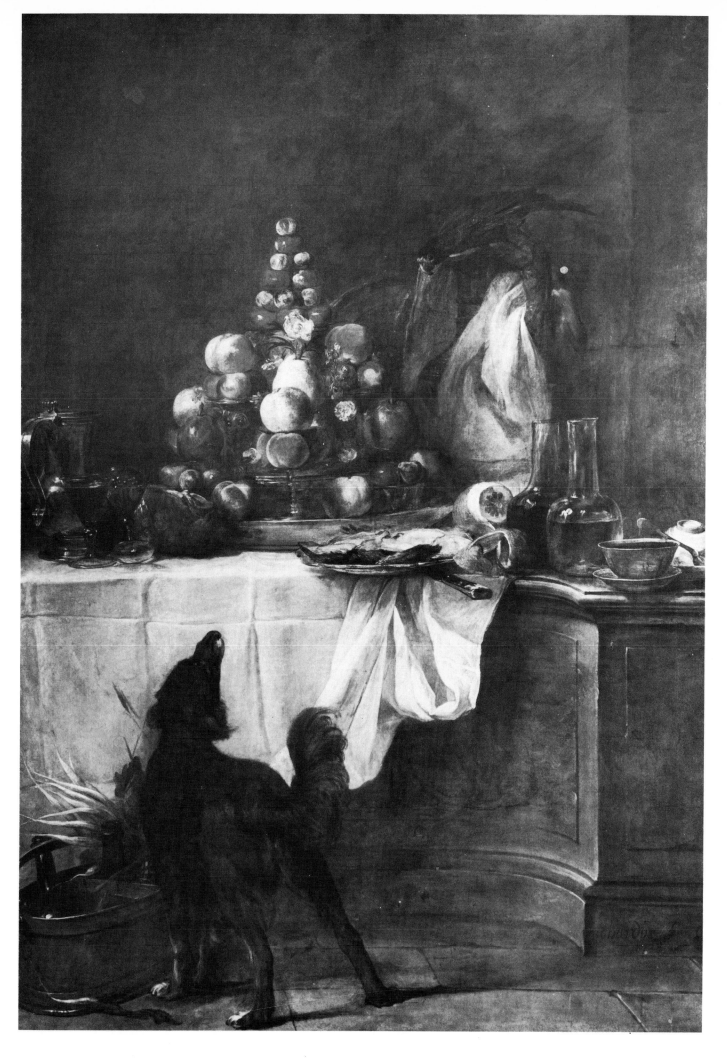

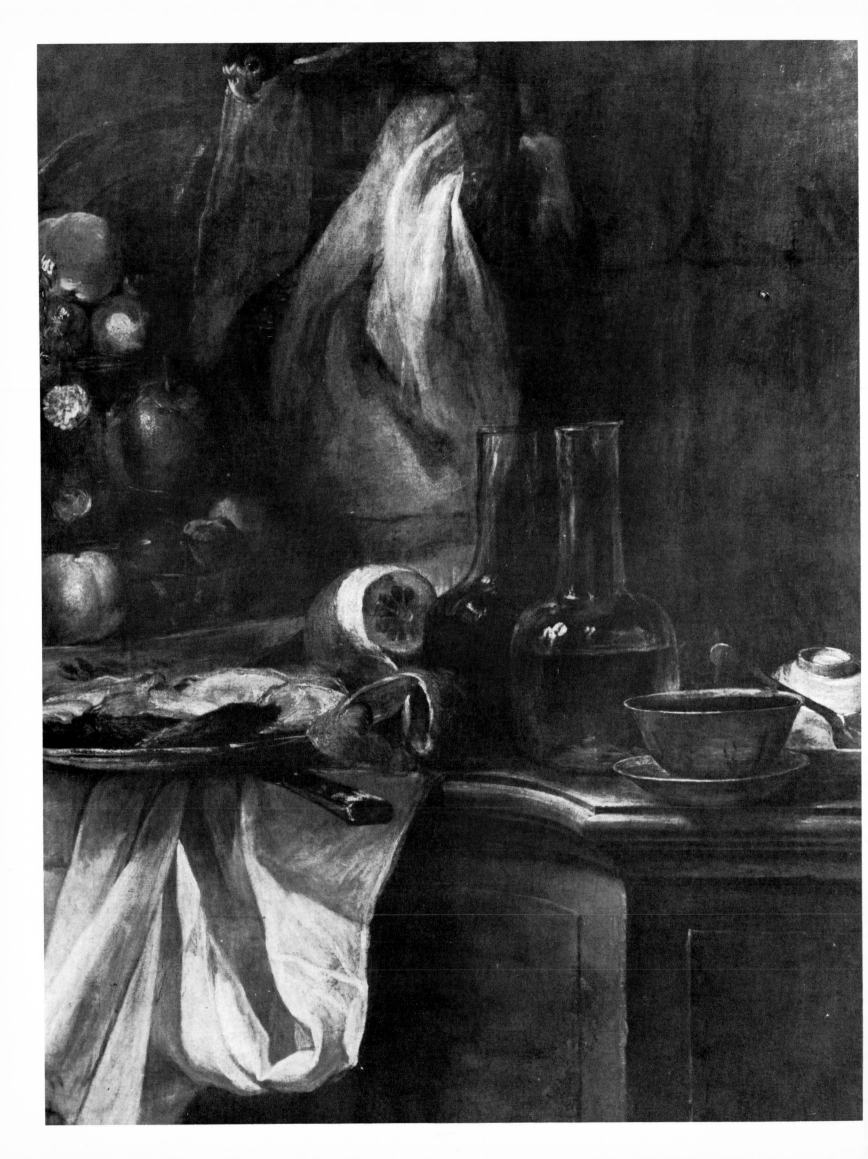

61. Detail of Plate 60.

62. Pieter van Boucle. *The butcher's table.*
1651. Oil on canvas, 44½ × 58⅞ in.
(113 × 149 cm.). Paris, Musée du Louvre.

peel sliced from the lemon, for example, is a quotation from such paintings, where
it was a virtuoso demonstration not only of foreshortening in drawing, but of the
painters' ability to render the different textures of skin, pith and the heart of the
fruit (Plate 61). The device is often employed by painters such as Abraham van
Beyeren (1620/1−90), for example in *The remains of a meal* (Plate 64), where we also
encounter the textures, translucency and surface reflections of metal, glass and fruit

63. Pieter van Boucle. *Fruit and vegetables.*
1651. Oil on canvas, 44½ × 58¾ in.
(113 × 148.5 cm.). Paris, Musée du Louvre.

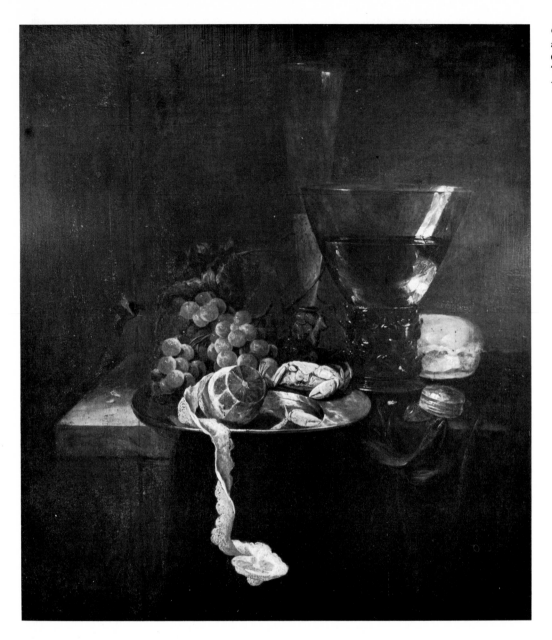

that were to fascinate Chardin. Such masterpieces of seventeenth-century still life carry their own mysterious poetry, assisted by a quite emotive use of shadow and subtle lighting, which was not lost on Chardin. Of a similar work by Willem Kalf (1619–93), Goethe was to observe in 1797:

> One must see this picture in order to understand in what sense art is superior to nature, and what the spirit of man imparts to objects when it views them with creative eyes. There is no question, at least there is none for me, if I had to choose between the golden vessels and the picture, that I would choose the picture.

Goethe's statement is one of broad aesthetic application, which might extend across the centuries, from the relative 'realism' of seventeenth-century Dutch works to the more formal concerns of Cézanne or Matisse.

But for all that *The buffet* is an eclectic work, drawing on the Northern traditions of still life of the previous century, it could hardly have been refused by an institution which had Desportes as one of its members, at the peak of his career at just this time. Chardin had worked on this scale only a couple of times before, notably in *The hound* (Plate 65), which may date from *c.* 1725–7, and in which he shows his study of the established master's works, such as *A pointer guarding game by*

65. *The hound.* 1725–7. Oil on canvas, 75¾ × 54¾ in. (192.5 × 139 cm.). Pasadena, The Norton Simon Foundation.

74

66. Alexandre-François Desportes. *A pointer guarding game by a rosebush*. 1724. Oil on canvas, 42⅛ × 54⅜ in. (107 × 138 cm.). Paris, Musée du Louvre.

67. Nicolas de Largillierre. *Still life with a spaniel. c.* 1677. Oil on canvas, 28¾ × 37¼ in. (73 × 94.5 cm.). Karlsruhe, Staatliche Kunsthalle.

68. Jean-Baptiste Oudry. *The dead wolf.* 1721. Oil on canvas, 77⅜ × 103 in. (196.4 × 261.4 cm.). London, Wallace Collection. This type of work, with which Oudry was securing his reputation in the early 1720s, must have impressed the younger Chardin. In the treatment of still life, Oudry's bright colour and strong lighting would give way in Chardin's hands to more dominant shadows, to muted, more tonal colour, and a greater attention to the texture of the paint.

a rosebush (Plate 66) of 1724. *The hound* is unusual in technique for Chardin, rapid and sketchy, especially in the execution of the dead game and the fluid handling of the dog. A landscape setting too is unusual, being one of only two or three merely suggested landscape settings in his entire work. Desportes was much more skilled at this sort of thing and would have created a far more unified effect. It is not surprising that Largillierre should have viewed Chardin's works so sympathetically, for he too had been a distinguished painter of still life since at least the mid-1670s, and his immaculate *Still life with a spaniel* (Plate 67) is an example of the genre. There is something to be said for the close affinity of the Flemish and French traditions of still life in the late seventeenth century – leading, as we have seen, to a confusion over Chardin's early works on the part of Largillierre himself – when we learn that, until the 1920s, Largillierre's own painting had been attributed to Jan Weenix (1640–1719) for the best part of a century!

Jean-Baptiste Oudry would quite possibly have felt more challenged by the rising reputation of the young Chardin in the late 1720s than would the older and established Desportes. We have said something in an earlier chapter of Oudry's training under the sympathetic Largillierre, whose most brilliant pupil he was. A painting like *The dead wolf* (Plate 68) displays his talent with both live and dead animals, and by the mid-1720s he was specializing in such works for the court and for the Beauvais tapestry works. From Largillierre he learned how to place a subject in a decorative landscape setting, as well as the immaculate and glossy surface of his

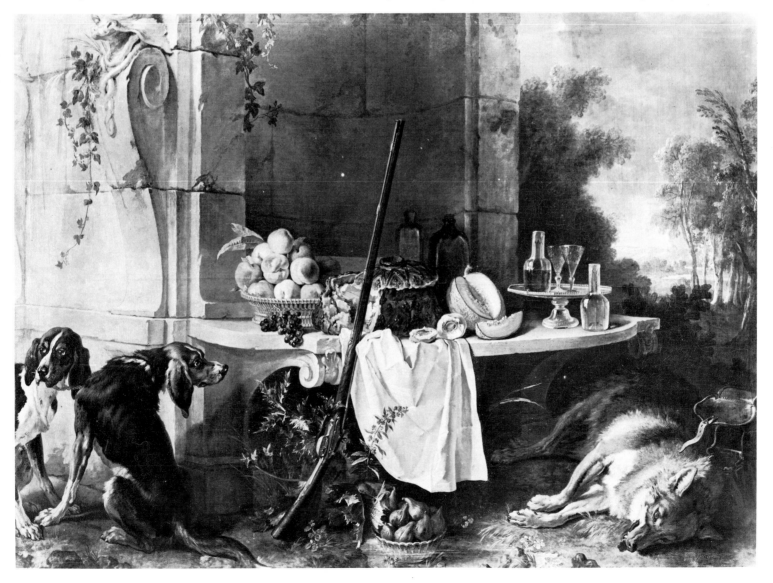

paint and his fine rendering of detail. We feel the hunters must be about to enter the picture, to enjoy the refreshing picnic laid out for them on the console of this piece of parkland architecture. Chardin was still struggling with academic routines, when Oudry executed this work in 1721, and would have had reason to envy the brilliant facility with which Oudry has painted the still life on the stone shelf. Oudry had an eye for what was vivid and pleasing, rather than profound, and a light, decorative sense of colour and tone.

Perhaps luckily for Chardin, and for us, Oudry more or less gave up still life in 1728, when he began the work of several years on huge tapestry cartoons representing Louis XV at the hunt. This was just the moment when Chardin caught the public eye with his own still lifes with dead game, and with his reception-pieces for the Académie. Similarly, when Chardin abandoned still life for figure painting in the later 1730s, Oudry was to turn back to still life. We shall have occasion to compare their approaches to still life in a later chapter; but any direct rivalry was avoided – quite coincidentally, it would seem – by the individual development of their careers. One imagines that the two fellow-Academicians held each other in respect, and there is nothing to suggest that these two different artistic personalities did not live in a state of happy coexistence.

The buffet is quite distinct from all these precedents, however, in the way it is painted. For all its formality – the large niche with its stone shelf and a somewhat self-conscious display of different surfaces and volumes, and other demonstrations such as the tilted glass and a porcelain bowl turned over – the handling of the paint is all Chardin's own. Desportes and Largillierre look fussy beside him, seeming as they do to render every hair, every feather, every petal and leaf. Their works have a hard, bright insistence, an evenness of focus, where Chardin's display emerges reticently from the shadows. It is in his use of shadow and of a dark, neutral background that part of his magic lies, now revealing, now concealing; they give greater value to the dry, crisp whites of the tablecloth (and what a range of whites), to the muted, saturated glow of fruits and wine, the hard glints of pewter and glass, each surface matched by an equivalent consistency and application of paint, in the endless invention of Chardin's touch.

The ray-fish (Plate 72) is Chardin's most arresting and dramatic work, where the young cat arching its bristling back seems to echo the frisson of horror felt by the spectator at the frightful sight of the grimacing fish, its bloody entrails on full display as they hang from its partially gutted underbelly. While *The buffet* is a relatively traditional painting – in all but its characteristic execution – recalling in the first instance the work of Desportes, *The ray-fish* is novel in French art, both in the raw ugliness of its central motif and in the dignified beauty with which Chardin invests the kitchen utensils to each side. The paradox of this work, in the painting of the ray-fish itself, is that something which is unanimously accepted as being a very ugly subject becomes movingly and irresistibly beautiful in this rendering. It is a tribute to the power of Chardin's art – and here lies one of the meanings of his art – that its magic can transform base matter into rare beauty. No wonder Diderot exhorted Pierre to look carefully at this work next time he went to the Académie, to see how nature at its most raw could be transformed by sheer artistic talent.

Within this one work, there is a remarkable variety of effect, from the silvery translucency of the fish's skin, to the meaty and viscous red, pink, brown and black of its entrails. By using highlights on the innards and broader sheens of white on the skin, Chardin gives a sense of its coldness, in spite of employing many warm colours. The utensils to the right almost form a picture in themselves; here, there is a soft ambience, partly created by numerous reflections and cast shadows surrounding the pottery bottle, the dark-green glazed jug, the pot, the pan and the

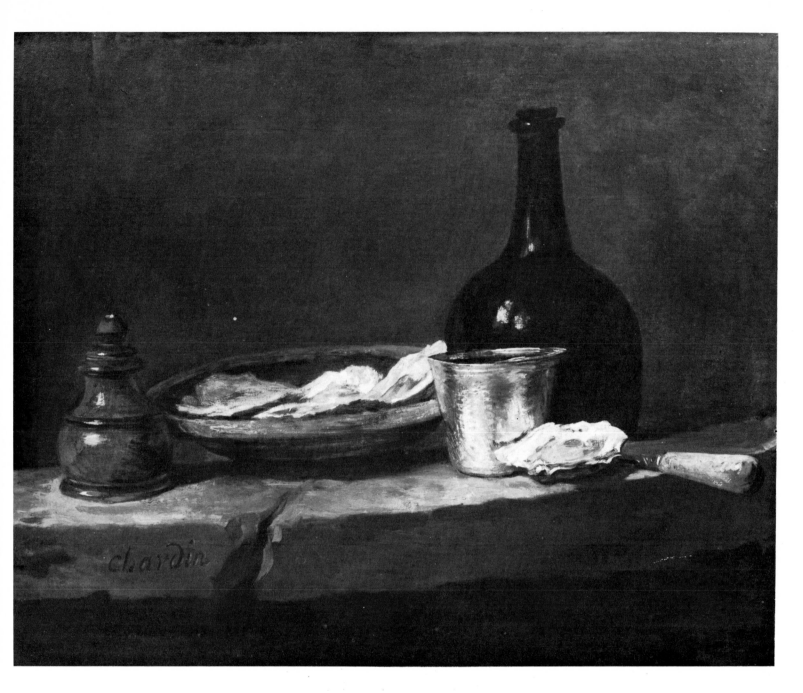

69. *A plate of oysters. c.* 1726. Oil on canvas, 16⅞ × 21 in. (43 × 53.5 cm.). Private Collection.

tablecloth. The contrast with this muted area makes the ray-fish all the more bold in its representation, as does the shadowy left-hand side, enlivened by the startled cat in black and white, the thick, off-white roots of the spring onions, and the translucent white skeins of thin paint that describe the oysters. It is the play of light and shade, and above all the variety and vitality of the brushwork – now light and rapid in the ray-fish and the oysters, now slow and meditated in the utensils – that have made this painting such a compulsive object of study, from Diderot, who would have had young students copy it, to Cézanne and Matisse, who did so.

The quite remarkable artistic statement of *The ray-fish*, which Mariette took pains to point out 'was painted several years before' the idea of membership of the Académie was even introduced into Chardin's mind, is in effect a synthesis of many smaller works, which were the products of his 'recognition of the need for an exact study of nature in the art of painting' (Cochin) in the early or mid-1720s. *A plate of oysters* (Plate 69), vigorously painted like parts of *The ray-fish*, probably dates from around 1726, and shows a similar simple stone kitchen shelf, with a plain meal of oysters and a bottle and metal goblet of red wine. Chardin employs a favourite

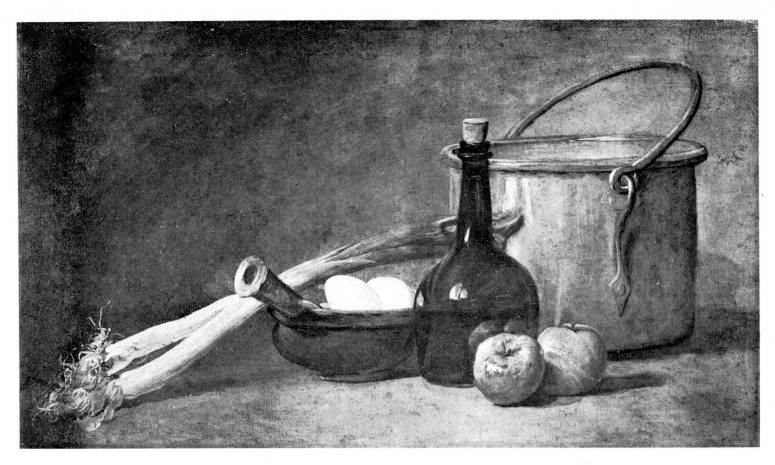

70. *Still life with a copper cauldron.* c. 1725. Oil on canvas, 18⅞ × 31¾ in. (48 × 80.5 cm.). Formerly Berlin, Kaiser Friedrich Museum (destroyed, 1945). This old photograph may record one of Chardin's earliest still lifes. This copper cauldron, and others like it, was one of Chardin's favourite still-life motifs in the 1720s and 1730s.

71. *The attributes of the painter.* c. 1725. Oil on canvas, 19⅝ × 33⅞ in. (50 × 86 cm.). Princeton, The Art Museum, Princeton University.

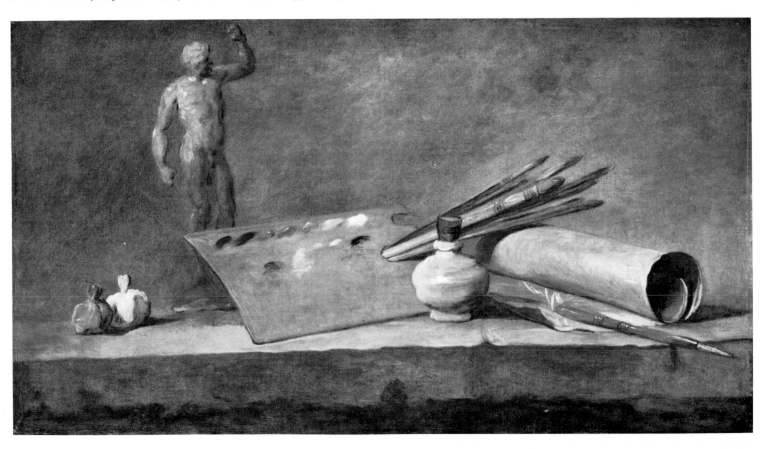

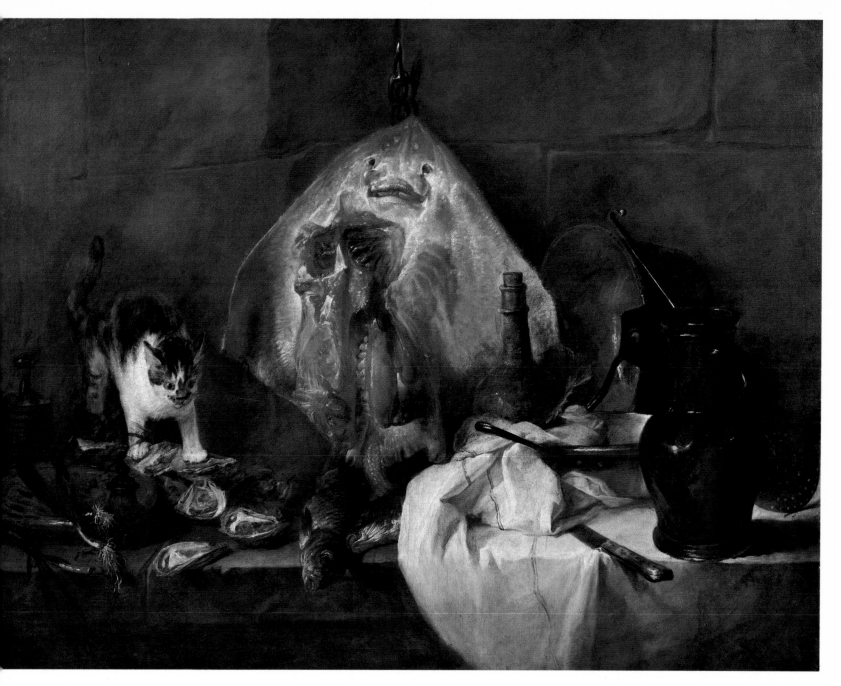

72. *The ray-fish. c.* 1726. Oil on canvas, 45 × 57½ in. (114.5 × 146 cm.). Paris, Musée du Louvre. The utensils in this picture would be found in most eighteenth-century kitchens, but it is worth remarking that some of the larger items are listed in Chardin's second marriage contract with Marguerite Saintard in 1731, in the 1737 inventory of her estate, and in the artist's own estate inventory of 1779. Smaller items, like the wooden spice-box, the wooden pestle and mortar, and the more common dishes, are not recorded. These same objects will be encountered again and again in Chardin's paintings of household utensils.

trompe-l'oeil device borrowed from Dutch art, the knife-handle projecting towards the picture-plane, which he was to use again, in his Académie reception-pieces, for example. His lighter-toned brushmarks are bold and assertive, especially in the handling of the oysters, and he stresses the reflections of light on the wooden spice-box, the bottle, and of the oysters on the side of the goblet, by a thicker impasto. In common with all his small early still lifes, the composition is set at a slight downward angle to the left, which gives a tension and interest to the design. The picturesque irregularities of the design, together with the choice of a wilfully bizarre main motif in *The ray-fish*, are Chardin's response to the contemporary '*genre pittoresque*' in decorative painting.

The slanting, off-centre arrangement is found in his earliest still lifes, such as *Still life with a copper cauldron* (Plate 70), now known only from old photographs. In this unusually wide-proportioned work, the space in which the objects are set is indeterminate, although the objects themselves are painted in a firm, confident manner, with a heavily loaded but fluid brush. The relatively large size and long format bring it close to *The attributes of the painter* (Plate 71) and *The attributes of the architect* (both in The Art Museum, Princeton University), which

share its vague background, against which the objects tend to float.

On the left of *The attributes of the painter* are two small bladders of red and white paint, the pot would contain a medium; palette and brushes complete the painting equipment. The roll of blue paper and the chalk-holder stand for the art of drawing, while the statuette would have served as a model for studying the human figure. Although Chardin employs a shelf in this work (and in its pendant), the indeterminate background, the unsure placing of the objects, and the fluid handling of the paint — especially in the sketchy little sculpture — suggest to the present writer a date very early in the 1720s, making this one of Chardin's earliest surviving still lifes.

By the time he painted his *Carafe, goblet and fruit* (Plate 76), which probably just predates *The buffet*, Chardin was placing his still-life objects much more firmly on their supporting surface. The silver goblet and the fruits rest unequivocally on their shelf, but are widely spaced. The second plane is carefully defined, by raising the carafe of wine up onto a higher ledge. The goblet with its reflections is the centre of interest in this work, which was beautifully described in 1863 by the brothers Goncourt:

> A silver goblet with some fruits around it, nothing more, is an admirable picture of his. The shine and sparkle of the goblet is done with a mere few touches of white, scratched on with dry paste. In the shadows there are all kinds of tones and colours: streaks of an almost purple blue, drips of red which are the reflections of the cherries against the goblet, a faded red-brown blurred into metallic shadows, specks of red and yellow playing in touches of Prussian blue — a continuous echo of all the surrounding colours gliding over the polished metal of the goblet.

It is a painting of bold contrasts, solid, decisive handling, and yet for all the cluster of interest near the centre, there is an unusually generous use of lateral space, which keeps the spectator's eye unexpectedly busy. But the strong colour-value of the bright red cherries at the left is a match for the paler, larger fruits at the right, dominated by the green apple. Even within this modest work, there is a striking range of brushmarks, adjusted to describe the different surfaces they represent — curved marks for the apple, flat smooth strokes for the reflections on the goblet, a gentle spread of paste for the soft cheeks of peaches, heavily loaded dabs for the gathered intensity of the reflected highlights on the carafe, and so on.

In a pair of paintings (Plates 73 and 74) which repeat respectively the motifs of pewter pitcher and glass carafe from either side of *The buffet*, Chardin creates an impressively monumental effect with remarkably limited means. This is achieved by taking a low viewpoint, so that pitcher and carafe dominate the images and the spectator's attention. Also in each case the still life is arranged on a thick stone shelf, which is now parallel with the bottom edge of the canvas, providing a substantial base. The sombre backgrounds and muted colours of these works also relate them to *The buffet*, as do the different interests they show in the various qualities of reflective surfaces.

Desportes explored the theme of reflections on more than one occasion, but never more splendidly than in his *Silver, peaches and game-birds* (Plate 75), which was painted in the 1730s and belonged to one of Chardin's keenest admirers, Count Tessin. Desportes displays a variety of silver-ware, including an elaborately ornate ewer, two highly polished plates with intricately chased edges, a tureen decorated with boars' heads and feet, and a small jug in the irregular shape of a shell. These gleaming objects are set against a rich brown velvet fabric, draped over a marble-

topped cabinet. Peaches are piled in the tureen and are reflected from two different angles in the plates – the painting, minutely finished, is a virtuoso demonstration of Desportes's powers. At the time he made it, he would have been aware of the younger artist's rising star; but Chardin did not really present a challenge to this kind of highly illusionistic precision and clarity, for all the conventional praise of his imitation we may read in the period.

There is something much more discreet in the two Karlsruhe pictures (Plates 73 and 74) about the way Chardin renders the distorted reflection of his peaches in the pewter jug, or the glowing reflections in the glass carafe and the silver goblet from the brilliant red apple placed near the centre. Cool and even dank, with its opaque dark background and predominantly greenish tones, this last painting is among his most remarkable small works of the late 1720s; the bright red apple strikes a vibrant note, which seems to disturb the otherwise sombre calm. This painting and its pendant were acquired in 1761 by the Margravine Karoline Luise of Baden-Durlach, through an agent in Paris who purchased them from Joseph Aved. Like many painters, Aved also sometimes operated as a dealer; at his death in 1766, he owned nine still lifes by his old friend.

Another pair of still lifes by Chardin, one of them dated 1728, are to be found at Karlsruhe, but they are completely different in subject, style and mood from those just discussed. These are *Two rabbits and an orange* (Plate 77), dated 1728, and *A partridge with plums and pears* (Plate 78). These too were purchased by Karoline Luise, who was avidly building up a gallery of French art during the 1750s and 1760s. She bought some very fine paintings, although not particularly as an exercise of her own judgement. In 1759 she had read Jacques Lacombe's highly

73. *The pewter pitcher. c.* 1728–9. Oil on canvas, 21⅞ × 18¼ in. (55.5 × 46 cm.). Karlsruhe, Staatliche Kunsthalle.

74. *Carafe, silver goblet and fruits. c.* 1728–9. Oil on canvas, 21⅞ × 18⅛ in. (55.5 × 46 cm.). Karlsruhe, Staatliche Kunsthalle.

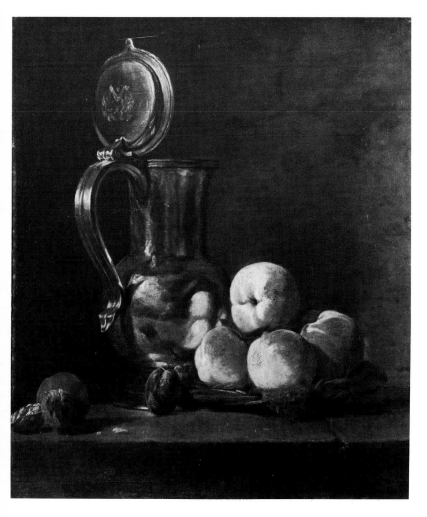 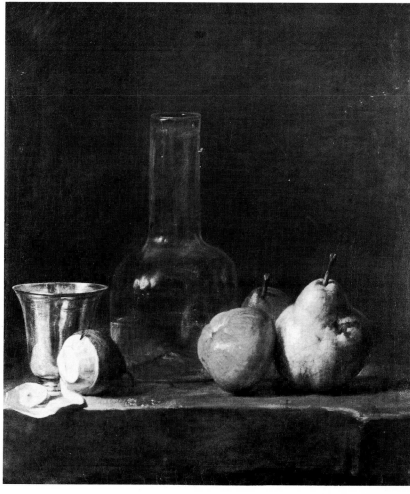

complimentary notice on the pair of small still lifes which Chardin had just completed for Abbé Trublet, and which were exhibited at the Salon that year (see page 18, and Plates 7 and 8). The Margravine wrote to her artistic adviser in Paris, Counsellor Georg Wilhelm Fleischmann, who knew both Trublet and the artist, to enquire how much Trublet had to pay for them. Fleischmann replied that he had been asked not to reveal the price paid, but, 'As this able painter has been one of my friends for more than ten years, you may, Madam, count on having replicas from him, which would hardly cost you any more than what the Abbé paid for his . . .' But the Margravine did not wish to commit herself to acquiring paintings by a reputedly expensive artist, especially when she had never set eyes on one of his works! However, she did accept from Fleischmann's own collection a small version of *A lady sealing a letter* (see Plate 101; the small version is now lost), and within two months took delivery of the pair of early still lifes with game, which were acquired for her from the painter-dealer François Joullain (1697–1778).

Before proceeding to discuss these two works, we might pause to consider a point in Fleischmann's letter which offers us one precious documentary insight into Chardin's working method: that he was prepared to make replicas of his own works. Why was this so? Why should an artist who could introduce an almost infinite range of subtle variations into works with often similar subject-matter wish to repeat himself? He often did so, for many of his works are known to exist in excellent duplicate or triplicate or even more replicas. Sometimes there are *pentimenti*, or changes, in the paintwork, visible either to the naked eye or with scientific investigation, revealing which version was the first to be conceived and executed. But sometimes it is impossible to tell, without documentary evidence.

Chardin was quite a slow worker. We know from Cochin and Mariette that painting did not come easily to him – in no sense was he a facile painter. This, of course, is perfectly obvious from an examination of the complex, meticulous, painstaking structure of his paint surface. The best reason for his slowness was a desire to achieve exactly the right effect, to attain that unity and harmony which

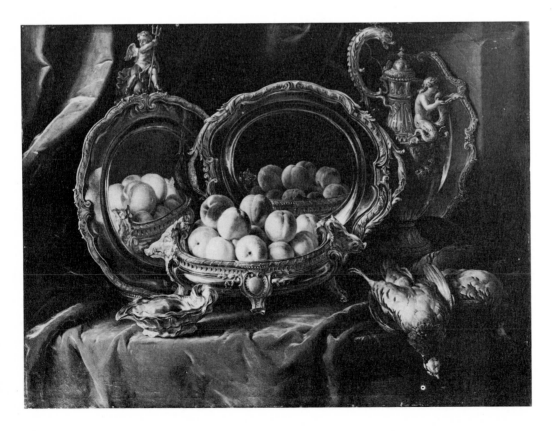

75. Alexandre-François Desportes. *Silver, peaches and game-birds. c.* 1739. Oil on canvas, 35⅞ × 46½ in. (91 × 118 cm.). Stockholm, Nationalmuseum. The painting would have been acquired by Count Tessin during his time in Paris, 1739–41.

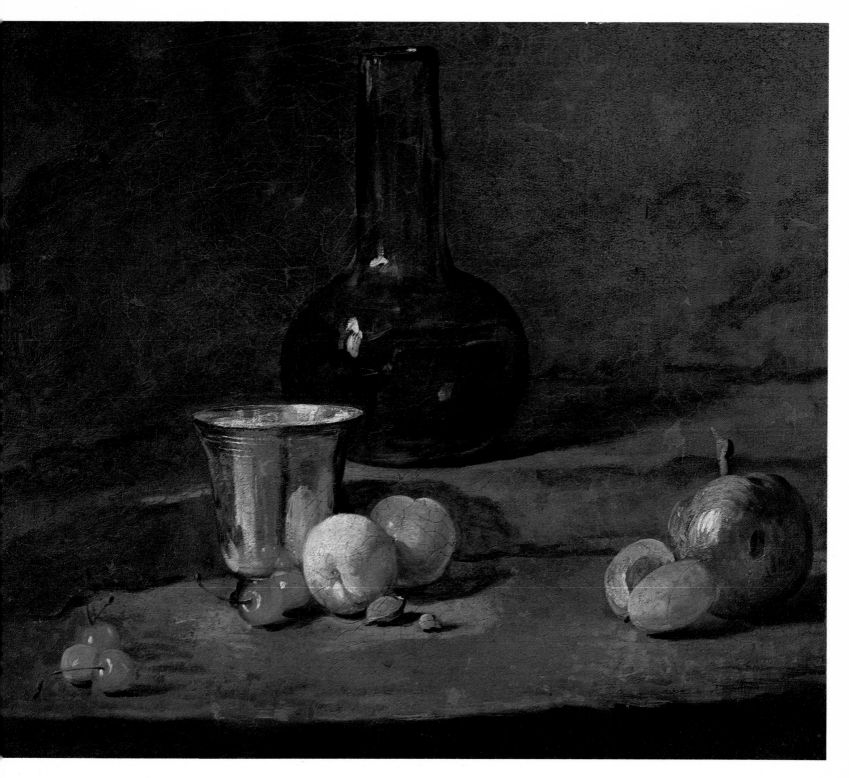

76. Carafe, goblet and fruit. c. 1727–8. Oil on canvas, 16⅞ × 19½ in. (43 × 49.5 cm.). St Louis, The St Louis Art Museum. The footed silver goblet appears in the 1737 Saintard inventory. It plays an important role in a number of Chardin's still-life arrangements.

distinguish his work. Throughout the working process, every element of the design – the selection of the subject, its arrangement (for he was totally dependent on the model), the adjustment of the lighting, the choice of viewpoint – and every movement of the brush from the palette to the canvas and back again, must have been the product of long meditation, of decision and revision. He was hard, exacting on himself, and he would not be hurried. The supreme perfection of his art was the outcome of a hard-won struggle to make his chosen medium a tractable means of expression.

When he was working on two domestic interiors for Luise Ulrike of Sweden in 1745–6, his patron grew madly impatient at their slow completion. The secretary of the Swedish embassy in Paris continually had to write back to Stockholm of the

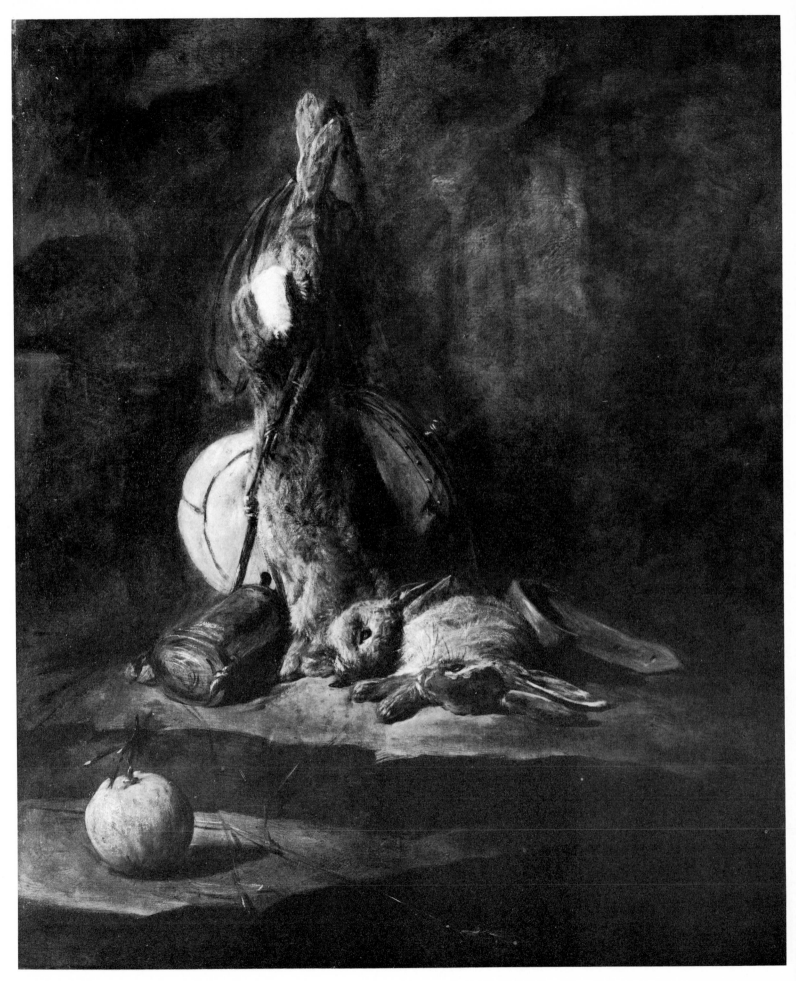

77. *Two rabbits and an orange.* 1728. Oil on canvas, 36¼ × 29¼ in. (94 × 74 cm.). Karlsruhe, Staatliche Kunsthalle. As far as we know, Chardin had no interest in country pursuits, so he probably borrowed items like the game-bag and powder-flask, or simply kept them as studio props. They appear frequently in his still lifes with dead game.

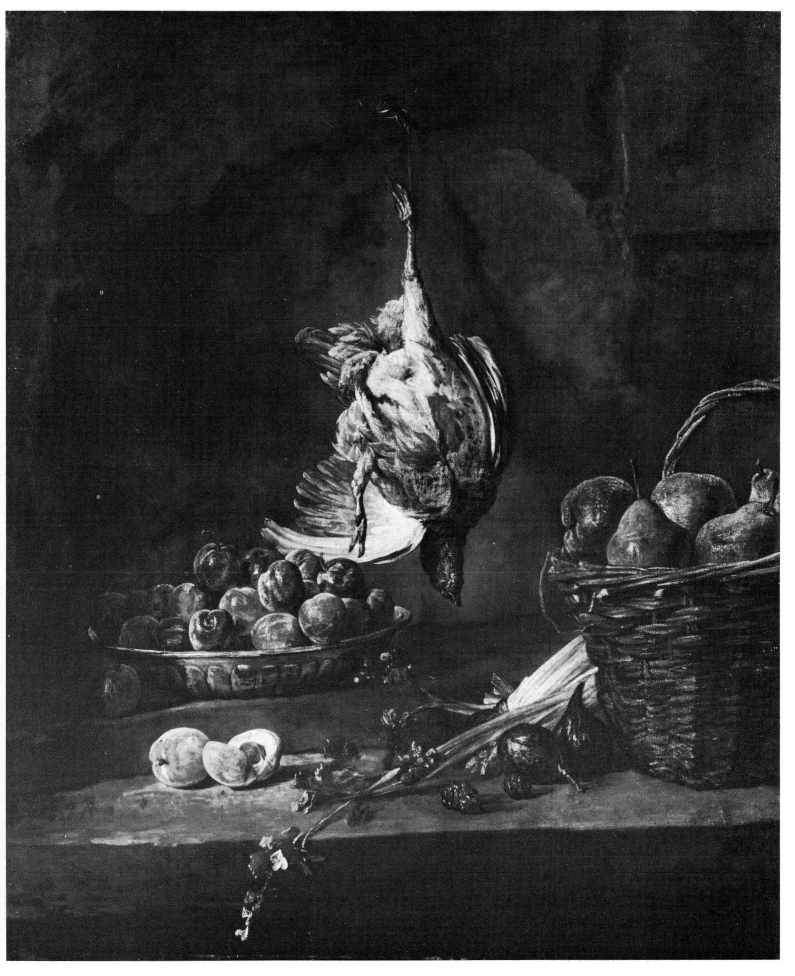

78. *A partridge with plums and pears. c.* 1728–9. Oil on canvas, 36¼ × 29⅛ in. (92 × 74 cm.). Karlsruhe, Staatliche Kunsthalle.

painter's 'slowness and the pains he takes . . . A painting he is working on now will take him another two months to complete. He never works on more than one thing at a time.' Eventually, Chardin felt bound to write one of his rare letters to justify himself and explain why a painting 'well advanced' at the beginning of October would not be ready before Christmas: 'I am not hurrying, because I have developed a habit of not leaving my works until, in my view, I see in them nothing more to be desired, and I shall be stricter than ever on this point . . .'

So rigorous was he with himself, such efforts did his works cost him, that he may have been pleased from time to time to exploit those efforts, to repeat a particularly successful design, to take as his indispensable model a familiar object that he knew and understood as no other ever could. The perceptive, and well-informed, Diderot put it neatly: 'Chardin copies himself frequently, which makes me think that his works cost him dearly.'

The painstaking struggle, however, was compounded by a certain laziness. When the text of Cochin's obituary of Chardin was embellished by the Secretary of the Rouen Academy for a reading in August 1780, Cochin objected to an additional remark, to the effect that for Chardin work was the be-all of his life. On the contrary, he wrote in a letter, Chardin was not very diligent; it was all very well to praise the virtues of a friend, but even the eulogist should not invent them!

As she was purchasing earlier works 'on the market', the Margravine of Baden did not have to wait long for her first Chardins, and when they arrived in Karlsruhe in December 1759 she was delighted with them, finding them far superior to a pair of still lifes by Jean-Jacques Bachelier (1724–1806) which were delivered at the same time. *A partridge with plums and pears* (Plate 78) is a clearly lit and precisely rendered work, which in some respects should be seen in relation to an active tradition of *trompe-l'oeil* painting – as if to underline this, Chardin's signature at lower right is made to look as if it were carved into the stone shelf, while his partridge hangs from an illusionistic nail of the type Braque would sport with in our own century. Indeed, almost a sub-genre exists of illusionistically painted game-birds suspended before an immaculately feigned surface, from a remarkable work of 1504 by Jacopo de'Barbari (*c.* 1440–*c.*1516), for example, showing a bird and a pair of gauntlets on a wooden panel, signed on a *trompe-l'oeil* fold of paper (Munich, Alte Pinakothek), to a Jan Weenix of a single partridge (The Hague, Mauritshuis), a likely type of source for Largillierre (Plate 79).

In our context, the term *trompe l'oeil* is not employed in its pure and aesthetically dismissive sense, which strictly speaking carries the implication of an illusion so complete that the spectator might think he is viewing actual objects, as opposed to their representation in paint, and to the extent that their execution may as well be anonymous. In the examples discussed here, the hand of the artist is always apparent, and the element of illusion is a matter of degree. For this type of work, the convenient term 'artistic *trompe l'oeil*' has been coined, to allow for the aesthetic refinement introduced by the painters we are discussing.

Both Largillierre (Plate 79) and Desportes (Plate 80) had on more than one occasion treated the subject of a partridge suspended before a niche, together with other still-life objects. Desportes paints with very fine detail, and manages to be at once a sharp observer and a brilliant decorator – in the illusionistic green-veined marble and in the variety of immaculately painted surfaces of feathers, fruits and bright, brittle Japanese porcelain. Working a decade earlier, Largillierre retains in his deeper shadows an element of the sombre gravity of the seventeenth century, with more depth of feeling. Against Desportes's brilliant surface, there is a painterliness in Largillierre's touch that might remind us of his later sympathy for the work of the unknown young Chardin.

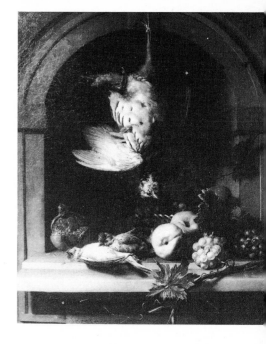

79. Nicolas de Largillierre. *A partridge before a niche. c.* 1680. Oil on canvas, 28 × 22⅞ in. (71 × 58 cm.). Paris, Musée du Petit Palais.

81. *Two rabbits, a partridge and a game-bag.* 1731. Oil on canvas, 32¼ × 25⅝ in. (82 × 65 cm.). Dublin, The National Gallery of Ireland.

80. Alexandre-François Desportes. *Partridges before a niche.* 1706. Oil on canvas, 42⅞ × 37¾ in. (109 × 96 cm.). Le Havre, Musée des Beaux-Arts.

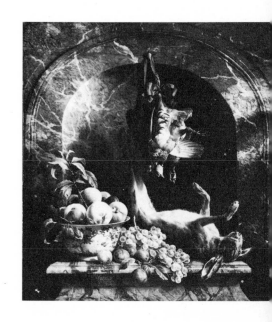

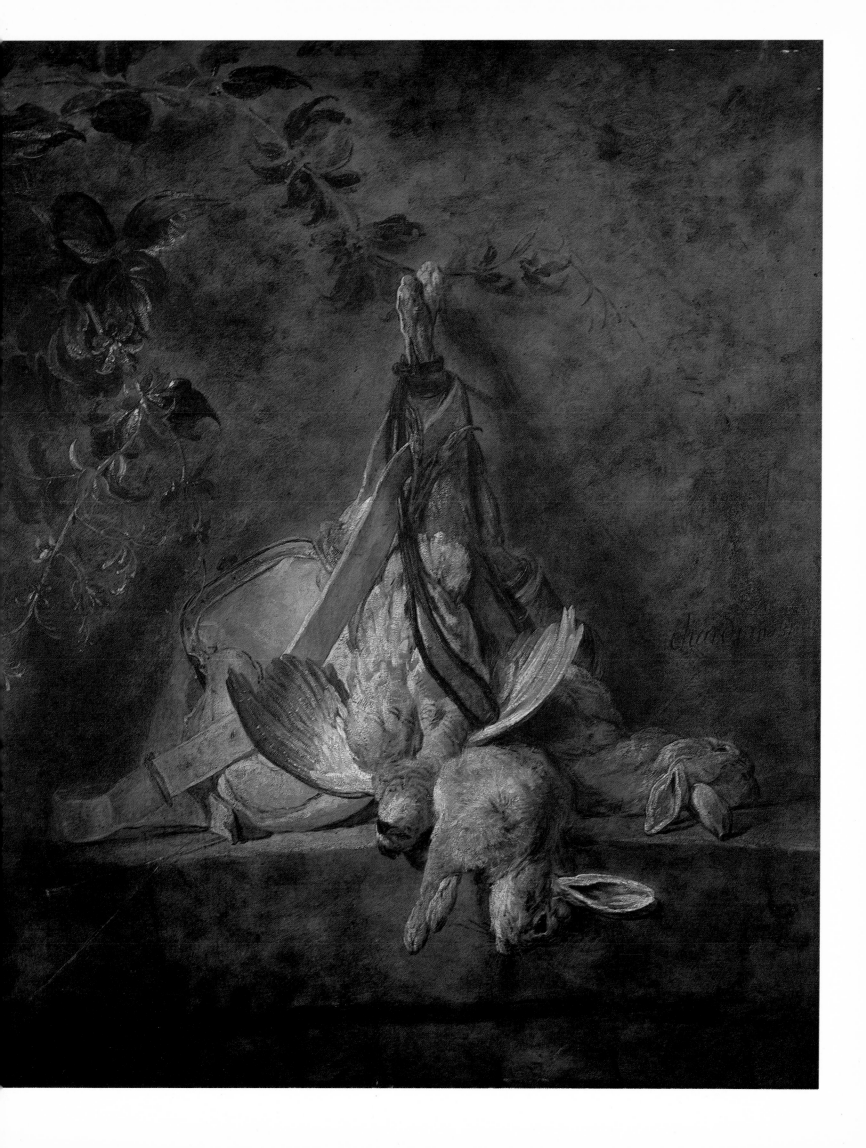

The tradition of the artistic *trompe l'oeil* was to be continued into the eighteenth century by Oudry and Bachelier, but Chardin was to define himself in relation to it in a characteristically personal way. His partridge is not hung before an architecture of perfect and symmetrical construction; his niche is a rough-hewn hollow, set asymmetrically and at an angle to the picture-plane, and rendered with free, flickering brushstrokes, which give a suggestive and neutral rather than a purely descriptive account of the background and the play of light and shade on it. As a result, the more precisely and thickly painted partridge and fruits stand out in more vivid relief. Chardin creates an extraordinarily strong sense of physical presence – but it is the physical presence of paint that we really experience, in the cunning guise of still-life objects.

The pendant to this last work, *Two rabbits and an orange* (Plate 77), also has a painterly background, which is here a foil to the scumbles and the flecked impasto of the rabbits' fur, quite distinct in technique from the partridge's feathers. We seem to see here an outdoor rocky setting, rather than the hewn masonry of *A partridge with plums and pears*. But in both works Chardin employs ledges to assist the clearer definition of foreground and middle-ground spaces. The effect of recession is made bolder by the placing of brightly coloured fruits in the foreground, and the precisely painted strands of straw and leaves of celery-tops, which teasingly trail out towards the space of the spectator, almost inviting us to reach out and touch them – or rather, those little ridges or reliefs of paint, that have dropped or run from his brushes, standing out on the flat surface before us.

Chardin's still lifes with dead game reach a formal perfection in his *Two rabbits, a partridge and a game-bag* (Plate 81), which in its rhythmically constructed pyramidal design almost recalls the perfection of the Madonna and Child groups of the High Renaissance. The soft forms of the slaughtered creatures and the leather game-bag are hung to rest gently on a thick stone ledge; the severity of the design is relieved only by the trails of honeysuckle coming in from the left, and by the fact that this is one of Chardin's softest tonal works. The blue ribbon which binds the legs of the animals acts as a foil to the gentle greys, beiges and browns of the rest of the design, which is swathed and unified by an atmosphere all but a mist. The work might stand as a quiet coda to this movement of Chardin's art.

Considering the important role played by kitchen utensils in *The ray-fish* (Plate 72), which dates from 1728 at the latest but is probably earlier by a year or two, it is surprising that no small-scale works with these objects, with the possible exception of the (destroyed) *Still life with a copper cauldron* (Plate 70), can be placed much before 1730, when the first such works known to us were dated. It may well be that after his reception into the Académie in 1728 Chardin made a conscious decision to develop a specialty in still life, which would distinguish him from the established masters of hunting and game subjects, above all Desportes and Oudry. Nevertheless, we might expect a painter so dependent on the model to have turned sooner and more readily to such simple objects close at hand. Several still lifes with kitchen utensils and basic foodstuffs are dated 1730/1, such as *The loin of meat* (Plate 83) and *Ray-fish and basket of onions* (Plate 84), which may originally have been pendants, but compared with the confidence with which Chardin was painting still lifes with dead game by this time, the brushwork of the kitchen subjects is both hesitant and fussy. It is as if he were having a struggle to control his paint, to make it tractable, to force it into an equivalent for surfaces and textures with which he was not yet completely familiar. This is especially noticeable in the former work, in the almost over-active criss-cross of brushstrokes on the meat, jug and copper pot, and in the generally somewhat confusing effect of too many highlights competing for our attention. It is nevertheless a highly distinctive and characteristic

82. Abraham van Beyeren. *Still Life with a turkey*. c. 1670. Oil on panel, 29⅛ × 23¼ in. (74 × 59 cm.). Paris, Musée du Louvre.

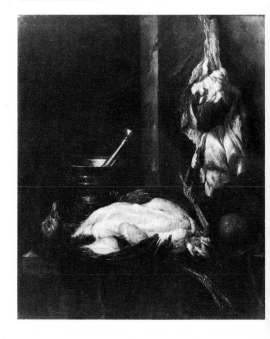

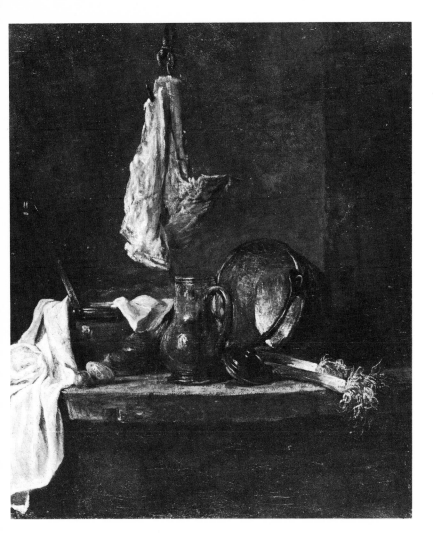

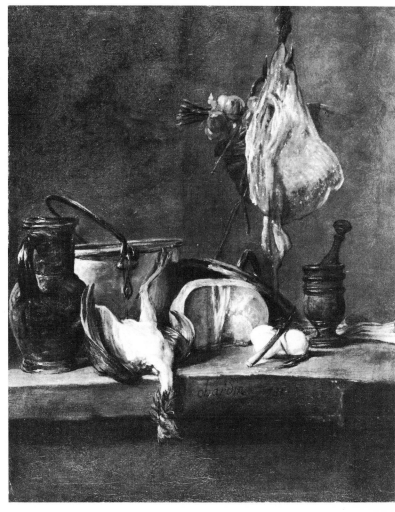

83. *The loin of meat.* 1730. Oil on canvas, 16 × 12¾ in. (40.5 × 32.5 cm.). Bordeaux, Musée des Beaux-Arts. Several autograph replicas of this painting exist, or are known to have existed. One dated 1739 (Oberlin, Ohio, Allen Memorial Art Museum) is much neater and tighter in execution than the 1730 picture, but lacks the freshness that goes with the more spontaneous earlier work.

84. *Ray-fish and basket of onions.* 1731. Oil on canvas, 15¾ × 12⅝ in. (40 × 32 cm.). Raleigh, The North Carolina Museum of Art. The pitcher and the copper pot are listed in the inventories of 1731, 1737 and 1779; the wooden pestle and mortar appear frequently, e.g, Plates 72, 86 and 98. A version of this composition dated 1728 is recorded in a nineteenth-century sale; this lost work would be the earliest dated small 'kitchen' subject by Chardin.

work, but perhaps more interesting for what it reveals of the artist's struggle to master his medium than for being the complete and seamless reconciliation of contending forces with which he usually presents us. These problems have been better resolved in later autograph replicas of this work, such as one dated 1739 (Oberlin, Ohio, Allen Memorial Art Museum), and one undated (Pasadena, California, The Norton Simon Foundation).

Ray-fish and basket of onions is more smoothly and fluidly handled than its pendant reproduced here. Everything is more carefully under control, for example his use of light and dark to articulate space: the dark profile of the jug against the illuminated copper pot, the light turkey on its darker ground, the pale cheese against the shadow of the pot-lid, and so on. Such assemblies of modest foodstuffs and kitchen utensils were painted by Northern artists in the preceding century, and Chardin's *Ray-fish and basket of onions* can be compared with the *Still life with a turkey* (Plate 82) by Abraham van Beyeren, mentioned above, a painter better remembered for his sumptuous large banquet pieces. But as always when we compare Chardin with his Dutch or Flemish predecessors, he seems more aware of the inherent character of his pigments, in addition to the possibilities of manipulating them to represent something else. And in his still lifes of kitchen utensils, he seems more self-conscious than his predecessors, more studied, more naïve in his arrangements of objects.

Chardin invented more than two dozen designs of this type in the early 1730s; and of these, there often exist several autograph versions, although a few are unique. *Ray-fish and basket of onions* is known in as many as nine versions, which attest to his considerable success and popularity in this specialization. This work

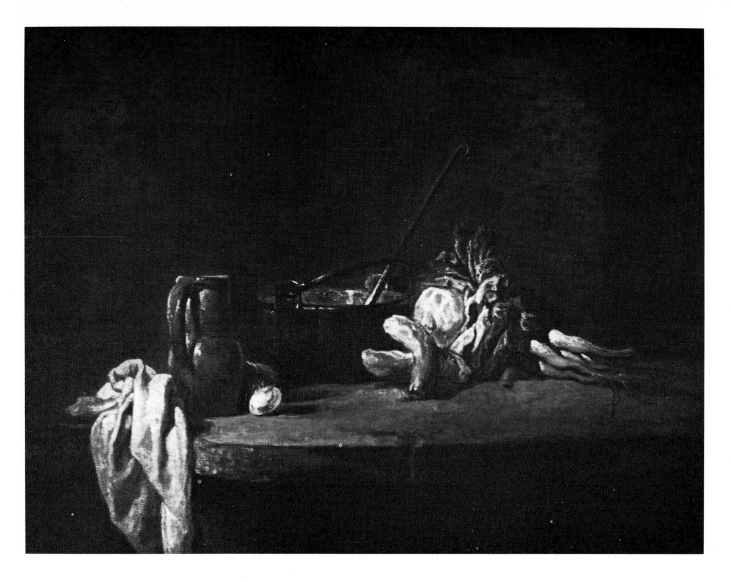

and his *Pitcher, copper pot and vegetables* (Plate 85) are no doubt the type of picture the public would have seen in the Exposition de la Jeunesse at the Place Dauphine in June 1732, when the *Mercure de France* praised the 'several small pictures of utensils' exhibited there by our painter. In the last-mentioned painting, Chardin has drawn well back from the subject, handling the volume of the different objects with confidence and allowing them an open and airy surrounding space. The cumulative effect of studying many of Chardin's pictures of this type is to see that they are variations on a single theme – but the variations are of course potentially infinite, in the combination of objects, their relative position, the viewpoint of the artist, bold changes or subtle modulations of light and shade. Chardin clearly delighted in assembling and reassembling certain familiar kitchen utensils – copper pots, earthenware dishes, pots and jugs, a spice-box, bottles, a skimmer, a ladle, and so on, which appear from one picture to another. He arranged one shape, silhouette or volume next to another, interspersing the softer and less regular forms of vegetables or meats. Through this consistent choice of subject-matter, and through his way of arranging and rendering it, Chardin's pictorial world remains recognizably and individually his own. For an artist who could paint only from observation, still life was the perfect genre to which to devote his attention. He could carefully choose and arrange a small corner of his familiar world to his own satisfaction, even before he set about translating it into an ideal pictorial realm.

Among the most accomplished and justly popular paintings of this kind are *The fast-day meal* (Plate 86) and *The meat-day meal* (Plate 87), both dated 1731.

85. *Pitcher, copper pot and vegetables. c.* 1731–2. Oil on canvas, 12¼ × 15⅜ in. (31 × 39 cm.). Indianapolis Museum of Art (Gift of James E. Roberts). Three replicas of this design are known.

86. *The fast-day meal.* 1731. Oil on copper, 13 × 16⅛ in. (33 × 41 cm.). Paris, Musée du Louvre. The earthenware pot in the background is a brazier, to contain hot coals and support a heating pan. This painting and its companion are celebrations of Chardin's favourite kitchen utensils and are among his works most admired by nineteenth-century Realists. They belonged to Theophile Thoré from about 1840, one of the principal 'rediscoverers' of Chardin in that period.

87. *The meat-day meal.* 1731. Oil on copper, 13 × 16⅛ in. (33 × 41 cm.). Paris, Musée du Louvre.

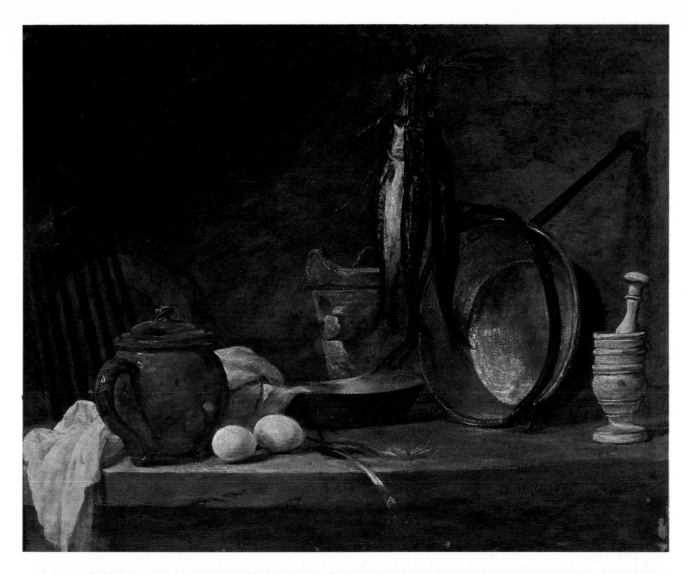

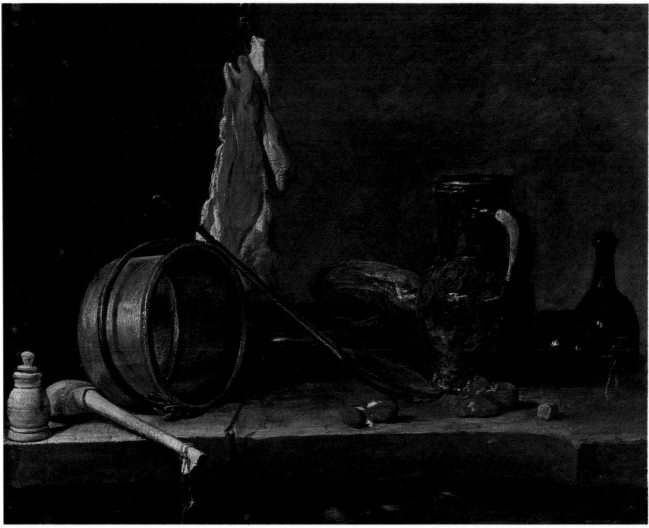

Unusually for Chardin, they are painted on copper supports, which allows a fluid ease of handling; but he still achieves a very tactile and substantial range of textures, giving all the objects a fullness of physical presence. In the latter painting considerable *pentimenti* can be seen from an angle with the naked eye, lending support to the idea that Chardin on occasion worked out his compositions in the course of execution. This has been proved in other works by Chardin through the use of X-rays. In the present case, the paint-layers of an earlier version of the copper pot can be perceived under the surface, further up and to the right of the final location.

We need not read any special meaning into these works, but only notice that they do reflect the two religious observances stated in the titles they were given in the nineteenth century. They form a pair, whose basic ranges of colour and tone correspond, except that instead of the cool silvery and blue tones of the herrings, answered by the warm brown glaze of the teapot, *The meat-day meal* has the red of the slice of meat and the raw kidneys, answered in their turn by the green bottles and the green-glazed jug. In the quantity and the relatively open arrangements of objects, these are Chardin's most complex and ambitious designs in this type of picture; his confidence in dealing with them may have been strengthened by the successful completion of his first commission for large decorative works at just this time.

Very little is known about the first owners of Chardin's still lifes of the 1720s and 1730s, although a few belonged to his friends among artists, such as Aved. But his income from such paintings was probably a modest one. The early eighteenth century was still a time when the great majority of paintings were commissioned as an element in an overall decorative scheme: light-hearted in a private interior, with a didactic bias in civic, royal or other institutional buildings, or as altarpieces in churches, for example. But the market for still lifes with game in the form of large-scale decorative painting was already divided up between Desportes and Oudry, and it is hard to imagine a demand for decorative paintings of humble kitchen utensils. *The white tablecloth* (Plate 88) is something of an exception, however, and would have originally formed a *devant-de-cheminée* or chimney-screen – that is, a screen to be set into a fireplace during the summer months for decorative effect. There was a vogue for these screens during the seventeenth and eighteenth centuries, and some designed by Oudry are known. Many were illusionistic in effect. Thus *The white tablecloth*, as well as being a decorative harmony of whites, greys and beiges, is meant to seem as if the low table, with its loaf, sausage and glasses, and the bin of cooling wine bottles, were set back in a recess which would be framed by the chimney-piece. But it is a somewhat awkward and perhaps hastily executed work, lacking the careful arrangement and exquisite handling of Chardin's cabinet pictures.

As far as we know, it was not until 1730 that Chardin received his first commission for large-scale decorative paintings of a more refined and ambitious character. In the previous year he had to supplement his income by assisting J.A. Meissonnier (1695–1750) in the execution of designs for an elaborate firework display at Versailles in honour of the birth of the Dauphin, and in 1731 he was working under Jean-Baptiste Vanloo (1684–1745) on the restoration of the sixteenth-century frescoes in the Galerie François Ier at Fontainebleau. However, for Count Konrad Alexander von Rothenburg, who from 1731 to 1734 was to be Louis XV's ambassador in Madrid, Chardin executed two sets of decorative paintings, for which he was paid in 1730 and 1731. How or why Rothenburg came to Chardin is not known, but he had connections with Aved, and indeed Chardin's portrait of Aved in the guise of a philosopher or alchemist (Plate 102) was to be

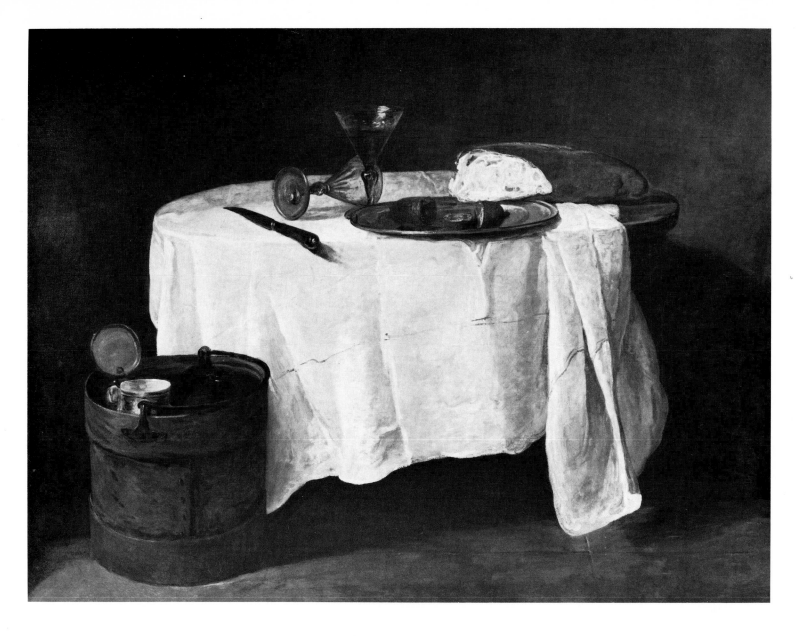

88. *The white tablecloth. c.* 1730. Oil on
canvas, 37⅞ × 43¾ in.
(96.2 × 123.8 cm.). The Art Institute of
Chicago.

commissioned by this same patron in 1734, on his return from Madrid.

Two out of the three overdoors for which Chardin was paid in 1730 still survive:
Musical instruments with a parrot (Plate 89) and *Musical instruments with a basket of
fruit* (Plate 90); both canvases were originally shaped at the corners, to fit into a
decorative architectural framework. Singled out for special mention by the *Mercure
de France* when they were shown at the Exposition de la Jeunesse in 1732, they
reveal new dimensions of Chardin's talent at this time. Against a neutrally toned
but unusually rectilinear background, the composition of *Musical instruments with a
parrot* unfolds rhythmically, from the elaborate forms of the gilt ewer, through the
rich brown of the violin, the bright red bag and ivory and ebony pipes of the
bagpipes, to the arched form of the blue and green parrot perched on a music-stand
at the right. The severity of the setting, the more precise painting of the
instruments, and the notes of strong, positive colour (set off by the subdued
background and the creamy-white sheets of music), are new. The companion
Musical instruments with a basket of fruit is altogether more rustic, in an outdoor
setting with fronds of honeysuckle, and the design is closer to some of the still lifes
with dead game. Here, the instruments are a guitar, with a bright blue strap, a
flute, a hurdy-gurdy, and a tambourine with pink ribbons. These adventurous
works seem but preparations for a pair of richly appointed and much larger still lifes

89. *Musical instruments with a parrot.* 1730. Oil on canvas, originally shaped at the corners, 46¼ × 56½ in. (117.5 × 143.4 cm.). Private Collection. Chardin executed this painting and its pendant, his first decorative overdoors, for Count Rothenburg, and exhibited them at the Exposition de la Jeunesse in 1732 and 1734, probably in the hope of attracting other similar commissions.

90. *Musical instruments with a basket of fruit.* 1730. Oil on canvas, originally shaped at the corners, 44 × 56⅜ in. (117 × 143 cm.). Private Collection.

91. (*opposite*) *The attributes of exploration.* 1731. Oil on canvas, 55½ × 86⅜ in. (141 × 219.5 cm.). Paris, Musée Jacquemart-André. Executed in the year of his marriage, and when he was soon also to have a family to support, Chardin must have hoped that more large-scale commissions like this one would come his way, but he shortly chose to diversify into figure painting.

92. *The attributes of the arts.* 1731. Oil on canvas, 55¼ × 45¼ in. (140 × 215 cm.). Paris, Musée Jacquemart-André.

completed for Count Rothenburg in 1731, apparently to be displayed on top of cupboards in the library of the Paris house he had recently refurbished: *The attributes of exploration* (Plate 91) and *The attributes of the arts* (Plate 92).

These are grand, even grandiose works, with large forms, sweeping rhythms, and rich saturated colours. They are clearly designed to be seen from below, which

reinforces the impression of monumentality. *The attributes of exploration* shows on the upper ledge a large globe, rolled maps, a telescope, books, a square and sextant, while below are a vase of Japanese design, a microscope, an oriental rug and an incense-burner: this work is commonly called *The attributes of science*, but exploration or foreign travel seems to be the theme – and just as likely to feature in the library of a cultured diplomat. The pendant *The attributes of the arts* is dominated by an antique-looking plaster bust, displayed before a swag of red velvet curtain, which looks as if it were borrowed from some painting of the seventeenth century. Next to it are rolls of paper, palette and brushes, and a sculptor's mallet; below are a plaster relief, *Children playing with a goat* after François Duquesnoy (1597–1643), one of the most celebrated sculptors of the previous century, an elaborate seventeenth-century gold vase containing a small orange-tree, and a monkey with a crayon-holder. In each of these works, Chardin gently reminds us of the vanity of human endeavour: the smoke from the incense-burner is not only an image of oriental exoticism, but also an emblem of the transience of our material world and our human efforts; while in the corresponding corner of the other picture he makes a monkey out of the artist.

The decorations for Rothenburg reveal an aspect of Chardin's talent quite unexpected, considering the character of the other still lifes we have seen so far. Yet even on this grand scale, he can happily control his design, from its perfect sense of space and mass to the resonant chords of its colour.

He was not again to produce as monumental an effect – positively in the grand manner, we might say – until 1765, when he executed a commission for overdoors in the royal Château de Choisy. Did no comparable commissions come his way during the intervening thirty years? Did he never have the opportunity to develop still life further on this more heroic scale? Or did he make a deliberate aesthetic choice to keep to a small and intimate format? Quite possibly, however, the grandeur and the ambitious scale of these works for Rothenburg gave him the confidence to tackle figure painting in the early 1730s. One of the first of these, *A lady sealing a letter* (Plate 101), painted in 1733, shares with *The attributes of the arts*, the general baroque affiliation, the colour-scheme, and even the specific detail of the swag of red curtain.

But in a sense the move from *The attributes of the arts* to *A lady sealing a letter* is less surprising than that the same artist in the same early years of the 1730s was painting the *Still life with a slice of salmon* (Plate 94). It is a variation on the 1731 *Fast-day meal* (Plate 86), though with a more simplified design, and it is more sensuous in effect. Not only the arrangement, but the lighting is more controlled by the introduction of a curving corner of wall and a corresponding curve in the stone shelf, which allow a greater range and a greater degree of modulation in the shadows. Thus, the herrings stand out, catching light in contrast with the shadowy curve of the wall, while the small lidded pitcher at the left and the larger jug at the right create dark silhouettes against lighter grounds (Plate 93). A soft, light-pink slice of salmon, laid across the hard, reflecting pot-cover, contributes to the sensuous character of the work, while the brightness of this fish corresponds to the silvery herrings and the white eggs, all standing out from the muted beiges and soft earth colours.

Chardin again introduced the device of the curved background wall in *The smoker's case* (Plate 95), which the present writer believes to be close in date to the *Still life with a slice of salmon*, about 1734. Although the objects loom slightly larger in the latter picture, the overall disposition in the two paintings is similar, and in each a strong light falls on the shelf, casting strong shadows. If the painting of *The smoker's case* is more refined, it is a more refined subject. The rosewood box, lined

94. *Still life with a slice of salmon. c.* 1734. Oil on canvas, 12⅝ × 15⅜ in. (32 × 39 cm.). Oxford, Ashmolean Museum. There is a replica of this work in a New York private collection, and another, of the finest quality, has recently been discovered in a French private collection.

with blue satin, is listed in the 1737 Saintard inventory (see caption to Plate 95), and some of its contents are also displayed; the blue and white faïence pitcher does not belong with the box, of course, nor the goblet with its unidentified contents at the right. The overall delicacy of the lighting, the brightness of the tone and refinement of the colour – turquoise blues and the touches of pink – are in perfect accord with the genteel character of the subject. Even the pattern incised in the wall at the left plays its part in elevating the social milieu of this work above the servants' quarters.

The extreme refinement in *The smoker's case* makes it an exceptional work in the first half of Chardin's career as a still-life painter. But, as he gains in confidence, he surprises us again and again. Before we are lulled into expectation, he can introduce a new radiance of light into his pictorial world with the cream and blue faïence jug, a glass of water and some glistening cherries (one dangling over the ledge), in *A jug, copper pot and two herrings* (Plate 96). The cool silvery herrings gleam in a honey-coloured light, against a foil of modulated tones created by the rough-hewn niche

95. *The smoker's case. c.* 1734. Oil on canvas, 12¾ × 15¾ in. (32.5 × 40 cm.). Paris, Musée du Louvre. The Saintard inventory of 1737 included: 'A smoker's case of rosewood, with key lock and metal handle, lined in blue satin, containing a silver set of two small goblets, small funnel, small candle-holder with extinguisher, four small pipe-stems and two small palettes, two crystal flasks with silver cap and chain, and two coloured porcelain pots – the entire case valued as a precious object at 25 livres.' To these items Chardin has added the faïence jug, the long clay pipe (glowing and emitting a wisp of smoke), and the goblet with unidentified contents at the right. The wisp of evanescent smoke makes this one of Chardin's most discreet *vanitas* images.

behind them. Chardin achieves a perfect harmony between design, colour and the form of his subject-matter, each object carefully considered in relation to its neighbours, and the whole unified by the pervasive light. One of the best modern Chardin scholars has described a sensation of 'spring-like joy' emanating from this little work. It is not easy to put into words the emotions we may feel in front of a still life by Chardin. As we have seen, the artist himself stressed the importance of 'feeling' in creating a work of art, and it is through feeling that we respond to the particular harmony and unity of a work. Chardin's approach seems to be echoed in the words of Henri Matisse in an interview in 1908 (and who still in our century felt the need to emphasize that as much could be learned from painting a jug or a copper pot as from studying antique statuary):

To copy the objects in a still life is nothing; one must render the emotion they awaken. The emotion of the ensemble, the interrelation of the objects, the specific character of every object – modified by its relation to the others – all interlaced like a cord or a serpent.

The tear-like quality of this slender, fat-bellied vase – the generous volume of this copper – must touch you. A still life is as difficult as an antique, and the

96. *A jug, copper pot and two herrings.* 1734–6. Oil on canvas, 16⅛ × 13¼ in. (41 × 33.6 cm.). The Cleveland Museum of Art (Purchase, Leonard C. Hanna Jr Bequest). There is an excellent replica in a Paris private collection.

proportions of the various parts as important as the proportions of the head or the hands, for instance, in an antique.

Chardin can happily adapt his approach, be it to sombre shade or bright clear illumination, to a large work of complex organization or the simplest statement of a few basic forms, and to supports of canvas, copper or wood. He did experiment briefly, in the early and mid-1730s, with the latter two supports. A handful of small paintings on wood, with very simple compositions of a few carefully chosen objects placed in quite a compact space, can be dated to this time, and perhaps as late as 1734. There are some related figure paintings, such as *The embroiderer* and *The draughtsman* which we have seen (Plates 9 and 10), and others. *A copper pot and spice-box* (Plate 97) and *A copper pot and mortar* (Plate 98), which may originally have been pendants, seem to develop in their clear, bright, honey-toned lighting, from *A jug, copper pot and two herrings*, while their thick, pondered, paste-like technique is comparable with that used for the little figure subjects painted on wood. The upright pot, swelling its dark cylindrical shape into the picture-space, and the powerful void displayed when a similar pot is turned on its side, play in turn against the bulging casserole and bowl, the bulbous shapes of spice-box and mortar,

97. *A copper pot and spice-box.* c. 1734. Oil on panel, 6¾ × 8¼ in. (17 × 21 cm.). The Detroit Institute of Arts. There is an autograph replica in the Louvre; X-rays suggest that both these paintings, and possibly some other small ones of the same date, have been painted over a larger panel with an earlier design on it, subsequently sawn up to create the smaller supports.

98. *A copper pot and mortar.* c. 1734. Oil on panel, 6¾ × 8⅛ in. (17 × 20.5 cm.). Paris, Musé Cognacq-Jay. This panel and its companion may have been among the 'three small paintings on wood . . . representing kitchen utensils and framed in gilded wood, estimated at 30 livres altogether' in the estate of Marguerite Saintard in 1737.

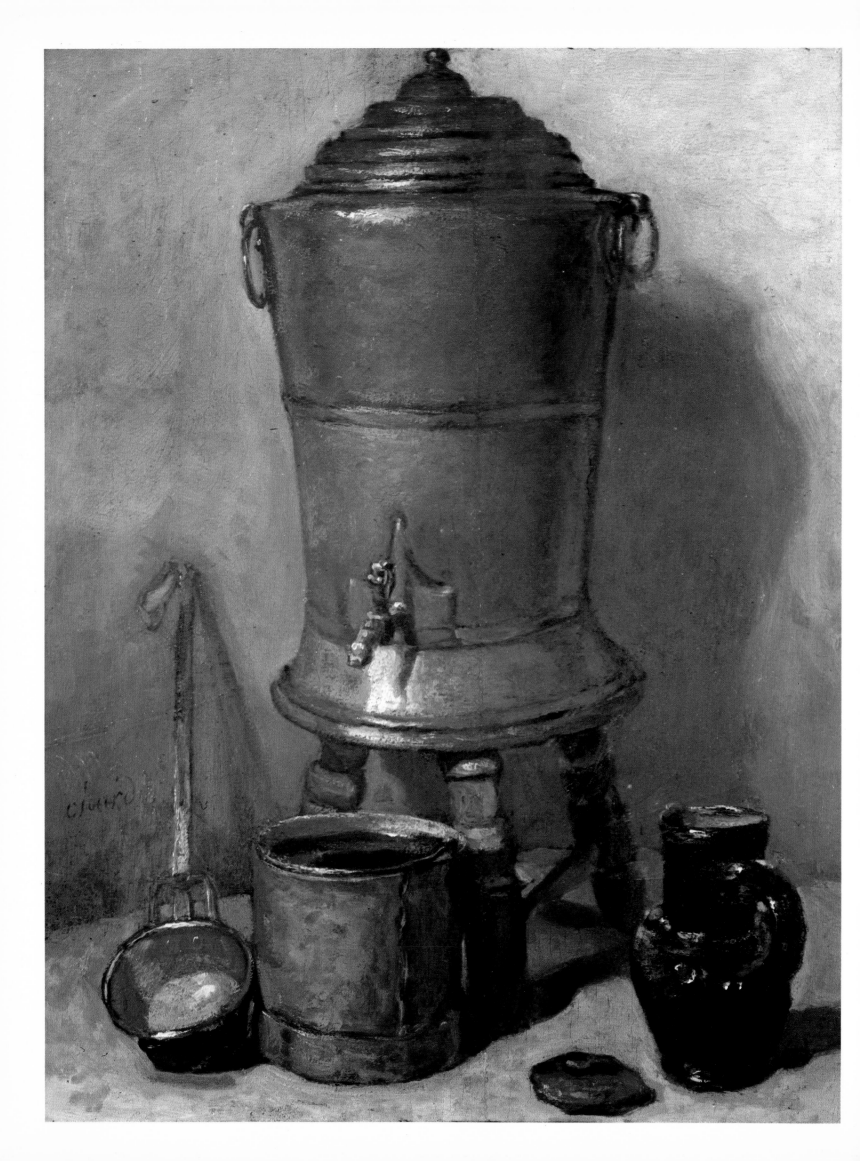

99. *The copper cistern. c.* 1734. Oil on panel, 11¼ × 9 in. (28.5 × 23 cm.). Paris, Musée du Louvre. The cistern itself was in the Saintard inventory of 1737: 'A copper cistern fitted with cover and rings, which are also of copper, containing two water compartments, with its metal tap, resting on wooden legs, valued at 25 livres'.

the solid ovoids of eggs and onions. In the one case, the blank edge of the stone shelf is interrupted by the pale stalk of a spring onion, in the other by a dark knife-handle. We are sensible of the rhythms of curves, convex and concave, of the generous shape of a pot, the tight contour of an egg or the pedestal of the mortar, of light, shadow and reflection, of the texture of things, the texture of paint – a still, monumental world of homely, everyday objects, moving in their simplicity, and given a special authority by Chardin's attention.

Three of these small wooden panels showing kitchen utensils are listed in the 1737 Saintard inventory. The two panels just discussed may have been among them, together with one of his most popular (in our era) still lifes, *The copper cistern* (Plate 99). The three panels share a similarly impasted handling, and a similar tonal range. But spatially *The copper cistern* is the more ambitious, for rather than taking a simple shelf at eye level, Chardin views the cistern and its trestle standing on the ground, juxtaposed with a green-glazed pitcher, a copper bucket, and a long-handled cooking-pan propped against the wall. Thus the viewpoint is more complex, to take in the full height of the cistern and its stand, and the perspective of the floor. It clearly took Chardin some pains to reconcile the volumes of the pan, trestle and pitcher with the floor on which they stand – for the painting of the floor around them is thickly impasted and worked over; and also, because it is much lighter, it seems in places to rise up around them towards the picture-plane. There is the feeling of each object having been intensely studied in its turn in relation to the floor below and behind it, sometimes to the neglect of other parts of the floor surface: the floor to the left and behind the cooking-pan, for example, has the effect of being nearer the spectator than that surrounding the pitcher. But in the final event any hints of visual dislocation as the artist moved from one object to another are resolved by the tonal harmony of the work, and by the unifying effect of the powerful tactile presence of the pigment itself across the whole panel. If the rich, warm brown of the cistern against the buff grey of the wall corresponds to its full, dominating form, Chardin has chosen the accompanying objects with equal attention to their shapes and colours – from the bright-yellow copper hollow of the pan with its cold grey metal handle, to the deep-green bulges of the pitcher, and the soft expansive brown of the cylindrical bucket as a neutral centre. For all that Chardin's signature is like a *graffito* on the wall, this is not illusionistic painting; the brown thong on the handle of the pan is suggested, not defined, an angular and twisting gesture of the paint-loaded brush. Placed firmly as these solidly painted objects are on the floor at the end of their kitchen, they take on a presence even more immediate than the utensils we have seen artfully arranged at eye level on their stone ledges. Somehow the spectator can identify with this space, could walk in on this small area of floor. It seems to require but one step for a maidservant to enter Chardin's pictorial world, and to confirm the already vivid existence of these vessels with use.

5 *Little Pieces of Common Life*

The establishment of Chardin's reputation as a painter of still life was officially marked by his reception into the Académie in 1728, and unofficially by the first commissions in the early 1730s. He had arrived; and having arrived, he probably took stock of his position in the complex Parisian art world of the day. In such a context, he must have been aware of the limitations of still-life painting – not only from the intellectual point of view of his academic milieu, but also he may have wished to improve his financial prospects by extending his range. In February 1731 he took on the responsibilities of marriage, and of parenthood before the year was out. Perhaps that early ambition to paint the human figure remained, now complemented by the confidence gained through experience. As a painter of still life he was competing with two older and well-established masters, Desportes and Oudry, and would be even more, if he were to expand in the obvious way and include live animals or paint larger-scale decorative works. As Mariette put it in 1749:

> He feared, and perhaps with reason, that painting only inanimate objects of little interest, people would soon get tired of his work, and that, attempting to paint living animals, he would remain too far behind MM. Desportes and Oudry, two redoubtable rivals, who had already taken the front rank and whose reputations were established.

Mariette and Cochin relate similar stories of Chardin's decision to turn to figure painting, a decision prompted by his close friend Joseph Aved, whose star was rising at much the same time as Chardin's own. Cochin places the event around 1737, which is clearly too late; Mariette gives the fuller and perhaps more accurate account.

> M. Aved, the portrait painter, was his friend, as he still is, and they saw each other often. One day a lady came to M. Aved for her portrait; she wanted it down to her knees, and she intended to pay only four hundred livres. She left without having made a deal, for, although M. Aved was not as fully employed then as he has been since, this offer seemed to him far too modest; M. Chardin, on the contrary, insisted that he should not let this chance go by, and wanted to prove that four hundred livres was a good price for someone who was as yet only half-known. 'Yes', said Aved, 'if a portrait was as easy to do as a sausage.' That was because M. Chardin was at that time painting a chimney-cover, with a sausage on a plate. This retort made its impression on him, and, taking it less as a joke than as a truth, he examined his talent seriously, and the more he considered it, the more he persuaded himself that he would never gain much from it.

Chardin's picture of 'a chimney-cover, with a sausage on a plate' is possibly the large painting now known as *The white tablecloth* (Plate 88), which we have discussed in the preceding chapter, although the awkwardness of its design and the lack of refinement in the painting of the details would incline one to place it rather earlier in his career than 1732 or 1733, the likely date of the anecdote.

So, no doubt for a combination of reasons, and some ten years after making *The surgeon's sign* (Plate 44) and *The billiard party* (Plate 49), Chardin again took up figure painting. This was with a work surprisingly monumental in the scale of its life-sized characters, *A lady sealing a letter* (Plate 101), dating from 1732 or 1733, and exhibited at the Place Dauphine in 1734. Discussing the exhibition, the *Mercure de France* describes the young lady as waiting impatiently while the candle is lit so that she can seal her letter. The red stick of sealing-wax in her hand stands out boldly in juxtaposition with the white folded paper of her letter. The amorous impatience of the lady is stressed in the verses appended to Fessard's 1738 engraving after the picture:

> O hurry up Frontain; look at your young mistress, with tender impatience lighting her eyes. She is already longing that the object of her desires should have received this note, measure of her affections. Ah Frontain, to be as slow as this, the god of love has never touched your heart.

This gallant type of theme can be matched in the works of older contemporaries, such as Jean-François de Troy (Plate 28) and Charles Coypel. These French artists were aware of the precedents in the works of Dutch and Flemish seventeenth-century masters, such as Caspar Netscher, Gottfried Schalken (1643–1706) and Gerard Ter Borch (1617–81; Plate 100). The subject of Ter Borch's *A lady sealing a letter* is closely analogous to that of Chardin, although the Dutch participants have a cool, detached air, compared with the more poetic mood and sense of urgency communicated by Chardin in the lady's leaning pose, the impatient readiness of her hands, and the eager hound. It is characteristic of Chardin that he should have chosen a more psychologically charged moment – in fact, an expectant moment *before* the actual sealing of the letter – investing his painting with a delicate tension reminiscent of some of Watteau's *fêtes galantes*. And against Ter Borch's smooth surface, Chardin takes characteristic delight in the scumbled silvery grey of the lady's hair, the smooth impasto of her cheeks and neck, the dragged paint of the highlights of her dress.

As his first (so far as we know) attempt at this type of subject, *A lady sealing a letter* is Chardin's most eclectic work. While the illumination of the figure against a shadowy background recalls Schalken, the play of folds on her dress, the lost profile, the varieties of painterly texture, and the psychological tension suggest Watteau writ large. There is a baroque residue in the use of the velvet curtain, in the rich, sombre harmonies of red, green, blue and brown, while details such as the painting of the lady's plump hand and neck have much about them of painters born well within the seventeenth century, such as Lemoyne and De Troy.

This somewhat grandiose and sumptuous picture recalls the pair of unusually large still lifes painted for Count Rothenburg in 1731 (Plates 91 and 92), in its chiaroscuro, its rich and sombre colour, and its low viewpoint; and even the same curtain and carpet seem to have been employed. Did the success of these grandly conceived still lifes give Chardin the courage to tackle a major figure subject? The figures of the lady and her servant are cast into a unified group, leaning towards one another around the carpeted table; but there are uncertainties – in the foreground space, for example, from the lady's knees somewhere under her voluminous skirt to a presumably uncomfortable perch on the edge of her chair. Chardin has

100. Gerard Ter Borch. *A lady sealing a letter. c.* 1660. Oil on canvas, 18 × 14⅛ in. (45.8 × 36.6 cm.). Present location unknown.

compensated for some of the anatomical difficulties by the arrangement of her striped dress into a rather self-conscious abstract pattern, a device he would soon learn to employ with much greater subtlety.

Related to *A lady sealing a letter* in size and in the large scale of its figure is the painting best known as *The alchemist* (Plate 102). It has recently been established that this work was commissioned by Count Rothenburg, the first important patron of Chardin's still lifes. The picture was completed at the end of 1734, but the patron only lived to enjoy it for a month or two; after his death early in 1735, the

101. *A lady sealing a letter*. 1733. Oil on canvas, 57½ × 57⅞ in. (146 × 147 cm.). Berlin, Staatliche Museen Preussischer Kulturbesitz, Schloss Charlottenburg.

102. *The alchemist*. 1734. Oil on canvas, 54⅜ × 41⅜ in. (138 × 105 cm.). Paris, Musée du Louvre. An 'elevated' portrait, showing his friend Aved in an idealized context.

108

painting, referred to simply as a '*philosophe*', was returned to the artist. Exhibited at the Salon of 1737 as '*A chemist in his laboratory*', and entitled '*Le souffleur*' in Lépicié's engraving of 1744, it became 'an alchemist in his laboratory, attentively reading an alchemical work' when the engraving was advertised in 1745; shown again at the Salon of 1753, it was '*A philosopher occupied in his reading*'. In this last year *The alchemist* attracted a good deal of attention from the Salon critics, who remarked on its ambitious size and its elevated, meditative theme.

It is not surprising that a number of critics were reminded of Rembrandt – the theme is reminiscent of some of the small early works by the Dutch master representing 'philosophers' reading or meditating in cavernous rooms (such as two works now in the Louvre, which were in Paris already in the eighteenth century), or some of his larger later fanciful images of Old Testament-type sages, studied among the Jewish population of Amsterdam. Although the general theme and the scale recall Rembrandt, Chardin's lighting is much less contrasted, the drawing is tighter, and the handling of the paint is flatter and much less impasted. The colour harmonies, of dark soft red, greenish blue (accented in the hour-glass), and obscure gold, have the pleasing decorative quality of *A lady sealing a letter* and would set *The alchemist* at home among the works of other French artists of the 1730s such as De Troy. Contemporaries recognized in this work a portrait of Chardin's friend Aved, who as we have seen had encouraged him to take up figure painting. The idea of a 'fancy' portrait, as it might have been termed in the eighteenth century, half-way between a straight portrait and the ideal realm of history painting, is another Rembrandtesque feature of this work. Any such 'Dutch' guise is probably a tribute to Aved, nicknamed 'The Batavian', who had for a time trained in Holland, and whose own portraiture is influenced by the sober realism of Dutch seventeenth-century painting.

Hardly noticed by critics when it was first exhibited in the 1730s, *The alchemist* found a sympathetic response in the rather more earnest artistic climate of 1753. After the decorative trends, which to many had seemed to dominate French painting since the 1720s, the serious and absorbed mood of Chardin's painting could be compared with the reflective and philosophical mood of the younger generation of painters such as Pierre, Vien, and others, who were affected by the reforms of the later 1740s we have discussed in Chapter 2.

Several features of Chardin's portrait of Charles-Théodose Godefroy (Plate 103) relate it in date to the portrait of Aved – the large scale of the figure in relation to the canvas, the play of forms of the figure, table and music, the slightly awkward pose and situation of the figure in space, and the range of colour. The painting has been trimmed at the right and extended at the left and bottom at some time, which alters its original aspect. Nevertheless, it is striking, not least for the way in which the youth turns to look directly at the spectator – a pyschological confrontation that is rare in Chardin's work. For this bold essay in portraiture he very likely adapted a Flemish or Dutch prototype, and his attention to the textures of the paint makes one think of a Rembrandt of the early 1630s, of the type of *A young man at a desk* (Leningrad, Hermitage) or the *Portrait of a seated man* (Vienna, Kunsthistorisches Museum). Chardin's friend Aved would have advised him on this sort of matter, although Chardin here seems to anticipate the sober realism of Aved's own portraits by several years! The transposition from Amsterdam to Paris in a hundred years conceals the source of such a work, however, which has a refined delicacy of mood and design that is quite of its own time and place. This seventeen-year-old son of an affluent banker and jeweller, a close personal friend of the artist, was a devoted amateur composer and musician and later, like his father, became a keen patron of the arts. Chardin seems perfectly to capture an air of eager but still as yet youthful

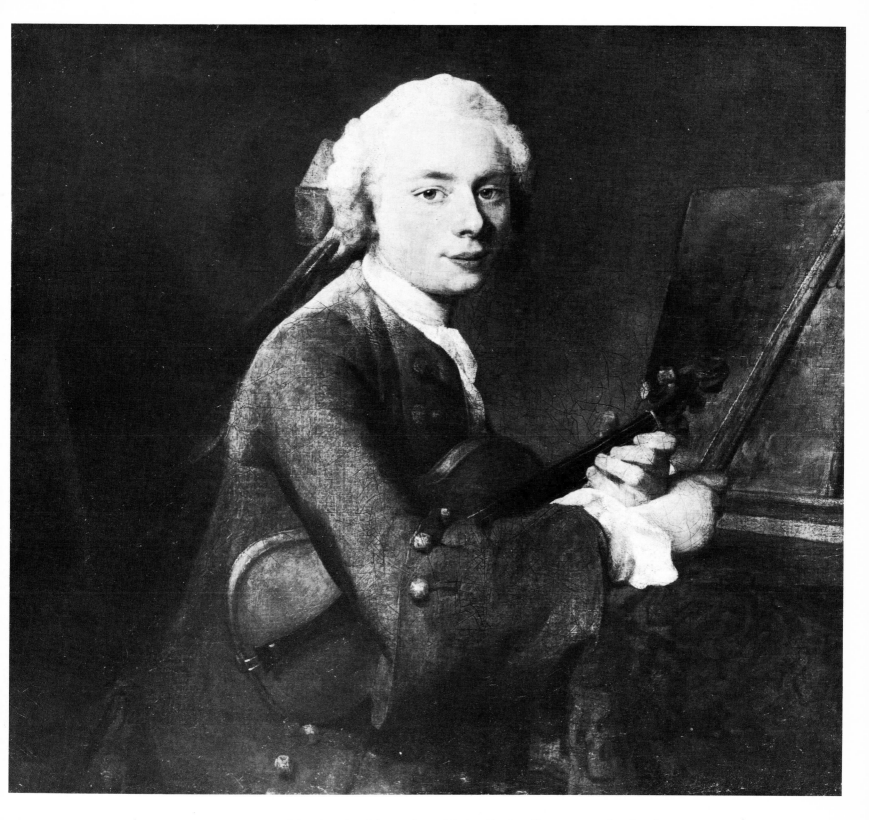

103. *Portrait of Charles-Théodose Godefroy.*
c. 1735. Oil on canvas, 26⅝ × 29⅜ in.
(67.5 × 74.5 cm.). Paris, Musée du Louvre.
Chardin's first pure portrait, a genre he was
to practise on only a few occasions.

cultivation in this work, with its lively silhouette and refined impasto.

By the mid-1730s Chardin was to become much more confident in his treatment of the half-length figure, as we shall see in due course. But with the exceptional *A lady sealing a letter* apart, he was to develop his pictorial language to incorporate the human figure out of the more mundane vocabulary of modest still-life objects. From *The copper cistern* (Plate 99) to *A woman drawing water from a cistern* (Plate 104; engraved by Cochin *père* in 1739 as *La Fontaine* or *The cistern*) must nevertheless have been a momentous step for Chardin – but his feet, so to speak, were on the same ground. In Cochin's biography we are told that the latter work (which he

104. *A woman drawing water from a cistern*. 1733. Oil on panel, 15 × 16⅞ in. (38 × 43 cm.). Stockholm, Nationalmuseum. Passing from one passionate admirer of Chardin's art to another, this painting and its pendant were acquired at the 1745 sale of the late Antoine de la Roque in Paris, through the dealer Gersaint and the former Swedish ambassador there, Count Tessin, on behalf of the heir to the Swedish throne, Prince Adolf Frederick.

erroneously dates to *c.* 1737) was the outcome of the friendly rebuke from Aved, which led Chardin to reassess his career. A kitchen-maid is drawing water from the same container painted in *The copper cistern*, into an earthenware jug with a dark-green glaze. In the right-hand background a door opens into a further room where another maid is sweeping the floor, watched by a child. The painting has a pendant, *The washerwoman* (Plate 105). While the washerwoman stands at her tub, pausing for a moment to look round, a child sits idly by, blowing a bubble with the soapsuds (Plate 106); beyond, a door opens to a further room, where a woman hangs up linen to dry.

From within the subdued, shadowy interiors of Chardin's rooms rendered with predominantly earthy browns, emerge bolder passages of painting – white (principally in the costumes of the women), a few glinting reflections (cistern,

105. *The washerwoman.* 1733. Oil on canvas, 14⅝ × 16¾ in. (37 × 42.5 cm.). Stockholm, Nationalmuseum.

water, glazed jug, soap-bubble, for example), and muted colours: a deep greenish-blue (the apron of one woman, the skirt of the other, the boy's costume) and a deep, soft red (meat, lining of the boy's cap). These colours are picked up more modestly elsewhere, for example the red and blue in the stripes of one woman's skirt, the less saturated red top of the woman hanging linen. Consistent with their meditative character, Chardin's two kitchen scenes are not fluent in design, especially in comparison with almost any works by his contemporaries. As we look from one part of the picture to another, there is a sense of stasis and self-containment in each object or figure, each set solidly in its place. There is a stiffness and naïvety in the figures, particularly in the woman bending down to fill her pitcher. Chardin would soon develop a more fluid sense of movement – although never like the rococo of his contemporaries – and certainly more charm in shape and silhouette. We can accept

113

his awkwardness as the awkwardness of deliberation and effort; there is a sense of honest toil in the construction and execution of these works, which perfectly matches their subjects.

The sense of difficulty and effort was something noted by most of Chardin's contemporaries. For the more academically-minded among them, such as Mariette, his lack of serious training in drawing, his inability to invent imaginative compositions with ease, his dependence on the model, remained fundamental deficiencies. While there is no doubt that Mariette was one of the greatest connoisseurs of the century, and assembled a matchless collection of old master and modern drawings, his taste was essentially for art of a fluent and confident kind, and with the elevated aspirations of the Renaissance masters he loved so much. Certainly in what he wrote, if less so in what he actually collected, he upheld these traditional standards. Of Chardin he said:

> The pictures of M. Chardin have too much feeling of hard toil and difficulty. His touch is heavy and not at all varied. His brush has no facility; he expresses everything in the same way, and with a sort of indecisiveness, which makes his work too cold.

Taking this rather classic/academic point of view, Mariette would not see the subtle variety of Chardin's art, nor appreciate his profound and novel attachment to nature and the degree to which his particular manner of painting was integral with it.

Cochin, on the other hand, could see here the very qualities which defined the originality of Chardin's genius:

> These pictures [Cochin refers to the figure subjects collectively] cost him a great deal of time, because he did not content himself with an approximate imitation of nature, but sought the greatest truth of tone and effect. That is why he worked at them again and again, until he arrived at that breaking of tones produced by the distance of an object and the reflections of those that surround it, so that at last he achieved that magic accord, which distinguished him in such a superior way . . .
>
> In this respect he held the principle that shadows are one, and that in some way the same tone should be used to break them all. This truth is hardly known, except to the colourists among painters . . .
>
> Although in general his touch was not very agreeable and in a way rugged, there were few paintings which could sustain themselves next to his, and it was said of him, that he was a dangerous neighbour . . .
>
> Moreover, his pictures had a very rare merit: truth and naïvety, both in the poses and the compositions. Nothing in them seemed specially introduced to group them nor to produce an effect; and yet these conditions were filled with an art all the more admirable as it was concealed . . . His successes were the fruit of the deep study he had made of nature; but he agreed that it had chilled his genius, and that he could not be satisfied unless she were present. However, it seems that he judged himself too rigorously. It was perhaps not so much a default of genius, as another manner of applying it – that is to say, a cruel severity in chastening it, a natural consequence of the outlook of a self-aware man, who would allow himself no licence, nor rest content with approximations.

The copper cistern and *The washerwoman* were exhibited at the Exposition de la Jeunesse in June 1734, and were presumably among 'the other subjects in the taste of Teniers, where one finds great truth' admired in the *Mercure de France*; when the engravings after the same two pictures were advertised in the *Mercure* five years later, again they are 'in the taste of Teniers'. Considering that the owner of the

107. *The Flemish spinner*. Engraving by P. L. Surugue after a painting by David Teniers.

Mercure, Antoine de la Roque, also owned the two paintings in question and very likely wrote the notice on them, it is not surprising that Chardin was singled out for special mention at the exhibition. More interesting is the comparison with the Flemish painter David Teniers, whose genre scenes were eagerly sought by French eighteenth-century collectors. Paintings like that engraved after him by Surugue as *The Flemish spinner* (Plate 107) were enjoyed for their meticulous description of the objects of everyday life – here, there is a plentiful supply of fruit and vegetables, fish and fowl; a variety of pots, pans and containers; and in this humble rustic interior the simple pleasures of drinking and gaming are indulged. The art-dealer Gersaint described Teniers as 'the true monkey of painting', a reference to his clever, if rather indiscriminate, powers of imitation in paint.

Equally admired in Chardin's day for his domestic and kitchen interiors (Plate

108. Willem Kalf. *Interior of a country kitchen*. *c.* 1642–4. Oil on panel, 15¾ × 20½ in. (40 × 52 cm.). Paris, Musée du Louvre.

108), but relatively neglected in our own, was the Dutch artist Willem Kalf. Kalf had worked in Paris during the 1640s, and many of his interiors date from this time, when they had a minor influence on some native French painters, such as Sébastien Bourdon (1616–71). Kalf's interiors form a marked contrast with his very opulent, ostentatious still lifes, which depict the most costly tableware in a sumptuous technique. Like the contemporary genre scenes of Teniers, his rustic and kitchen interiors are carefully controlled in tone, with a restricted palette of ochres and browns, broken by the sparkle of reflecting surfaces, although his touch is more painterly and less smoothly polished than that of a Teniers. Such works were frequently engraved in the eighteenth century, and sometimes given moralizing titles by their engravers, usually extolling the virtues and advantages of the simple life: an engraving by Basan after a humble country kitchen by Kalf (very similar to the interior by Teniers illustrated in Plate 107) carries the legend '*La cabane, ennemie de l'envie*', or 'The hut, enemy of envy'.

These finely wrought little paintings, however, were executed above all to please the eye, to be enjoyed as precious objects, and studied closely for their rendering of detail and their lively technique. They were models for many a French painter in the eighteenth century who worked on a small scale for the private collector. The example we illustrate here belonged to François Boucher. Watteau's early *Pot-scourer* (Plate 109), for example, is an essay in the manner of Kalf; and Watteau's rival and imitator, Nicolas Lancret, places his humorous *Flea-hunter* (Plate 110) in a similarly Kalf-like interior. If we add that Antoine de la Roque also had some fine works by Kalf (including one with figures added by Lancret), then perhaps enough has been said to show that Chardin in 1733 was working within a recognized, even popular, tradition of subject-matter. Indeed, it might have been something of an

109. Antoine Watteau(?). *The pot-scourer.* c. 1702–4. Oil on canvas, 20⅞ × 17⅜ in. (53 × 44 cm.). Strasbourg, Musée des Beaux-Arts.

110. Nicolas Lancret. *The flea-hunter.* c. 1730. Oil on panel, 13 × 10¼ in. (30 × 26 cm.). London, Wallace Collection.

encouragement to the young artist, had he known that in a lecture published in 1721 Antoine Coypel (1661–1722), Director of the Académie and Premier Peintre du Roi, had expressed considerable admiration for Kalf, who:

> in the objects he imitated from nature, seems to have spoken the language of painting as well as Giorgione and Titian, with the difference that he did not know how to make such grand statements as those two great masters of the art.

In other words, Coypel admired Kalf as a masterly (and 'painterly', in the Venetian tradition!) painter, albeit in a minor genre, much as he had done Watteau, for example, when he agreed to his exceptional reception into the Académie in 1717 as 'painter of *fêtes galantes*'.

Yet anyone who has looked at genre scenes by Teniers or Kalf in the original, delightful as they are, and at *A woman drawing water* and *The washerwoman* by Chardin can see that he is dealing with different orders of experience. An anonymous commentator who noted on Mariette's copy of the 1737 Salon catalogue (when Chardin exhibited these works) that 'the author has a manner all his own which is original, and which approaches Rembrandt' was perceptive, especially if we take his words in an intuitive, general sense, rather than literally. For all that we could detail the differences between these two artists, yet Chardin shares with Rembrandt qualities which carry his expressive powers beyond those of a Kalf or a Teniers. Like Rembrandt, Chardin has a powerful feeling for chiaroscuro, as we have noted in earlier chapters, for the way light and shade can create an ambience and give a sense of unity to colour and tone. The two masters also share a special sensibility towards the substance of paint and its potential for beautiful effects in its own right. When it came to this 'rugged' ('*raboteux*', as Cochin called it) manner, that of Rembrandt *was* the closest comparison – what other analogy could a Parisian observer hope to make in the 1730s? Or, indeed in the 1760s, when a sympathetic commentator on the Salon of 1769 said that Chardin could with reason be dubbed 'The Rembrandt of the French School'. One sometimes wonders if Chardin's impasto of the early and mid-1730s was not a gesture of defiance at the well-bred manners of contemporary painting. But his technique is inseparable from the highly personal nature of his subject-matter, from the attention he gave it, and the tremendous effort involved in bringing his works to the perfection required by his own exacting standards. Cochin and Mariette recalled the impact of his distinctive manner. Alas, first-hand reactions recorded in the 1730s are rare. But against the platitudes of the *Mercure* we can quote again Chevalier de Neufville de Brunaubois-Montador, who seems to have understood Chardin's technique very well in 1738:

> His manner of painting is all his own. It is not a case of finished outlines, nor of a fluid touch; on the contrary, it is brutal and rugged. It seems as if the strokes of his brush are exaggerated, and yet his figures are of a striking realism, and the singularity of his manner only makes them more natural and spirited.

In no way was Rembrandt accommodated by the theory or the practice of French classicism – but his awesome genius was still admired, if not recommended for imitation. Félibien, for example, who codified so much of academic doctrine at the end of the seventeenth century, nevertheless had a very real appreciation of Rembrandt's free handling, heavy impasto, and bold use of chiaroscuro, and the way these features differed from the smooth, licked (*léchée*) manner of most Dutch art. There was considerable interest in Rembrandt in the eighteenth century too, although usually with the academic reservations we might expect. But the tone of appreciation was already set in 1699 by the theorist Roger de Piles (1635–1709), when he said that the brushmarks of Rembrandt

are very broken when seen at close range, but at the right distance they are so skilfully placed that they blend very well... This technique is used only by Rembrandt and is a convincing proof that the ability of this painter was in no way the result of chance, that he was a great master of colour, and that he was a king among artists.

Most of the great collections of the day contained works by or attributed to Rembrandt. In the notable collection of the Comte de Vence (auctioned in 1761), for example, one of his twelve Rembrandts was hung between a pair of exemplary academic nudes by Pierre (Plate 52 is one of these); one commentator in 1753 found the Pierres to be equally well coloured, but they only showed up the Rembrandt 'in correction of elegance and drawing'! And this shameless piece of flattery towards a well-placed contemporary history painter came from Jean-Baptiste Descamps, the most sympathetic contemporary scholar of Dutch art. However, it is interesting to see Descamps struggling with Rembrandt's technique (as others struggled with Chardin's), which he saw as a law unto itself; so vigorous was his manner, so bold his contrasts of light and shade, that:

> He seemed rather to wish to model, than to paint... The handling of Rembrandt is a sort of magic. No one knew better than he the mutual effects of the different colours, nor better distinguished those which accorded from those which were opposed. He set each tone in its place with such justice and harmony, that he did not need to mix them and lose their bloom and freshness... Everything Rembrandt composed is without nobility... His is a spirited genius, without any elevation.

Chardin's own interest in Dutch and Flemish works reflects a general growth of interest among collectors and artists during the first forty years of the century. Indeed, Antoine Coypel's basically sympathetic attitude, mentioned above, to the talents of Kalf and Watteau typifies the liberal and eclectic approach of the Académie in the same period, happily accommodating the example of the popular Dutch and Flemish 'little masters' of the previous century. By the time that Descamps began to publish his four-volume *La vie des peintres flamands, allemands et hollandois* in 1753 (from whence his comments on Rembrandt above), he said that this historical guide was necessitated by the demand for such pictures. In 1757, the dealer Pierre Rémy observed that the vogue for collecting Northern works had been started early in the century by the Comtesse de Verrue, in whose collection 'the Flemish and Dutch pictures had preference; many people of distinction followed her example. The Italian pictures fell, so to speak, into oblivion'. Indeed, the auction of her great collection in 1737 was the public initiation of a remarkable trade in such pictures, which was to flourish in Paris until the Revolution. It is likely that the development of this market was encouraged by the fact that a work of art usually proved a sound investment, at the time when paper financial speculations were very precarious. Fortunes disappeared overnight, when John Law's financial system collapsed in 1720 – but a work of art was materially there, handy, easily transportable, and attractive too. However, the nature and the motivation of the art market and especially the role of dealers in France during the first two-thirds of the century still await fundamental research.

The novelty of the taste for Northern art in early eighteenth-century Paris lay in the scale of this interest. Some classically minded critics came to feel it was usurping more elevated artistic concerns. Northern genre, landscape and still-life paintings did not make the same intellectual demands on the spectator as the ideal art encouraged by academic doctrine. While the rhetoric of 'high art' was well suited to the church or the royal palace, small works in the lesser genres were

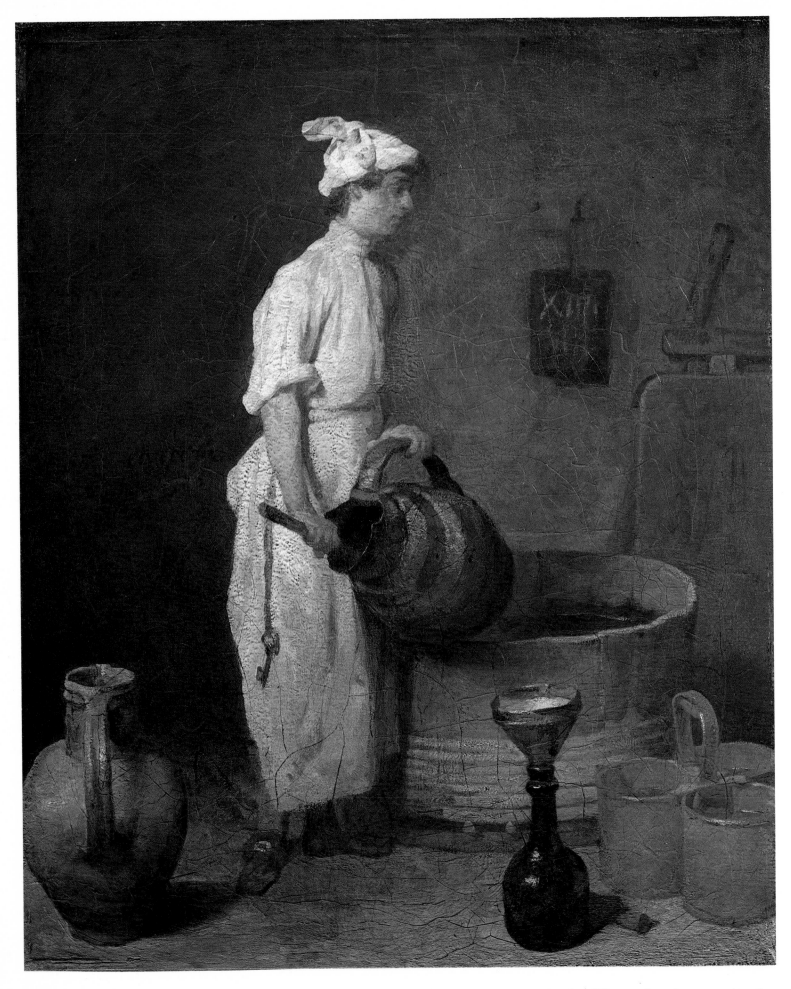

111. *The cellar-boy.* 1736. Oil on canvas, 18⅛ × 14⅝ in. (46 × 37 cm.). Glasgow, Hunterian Art Gallery, University of Glasgow. One other autograph replica of this work is known in a private collection, and was probably the work exhibited at the Salon of 1738. The unclear date on the Glasgow picture has recently been reinterpreted as 1736 or 1735, earlier than its pendant.

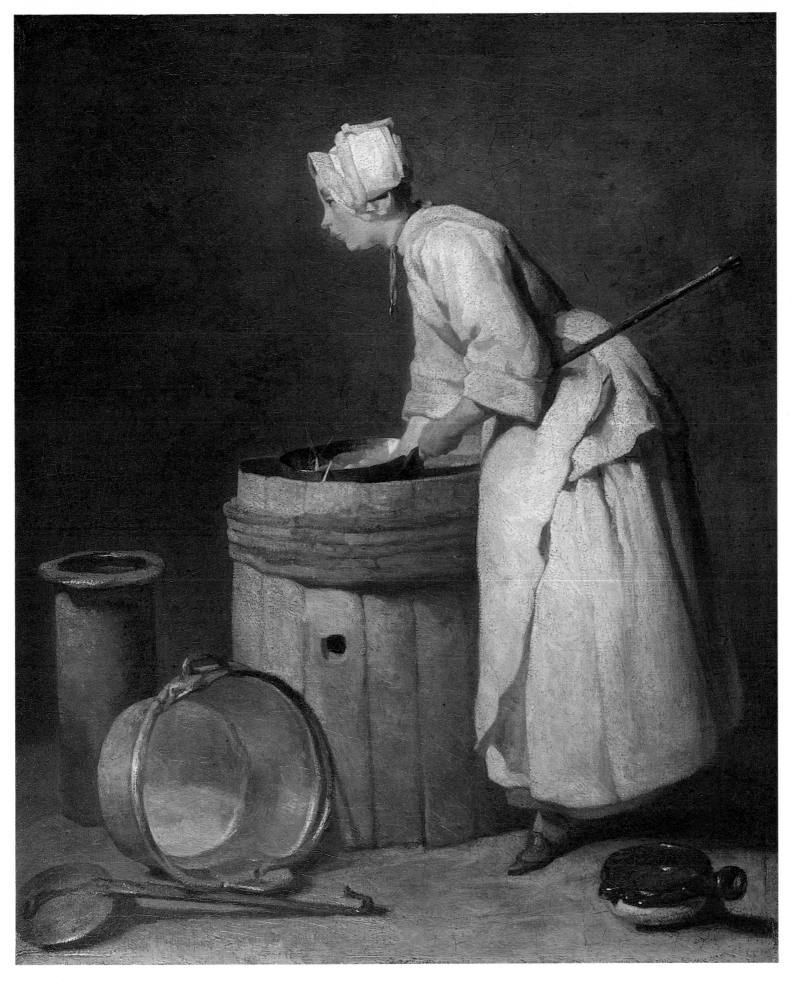

112. *The scullery-maid*. 1738. Oil on canvas, 17⅞ × 14⅝ in. (45.5 × 37 cm.). Glasgow, Hunterian Art Gallery, University of Glasgow. It was probably another version of this painting, engraved by C.-N. Cochin in 1740, which was exhibited at the Salon in 1738 and again in 1757, but destroyed in World War II. A replica of the Glasgow picture has recently been identified at the Corcoran Gallery of Art, Washington.

simply more enjoyable. Such paintings could be appreciated on the one hand as cleverly realistic imitations, and on the other for their wealth of detail and anecdote. Their small scale made them easily movable, so that they could take their place beside other objects with which rooms were decorated: clocks, mirrors, candelabra, porcelain or exotic shells. It is significant that dealers such as Gersaint traded in these objects, as well as in paintings. Such small-scale forms of decoration were comfortably housed within the lighter and more intimate interiors, which developed in Parisian *hôtels* during the first half of the century, where walls were broken up with mirrors and carved panelling. By the 1740s critics such as La Font de Saint-Yenne, as we have seen in Chapter 2, were complaining that modern interior decoration was contributing to the decline in demand for 'serious' history painting. Moreover, the vogue for Northern art was even affecting reproductive engravings by the 1740s, when Mariette, as we have also noted above, observed with regret that prints after Chardin, Lancret and various Northern 'little masters' of the preceding century were far more popular in eighteenth-century Paris than those after the more elevated and demanding classical masters.

In a sense Chardin's figure pieces were a response to the demand for small-scale works in the Northern manner, just as the works of Watteau and his followers, if in a more fanciful style, had been the response of an earlier generation. His kitchen interiors are the works with the closest connections to Northern art of the preceding century, while at the same time enlarging the context, as it were, of his own still lifes.

But from the late 1730s servants and kitchens feature less prominently in Chardin's work than scenes of governesses or mothers with children, or studies of individual children, or more leisured women in their 'upstairs' world. We witness also a gradual refinement of Chardin's style. He was to adjust his manner of painting to match his subjects, in the sense that a bourgeois dressing-room (Plate 155) demanded a different type of execution from the scullery (Plate 105). But even his kitchen scenes became more refined in observation, more delicate in handling and colour, and more modulated in their lighting. It was no doubt a matter of gaining greater technical confidence and for all that painting never came easily to Chardin, by the later 1730s works such as *The cellar-boy* (Plate 111) and *The scullery-maid* (Plate 112) betray a sureness of design and a relative fluency of execution, where any gaucheness has become a calculated aesthetic effect. Some measure of that calculation can be taken from the fact that small *pentimenti* are visible to the naked eye at the back of the scullery-maid, while X-rays have revealed substantial alterations in the pose of her companion.

These two lovely works present single figures, each set in a simple, shallow space, closed by a neutral wall parallel to the picture-plane; they are placed in relation to the basic cylindrical volumes of various barrels, jugs, urns and cauldrons. The pictures form two openly arranged still lifes with figures. By now, Chardin's drawing of the figure is more controlled – in a perfectly observed profile, in the turn of a wrist, the grip of a hand, and the soft folds of clothing, which now gives as much information about the pose and build of the bodies underneath as it equally creates silhouettes of great beauty, interest and variety. The lighting is more diffused, the ambience more atmospheric and suffused with soft nuances of reflected light and colour. Chardin's observation is also psychologically more acute; the paintings are not only formally related, but also dramatically, for although the young man seems to be simply lost in thought, there is no doubt that the maid is looking out of her picture into his. It is not common for Chardin to handle pendants in this way – his single figures are normally self-absorbed, and it is when he brings two or three figures together in one image that he carefully explores their

reactions. But at the same Salon of 1738, when versions of *The cellar-boy* and *The scullery-maid* were first shown, he also exhibited *The young draughtsman* (Plate 23) with a companion (which is now lost and was never engraved), variously described at the time as '*A girl distracted from her tapestry*', and '*A young worker, on a straw-seated chair, interrupting work on her tapestry, her eyes fixed on the draughtsman*'. Similarly, at the Salon of 1737 Chardin had shown *The house of cards* with its pendant *A girl with a shuttlecock* (Plates 136 and 135), where the girl again gazes across to her absorbed companion. Such a thinking-through of the implications of pendant paintings, such an interdependence not merely formal, but psychological, is not only rare in Chardin's art but unusual in the history of art as a whole. For lack of evidence to support speculation on the meaning of *The cellar-boy* and *The scullery-maid*, we can do no more than note with other commentators the visual echo from the key hanging at the boy's waist to the medallion or keepsake suspended from the girl's neck by a similar blue ribbon. A Dutch emblem-book of the seventeenth century does show a couple of kitchen servants cleaning a pan and scouring a pot, the maid looking at the young man (Plate 113); its title is, 'When slovenly people turn tidy, they clean the undersides of pans', while the explanatory text exhorts us to respect rules and measure in all forms of behaviour. But it is most unlikely that Chardin or any of his French contemporaries was aware of such a specific and local Dutch emblematic tradition. A more typical response to his works seems to have been that of an English visitor to Paris in 1749 who, in writing home about various French artists, recognized Chardin simply as one 'who paints little pieces of common-life'.

113. '*When slovenly people turn tidy . . .*' Engraving in J. Cats, *Spiegel van de Ouden ende Nieuwen Tydt*, 1652 edition, p. 219.

114. Gottfried Schalken. *And old woman scouring a pot. c.* 1665. Oil on panel, 9⅞ × 9 in. (22.5 × 22.8 cm.). London, National Gallery.

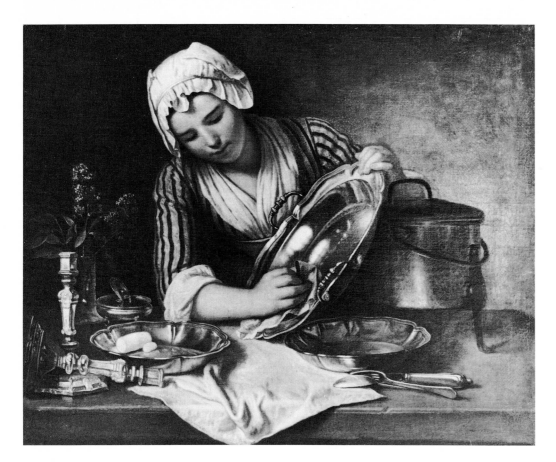

115. André Bouys. *A servant polishing silver-ware*. 1737. Oil on canvas, 31¼ × 38⅝ in. (79 × 98 cm.). Paris, Musée des Arts Décoratifs.

To modern eyes, the poetry will lie in the very ambiguity of such paintings; and they have an extraordinary tenderness of mood expressed in the delicately leaning stance of the figures, the soft varieties of tone in the atmosphere (all the softer for the vivid red painted vessel in the right foreground of *The cellar-boy*), and the finely nuanced colour, for example the pale pink, cream and palest yellow of the maid's garments. It is through these artistic devices, and perhaps most of all through the actual application of his paint – now in quite a smooth paste and subtly varied to express each different substance it represents – that Chardin makes his special contribution to the traditional representation of such subjects. For Watteau, for example, *The pot-scourer* (Plate 109) was an excuse for a picturesque and humorous essay in the manner of Kalf; for Gottfried Schalken in the seventeenth century *An old woman scouring a pot* (Plate 114), with its broken vase and a butterfly perched on the window-frame, could suggest the idea of transience and the vanity of the world. Yet André Bouys (1656–1740), a French still-life and genre painter a generation older than Chardin, sent *A servant polishing silver-ware* (Plate 115) to the Salon in 1737, where the spectator was surely asked no more than to admire the artist's powers of imitation, the attractive silver-ware and the pretty girl. Incidentally, this painting had as a pendant *Two servants returning from market* (now lost), a theme Chardin was to take up the following year. The monumental form and dignified conception of Chardin's maid only finds a parallel among the figures drawn from everyday working life by the sculptor Edme Bouchardon, such as *The scullery-maid* (Plate 117b) in his first suite of *The cries of Paris* engraved by the Comte de Caylus in 1737. Jean-Baptiste Greuze was also to treat this theme, almost certainly as a direct challenge to Chardin's manner, in a drawing (Vienna, Albertina) which he exhibited at the Salon of 1757, and which was subsequently engraved by Beauvarlet (Plate 118). Greuze's scullery-maid leans forward in what is for many of his women a characteristically calculated and brazen way, successfully competing for attention with the array of pots and pans before her. As we shall see below, at least one

116. *The kitchen-maid*. 1739. Oil on canvas, 18⅞ × 15 in. (47 × 38 cm.). Paris, Musée du Louvre. Two other autograph versions of this work exist: one in Berlin, dated 1738, and acquired at the Antoine de la Roque sale in 1745 for Frederick II of Prussia; the other, also dated 1738, in Ottawa, was acquired in Paris by the Prince of Liechtenstein by 1741. A fourth and later version, with changes, exhibited at the Salon of 1769, was destroyed in World War II.

117a and b. *The stonemason* and *The scullery-maid*. 1737. Engravings by the Comte de Caylus after drawings by Edme Bouchardon. Title-page and Plate 11 of the First Series of *The Cries of Paris*.

commentator on this Salon, where Chardin also exhibited a version of his own *Scullery-maid*, took the opportunity to compare and contrast the merits of the two artists.

While Chardin's genre scenes of kitchen servants belong to a tradition which derives from seventeeth-century Dutch and Flemish models, one of the innovations of his treatment lies in the particular moment of action – or, rather, inaction – that he chooses to depict. More often than not he selects a moment of absorbed reflection; this occurs during the routine daily activity – washing, scouring, returning from market or preparing vegetables – but not, as in some Northern genre pictures, in the reprehensible sense of falling asleep or otherwise neglecting the task in hand. Maes, Vermeer and Steen, for example, would show maids fallen asleep at work, sometimes as a result of excessive drinking; or they would alternatively be seen actively occupied with their chores. Eighteenth-century genre painters before Chardin continued this tradition, with Watteau's pot-scourer busy at work (Plate 109) and Lancret's kitchen-maid (Plate 110) neglecting her duties in order to search for a flea – this also has a mildly erotic, but certainly not meditative, connotation!

Chardin's most celebrated painting of this type – of which three superb autograph versions are known – is *The kitchen-maid* (Plate 116), where a servant, carrying a bag of meat from which a leg of lamb projects, rests for a moment, leaning on the sideboard where she has just placed two large loaves of bread. From this dim, cool room, a door opens into a lighter outer room, where a younger maid opens another door to a caller; the black triangle of the caller's hat is echoed by the small triangular patch of blue sky visible above the door. *The kitchen-maid* is one of

118. *The scullery-maid.* Engraving by C. F. Beauvarlet after a drawing by Jean-Baptiste Greuze exhibited at the Salon of 1759.

Chardin's most classically conceived designs, where the monumental pyramidal volume of the maid gives her all the status of one of Raphael's Madonnas. There is a beautiful pattern of light and shade, and a play of space, as we move from one room to another. But it is not only the immaculately balanced rhythm of light and shade, volume and void, nor the subdued tonal unity, nor the tactile impasto which engage the sympathies of the spectator. These formal features complement the contemplative mood of the maid, and it is this perfectly captured moment of reflection which puts the spectator into a reflective attitude to the painting as a whole. Chardin teases us as to the nature of her reflection – is it a matter of the heart? Does the medallion or keepsake she wears prominently round her neck provide a clue? Is she catching the conversation at the door?

The painting was engraved by Lépicié *père*, who added some verses to his print, supposedly expounding the meaning of the image. We have already noticed the use of such verses on contemporary engravings – for example on Fessard's print after *A lady sealing a letter* – and it was a common practice to add such 'explanations' to prints after old and modern masters. But it is important to remember that the verses were added by the engraver, and do not necessarily reflect the meaning intended by the painter. The engravings were aimed at a wider and more popular market than the paintings on which they were based, with the result that the verses tend to be given a more ready appeal, which often trivializes the painter's original idea. In the present instance, the verses on Lépicié's prints are not much help – on one edition, surely wide of the mark, they accuse the maid of dipping her fingers into the household purse to keep herself in clothes, while another edition suggests we should take as much trouble to nourish our hearts as we do our bodies.

LA MENAGERE.

Que maudit soit le jour ou la vanité *Dans ces tems bien heureux du monde en son Enfance*
V'int icy de nos mœurs souiller la pureté ! *Chacun mettoit sa gloire en sa seule innocence.*

a Paris chez Crepy rue S.t Jacques a S.t Pierre

119. *The housemaid. c.* 1740. Engraving by
P. Dupin, falsely 'after Chardin'. Apart from
infelicities in the drawing and in the
perspective, the execution of the engraving
itself is much cruder than the fine
craftsmanship of the engravers who normally
worked after Chardin's authentic works.

A number of rather crude engravings with moralizing or admonitory verses were published in the late 1730s and early 1740s, purporting to be after paintings by Chardin, attesting to the popular market for these images. For example Dupin engraved *The housemaid* (Plate 119), falsely adding '*Chardin inv.*' at the bottom of the plate. Here, the housemaid, with a knowing look on her face, sweeps away a crumpled playing-card, and the verses say: 'Curse the day when vanity arrived to soil the purity of our ways! In those happy times when the world was in its infancy, people took pride only in their innocence.' This legend extols a simpler and more moral era, and the combined effect of verses and image suggests these thoughts are passing through the mind of the housemaid, as she sweeps away the evidence of the previous night's activities. Should we see Chardin's nobly conceived servants as somehow untouched and unsullied by sophisticated modern manners? Unfortunately, contemporary commentators offer little guidance in this matter, and we are left with his powerful, but mysterious and ambiguous images.

The turnip-scraper (Plate 120), a version of which was companion to *The kitchen-maid* at the Salon of 1739, also shows a kitchen-maid pausing for thought during her daily task. *The turnip-scraper* has never enjoyed quite the same critical esteem as *The kitchen-maid*. This is partly because the conception is less noble: she is seated, somewhat closed in form, and our viewpoint is more down onto her, rather than up at the monumental figure of the kitchen-maid. Also, *The turnip-scraper* does not meet the normal expectations of Chardin's colour – the bright, dusty orange colours of the pumpkin in the foreground take us by surprise, while the maid is almost brash in this respect, with a strong contrast between an orange skirt, brown over-skirt, blue and brown striped scarf, and white apron; and there is an unusual hint of violence in the bloodstained meat-cleaver and chopping-block. The source of the

120. *The turnip-scraper.* 1738. Oil on canvas,
18¼ × 14¾ in. (46.2 × 37.5 cm.).
Washington, D.C., National Gallery of Art
(Samuel H. Kress Collection). A lost replica
once in Berlin was acquired for Frederick II
of Prussia in about 1746; a replica now in
Munich was in the ownership of Prince Karl-
August of Zweibrücken by the last quarter of
the eighteenth century.

121. Nicolaes Maes. *A woman scraping parsnips*. 1655. Oil on panel, 27½ × 21 in. (70 × 53.2 cm.). London, National Gallery.

122. Gabriel Metsu. *The apple-peeler. c.* 1660. Oil on panel, 11 × 10¼ in. (28 × 26 cm.). Paris, Musée du Louvre.

LA BELLE CUISINIERE

123. *The pretty kitchen-maid.* 1732.
Engraving by P. Aveline after a lost painting
by François Boucher.

subject lies in Dutch seventeenth-century genre – for example Maes's *A woman scraping parsnips* (Plate 121), where the woman is engrossed in her task, or Metsu's *The apple-peeler* (Plate 122), who seems almost to converse with the spectator while she works. However, Chardin's painting differs profoundly from these, not only in its more boldly impasted and less minutely descriptive technique, but also in his choice of a moment of self-absorbed reflection. Both these factors have the effect of endowing the painting with more meaning than may at first be apparent. *The turnip-scraper* was engraved by Lépicié in 1742, but as so often the verses on his engraving do not reflect the painter's intention, while Chardin himself offers no clues as to what *is* on the mind of this reflective young woman. 'When our ancestors picked these vegetables from the hands of nature, a guarantee of their simplicity, the art of making a poison of our food had not yet been invented.'

Whatever is passing through the minds of Chardin's maids – and it is surely not the state of contemporary cuisine – they are paragons compared with those we meet in the works of many of his contemporaries. In Boucher's *The pretty kitchen-maid* (Plate 123), for example, cucumbers, which would be wholesome vegetables to Chardin's turnip-peeler, become rampant phalluses; where Chardin dwelt on the perfect shape of an egg, those of Boucher's girl are getting broken in the grasping advance of her young man ('A young girl should keep an eye on the eggs in her apron', goes the verse on one version of this engraving); it is not only the cauldron on the fire that is boiling over; and the cat's grip on the fowl at the left is all but blatantly sexual. If Chardin's exemplary kitchen-maids of the late 1730s were a lesson to those of Boucher, then Greuze in his turn was more intrigued by human

131

124. Jean-Baptiste Greuze. *The lazy Italian*. 1757. Oil on canvas, 25⅝ × 19¼ in. (64.8 × 48.8 cm.). Hartford, Conn., Wadsworth Atheneum (Ella Gallup Sumner and Mary Catlin Sumner Collection).

weakness. Among the works he sent to his second Salon in 1757 was *The lazy Italian* (Plate 124), showing the debilitating effects of indolence on a servant who is unkempt, slipshod, and surrounded by a clutter of unwashed dishes, bottles and garments. This theme is close to seventeenth-century works such as *The sleeping kitchen-maid* (London, National Gallery) by Nicolaes Maes (1634–93), but it is surely in the first instance a comment of sorts on Chardin's works. Indeed, the beautifully painted details of still life, such as the pottery, fabrics, glass and raffia, are a positive compliment to Greuze's rival.

6 Modern Moral Subjects

At about the same time as he painted *A lady sealing a letter* and *A woman drawing water from a cistern* – that is, around 1733 – Chardin made a painting on the theme of a youth blowing bubbles, which according to Mariette was the outcome of Aved's quip. The painting now in Washington (Plate 125) is very likely the work in question, or else a very close autograph version of it. It seems that Chardin has used the same young man as for the servant in *A lady sealing a letter*; and the dragged paint and the impasto of the garments, the modelling of the head and hands, and even the slight difficulty in the foreshortening of the left hand in *Soap-bubbles* can be compared with the other dated canvases of 1733.

A version of *Soap-bubbles* was engraved by Filloeul in 1739, together with a pendant, *The game of knucklebones* (Plate 126). This latter work is unusually heavily impasted for Chardin, which may be evidence of the difficulty he had in executing such an ambitious subject. It was Chardin's first and last attempt to depict a figure in action, and is one of his least happy designs. He has chosen the instant when the girl releases the ball and is about to drop her arm to scoop up the four knucklebones on the table; but the conception of the figure is an unusually 'open' one for Chardin, not the closed and self-contained silhouette which was to be his usual way of simplifying the complexities of the human figure. Moreover, he normally avoided the additional problems of expression with a simple profile, or a turn or drop of the head. This is the painter to whom life-drawing did not come easily (see Plate 40), yet he has set himself some difficult problems of anatomy and foreshortening, in the painting of hands, wrists and forearms, neck and shoulders, and an almost full face at a tricky tilt. These are the passages to which he has had to return again and again, with the result that the paint is in places overloaded – for example, from the girl's chin to her ear he has not happily reconciled the demands of drawing and foreshortening with the subtle and complex demands of shadows and reflected lights.

Filloeul's engravings carry rather rudimentary verses, which on *Soap-bubbles* liken the transient bubble to the fickleness of a woman's love; and *The game of knucklebones* is also given an amatory implication, for 'Lisette', as the girl is dubbed, is coming to the age when she will prefer to join in games with some young lover. Chardin's intention, however, was almost certainly less trite. While on one level *Soap-bubbles* can be read simply as a moving observation of a youth engrossed in a simple childhood activity, it also belongs to a long iconographical tradition reminding us of the transience of all wordly endeavour: 'Vanity of vanities; all is vanity . . .', as the Preacher in Ecclesiastes said. A full exploration of this theme is found in an engraving by Hendrik Goltzius (1558–1617), *Quis Evadet?*, 'Who can evade it?'

133

125. *Soap-bubbles. c.* 1733. Oil on canvas, 36⅝ × 29⅜ in. (93 × 74.5 cm.). Washington D.C., National Gallery of Art. The Washington and Baltimore (Plate 126) paintings may not originally have been pendants, but a comparable pair was engraved as such in 1739.

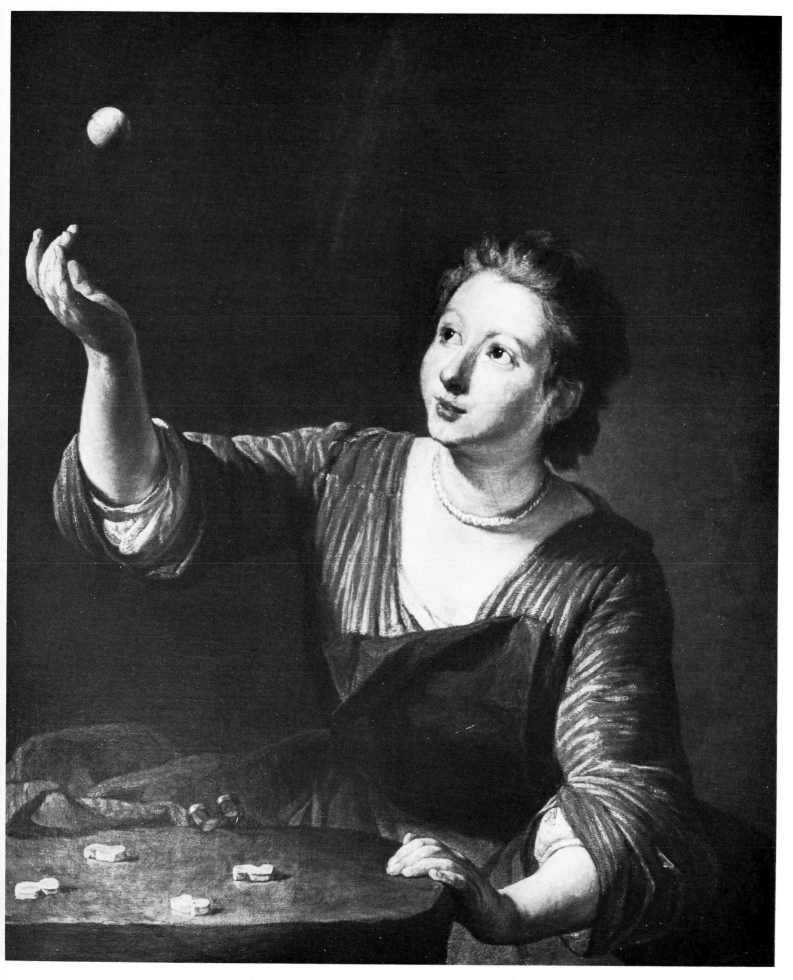

126. *The game of knucklebones. c.* 1733. Oil on canvas, 32⅛ × 25⅜ in. (81.5 × 64.5 cm.). The Baltimore Museum of Art (Bequest of Mary Frick Jacobs).

(Plate 127), where a *putto*, leaning on a skull, blows bubbles, while behind him transient smoke blows away, and beside him flowers bloom all to briefly. This theme was popular among the Dutch seventeenth-century painters whom Chardin and his contemporaries admired, as for example in the painting in this tradition by Willem van Mieris (1662–1747) in the Louvre (Plate 128), which Chardin may have known even before it was acquired by Louis XV in 1742. Chardin's *Soap-bubbles* is characteristically more simple in design and more serious in mood, but the idea of the figures framed in a window with a bas-relief below (now obscured in Chardin's picture by later repaints and the addition of the honeysuckle) clearly comes from this sort of Dutch prototype. When Filloeul's engravings were announced in 1739, the works were described as being 'in the manner of Gerard Dou' (1613–75), another Dutch painter who executed this type of picture.

The meaning of *Soap-bubbles* is reinforced by the serious and absorbed mood of the youth – forming a deliberate contrast with the carefree aspect of the girl in *The game of knucklebones*. This latter is an admonitory work, whose meaning is heightened in conjunction with its pendant reminder of the transitoriness of life. The girl is wasting time playing at knucklebones, when she should be attending to her work: this is indicated by the prominence given to her scissors, which, although attached to her waist by a red ribbon, are propped somewhat awkwardly and conspicuously on the edge of the table, in juxtaposition with the pieces of her game. Chardin is reducing to everyday terms the choice between frivolous amusement and the more worthwhile activities of work or creative endeavour, an idea expressed in its most elevated and idealistic terms in the engraved frontispiece to the 1694 edition of

127. Hendrick Goltzius. *Quis Evadet?* 1594. Engraving. The accompanying verses read: 'The fresh, silvery flower, fragrant with the breath of spring, withers instantly as its beauty wanes. Likewise the life of man, already ebbing in the newborn babe, disappears like a bubble or like fleeting smoke.'

128. Willem van Mieris. *Blowing bubbles*. Oil on panel, $12\frac{5}{8} \times 10\frac{3}{8}$ in. (32×26.5 cm.). Paris, Musée du Louvre. This painting was acquired for the French royal collection in 1742, with a pendant showing a kitchen-maid bartering with a merchant over dead game. The little *trompe-l'oeil* painted relief is very similar to one painted by Chardin in 1732 (Paris, Private Collection), after a well-known sculpted relief by François Duquesnoy (1597–1643).

Franciscus Junius's *De Pictura Veterum* (Plate 129). Here, a boy is led away from his frivolous young companions, busy at their childish games, to admire a classical configuration of ideal painters and sculptors. This engraving represents exactly the type of high-flown imagery which Chardin was to reject in favour of the down-to-earth observation which he found in Northern, non-academic traditions of art. He incorporates his didactic message into the depiction of an everyday event, in an almost demotic manner.

Chardin's visual criticism of this type of time-wasting activity can interestingly be paralleled in a passage of John Locke's *Some Thoughts Concerning Education*, one of the most popular handbooks of educational theory in the early eighteenth century on both sides of the Channel. Locke selects knucklebones (or 'dibstones', as he calls the game) as a fruitless amusement:

> I have seen little Girls exercise whole Hours together, and take an abundance of pains to be expert at *Dibstones*, as they call it: Whilst I have been looking on, I have thought it wanted only some good Contrivance to make them employ all that Industry about something that might be more useful to them.

It is not suggested that Chardin was especially interested in eighteenth-century educational theory, nor that he necessarily read Locke (although this would not have been at all unusual), but that in common with many informed contemporaries, he had absorbed Lockeian ideas. Many, although not all, of Chardin's figure paintings can be read as moralizing or admonitory, and some are more so than others. The absence of much contemporary comment on this aspect of his art should make us cautious not to overstress the moralist in Chardin; but on the other hand we must try not to read the art of the eighteenth century – even the formally incomparable works of Chardin – with only the one eye of twentieth-century formalist aesthetics.

129. Frontispiece to Franciscus Junius, *De Pictura Veterum*, 1694. Engraving.

Recent scholarship has begun to reveal that there is more to many eighteenth-century pictures than meets that formalist eye. A case in point is the so-called *Gersaint's shop-sign* (Plate 45) by Watteau, which, there can be little doubt, provided a model for Chardin's early attempt at a realistic street scene, his *Surgeon's sign* of only a year or two later. Apart from the fact that *Gersaint's shop-sign* is on the large scale (approaching two by four metres) of a history painting, it is also one of Watteau's most complex and carefully thought-out designs – in every sense something more than a mere signboard, which even Gersaint would have us believe. But its basic theme can be shown to be one which Watteau explored on more than one occasion: vanity. Even kings – like Louis XIV, whose portrait is being packed away in a box – are subject to the vagaries of time, even the days of kings are as of grass (or straw!). Inside the imaginary shop an impressive ormolu clock, prominent at the left, marks the passing of the hours. Several large mirrors decorate the walls, while the group of customers at the right admire their own transient reflections in a small looking-glass – and before it we also see a jewellery casket and an open vanity-case, again traditional symbols of the temporary and superficial blandishments of our material world (Plate 130). If the walls of the shop are dominated by erotic mythologies, there is something both absurd and touching in the stiff, elderly couple at the back, who squint closely at an array of youthful nymphs who joyfully display their charms. Watteau expresses his meaning in a light, amusing and ironical way, which in combination with the delicate rhythms of his design and the exquisite beauty of his paint have perhaps obscured the fundamental gravity of his theme.

For Chardin such a work may have become more than just the inspiration for a passing street scene, when in the early 1730s he came to ponder deeply his own future as a figure painter. Perhaps it taught him how to define himself in relation to tradition, how he might absorb the moralizing emblem into an everyday world, how he might reconcile his commitment to nature with a theme as profound as the fragility of human happiness. Much as Watteau in his other works too – his rustic weddings, his gardens of love, his amorous musicians and his flirting couples in vaguely theatrical costumes – drew on established traditions of Northern sixteenth- and seventeenth-century art, so too Chardin looked to and absorbed similar traditions, with and without more meaningful undertones. But his audience was often too readily diverted by the distinctive character of his technique, or allured by the vivid actuality of his subjects, to see that there was more to the picture than met the eye.

Chardin continued to explore the half and three-quarter-length figure through the mid-1730s, and very soon developed these works to their formal perfection. In *A lady taking tea* (Plate 132), which is dated 1735, he arrived at a basic simplicity of design which was to be repeated with variations on several occasions: filling one half of the canvas with a figure in profile, against a flat or ambiguous neutral background, such as we have seen in the still lifes. *A lady taking tea* has as pendant *The house of cards* (Plate 131, engraving), where a youth leaning on a table by a window builds a precarious structure out of playing-cards; the thick curtain with its silk tassel, and the strong contrasts of light and shade lend this work a heavy, sumptuous feeling, in common with *The alchemist* and *A lady sealing a letter*. Although Chardin seems to employ the same model, and certainly the same dress, as in the latter painting, *A lady taking tea* painted two years later is more refined in handling, cooler in tone, and more classical in design. The verses on Filloeul's engraving of this picture attribute to it an amatory meaning, to the effect that her suitor hopes the hot drink will warm her heart and the sugar sweeten her feelings. It is far more likely, however, that the theme is related to that of the pendant, *The*

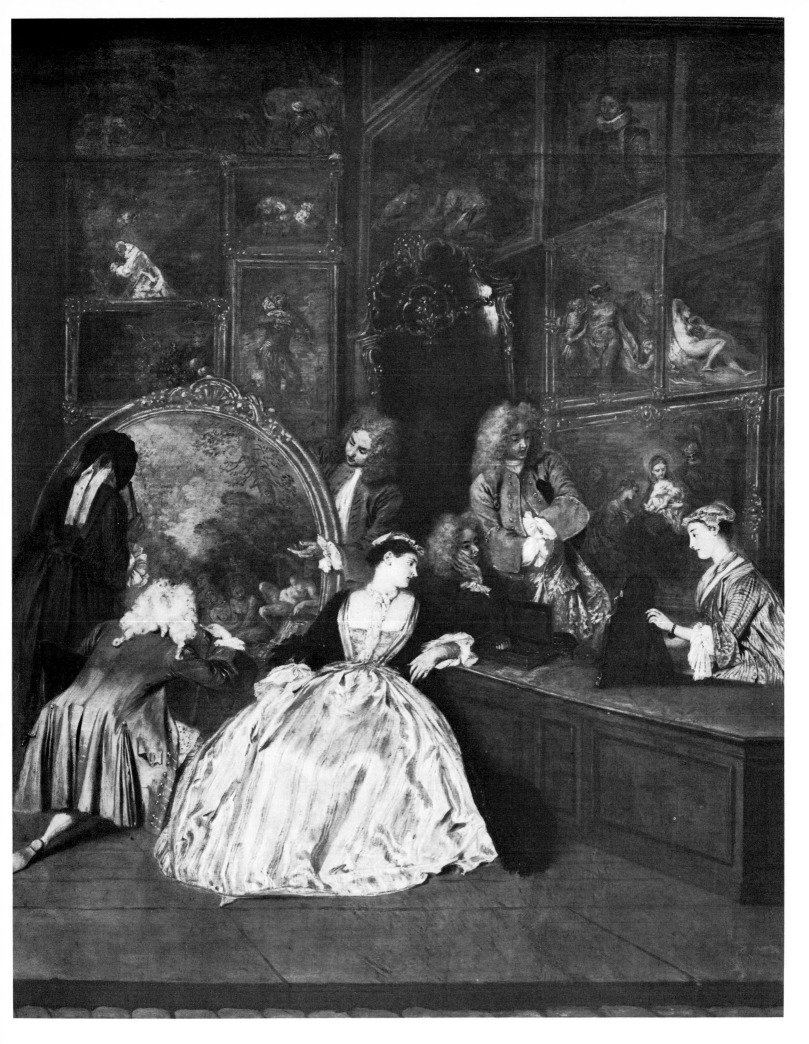

house of cards, which is basically a vanity image along the lines of *Soap-bubbles*, reminding us of the insubstantiality and transience of all endeavour. We are gently reminded of this in the evanescent steam rising from the lady's tea-making – to compare with the smoke blowing away in the background of Goltzius's *Quis Evadet?*, or the smoke from the pipes of certain figures in Dutch seventeenth-century genre. The fact that Chardin conceived so many works in pairs means that we should normally read the one in relation with its pendant, for in this way their meanings are often revealed or reinforced.

Chardin returned to the theme of a youth building a house of cards on several occasions, and at least two of these should be read in conjunction with a pendant. For example, the upright version in Washington (Plate 136) had as its pendant *A girl with a shuttlecock* (Plate 135). The two paintings are among Chardin's most perfect and moving images of childhood. When *The house of cards* was engraved by Aveline, verses were added to say that no human undertaking is any more certain or solid than this boy's house of cards. That this general truth also applies to affairs of the heart is emphasized by the Queen of Hearts, prominently projecting from the

131. *The house of cards. c.* 1735. Engraving by P. Filloeul after the painting by Chardin (Private Collection), which originally formed a pendant to Plate 132. The engraving is in reverse. The painting itself is relatively broad in execution and has visible *pentimenti* around the boy's hat and in the position of his hands, indicating that it was painted before its more confidently designed and executed pendant, and probably in 1734.

Chardin Pinx. Filloeul Sculp.

LE CHATEAU DE CARTE

Vous vous moquez a tort de cet adolescent a Paris chez Filloeul à l'entrée de la rüe du Fouarre au bâtiment neuf Barbons dans l'age meme ou l'on doit etre sage
 Et de son inutile ouvrage par la rüe Galande Avec Privilege du Roy . Souvent il sort de vos cerveaux
49. S. Vd. Prest a tomber au premier vent et chez Le Bas Graveur du Roi, rue de la Harpe Deplus ridicules chateaux 20

132. *A lady taking tea.* 1735. Oil on canvas, 31½ × 39¾ in. (80 × 101 cm.). Glasgow, Hunterian Art Gallery, University of Glasgow. This painting was acquired by Dr William Hunter at the 1765 London sale of the Prince de Carignan, and he bequeathed it to the University of Glasgow in 1783. Chardin employed the same dress in a slightly earlier picture (Plate 101), and the sitter seems to be the same too. It has been suggested she may be Marguerite Saintard, Chardin's first wife, who died aged thirty-eight only two months after this picture was completed. The teapot and red lacquered table are probably those mentioned in her 1737 estate inventory, and the table appears in later pictures (Plates 188 and 192).

trompe-l'oeil drawer at the front of the picture. The air of childish innocence expressed by his young companion, *A girl with a shuttlecock*, is underlined by the legend on the engraving after her picture by Lépicié: 'Without cares, without sorrows, tranquil in my desires, a racquet and a shuttlecock provide all my pleasure.' The implication is that more adult desires and pleasures will bring her care and sorrow enough. Her tender look towards her companion and the presence of the Queen of Hearts in his picture suggest the first stirrings of adult desire – but her shuttlecock, easily carried as it is by the wind, is, like the house of cards, another emblem of the uncertainties and vagaries of love.

Both children are wearing aprons for work, while at the girl's waist hang a pair of scissors and a pin-cushion: is Chardin here suggesting the opposition between the moral duties of work and the insubstantial, time-wasting activities of play, as he demonstrably does on other occasions? It could well be that this is an intended reading, supported as it is by both works, rather than, as one scholar has proposed for *A girl with a shuttlecock*, the advocation of physical games as a healthy activity for

children! Childish play, Chardin suggests, like adult affairs of the heart, is as ephemeral and insubstantial as a house of cards or a shuttlecock in the breeze. Similar admonitory imagery is occasionally met in the work of French painters earlier in the century. An engraving by Joullain after a painting by Charles Coypel (Plate 133), for example, shows a boy mocking a girl who has built a house of cards (topped by Hearts), and about to spoil her game; the caption runs: 'He who smiles, seeing these children erect a house of cards, prey to the slightest wind, would have passed for a wise man, if he never put cards to any other use.' An engraving of 1732 by Tardieu, after a painting by Lancret, which is nominally a representation of the element *Air* (Plate 134), is a veritable catalogue of vanity symbols: soap-bubbles, houses of cards, kites and windmills, while the youngsters are already flirting in a setting derived from Watteau's *fêtes galantes*.

All this is not to suggest that these lovely paintings by Chardin do not act on other levels, and not least as profoundly sympathetic depictions of the innocence of childhood. It is precisely the veiled emblematic references that lend a particular sharpness to our awareness of that innocence. Moreover, Chardin's evident fascination with children and their upbringing and occupations does reflect an

133. *He who smiles . . . c.* 1725. Engraving by F. Joullain after a painting of 1725 by Charles-Antoine Coypel.

Tel qui rit, voyant ces Enfants
Elever un Chateau soumis aux moindres vents,
auroit passé pour homme sage
Si des cartes, jamais il n'eut fait d'autre usage.

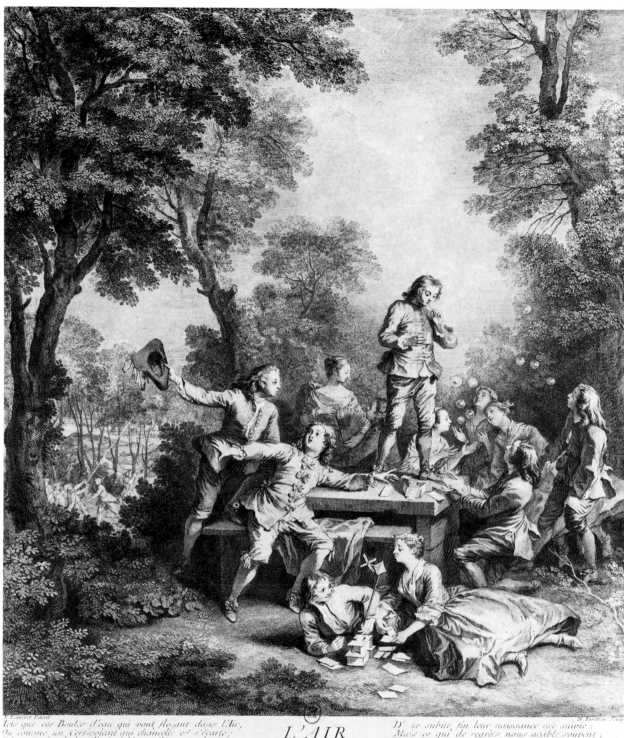

N. Lancret Pinxit

Tels que ces Boules d'eau qui vont flotant dans l'Air,
Ou comme un Cerf-volant qui chancelle et s'écarte;
Tels nos plus beaux Projets, légers Chateaux de Carte,
Sont formés et détruits plus vite que l'Eclair.

L'AIR

Tiré du Cabinet de Monsieur le Premier.

S. Tardieu Sculp.

D'ue subite fin leur naissance est suivie;
Mais ce qui de regrets nous acable souvent,
Est que tous les plaisirs les plus doux de la vie,
Ainsi que nos beaux jours, passent comme le Vent.

Illustrissimo et Nobilissimo viro D.D. Marchioni de Beringhen Equiti Torquato, alterius Regij stabuli Præfecto, &c.
Vovet et dicat Nicolaus Lancret.

134. *Air.* 1732. Engraving by N. Tardieu after a painting by Nicolas Lancret.

interest that became especially developed in his own century. But what renders these images so moving is the knowledge they embody of the uncertainty and fragility of life itself. This poignant awareness is only heightened by the rare beauty of Chardin's designs, and especially that of *A girl with a shuttlecock*: the perfect equilibrium of the figure in its space, the shape of silhouette, the extreme tenderness with which his brush strokes her cheek, her hair, her diminutive features not yet fully formed; and the delightful substance of his paint, for example in the creamy white ribbon round her neck and the white edge of her bodice, or in the soft, blond and tender light.

135. *A girl with a shuttlecock.* 1737. Oil on canvas, 31⅞ × 25⅝ in. (81 × 65 cm.). Private Collection. Chardin's maternal grandfather, and his uncle, were manufacturers of racquets, and Chardin characteristically draws on his own milieu in this work. There is an autograph replica in Florence, but of poorer quality.

136. *The house of cards*. 1737. Oil on canvas, 32¼ × 26 in. (82 × 66 cm.). Washington, D.C., National Gallery of Art (Andrew W. Mellon Collection). There is an autograph replica of this painting in Florence, but not of such high quality.

137. *Card-tricks*. 1744. Engraving by P.-L. Surugue after the lost painting exhibited by Chardin at the Salon of 1743.

Chardin Pinxit *P.L. Surugue filius Sculp. 1744*

LES TOURS DE CARTES

On vous séduit foible Jeunesse , *Le Tableau Original est dans le Cabinet* *Dans le cours du bel age ou vous allez entrer ,*
Par ces tours que vos yeux ne cessent d'admirer ; *de Mr Choc Degruechs .* *Craignés pour votre cœur mille autres tours d'adresse .*
 Danchet

A Paris chez L. Surugue, Graveur du Roy, rue des Noyers, attenant le Magasin de papier vis-à-vis St Yves . A.P.D.R.

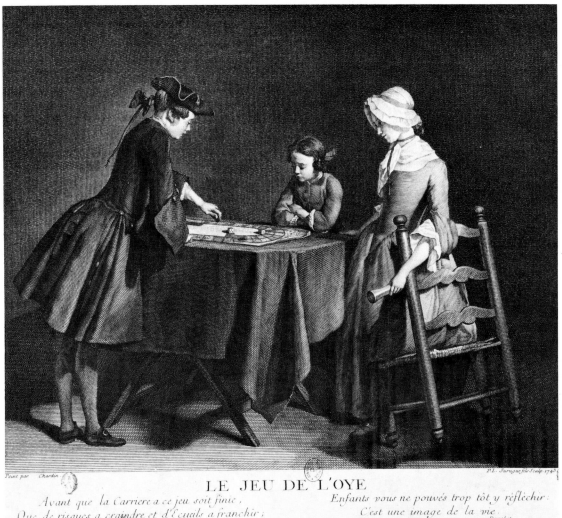

138. *The game of goose.* 1744. Engraving by P.-L. Surugue after the lost painting exhibited by Chardin at the Salon of 1743.

Peint par Chardin *P.L. Surugue fils Sculp. 1743*

LE JEU DE L'OYE

Avant que la Carriere a ce jeu soit finie , *Enfants vous ne pouvés trop tôt y réflèchir :*
Que de risques a craindre et d'Ecueils a franchir ; *C'est une image de la vie .*
 Danchet

Le Tableau Original est dans le Cabinet de Mr Choc D'espuechs .
A Paris chez L. Surugue Graveur du Roy, rue des Noyers attenant le Magasin de papier vis-à-vis St Yves . A.P.D.R.

139. *Ut est vita hominum*. Anonymous engraving, Emblem XII in Le Bey de Batilly, *Emblemata*, 1546.

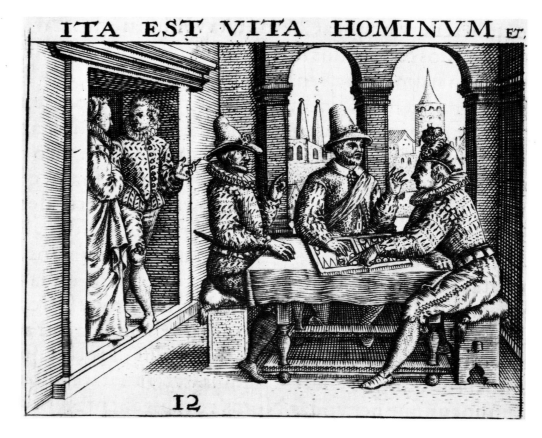

ITA EST VITA HOMINVM *ET*

12

Two of Chardin's most ambitious figure compositions, now known only through copies and the engravings by Surugue, show children at play – *Card-tricks* (Plate 137) and *The game of goose* (Plate 138). The paintings, shown as pendants at the Salon of 1743, are ambitious in their grouping of three figures, two of them full-length, around a table. In each case, the legend on the engraving makes clear the meaning, although not as movingly as Chardin can. *Card-tricks* shows a knowing young adolescent performing card-tricks for two credulous younger children – the legend runs: 'You are beguiled, helpless youth, by these tricks you cannot take your eyes off. When you grow up, guard your heart from a thousand other tricks.' With an Ace of Hearts on the table, the message is in any case plain to see. Chardin's power lies especially in the way he captures the knowing look of the youth, which contrasts with the credulous absorption of the two youngsters. In *The game of goose*, too, one has a sense of the disdainful superiority of the older child, who, the dice thrown, is moving his counter on the board of this popular game of chance. 'Before this game is played out', goes the legend, 'how many dangers to fear and perils to avoid. Children, you cannot reflect too soon, that it is an image of life.' There was a long tradition associating games of cards and dice with the chanciness of life itself: in an emblem-book of 1596, for example, the dice-game tric-trac is captioned 'So is the life of man' (Plate 139). Chardin would have been aware of this tradition through Dutch and Flemish painting of the seventeenth century. If we consider our reading of *The game of knucklebones*, these paintings may also have an admonitory meaning, for they too represent time-wasting activities; again Locke, for example, criticizes such 'unprofitable and dangerous *Pastimes*' as cards and dice in his *Some Thoughts Concerning Education*.

The horizontal version of *The house of cards* (Plate 140; and see detail, Plate 142) now in the National Gallery, London, was quite likely painted as a pendant to *The young schoolmistress* (Plate 141) in the same collection. The minor variation in dimensions and the differences of handling in these two works, as in some other pairs of pendants by Chardin, can probably be attributed to the space of about a year

in their execution, with *The young schoolmistress* the earlier. This latter is a more exemplary moral subject, where a girl is teaching a much younger child to read. Several other versions of this picture are recorded in the eighteenth century, incidentally, but usually as pendants to versions of *Soap-bubbles*. The theme of the two paintings can be read as the contrast between industry and idleness, learning and play. Again, this type of subject was popular in seventeenth-century Dutch art – as for example in a painting by Caspar Netscher (Plate 144), where a child being taught to read is contrasted with a second child, who plays idly with a small dog, while other attributes of childish idleness, a spinning-top and an illustrated broadsheet, are scattered on the floor around her. Considered as a pair, *The house of cards* and *The young schoolmistress* are among the most perfect in design of Chardin's three-quarter-length figures, with their silhouettes adjusted for maximum effect – compare the shape given to the back of the boy's coat, for example, with the less

140. *The house of cards. c.* 1737. Oil on canvas, 23⅝ × 28⅜ in. (60 × 72 cm.). London, National Gallery. The father of this boy was Jean-Jacques Lenoir, a cabinet-maker and furniture dealer, and it is tempting to see in the carefully rendered pieces of furniture in this painting and its probable companion (Plate 141) two of the more workaday items in which he may have dealt. The beechwood gaming table with its green baize top appears in several other paintings (Plates 136 and 145), and also in the 1737 and subsequent inventories. In January 1762, purchasers of *The British Magazine* were given an impression of F.-B. Lépicié's 1743 engraving after this painting, and the magazine published an explanation of its *vanitas* symbolism.

141. *The young schoolmistress. c.* 1736–7.
Oil on canvas, 24¼ × 26⅛ in.
(61.5 × 66.5 cm.). London, National
Gallery. For stylistic reasons, this painting
should probably be dated a little earlier than
its companion, if indeed they were originally
pendants. Three other versions of this work
are known – the two best are in Washington
and Dublin – but they may not be
autograph.

rhythmic treatment of the figure in the Washington *House of cards* (Plate 136). The two works are complementary in colour, *The house of cards* based on a cool range, *The young schoolmistress* with positive warm notes such as the burnt orange colour in the band on the girl's bonnet. The two main figures are fomally related one to another and, in answer to the open drawer of the boy's table and the sharp highlights of handle, nails, coin and cuff-links, we find in its companion a projecting key, with highlights on the cabinet, needle and the girl's thumbnail. Against the complete self-absorption of the boy, Chardin explores a psychological contact between the youngest child, slightly out of focus and not fully comprehending, with its plump, unformed features and chubby hand, and the more sharply defined instructress (Plates 143), where he brilliantly expresses her sense of young womanhood and a purse-lipped impatience with her charge.

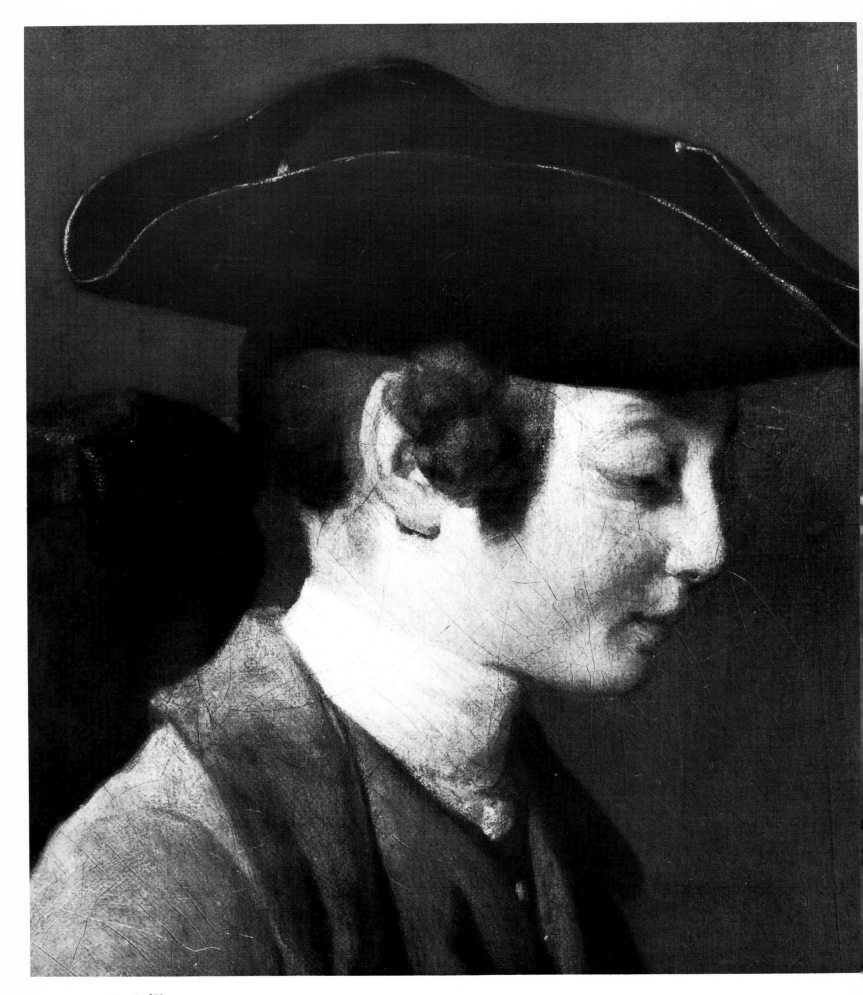

142. Detail of Plate 140.

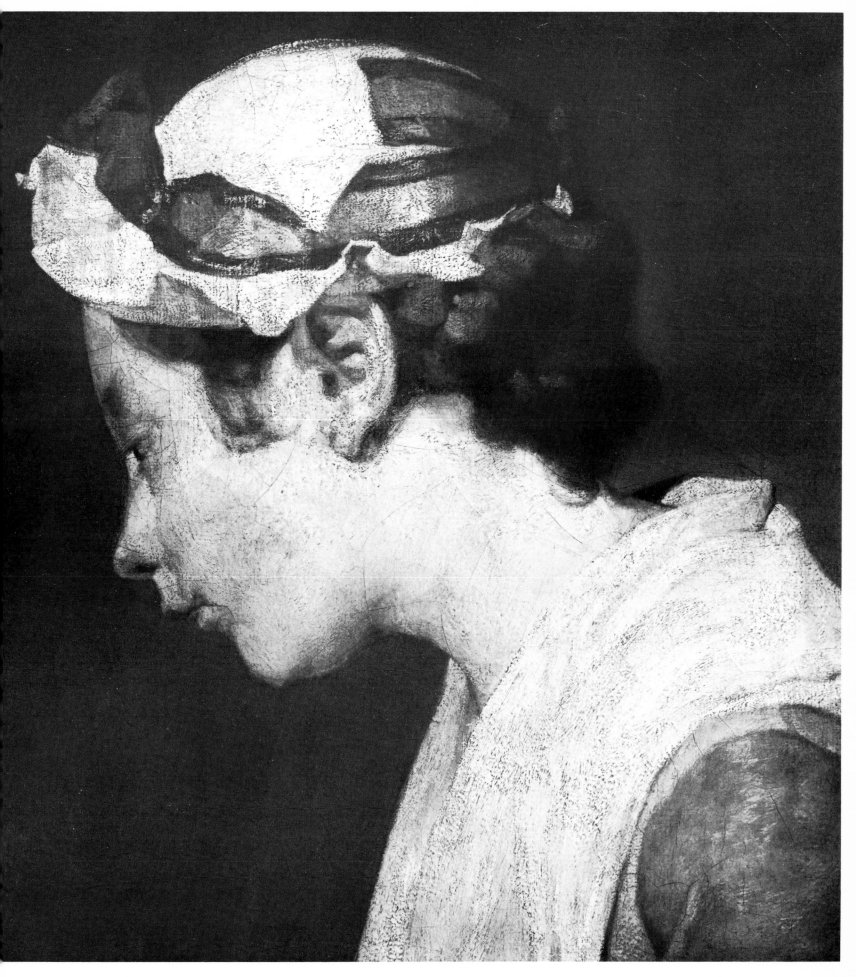

143. Detail of Plate 141.

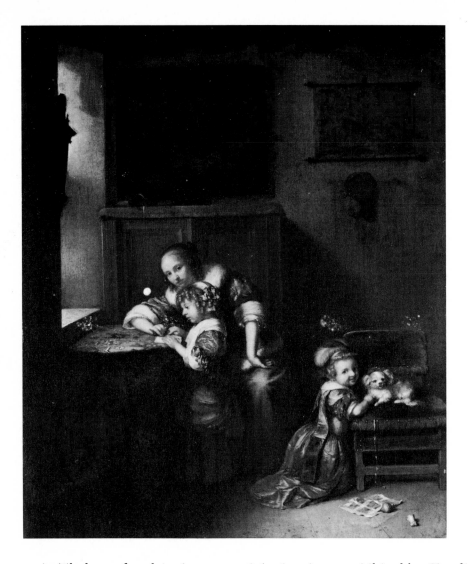

144. Caspar Netscher. *A lady teaching a child to read. c.* 1675. Oil on panel, 17¾ × 14⅝ in. (45.1 × 37 cm.). London, National Gallery. In Chardin's day, this painting was in the collection of the Duc d'Orléans, at the Palais-Royal.

As *The house of cards* is almost certainly the picture exhibited by Chardin in 1741 as '*The son of M. Lenoir playing at making a house of cards*', it has very plausibly been suggested that *The young schoolmistress* represents two of his siblings; in 1743 Chardin was to exhibit a portrait of *Madame Lenoir holding a book* (now lost, but engraved, Plate 146). Madame Lenoir is seated, cosily surrounded by a movable screen to keep off draughts, and with a firescreen before her. She pauses to look up reflectively, as if addressed by the spectator. It is a surprisingly direct encounter for Chardin, attempted only once before in his more gauche early portrait of Charles-Théodose Godefroy (Plate 103). The fact that Madame Lenoir is sensibly occupied in reading a book is emphasized in the legend appended to Surugue's engraving of 1747: 'This entertaining work, this pleasant read, occupies the leisure of wise Philis. When we know how to unite the useful with the agreeable, innocence is always the basis of pleasure.'

By showing his sitter in a flattering, perhaps characteristic occupation, Chardin was following a recent innovation of his friend Aved. Aved's celebrated portrait of *Madame Crozat* (Plate 147), greatly admired at the Salon of 1741, has the sitter working a tapestry and pausing for a moment to look up. The activity in which she is engaged — like knotting or reading — was seen as a suitable occupation for a lady of the leisured class, rather than wasting time on coquettish pursuits and less innocent pleasures. This type of portrait was to remain popular throughout the following decades; much later, at the Salon of 1771, Nicolas-Bernard Lépicié exhibited a work with the title *The useful recreation* (Private Collection), showing a lady seated reading, with her embroidery beside her. It is also noteworthy that

145. *The governess.* 1738. Oil on canvas, 18¼ × 14¾ in. (46.5 × 37.5 cm.). Ottawa, National Gallery of Canada. A version of this painting, possibly autograph, is at Tatton Park (National Trust), Cheshire, and may be the 'copy, retouched by M. Chardin' which was in the Antoine de la Roque sale in Paris, May 1745.

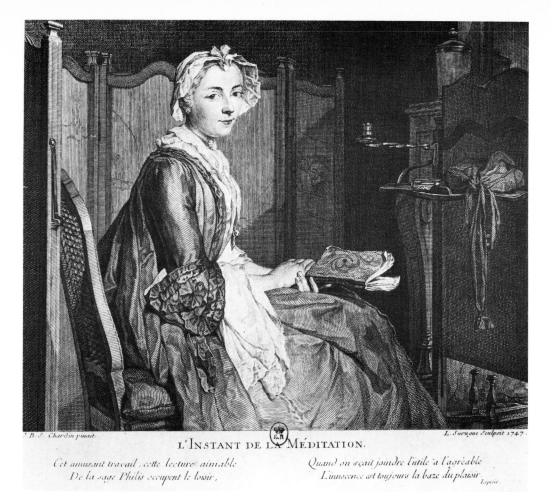

146. *The moment of meditation.* 1747. Engraving by P.-L. Surugue after Chardin's lost *Portrait of Madame Lenoir holding a book* exhibited at the Salon of 1743.

L'INSTANT DE LA MÉDITATION.

Cet amusant travail, cette lecture aimable / De la sage Philis occupent le loisir,

Quand on sçait joindre l'utile à l'agréable / L'innocence est toujours la baze du plaisir.

147. Joseph Aved. *Portrait of Madame Crozat.* 1741. Oil on canvas, 53⅞ × 39⅜ in. (137 × 100 cm.). Montpellier, Musée Fabre.

148. Jean-Baptiste Massé. *The Godefroy children.* 1736. Red chalk, 22 × 16½ in. (56 × 42 cm.). Paris, Musée Nissim de Camondo. In his will, the engraver, draughtsman and miniaturist Massé (1687–1767) left this drawing to Charles-Théodose Godefroy, seen on the right aged eighteen (see Plate 103); the child on the left is his eight-year-old brother, Auguste-Gabriel (see Plate 149), while the central figure is a 'M. Fallavel the Elder', possibly tutor to the two brothers. The drawing conveys an impression of a highly literate, travelled and cultured household; the two boys, like their father, who was a jeweller and banker, and a friend of Chardin, were to become enthusiastic patrons of the arts in later life.

Aved should have chosen such a casual moment in his portrait, as Madame Crozat removes her pince-nez, which adds to the informal air of the work. A teapot sits ready behind her, and we may feel that in a moment she will be taking a cup, like Chardin's gentlewoman of six years earlier (Plate 132). The studied sobriety of Aved's image may well owe something to Chardin in turn, not only in its mood of reserved diligence, but in its careful attention to details like the work-basket, the tapestry-frame and the creamy painting of the sitter's lace. This sober approach – of

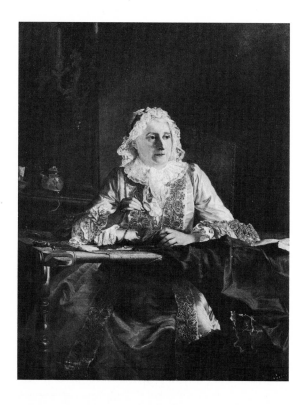

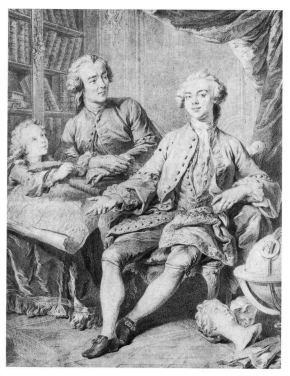

both Aved and Chardin – was to be immensely influential on much subsequent portraiture, and was seen as a realistic alternative to the allegorized portraits being introduced by Jean-Marc Nattier (1685–1766) at this time – such as his *Comtesse de Brac as Aurora*, also shown at the Salon of 1741 – which some critics were to attack for their absurd pretension. In fairness to Nattier, however, we have to recognize that he was trying to narrow the gap between the academic status awarded to history painting and the more lowly genre of the portrait; he earnestly wished to reconcile the imaginative demands of the grand manner with the more limited ones of achieving a flattering likeness. But it is not only to modern eyes that the deceptively simple and reticent manners of Aved and Chardin would seem more sympathetic.

With the exception of two later works (two busts of surgeons, now known only through engravings, and not well received at the time), Chardin's portraits are more than merely descriptive of appearances. Aved was cast as a sage (Plate 102), and Charles-Théodose Godefroy (Plate 103) with an attribute of his musical culture. Madame Lenoir, like her daughter (Plate 141), is shown usefully, rather than vainly, employed; and her son (Plate 140) becomes a vehicle through which we contemplate the precariousness of our existence. As always, Chardin has more depth than the exquisite surface led many of his contemporaries to believe. Thus, his portrait of Auguste-Gabriel Godefroy, younger brother of Charles-Théodose (and see Plate 148, caption), was depicted as a small boy spinning a top (Plate 149). But *The spinning-top* (the title of the engraved version) is both portrait and genre painting, and also much more than the sum of these two parts. It has recently been suggested that the source was a Spanish emblem-book of 1610, where the image of

149. *The spinning-top. c.* 1737. Oil on canvas, 26⅜ × 29⅞ in. (67 × 76 cm.). Paris, Musée du Louvre. Characteristically for Chardin, this work is more than just a *Portrait of the son of M. Godefroy, jeweller*, as it was called in the Salon catalogue of 1738. It makes a moral point about industry and idleness, and, more profoundly, about the precariousness of life itself. A probably autograph replica dated 1741 is at São Paolo.

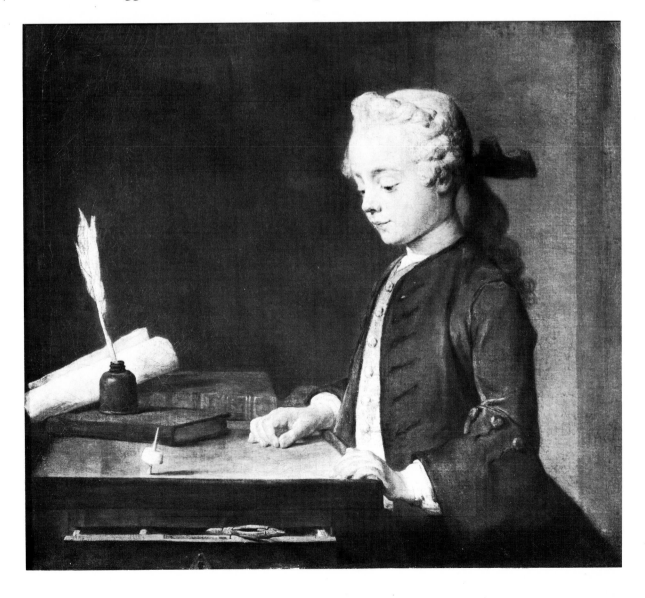

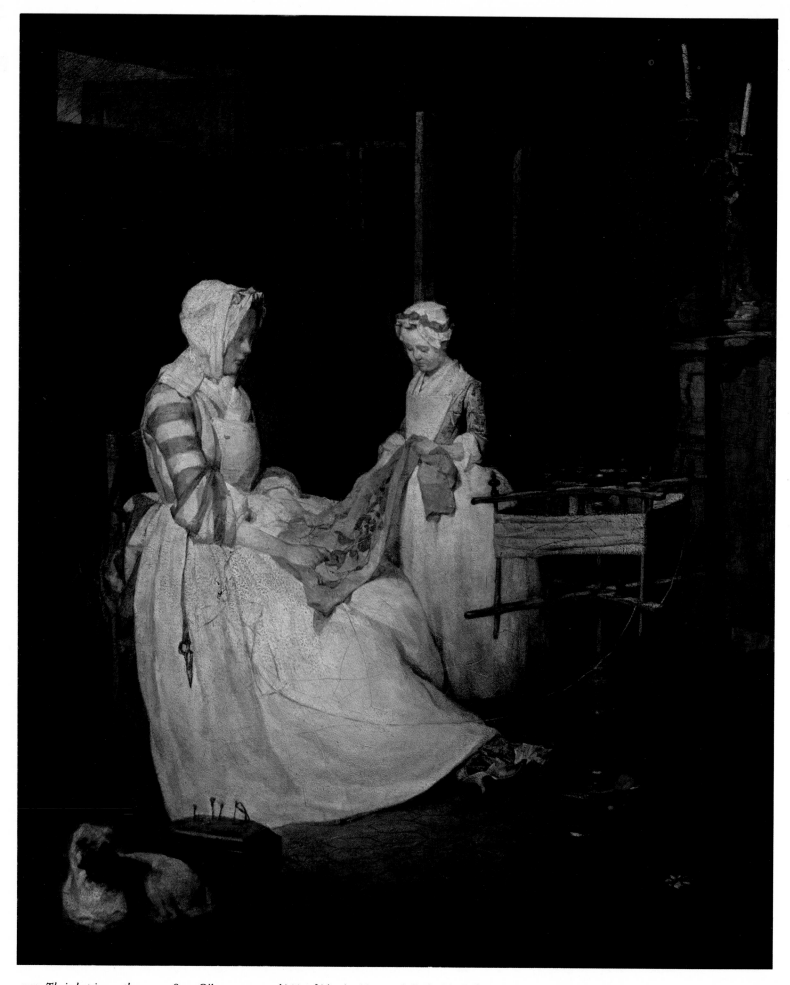

150. *The industrious mother. c.* 1738–9. Oil on canvas, 19¼ × 15⅜ in. (49 × 39 cm.). Paris, Musée du Louvre. Two good period copies of this work are known, companions to the two copies mentioned in the caption to Plate 151.

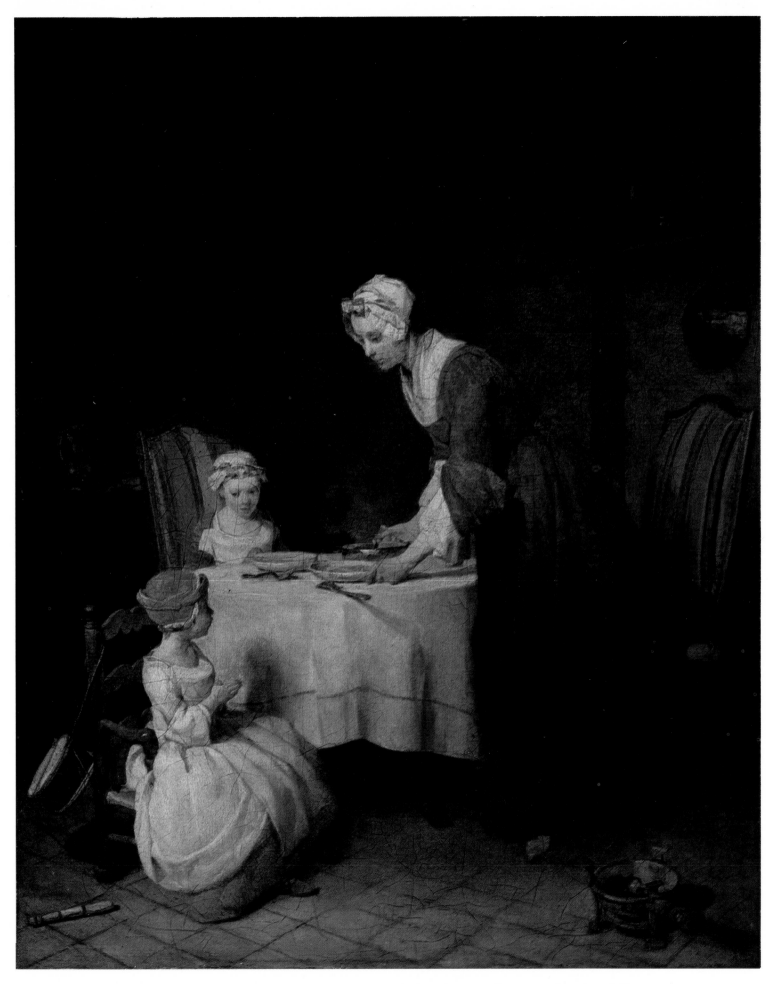

151. *Saying Grace. c.* 1740. Oil on canvas, 19½ × 15⅛ in. (49.5 × 38.5 cm.). Paris, Musée du Louvre. Two autograph versions of this composition, with slight changes, are known: one in the Louvre (probably from Chardin's own collection) and the other in Leningrad (dated 1744). Good period copies are in Stockholm and a British private collection.

L'INCLINATION DE L'AGE.

Sur les frivoles Jeux, dont s'occupe cet âge,
Gardons nous de jetter des regards méprisans ;
Sous des Titres plus imposans,
Ils sont aussi notre partage.

152. *The inclination of her age.* 1743.
Engraving by P.-L. Surugue after the lost
painting by Chardin exhibited at the Salon of
1738. The verses on the engraving read: 'Let
us beware of casting scorn on the frivolous
games of her age, for under more imposing
names they are also our occupation.'

a top is captioned 'Only through beating', as a symbol of the sloth of men, who will
only make an effort if they are beaten; this meaning is echoed in a Dutch emblem-
book of 1614, where the whipping of a top is seen in a religious context, in the
relation between Man and God: 'So long as the rod beats,' goes the caption, which
is further explained with, 'The further the rod is from the backside, the lazier they
grow in the service of God.' However, we must always be cautious in assigning
emblematic meanings to Chardin's paintings, and weigh these against the verses on
contemporary engravings and what we know of his other works. In *The spinning-top,*
the top is to be spun with the fingers; there is no whip. And the legend on Lépicié's
engraving gives a simpler and more convincing meaning: 'In the hands of caprice,
to which he is abandoned, man is a real spinning-top, turning incesssantly. And
often his destiny depends on the direction the turn of fortune gives it.' Once more
we may feel that Lépicié has interpreted the image in the spirit Chardin intended –

and we might recall the chancy life of the soap-bubble and of the feather shuttlecock carried off course by the wind. We are also reminded by the visual evidence in this picture that the child is engrossed in a useless pursuit, instead of devoting his precious time to his book, his quill-pen, and his drawing crayon, which projects from the open drawer of the table.

This work was exhibited at the Salon of 1738 as '*A small picture representing the portrait of the son of M. Godefroy, jeweller, engaged in watching a top spinning*', but when it was engraved it was given the generalized title *The spinning-top*. Similarly, another portrait at the Salon of 1738 was exhibited as '*The portrait of a daughter of M. Mahon, merchant, amusing herself with her doll*'; but the picture (which is now lost) was engraved in 1743 with the title *The inclination of her age* (Plate 152). In this work there is something disconcerting and almost sinister in the way the girl toys with her doll dressed as a nun! It is interesting to note that these portraits – and that of Madame Lenoir is another (Plate 146) – were engraved with general, moralizing titles. Presumably no one was keen to purchase portrait engravings of 'unknown' people, who played no part in public life, and the engraved titles were to give these images a wider appeal.

After completing his first kitchen interiors in 1733 (Plates 104 and 105), Chardin explored the human figure in a number of small paintings (all less than 20 cm in width) executed on wooden panels. They show single full-length figures, including several versions of *The embroiderer* and *The draughtsman* (see Plates 9 and 10), and a pair of studies of children, *A girl toying with her lunch* and *A child with the attributes of childhood* (Plates 153 and 154), which were shown at the Salon of 1737. It is tempting to date the former pair back towards 1733, for their drawing and handling recall *A woman drawing water from a cistern* (Plate 104), while the latter pair, more refined in treatment, seem consistent with a date nearer 1737. The two

153. *A girl toying with her lunch. c.* 1737. Oil on panel, 7⅛ × 7⅛ in. (18 × 18 cm.). Destroyed during World War II. Exhibited at the Salon of 1737, this painting and its companion were engraved by C.-N. Cochin in the following year.

154. *A child with the attributes of childhood. c.* 1737. Oil on panel, 7⅞ × 7⅛ in. (20 × 18 cm.). Destroyed during World War II. The painting was exhibited at the Salon of 1737 with the present title, while C.-N. Cochin's print of 1738 was known as *The young soldier*.

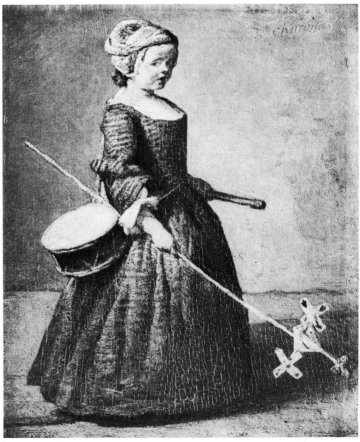

155. *The morning toilet.* 1741. Oil on canvas, 19¼ × 15⅜ in. (49 × 39 cm.). Stockholm, Nationalmuseum.

156. Abraham Bosse. *The blind man.* Engraving. The accompanying verses read: 'You must admit that I am certainly to be pitied, and that with the dangers I have to fear, having the misfortune to live without sight, my passage is dependent on a stick and a dog.

157. *The blind man.* 1761. Engraving by P.L. Surugue after the painting by Chardin exhibited at the Salon of 1753.

delightful studies of children were unfortunately destroyed during World War II, but are known from engravings and the old photographs reproduced. The verses which accompany the engravings stress the innocence of the children's amusements – but imply that there are also, or will be when these children reach the age of experience, amusements which are less innocent. Cherries, with which the little girl plays in her lap, were quite well-known erotic symbols in the eighteenth century; the legend on her engraving reads, 'Simple in my pleasures, I can even find amusement in my meal.' The verses appended to *The young soldier*, as her 'companion' was also known, read: 'Without troubles, without sorrow, modest in my desires, a windmill and a drum form all my pleasures'; the windmill, certainly, can be read as an emblem of transience and the vagaries of fortune.

A third small panel with a single figure, also destroyed during World War II when in the remarkable collection of Baron Henri de Rothschild in London, was *The blind man* (Plate 157, engraving). It was not exhibited until 1753, but in scale, support and execution it has every appearance of belonging in date with the two panels exhibited in 1737. Its subject, a scene from Parisian street life, which might put us in mind of Chardin's very first figure painting, is unique in his career; and it is also unique in that it was fairly directly based on a work (Plate 156) by Abraham Bosse (1602–76), a French Huguenot engraver celebrated in the previous century. Depictions like these can be read as merely picturesque slices of contemporary street life, such as Bouchardon illustrated in his engraved *Cries of Paris* (see Plate 117) in the 1730s, or such as Watteau had drawn earlier in the century; or we can follow

the legend on Bosse's print as a further inducement to pity and an act of charity. Chardin transforms this tradition, however, into a characteristically personal image of impressive inwardness that knows not the guile of human, nor artistic, facial expression.

Despite the evident public success of the works Chardin exhibited in 1737 and 1738, it was his exhibits at the Salon of 1739, and notably *The governess* (Plate 145), which according to Mariette made Chardin's real reputation in this genre. Although when exhibited in September 1739 *The governess* belonged to a Parisian collector, the *Mercure de France* noted with regret in December that it was already sold to the Austrian ambassador, Prince Joseph Wenzel of Liechtenstein. No longer are we below stairs with kitchen-maids and servants, but above stairs in the bourgeois world of boys building houses of cards and girls with battledores and shuttlecocks. It was the narrative element in *The governess*, his most popular work of 1739 according to the *Mercure*, which seems to have engaged the attention of visitors to the Salon. The governess, pausing for a moment in brushing dust from the boy's hat, remonstrates with him before sending him off to his lessons with his books under his arm. With the lowered eyes of the guilty child, the governess leaning towards him, and a perfect interval of eloquent space between them (Plate 158), Chardin has captured the psychological moment with the greatest delicacy. Curiously enough, none of the contemporary commentators mentions the juxtaposition of the playing-cards, battledore and shuttlecock on the left (whose time-wasting attributes we have discussed above) with the open work-basket of the governess at the right. The prominence given to these mute objects underlines their supporting role in the choice to be made between work and play, duty and pleasure, which is doubtless the theme of the dialogue above them. If there is psychological nicety in the way Chardin juxtaposes his two protagonists, there is also a distinction between the workaday apron of the governess and the elegant, almost jauntily cut, frock-coat of the boy. The setting is a fairly refined salon, with parquet floor, card-table and upholstered chair; and this refinement is carried throughout the rhythms and delicate colours of the whole design.

Not only was Chardin now increasingly sought after by foreign collectors – the Prince of Liechtenstein was to be followed by Count Carl Gustav Tessin from Sweden – but his standing was confirmed when in November 1740 he was presented to Louis XV, to whom he gave a pair of genre scenes, which had been shown with acclaim at the Salon that year: *Saying Grace* (Plate 151) and *The industrious mother* (Plate 150). The element of narrative, of mute dialogue, is again strong in these two works, where Chardin develops his theme of mother and child. In *The industrious mother* a girl is being upbraided for some careless work on an embroidery; her mother points out the error, and the girl has a disconsolate expression. The mother, a work-bag on the back of her chair and scissors hanging from her waist, has been winding wool on the frame before her; completed red and blue balls of wool are in its base. At her side is a work-box with embroidery needles stuck in the top; and a pug-dog is contentedly curled up and looking out at the spectator. It is a comfortable bourgeois household, with rococo candelabra, a firescreen and teapot at the fireplace, and a large folding-screen arranged to keep off the draught from the door in the background. The open door recalls that which frames the boy in *The governess*, while the screen is used to help define the space of the room.

In *Saying Grace* (at the Salon it was called *Bénédicité*, which is the first word of Grace, from the Latin *benedicite*), a mother pauses in the process of ladling out the meal of her two young children, as the smaller of these falters over the simple prayer, glancing up to her for assistance (Plate 159). His sister looks on, not

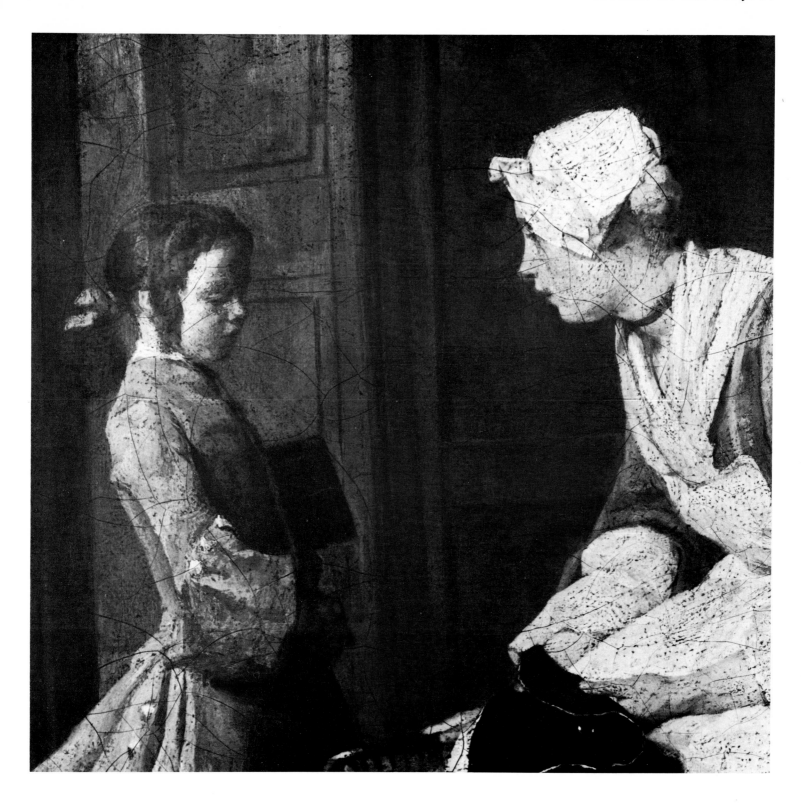

158. Detail of Plate 145.

without malice, at his difficulty. The legend on Lépicié's engraving of 1744 suggests rather that the little boy is gabbling his prayer as fast as possible, because his mind is more on his food. Again the setting is a simple bourgeois living-room, comfortable with its damask tablecloth and a pair of good upholstered chairs; the brazier at the right 'answers' the pug and work-box in the companion picture. There are precedents for this subject in Northern art of the preceding century, for example Jan Steen's *A peasant family at mealtime* (Plate 160). But Chardin has characteristically rethought the theme in an original way, and chosen a moment of hesitation, which creates a much greater interest and psychological tension. The mood is one of greater solicitude than in *The industrious mother*, but these works and

160. Jan Steen. *A peasant family at mealtime.*
c. 1665. Oil on canvas, 17¾ × 14¾ in.
(44.8 × 37.5 cm.). London, National
Gallery. Steen painted many variations on
the theme of peasants saying Grace before
their meal.

The governess have in common silent communion, not without tension, expressed by the inclination of one figure towards another, by the rhythmic curve of empty space that links them, and by looks which are rarely met. Just as he rejects the classical repertoire of expression, so the rhetorical gesture is replaced by the firmer grip of a hand on a dinner-plate, the raising of a hat-brush, the lowering of a child's head. In *The industrious mother* and *Saying Grace* the paint is less granular than before, but still impasted. There are penumbral green and brown atmospheres, which his rooms seem palpably to contain, and patches of more intense colour where favourite pigments are isolated and concentrated – blue stockings and red shoes, red and blue wools, a blue drum and a deep-pink cap, the red and blue stripes of chairs.

A precious document of Chardin's working method exists in the form of an oil sketch (Plate 161) close in size to *Saying Grace*, which seems to represent the first idea for this subject. Here, the seated mother is waiting for the small seated child, his hands together, to finish his prayer; as far as it is possible to decipher the sketchy handling, the mother is holding some kind of small container and a spoon, ready to feed the child; a protective cloth is spead across their knees. Behind, an older child waits and watches. The composition of this sketch, if reversed, is also remarkably close to that of *The industrious mother*, when we omit the seated infant and substitute embroidery for the giant improvised napkin. In other words, the sketch contains the beginnings of both works, as if it had suggested to Chardin two pictorial ideas.

Two other oil sketches by Chardin are known – for *Household economy* (see Plate 168, engraving; the sketch is in a Private Collection) and *The convalescent's meal* (Plate 178) – but in the estate inventory made after his death 'twelve sketches' (*ébauches*) were listed, and another two, 'two children, life size'. Given the slowness and difficulty of working which Cochin and Mariette report, we might expect Chardin to work out his compositions in some preliminary form, and it would seem that he preferred the painterly sketch, with its bold masses, to any kind of preparatory drawing. Contemporary history painters commonly made such oil sketches for their designs, although of course on a smaller scale than their large finished works. Chardin was also able to work out the broad dispositions of light and shade in his full-size sketches. In the present case, the bright open window of the sketch was to be abandoned, in favour of a more easily controlled interior lighting.

It is interesting to observe how that intimate and privileged relation which the spectator has with the world of Chardin's domestic interiors can be broken by an intruder on the scene. This is the case with a version of *Saying Grace* (Plate 162) now in Rotterdam, which, if it is not from Chardin's own hand, is most likely a copy of the composition he sent to the Salon of 1761, which is recorded in a drawing by Gabriel de Saint-Aubin. The intrusion of a serving-boy at the left completely breaks the spell. As we are drawn back, we no longer have an exclusive, keyhole view of the scene around the table, and the family itself is no longer oblivious of being watched: they have their own spectator, as it were, and his presence breaks the intimacy of the scene in a way comparable with the boy in Steen's *A peasant family at mealtime*, whose direct look at us denies any naïve self-containment his pictorial world might otherwise possess.

In the early 1740s, Chardin's manner of painting becomes more refined. This is most marked in a painting such as *The morning toilet* (Plate 155), in itself a more refined subject, to which the artist is responding. But even his kitchen scenes of this decade, such as *The convalescent's meal* (Plate 174) of 1747, are more delicate in touch and more pearly in light than before. Most commentators appreciated the fact that his figure-pieces from about 1740 onwards were more elevated in aspiration than the low-life works of the Dutch and Flemish genre painters with whom he was

159. Detail of Plate 151.

161. Sketch for *Saying Grace. c.* 1739. Oil on canvas, 18¼ × 15 in. (46.5 × 38 cm.). Private Collection.

normally compared. Thus, writing in the *Mercure de France* in 1753, Abbé Raynal observed:

> The compositions of this painter, although simple and compatible with the manners of the day, have no pretensions to the heroic. But the justness of his choice and the charm of his images make for a lively critique of the Flemish painters in general. In effect, the smoking-room, the brawls, the basic needs of the body, in short nature taken at her most abject, are the subjects most commonly treated by the Brouwers, the Ostades, the Teniers, etc. M. Chardin has always avoided these images, humiliating for humanity.

In *The morning toilet* a mother is putting a final pin into the ribbon on the bonnet of her young daughter, just before setting off for the seven-o'clock Mass (as the clock in the background shows us). A missal and the mother's muff are ready on the chair in the left foreground. The painting was shown at the Salon of 1741, together with *The house of cards* (Plate 140), but *The morning toilet* attracted the most

attention. The *Mercure de France*, for example, admired the brilliant way Chardin has expressed that hint of nascent coquetry in the little girl, how the movement of her heart is revealed as she glances over her shoulder into the mirror, to satisfy her vanity and to see for herself the effect of her mother's embellishments. The legend on the engraving by Le Bas, published also in 1741, is ironically chiding in tone: 'Before reason enlightens her, she takes from the mirror seductive advice on desire and the art of pleasing; beautiful women, I see, are never children.' The delicate poses and movements of the figures, which express their interior movements, the gentle slope of their silhouettes, are complemented by the greater area of positive colour Chardin has introduced into this work: the rich red fabric on the chair and draped over the mirror, setting off the still life of silvers, white fabric, white candle, wisps of silver smoke; the muted pink of the girl's dress, topped by a turquoise jacket and ribbon; the sumptuous red and white overskirt of the mother, and the soft gold underskirt. The black of her cape and hood anchors all these.

The mirror, the candle with its brief life, valuables (here, the candlestick and silver containers on the dressing-table), the timepiece, and even youthful beauty itself, are all traditional symbols of the vanity of the world. It is the profundity of this underlying theme that lends a special poignancy of mood to what is Chardin's most delicate and moving genre picture. As we have seen in other works, he hints also at a moral choice the child — and we ourselves — might make: in this case,

162. *Saying Grace. c.* 1760? Oil on canvas, 19⅞ × 26⅛ in. (50.5 × 66.5 cm.). Rotterdam, Boymans-van Beuningen Museum. This painting is very close to one exhibited by Chardin at the Salon of 1761, and which is recorded in a tiny drawing by Gabriel de Saint-Aubin in the margin of a copy of the Salon *livret*. The handling of the Rotterdam picture is rather stiff, and it is probably a contemporary copy.

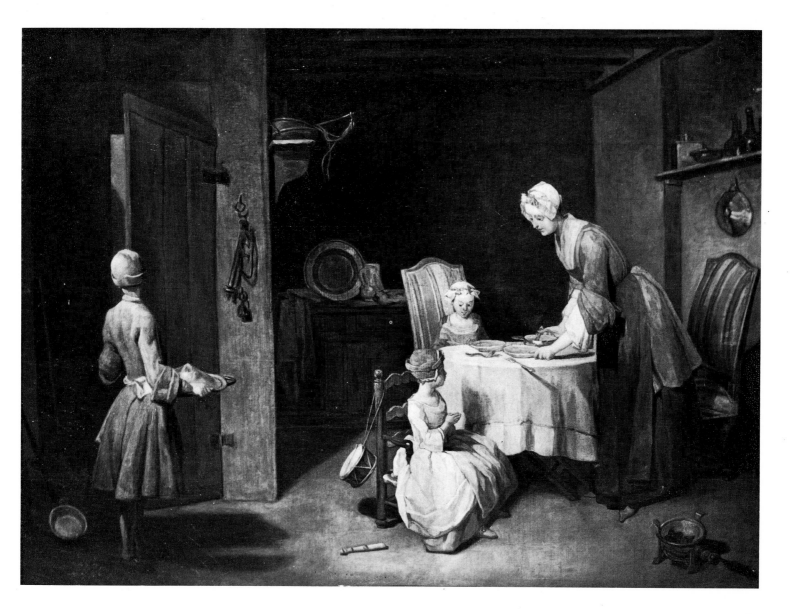

between the ephemeral blandishments of the material world and the eternal truths of religion. *The morning toilet* may even be a wry comment on the dichotomy between the spiritual and the social motivations of this particular outing.

One of the most interesting contemporary comments on this picture was made by an anonymous writer on the Salon of 1741:

> It is always the *Bourgeoisie* he brings into play . . . There is not a single woman of the Third Estate, who does not think it an image of her figure, who does not see there her own domestic establishment, her polished manners, her countenance, her daily occupations, her morals, the moods of her children, her furniture, her wardrobe.

In other words, to the Parisian bourgeoisie of his day, Chardin presented a self-image; they looked, and saw reflected in his art the image of an ideal of daily life to which they aspired.

163. Joseph Aved. *Portrait of Count Tessin*. 1740. Oil on canvas, 58⅝ × 45⅝ in. (149 × 116 cm.). Stockholm, Nationalmuseum. Chardin's friend Tessin is shown in his private role as a cultivated *amateur*, holding an engraving after Raphael's *Galatea*.

164. Alexander Roslin. *Portrait of the Marquis de Marigny*. 1761. Oil on canvas, 49¾ × 44⅛ in. (126 × 112 cm.). Musée National du Château de Versailles. The Marquis de Marigny (1727–81), brother of Madame de Pompadour, is shown in his role as Directeur des Bâtiments, holding a plan of the Louvre colonnade.

7 *Women and Children*

No doubt the same public which we are told liked to contemplate its own image and aspirations in Chardin's works at the Salon was the chief customer for the fine engravings made after these figure-pieces. The whole question of the print trade in eighteenth-century France needs study, and the kind of financial returns both engravers and the original artists could expect. It may well be that one reason for the limited number of designs Chardin invented in figure painting was that he stood to make a better return on the engravings than on the paintings themselves, as Hogarth was to find across the Channel in exactly the same decades of the 1730s and 1740s. By modifying his subject-matter from *The governess* (1738; Salon of 1739, his first major Salon success) onwards, Chardin may simply have made a clever calculation of the likely tastes of the Salon-visiting public. There were no Salons where he could catch the public eye before 1737, and it is no coincidence that engravings after his works appear only after 1737. From then on, with the exception of one work (*The convalescent's meal*) which was never engraved, and another (*Household economy*) which was never exhibited but was engraved, the prime versions of all Chardin's figure-pieces were engraved soon after their appearance at the Salon.

The paintings themselves were more likely to end up on the walls of aristocratic or royal palaces or picture galleries than in the modest apartments of the Parisian bourgeoisie. The first versions of *Saying Grace* and *The industrious mother* were given by the artist to Louis XV in 1740 (and the captions on Lépicié's engravings told the world to whom they belonged!). Of the other more refined figure subjects, *The governess* and *The convalescent's meal* went to Prince Joseph Wenzel of Liechtenstein; *The morning toilet* was commissioned by Count Tessin (Plate 163); Princess Luise Ulrike of Sweden commissioned *Domestic pleasures* and *Household economy*, then *The drawing lesson* and *The good education*; the last such work, *The bird-song organ*, was commissioned for the French Crown, although it found its way into the collection of the Directeur des Bâtiments, the Marquis de Marigny (Plate 164).

There is nothing unusual in the fact that Chardin's works were so eagerly collected by foreigners – much to the regret of his admirers at home. But it was one of the consequences of that cultural and social leadership which Paris assumed throughout Northern Europe during the eighteenth century. Foreign collectors took the lion's share of the work of many a French painter, once he had established a reputation: Oudry, for example, found his greatest patron, to compare only with his own king, in the Duke of Mecklenburg-Schwerin; Vernet was eagerly sought by patrons from all over Europe, especially the British; Greuze became a favourite with the Russians. A vogue for things French swept England in the 1730s – 'the

ridiculous imitation of the French is now become the epidemical distemper of this Kingdom,' wrote one observer in 1738, the year in which a painting of *A girl with cherries* (see Plate 153) was already up for sale in London, perhaps the picture seen at the Salon of 1737; and *The young draughtsman* (Plates 23 and 25) was in London by 1740 at the latest. Dr William Hunter (Plate 165), a noted Scottish physician who moved to London in 1741 and became Professor of Anatomy to the Royal Academy in 1768, had three superb Chardins in his varied picture collection. *A lady taking tea* (Plate 132) was purchased by him at the sale of the Prince de Carignan's effects in London in 1765; but when he acquired his versions of *The cellar-boy* (Plate 111) and *The scullery-maid* (Plate 112) is not known, although he was in Paris in 1748. He bequeathed his collection to the University of Glasgow, where it remains to this day.

Frederick the Great of Prussia – brother of Luise Ulrike of Sweden – had several Chardins in his unrivalled collection of contemporary French pictures (above all Pater and Lancret); Catherine II of Russia owned five important works by our artist, and bought or commissioned works from many other Parisian artists; the Margravine of Baden-Durlach had four of his still lifes in her impressive collection of modern French works. To this day, Stockholm, Berlin, Karlsruhe, Leningrad and Moscow retain some of the major collections of French eighteenth-century paintings outside France.

Evidently impressed by Tessin's *The morning toilet*, Princess Luise Ulrike of Sweden ordered through him a pair of Chardins as part of the picture collection she was forming to furnish the new gallery in her château at Drottningholm. The princess must have had a taste for genre, for Tessin had already acquired for her in Paris a delightful painting by Pierre Parrocel (1670–1739), *A woman reading before a fireplace* (Plate 166). Better known for his religious and secular history paintings, Parrocel probably executed this little work in 1735 under the recent inspiration of Chardin, for the child holds a straw for blowing bubbles. But the type of subject that may have been a simple vignette from daily life for Parrocel, or a relaxation from more elevated tasks, would be a major concern for Chardin. We know through

165. Allan Ramsay. *Portrait of Dr William Hunter. c.* 1758. Oil on canvas, 37¾ × 29½ in. (96 × 75 cm.). Glasgow, Hunterian Art Gallery, University of Glasgow. Ramsay's portrait shows the famous anatomist, physician and connoisseur at about the age of forty. This refined image reflects Ramsay's own interest in contemporary French painting, and the pose can be compared with Chardin's portrait of *Charles-Théodose Godefroy* (Plate 103) of *c.* 1735. Ramsay had been in Paris in 1736 and 1754.

166. Pierre Parrocel. *A woman reading before a fireplace.* 1735. Oil on canvas, 14⅛ × 18½ in. (36 × 47 cm.). Stockholm, Nationalmuseum.

167. *Domestic pleasures.* 1746. Oil on canvas, 16¾ × 14¼ in. (42.5 × 35 cm.). Stockholm, Nationalmuseum. The small serving-table and the corner cupboard are listed in the 1737 Saintard inventory. The setting, however, is now more opulent than in the earlier interiors painted by Chardin, as can be seen by the comfortable armchair in which the lady relaxes, and in a detail like the silver-rimmed covered bowl displayed in the background.

168. *Household economy.* 1754. Engraving by J.-P. Le Bas after Chardin's painting of 1747. The engraving is in the same direction as the original painting, but the illustration shows a state before the addition of 'explanatory' verses; in the final state these read: 'What a wonder! A woman occupied with her household, instead of concerning herself with vainer affairs. This simple scene of a bygone age is taken from nature, not our modern manners.'

some correspondence of Tessin which has recently come to light that the princess's Chardins were ordered late in 1745; 'Leave the choice of subjects to him', wrote Tessin from Stockholm to his representative in Paris, 'but as he succeeds perfectly with governesses and children, propose to him the gentle education and the strict education.' Tessin knew the artist and his work well enough to suggest their didactic moral themes. But Chardin could not promise to complete them for at least a year. The subjects were clearly inspired by a pair of paintings by Charles Coypel, only recently engraved in 1738, on the theme of the fruitful and the fruitless ways of giving girls a religious education: *A gentle and insinuating education given by a saintly woman* and *A dry and tedious education given by a prude*. For reasons unknown today, Chardin eventually executed different subjects for Luise Ulrike – still didactic in nature, but, as we might expect, infinitely more reticent than any that Coypel could conceive, totally personal, and more profound for their lack of declamation.

Domestic pleasures (Plate 167) was exhibited at the Salon of 1746; and its pendant, *Household economy* (Plate 168, engraving), was completed early in 1747 and dispatched to Sweden without being seen by the Parisian public. In spite of its imperfect condition, *Domestic pleasures* still glows with its saturated reds and blues in their sombre chiaroscuro; the resonance of dense colours and the sheen of reflective surfaces were soon to be developed by Chardin in his later still lifes – here there are glints from the spinning-wheel and the silver-mounted porcelain dish. Contrary to some contemporary critics, who saw in this work a woman either negligent and lazy or aroused to amorous reverie by the novel she has been reading, the theme is rather in praise of the contemplative, thoughtful frame of mind

induced by reading. The focus of attention is clearly on the book and the spinning-wheel behind – two highly proper occupations for the woman of leisure. There is an analogy here with the earlier portrait of *Madame Lenoir* (Plate 146); surely Chardin would never be so impertinent as to suggest that his friend's wife was being stirred by dangerous speculations! It seems that we are shown two useful leisure occupations, as a pendant to Chardin's other image of a dutifully economical wife who attends to her household accounts, as she takes stock of her purchases of a sugar-loaf, bottles of wine and oil, and other packages. The original completed version of *Household economy* (Stockholm, Nationalmuseum) is in such poor condition that it is represented here by Le Bas's engraving of 1754.

Some idea of the original finish of Luise Ulrike's picture can perhaps be gained from a comparison with *The convalescent's meal* (Plate 174), shown at the Salon of 1747, whose subject elicited from Chardin a similarly austere conception. *The convalescent's meal* was painted for the Prince of Liechtenstein, some six years after his return to Vienna from his ambassadorial post in Paris, and probably as a pendant to the version of *The kitchen-maid* (Ottawa, National Gallery of Canada; see Plate 116) which he had acquired in France. If he hung them together, he would have been struck by the much smoother surface of the later work, and by its more limpid, pearly light. The setting of the table, in its harmony of different whites – tablecloth, jug, plate, egg, silver goblet (Plate 169) – is reminiscent of the appropriately more delicately handled dressing-table in *The morning toilet*, and so are the muted pinks, which dominate the maid's costume. But the pale radiance of the maid and her table, bathed in a light that will remind the modern spectator of the Delft School of the seventeenth century, expresses by its very reserve a pictorial idea close to the restraint and thrift lost to us among the ruins of the Stockholm *Household economy*.

We have noted above in Chapter 4 (page 85) how frustrating Luise Ulrike found Chardin's slow progress on her commissions; and she in turn caused irritation to Count Tessin over this issue – 'Whoever says Princess says Impatient Woman', wrote Tessin in one moment of exasperation; while on another occasion, ordering some pills for a malady of the princess's stomach, he remarked that they could be delivered at once, as Chardin was not making them! But when *Domestic pleasures* and *Household economy* eventually arrived in Sweden in June 1747, it was felt they had been well worth the wait. Tessin wrote to Paris:

> The pictures by Chardin are something to go on your knees before and, from one desire to another, we have come to want two more, but each with two figures; I know very well it is a matter of a year, but we shall rant, and we shall bear with patience.

Chardin agreed to execute the pictures, on the understanding that they would take about a year, and that they would cost more than the first pair. Tessin replied on behalf of his princess that the two new pictures were wanted, 'at whatever price it would be . . .'. The price would be a thousand livres apiece; the two-figure work for Tessin in 1741, *The morning toilet*, had cost 600 livres.

The two works in question were to be *The drawing lesson*, completed in time for the Salon of 1748 and of which we reproduce the engraved version by Le Bas (Plate 170), and *A girl reciting her Gospels*, completed in 1749, two years after the original commission, and engraved by Le Bas as *The good education* (Plate 171). For the last time in Chardin's work we witness an intimate encounter between mother and daughter, where again he selects a favourite psychological moment – the girl lowers her head, fumbling and faltering over her recitation, avoiding the critical gaze of her mother, which shows a mixture of solicitude and dismay. It is in choosing such

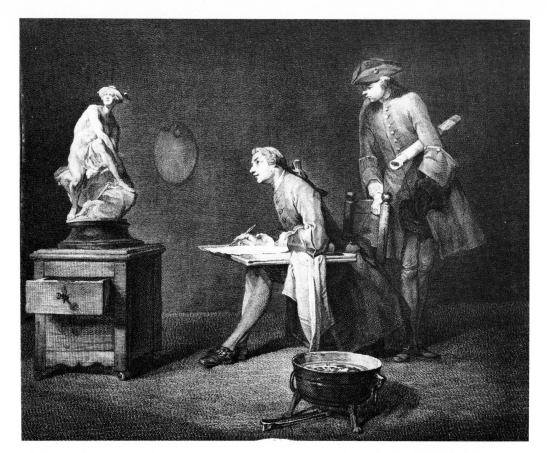

170. *The drawing lesson*. 1757. Engraving by J.-P. Le Bas after the painting by Chardin which belonged to the Queen of Sweden, but is now lost. See caption to Plate 17.

a delicate moment, where an instant of mutual disappointment and embarrassment is expressed by the interval of space between the protagonists, that Chardin saves the subject from the portentous or the prosaic. The setting is a comfortable bourgeois home, such as we see in *Domestic pleasures*. As well as doing her best for her daughter's spiritual education, this exemplary mother will no doubt initiate her into the mysteries of the work-basket, bobbin and pin-cushion on the chair at her side. In this painting and its pendant, both educative in theme, there is a clear echo of that earlier, but much modified, commission for a pair of works illustrating *A*

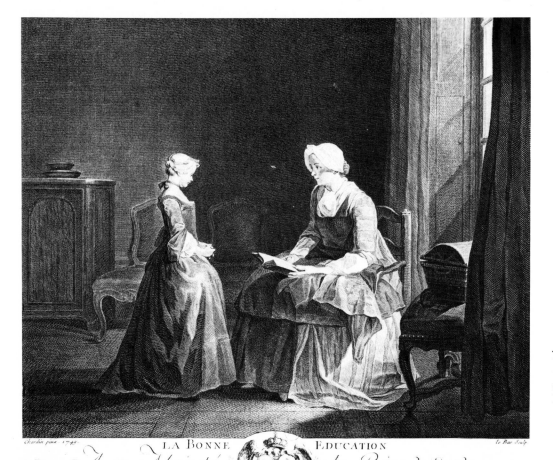

LA BONNE EDUCATION

A sa Majesté la Reine de Suede

171. *The good education*. 1757. Engraving by J.-P. Le Bas after the painting by Chardin which belonged to the Queen of Sweden. A version of this lost painting, and pendant to our Plate 17, was acquired in 1983 by the Museum of Fine Arts, Houston.

172. François Boucher. *Morning: the fashion-seller*. 1746. Oil on canvas 25¼ × 20⅞ in. (64 × 53 cm.). Stockholm, Nationalmuseum.

173. *The bird-song organ. c.* 1751. Oil on canvas, 20 × 17 in. (50.8 × 43.2 cm.). New York, The Frick Collection. As in Plate 167, Chardin now shows us quite an opulent interior, very likely reflecting the prosperity of the artist and his second wife, which is also suggested by the subject-matter of his still lifes in the second half of his career.

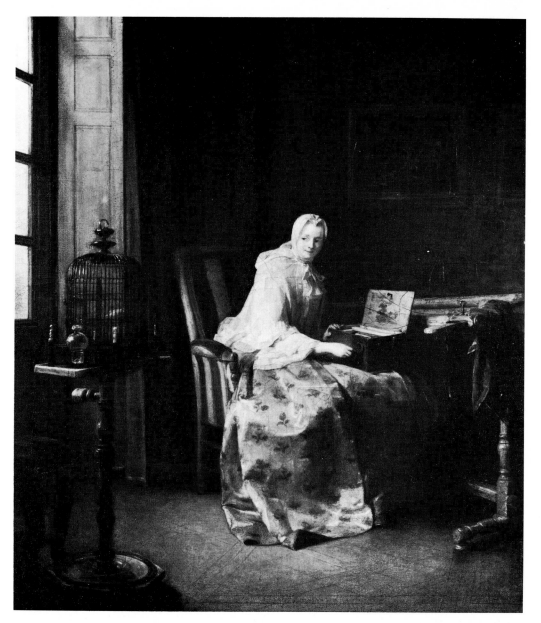

gentle and *A strict education*. Evidently Luise Ulrike (or more likely Tessin, acting on her behalf) saw Chardin as the painter to approach for a morally exemplary subject; from Boucher she was also supposed to have a set of genre pictures, representing *The four times of day* – but in the only one he completed, *Morning* or *The fashion-seller* (Plate 172), we have a typically rococo and more indulgent theme.

By the late 1740s, Chardin was inventing fewer new compositions with figures: 1747 saw *The convalescent's meal*; 1748, *The drawing lesson*; 1749, *The good education*. Only in 1750 did he receive official recognition of his talents in this genre, when he was commissioned by Le Normant de Tournehem, Directeur des Bâtiments, to paint *The bird-song organ* (known also as '*A lady varying her amusements*'). It has recently been convincingly argued that the version reproduced here (Plate 173) is a good early replica by Chardin of the original (Paris, Private Collection), which was exhibited at the Salon of 1751 and engraved two years later. Although Le Normant was acting for the Crown, by 1753 (when it was engraved) the original, for reasons unexplained, was in the collection of M. de Vandières, later Marquis de Marigny, Le Normant's nephew and successor in the official post. In 1752 Vandières in his turn commissioned a companion picture for the Crown; but Chardin was still supposedly working on this in 1760, and in fact it was never executed. *The bird-song organ* remains his last invention in figure painting.

We witness a genteel young lady of quality, as she takes a rest from her embroidery – the frame, with her work-bag hanging from it, is on the right – in order to turn the handle of a bird-song organ, whose musical notes should encourage her canary, in its cage at the left, to sing. It is a comfortably appointed room, comparable with that in *Domestic pleasures*, with a fine parquet floor and decent furniture, such as the armchair covered in a boldly striped linen fabric. The model, as in the earlier painting, is Madame Chardin. On the wall hang two framed engravings by François-Bernard Lépicié (Secretary of the Académie) after paintings by Charles-Antoine Coypel (Premier Peintre du Roi and Director of the Académie), representing *Children's games*, of which we see the edge only, and *Thalia ejected by Painting* (Plate 4). Chardin was paying direct homage to his two distinguished colleagues, the latter of whom had been instrumental in obtaining for him this royal commission.

While it is generally acknowledged that the Frick Collection's *The bird-song organ* is not in immaculate condition, it is still a beautiful painting, and one of Chardin's most refined in effect. The paint is delicately and smoothly applied, as he is still developing his style away from the early, granular, painterly manner, towards a higher finish, which can be compared with that of some later seventeenth-century Dutch and Flemish painters. Most impressive is the subtle control of the lighting, from a bright window at the left, to the penumbral recesses of the room. Passages of delicate pastel colours, such as the green and pink flowers embroidered on the light dress, and the green of the work-bag, contrast with the bright highlights of hard, reflective surfaces, such as the embroidery frame and the bird-cage with its glass water-bottle. But for all its delicate beauties, there is a certain lack of vitality in *The bird-song organ*. This may in part be due to the fact that Chardin laboured at and polished this work, but it is also the result of the somewhat flat and even illumination of the face and hands of the woman: 'Her head, seen close to, does not have enough relief,' noted one critic in 1751. But overall, as his technique becomes finer and more descriptive, so the paint itself loses that independent life it had had in the works of the 1730s and 1740s. Chardin's art seems to move more towards illustration only, so that we lose that lively dialogue between the paint as an individual substance and what it sets out to represent.

Already when he sent *The drawing lesson* (Plate 170) to the Salon of 1748, Abbé Gougenot (in principle, sympathetic to Chardin's art) remarked that not only was the depth of the room less convincing than in earlier works, but the figures were lacking in relief. When he artist sent versions of *The drawing lesson* (Plate 17, recently cleaned) and *The good education* (acquired in 1983 by the Museum of Fine Arts, Houston) to the Salon of 1753, they too did not attract unanimous praise. In the former, the critic Pierre Estève found the men's legs too long in proportion and the *Mercury* of Pigalle too indistinctly drawn. La Font de Saint-Yenne observed: 'Many people have remarked that his brushmarks, normally firm and bold, have become feebler, and some have been found slack, soft and less fine, above all in the draughtsman and the little girl.'

Abbé Garrigues de Froment compared these two works, and especially *The good education*, unfavourably with the bold manner of earlier paintings (*The alchemist, The blind man* and some early still lifes), shown by Chardin at the same Salon. Of *The good education* he writes:

There reigns throughout a mist, which does not clear near to nor far away, and which I think I am right to see as the effect of too soft and indecisive a touch . . . Nowadays he polishes and finishes his works. Is this change of manner to our advantage? Good connoisseurs claim that it is not.

174. *The convalescent's meal.* 1747. Oil on canvas, 18⅛ × 14⅝ in. (46 × 37 cm.). Washington, D.C., National Gallery of Art (Samuel H. Cress Collection). The preparatory oil sketch for this work is reproduced below, Plate 178.

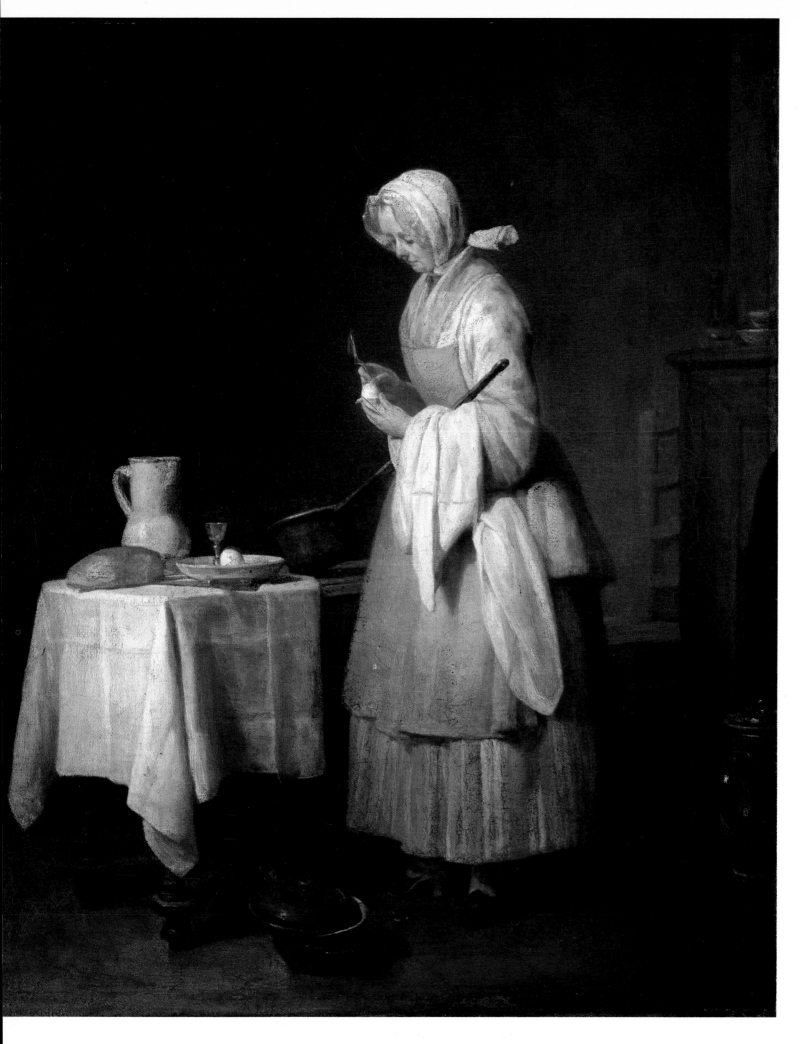

Chardin invented no more figure compositions after *The bird-song organ* of 1751, in spite of the lucrative and prestigious commission from Vandières to make a pendant for it. He had realized himself, no doubt, that he was exhausting his limited resources as a figure painter. But he had also begun to drink again at the source: he had already returned to the simpler thing seen, by taking up still life again in 1748.

For all that Chardin's more academically minded critics regretted that he never attempted the elevated genre of history painting, an anonymous obituarist in 1780 felt that in the choice of subjects for his figure-pieces he expressed the noble simplicity of mind which was the ideal aspiration of history painters: 'Noble in his simplicity, M. Chardin came close to the class of history painting by the choice of his subjects.'

While elsewhere in this book we have discussed Chardin's work in the light of contemporary attitudes to history painting, we might consider for a moment the general nature of his preferred subjects, which do express a consistent and selfconsciously motivated choice of theme and moral tone. There is an awareness of this in an announcement published in the *Mercure de France* in November 1753 of Laurent Cars's engraving after *The bird-song organ*; after pointing out the refined and genteel nature of Chardin's subject and his polished manner of execution, in contrast with the vulgar 'little masters' of the North, the author continues:

> By composing like M. Chardin, it is permissible to treat the business of homely life. It is a matter of making it attractive and enviable. We can also say, without hyperbole, that the model M. Chardin has chosen on this occasion indicates a person devoted to her duties, honest, full of gentleness, and finally who knows how to occupy herself. At least that is the idea she gives us.

Chardin's pictorial world is inhabited almost entirely by women and children. The few men he depicts are exceptions that prove this rule. His women range up the social scale from scullery-maids, to governesses, to bourgeois mothers, and as far up as one or two rather grander bourgeois ladies. It is a quiet domestic world of attention to everyday routines, interrupted only by absorption in other thoughts which momentarily distract from the task in hand. The various children idle or help in the kitchen; play games of one kind or another; concentrate on their lessons, but are easily diverted from them, for which they are sometimes rebuked.

In his depiction of women, we can say with appropriate simplicity and economy that Chardin extols '*les vertus simples et paisibles*', moderation, modesty and good order, which were, for example, those advocated by Madame de Lambert in her widely read educational manual *Avis d'une mère à son fils et à sa fille*, first published in 1728. In this and similar treatises of the late seventeenth and eighteenth centuries, parents were encouraged to train their daughters to be exemplary domesticated wives, as they were not expected to play any significant role in the world outside a narrow domestic circle. The qualities of the ideal wife, the prolifically published Jansenist Pierre Nicole wrote, 'are to have an ordered, reasonable mind . . . to be established in the practice of Christian living . . . and to love retirement, work and an ordered life'; she should lead 'a Christian life which is in itself a sober life, a life of work and not of recreation, games and pleasure . . . filled with some useful, serious occupation, corresponding to her station'.

Similar ideals of womanhood are expressed in the great compendium of enlightened thought, the *Encyclopédie*, edited from 1751 by Diderot, and with the more secular emphasis one would expect in this publication. The author of the article 'Woman', for example, contrasts different types of women – the feather-brained, coquettish type, whose head is easily turned by the blandishments of the

material world; and his ideal type, who takes on an almost Madonna-like status:

> Her happiness lies in her ignorance of what the world calls *pleasures*, her glory is
> to live unknowing. Confined to her duties as *wife* and mother, she devotes her
> days to the practice of modest virtues: occupied in running her family, she rules
> her husband with kindness, her children with tenderness, her servants with
> goodness; her house is the home of religious feeling, of filial piety, of conjugal
> love, of maternal tenderness, of order, of inner peace, of untroubled sleep, and of
> health; economical and settled, she is averted from passions and wants . . .she
> emanates a gentle warmth, a pure light, which illumines and brings to life all
> that is around her. Is it nature that has disposed her thus, or reason which has led
> her to the supreme rank where I see her?

The coquettish and materialistic type of woman criticized in the *Encyclopédie* could well be illustrated by Boucher's painting representing *Morning* (Plate 172), which was engraved as *The fashion-seller* — although Boucher's intention was certainly not to be critical. Rather, he is titillating the spectator with the sight of a pretty young woman in her boudoir, examining the various new frills and furbelows offered her by an equally decorative milliner. When the painting was engraved (in 1746, or soon after), some rather stilted but amusingly ambivalent verses were appended, which, while seeming to advocate a more pure-minded ideal of natural beauty unadorned by artificial trimmings, in fact endorse the eroticism of Boucher's intentions, by inviting into the spectator's imagination the notion of the young woman with no clothes on at all!

> The gods took pleasure in making you perfect, and these vain ornaments which
> you mistakenly adopt, only serve to hide your real beauties; Philis, leave your
> toilet for ever; if you wish to excite the liveliest ardours, to submit hearts to your
> pleasant rule, then as in the Golden Age, without rouge and without finery,
> show yourself in the state of simple nature.

That Boucher's painting was not particularly moralizing in tone is underlined when we consider the three pendants commissioned with it by Luise Ulrike (but never executed): '*Mid-day*: a conversation at the Palais-Royal between a woman and a wit . . . *Evening*: love notes brought to a meeting-place . . . *Night*: merry-makers dressed for the ball, who mock someone sleeping.' In a rather similar work to that of Boucher, *The hairdresser*, engraved in 1750 after a painting by Etienne Jeaurat, a pretty girl is selling bonnets to another, but here the verse message is a moralizing one, that the short-lived caprice of modern fashion in female attire has replaced the simplicity of former times: 'Replace that bonnet, Lisette, the simple manner is no longer fashionable; the caprice of the comet has won over reason.'

From the 1720s onwards, under the general pictorial inspiration of Watteau's *fêtes galantes*, a number of artists such as Lancret and De Troy — for example in the latter's *Declaration of Love* (Plate 28) — had painted scenes in contemporary dress, which have as their theme the worldly ways, coquetry and flirtatiousness of women, especially, of course, in the encouraging company of men. But such artists nearly always turn Watteau's ambiguous and evocative poetry into everyday prose. Moreover, the presence of a male figure, whether boldly advancing as in De Troy's picture or, more discreetly, adjusting a lady's ice-skate in a celebrated image by Lancret, invests these pictures with an explicit sexual charge — something only very rarely and discreetly implied in works by Chardin.

Chardin almost invariably preferred to present an image of womanhood closer to the ideal advocated by the *Encyclopédie* and other treatises where her role in modern society is discussed: this woman is devout, domesticated and withdrawn from the

bustle and temptations of the larger world. In some works, such as Count Tessin's *The morning toilet* (Plate 155) – a painting which provides an interesting comparison with Boucher's *Morning*, not least because the latter commission was through the agency of Tessin – Chardin provides a subtly allusive play on the choice to be made between the vanity of the world and the path of Christian devotion. But he is also fascinated by the domestic virtues in themselves, most obviously in a picture such as *Household economy* (Plate 168). A sense of domestic economy should be inculcated into girls by their mothers, according to the *Encyclopédie*, along with the other rudiments of education; in the article 'Mother' we are told that, 'She should look after their education in all matters within her competence, particularly in the case of girls, to whom she should teach household economy.'

The economic role of the woman at home seems to be particularly stressed in the *Encyclopédie* articles on 'Woman' and 'Mother', which shows the increasing secularization of thought by the 1750s, and especially in that publication. In the 1680s Fénelon, in his influential *Traité de l'éducation des filles*, had seen the merit of keeping girls and women occupied within the confines of the home not only as a protection from the dubious attractions of worldly pleasure, but also, and for him ultimately more importantly, so that their acceptance of the authority of the Church should not be undermined by contact with liberal ideas:

> Keep her busy with a piece of needlework that will be useful in your house and which will accustom her to avoid dangerous relations with the outside world . . . The virtuous woman spins, confines herself to her home, keeps quiet, believes and obeys; she does not argue against the Church.

175. *The coquette.* 1734. Engraving by M.-G. Aubert after a design by Etienne Jeaurat.

176. *The economical wife.* 1734. Engraving by M.-G. Aubert after a design by Etienne Jeaurat. The two original paintings by Jeaurat have recently (1983) appeared on the New York art market.

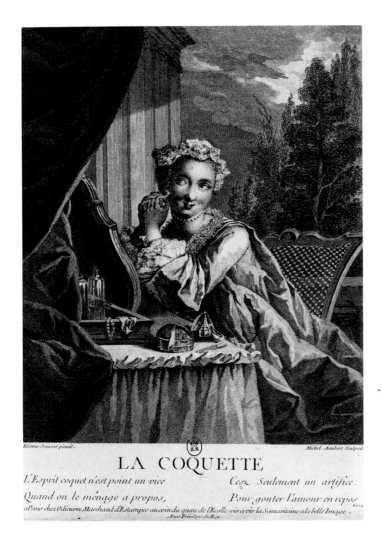

LA COQUETTE

L'Esprit coquet n'est point un vice Cest Seulement un artifice.
Quand on le ménage a propos, Pour gouter l'amour en repos.
a Paris chez Odieuvre Marchand d'Estampes au coin du quay de l'Ecolle vis a vis la Samaritaine a la belle Image.
Avec Privilege du Roy.

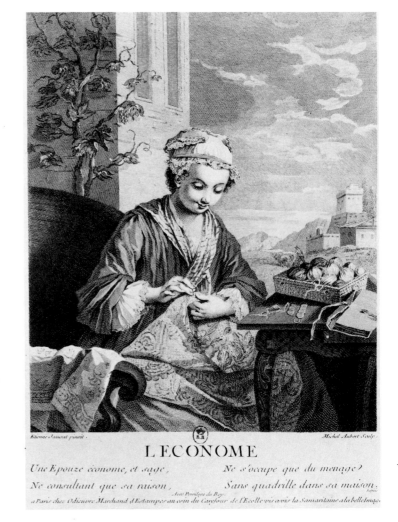

L'ECONOME

Une Epouze econome, et sage, Ne s'occupe que du menage?
Ne consultant que sa raison, Sans quadrille dans sa maison.
a Paris chez Odieuvre Marchand d'Estampes au coin du Carefour de l'Ecolle vis a vis la Samaritaine a la belle Image.

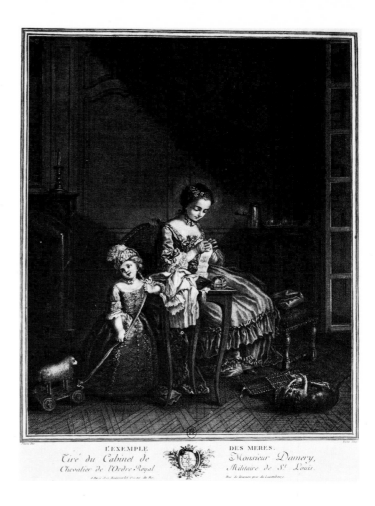

L'EXEMPLE DES MERES.
Tiré du Cabinet de *Monsieur Damery,*
Chevalier de l'Ordre Royal *Militaire de St. Louis.*

While Fénelon (soon to become an archbishop) was concerned above all to preserve the Christian life and the authority of the Church, the more practical-minded and popular theologian Pierre Nicole placed at least as much stress on the simple economic advantages of the virtuous wife at home, who must be capable 'of managing the family's property without dissipating it through luxury, unnecessary expenditure or neglect'.

By the mid-1730s the engraver Aubert had already made four prints after designs by Etienne Jeaurat, illustrating different female types – *The religious zealot, The bluestocking, The coquette* (Plate 175) and *The economical wife* (Plate 176). Taken together, the engravings are clearly intended to extol the virtues of the wife who devotes her energies to household economy, for only in the fourth image does Jeaurat refrain from caricature, as, for example, can be seen in the comparison with *The coquette*. The meaning is underlined in the verse accompanying *The economical wife*: 'A wise and economical wife, consulting only her reason, occupies herself solely with the household, with no dancing in her home.'

A rather more refined print after a domestic interior by Jeaurat is entitled *The example of mothers* (Plate 177), where a model mother is busy at her sewing. In this case the child is paying no more attention to her than is the cat; but in Chardin's treatment of a similar theme, *The industrious mother* (Plate 150), which is of approximately the same date as Jeaurat's image (whose exact date is unknown), he has successfully introduced a good deal more psychological interest in the direct confrontation between mother and daughter.

If Fénelon felt that needlework would keep a girl's mind sufficiently occupied not to entertain impious ideas, he realized that the attractions of the mortal world offered a more immediate danger – the '*Cards, Dice,* and Drinking' to which Locke feared idle youths were too easily attracted had their feminine equivalents. These

words of Fénelon might have provided a timely warning for the mother of the young coquette in Chardin's *The morning toilet*:

> The chief fault to be found in girls is vanity. They are born with an eager desire to please. As the avenues which lead men to positions of authority and to glory are closed to them they try to compensate for this by graces of the mind or of the body. This explains their sweet and insinuating way of talking and why they aim so much at being beautiful, and at possessing a charming appearance, and why they are so inordinately fond of dress. A hat, a piece of ribbon, a curl of hair that is too high or too low, the choice of a colour, are for them matters of the highest importance. This excess is more marked in our nation than in any other...

Some confirmation of the bourgeois character of the social world depicted by Chardin can be found in the memoirs of Madame Roland, *née* Manon Phlipon (1754–92). Indeed, hers was a milieu very much like Chardin's own would have been during his rise to fame in the 1720s and 1730s. Her father, Pierre Phlipon, was a master-engraver and small-time art-dealer, with friends among minor artists and draughtsmen outside the orbit of the Académie Royale. Their household was a cultivated and literate one, comfortably off but not wealthy by contemporary Parisian standards. We learn that as a child young Manon was brought up almost entirely by her mother. She attended a Sunday school to prepare her for confirmation, and she had to learn by heart passages from the Old Testament, the Gospels, the Epistles, and the Catechism. Her mother was pious, without being a zealot, modestly and regularly conforming to the rituals of the church, respecting the broad principles of religion without questioning the details. Various tutors came into the home to teach special subjects, such as writing, history and geography, dancing and music; she had a work-table in the corner of her mother's bedroom, and when she was a little older, she took lessons and worked in the main salon of the house. She had little contact with her father, who was severe and authoritarian, and who sometimes beat her for misdemeanours, until she was about seven years old. Her mother, by contrast, 'able and prudent', was gentle in her approach, and would appeal more to her reason and her sentiment, 'and met no resistance'. With her mother she led a secluded domestic life, occasionally receiving visitors and going out about twice a week to visit elderly relatives, or to go to church and take a walk on Sundays. Her mother over-dressed her – 'her daughter was her doll, and in my childhood I had an appearance of elegance, even richness, which seemed above my station.' She observes in passing the absurdity of Parisian womenfolk spending small fortunes on clothes, only to appear in public to go to church or for a walk in the Tuileries. Occasionally she and her mother went to market, more simply dressed, and now and again she was allowed out on her own to fetch some parsley or a lettuce the housekeeper had forgotten. In the kitchen, she would be expected sometimes to cook an omelette, prepare herbs, or skim a pot.

Her father purchased books for her – including Fénelon's *Traité de l'éducation des filles* and the French edition of Locke's *Some Thoughts Concerning Education*. In her teens, she would amuse herself during the day, spending the evenings with her mother. Her only real contact with her father was during the 'season', when he would take her to exhibitions (presumably including the Salon at the Louvre) and discuss them with her. Sometimes on Sundays there would be trips to Paris parks, or out to Meudon, Saint-Cloud or Bellevue. She also gives an interesting account of a visit to a Madame de Boismorel at her *hôtel* in the Marais (still a grand, but, in the mid-eighteenth century, no longer fashionable, part of Paris) – a more formal experience than she was accustomed to; this elderly noblewoman evidently found the girl rather earnest, with her interest in religion and reading, and her lack of

coquetry – a fascinating contrast between a sober bourgeois upbringing and the more worldly values of this particular lady of quality (it might be noted, however, that Madame Roland was writing during the Revolution, in prison, awaiting the guillotine).

The solicitude of Manon Phlipon's parents, especially her mother, for her upbringing and education, reflects a respect for children, which developed especially during the early eighteenth century, and of which the educational writings of men like Locke and Fénelon were both a symptom and a cause. Locke's ideas were influential in France, not only through a general interest in British ideas and manners in this period, but perhaps more significantly because his closest friend and amanuensis in his last years was a Frenchman, Pierre Coste, whose 'approved' French edition of *Concerning Education* went through twelve printings between 1695 and 1747 and formed, for example, the basis of the *Encyclopédie* article on 'Childhood' in 1755. Locke and his eighteenth-century followers in a sense consolidated what had, until then, been a slow and gradual discovery, that children were human beings 'who must be tenderly used' and whose evolution of rationality and self-control had to be recognized, respected and nurtured, for 'of all Men we meet with, Nine Parts of Ten are what they are, Good or Evil, useful or not, by their Education'. There is no evidence to suggest that Chardin was interested in educational theory; but the values that many of his finest works embody, and his distinctive interest in the world of the child, do reflect a contemporary concern, a new solicitude for children.

Nevertheless, his perception was unique. No painter before him – and in his own century, only Goya after him – captured that precious, innocent otherness of childhood. Northern children of the seventeenth century are depicted as knowing, or silly, or as aping adult manners, and they solicit the spectator. It is in his paintings of children, now isolated, absorbed and reflective, now in the gentle care of their mother or governess, that Chardin created some of the most compelling imagery of the eighteenth century. In their innocent absorption, often toying with the emblems of terrible, adult, truths, they are in every sense in a world of their own, remote, dignified, authentic – it is a world we can view only with regret. And there are moments of contented, reflective tranquillity, where for an instant even his younger adults seem to retain that equilibrium, that innocence, that rare peace with the world, something they have not yet quite lost.

8 Back to Nature

Chardin would have needed little convincing that to paint a bouquet of flowers well was, as his colleague Massé asserted in 1750, a much more worthwhile exercise than an indifferent attempt at figure painting. The only survivor of this type of subject in Chardin's work, *A vase of flowers* (Plate 179), has a distinctive handling, especially in the flowers themselves, where the artist finds a perfect equivalence or correspondence in the sensation of the paint itself for the fleshy petals he is rendering – sweet peas, tube-roses and pinks. The flowers begin as thin, liquid underpainting, over which thicker, more impasted but still fluid strokes are laid, building up their sense of form and texture. The fallen flowers on the ledge are mere smears from the brush. The background is unusually cool and greyish, in harmony with the dominant blues and greys of the subject.

Chardin's return to still life was also a return to the freely applied brushstroke – freer, more relaxed and open than ever before. In a remark reported by Diderot in 1765, Chardin once quoted the opinion of the painter Lemoyne, that it might take an artist thirty years of practice to 'keep his sketch' ('*conserver son esquisse*') – that is, to transfer successfully the concept of a picture worked out in a small oil sketch to the large scale of the finished painting, without losing any of its vitality. This essential vitality is something that Chardin himself was losing in his last figure compositions, but which he regained on his return to still life. There is a full-sized oil sketch for *The convalescent's meal* (Plate 178) of 1747, which shows that he had not necessarily lost his 'touch' in the initial stages of a work; indeed, it is a short movement from such a sketch to *A vase of flowers*. Returning to still life, to a modest subject displayed before him, he found that he could, in a sense, 'keep his sketch', something that was getting lost in the increasing conceptualization of his later figure scenes. *A vase of flowers* is normally dated around 1760. But we should remember how readily Chardin could adapt his manner to suit a particular artistic occasion. The quite remarkable freedom of touch in this work, with one brushmark laid quite frankly over or next to another in the cluster of flowers, not only recalls a sketch like the one we have just seen, but also the loose, graphic handling of the feathers in his *Dead partridge and a pear* (Plate 180), dated 1748.

The dated *Dead partridge and a pear* is a valuable piece of evidence, as it is the first dated still life since the mid-1730s. It differs from the earlier treatments of dead game subjects in a number of ways, in addition to its much freer handling. There is little attempt to suggest the nature of the background wall, and the setting is altogether darker. This has the effect of creating a greater sense of ambience, and there is a stronger play of chiaroscuro, with the light isolating the subject in the surrounding darkness. The objects are smaller in relation to the canvas as a whole

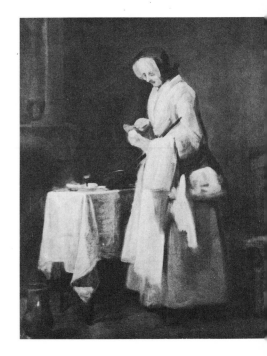

178. Sketch for *The convalescent's meal*. *c.* 1747. Oil on canvas, 16½ × 12⅝ in. (42 × 32 cm.). Private Collection. The finished painting is reproduced in Plate 174.

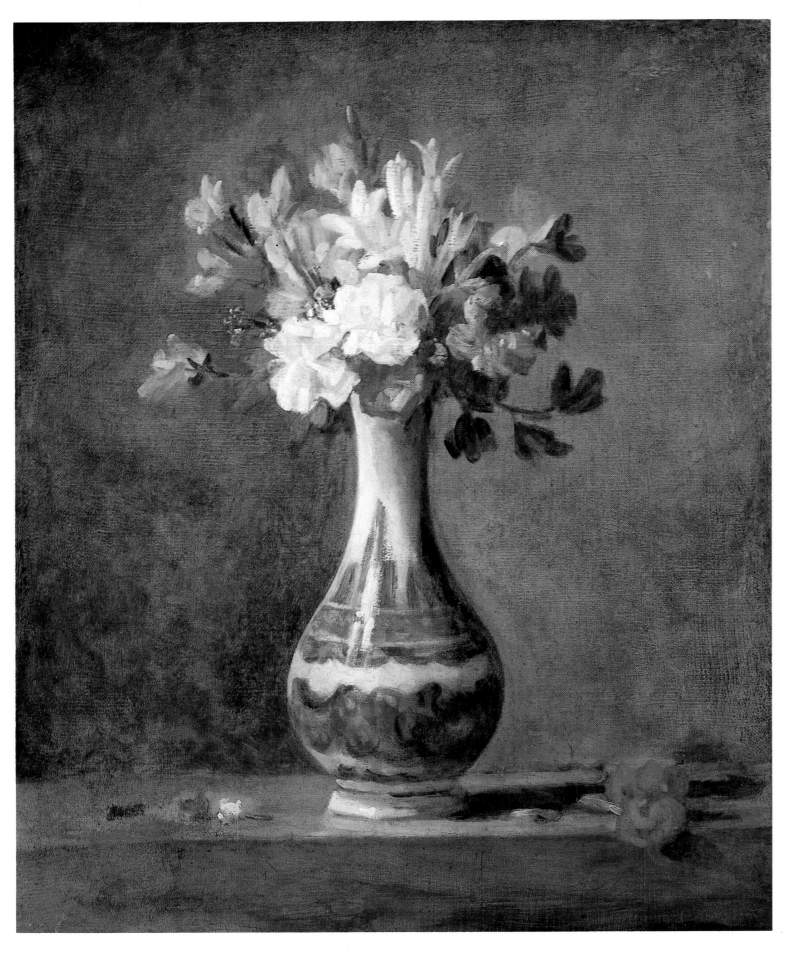

179. *A vase of flowers. c.* 1750? Oil on canvas, 17⅜ × 14⅛ in. (44 × 36 cm.). Edinburgh, National Gallery of Scotland. By suggesting the transient life of these delicate flowers, whose petals are already falling, Chardin has made one of his most discreet images of *vanitas*. Compare the emblematic engraving reproduced in Plate 127, and its legend.

than in the works of the 1720s and 1730s, with a larger empty space above. This sense of isolation makes all the more vivid the solid volume of the pear, the brilliant brushwork of the ruffled feathers, and the sinister loops and knots of the noose, a pale paint lightly dragged off the brush with a dextrous ease over the shadows.

This assertive painterliness in Chardin's return to still life may also have been his response to the artistic *trompe-l'oeil* illusionism in this genre, which had been continued during the 1740s by Oudry and his follower Jean-Jacques Bachelier. Some of Oudry's earliest known paintings of 1712–13 show birds and insects portrayed against a plain background with minute attention to detail, but he soon developed the more complex and animated compositions which we normally associate with his official career as a decorative painter and designer of tapestries. Perhaps it was Chardin's retirement from this field that encouraged Oudry to produce more modest still lifes of dead game in the late 1730s – but when he did so, it was much more in the mode of artistic *trompe l'oeil*, although with his own exquisite delicacy of touch and effect.

Even as official painter of the royal hunt Oudry was able to exploit his immaculate virtuoso technique, as in the bizarre *Deformed stag antlers* (Plate 181)

180. *Dead partridge and a pear.* 1748. Oil on canvas, 15⅜ × 17⅞ in. (39 × 45.5 cm.). Frankfurt, Städelsches Kunstinstitut.

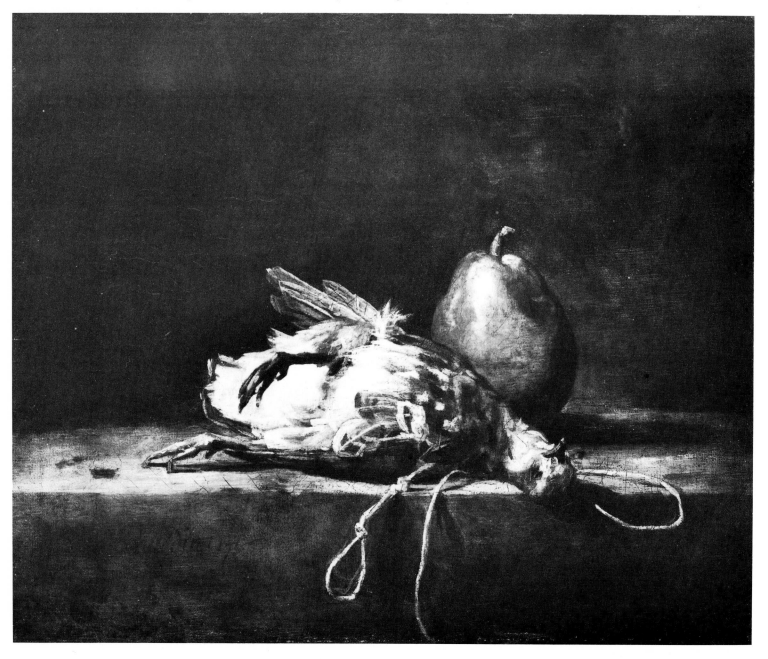

181. Jean-Baptiste Oudry. *Deformed stag antlers*. 1741. Oil on canvas, 45¼ × 27½ in. (115 × 69 cm.). Musée National du Château de Fontainebleau.

182. Jean-Baptiste Oudry. *The white duck*. 1753. Oil on canvas, 37 × 24 in. (93.9 × 60.9 cm.). Private Collection. Exhibited at the Salon of 1753, where it was greatly admired by the critics, this painting was acquired for Count Tessin, one of Chardin's most ardent admirers. The painting was executed to demonstrate the relativity of whiteness, and the lineage of such an academic exercise can be traced back to a passage in Leon Battista Alberti's Renaissance treatise *Della pittura* (1435). The Salon *livret* of 1753 described it as, 'A picture representing all white objects on a white ground, such as a white duck, a damask tablecloth, porcelain, cream, candle, silver chandelier and paper'.

183. Jean-Jacques Bachelier. *Duck hanging on a pine plank*. 1753. Oil on canvas, 26 × 12⅝ in. (66 × 32 cm.). Angers, Musée des Beaux-Arts.

exhibited at the Salon of 1741, where it was eulogized by one critic. The painting commemorates the taking of a strangely antlered stag by Louis XV on 3 July 1741, so the paint can hardly have been dry when it was exhibited in August. As the critic said, the detailed rendering is impressive, and we feel we could reach out and take hold of the antlers. The signed and inscribed fold of creased paper pinned to the pine planks is an illusionistic device with a long history, as we have remarked in Chapter 4.

In addition to several other official commissions of this sort, Oudry painted a number of still lifes with hanging game and arrangements of other objects during the 1740s and 1750s. The simple monumentality of the game and the careful organization of the composition here show the clear influence of Chardin's still lifes of the 1730s. An example of this type is *Hare, pheasant and partridge* (Paris, Louvre), exhibited in 1753 as a pendant to the more famous *White duck* (Plate 182). The latter painting, which has a character all its own, was executed to illustrate a point Oudry made in his lecture read to the Académie in 1749, 'Reflections on the method of studying colour', that whiteness was a matter of degree. The picture, which is signed and dated on a piece of illusionistically painted white paper, shows a white duck against a white stone wall, with a white candle in a silver holder, a white tablecloth, and a cream dessert in a white bowl. The companion, which is close in character to Chardin's works, shows a variety of coloured objects – beiges, browns, reds – on a warm-coloured ground of pine planks. The execution is of a remarkable finesse, as if the spectator were expected to forget he is looking at a painting. This would never be an issue with Chardin however. One critic at the Salon of 1753 did compare the manners of painting of Chardin and Oudry. Abbé Garrigues de Froment expressed the difference simply, when he wrote, 'The handling of M. Chardin... is bolder and more picturesque, and that of Oudry slacker, but more studied, more caressing.'

Oudry's perfection of finish was matched only by Bachelier, in a work such as his *Duck hanging on a pine plank* (Plate 183), which was also shown at the Salon of

1753. In this work Bachelier has evidently followed the example of Oudry rather than Chardin, and indeed after the death of Oudry in 1755 he was to continue the strange and gruesome official task of depicting the antler trophies of the king.

After studying these works, with their glossy surfaces of feathers and fur and their sharply focused fine-grained pine boards and smooth masonry, we are all the more struck by the mysterious and poetic ambiguities of Chardin's works: the shadowy, imprecise backgrounds of his *Dead partridge and a pear* and *Vase of flowers*, the absence of clear definition of the ledges on which they rest, and his final refusal

184. Detail of Plate 185. This detail shows Chardin's distinctive handling of fur and plumage.

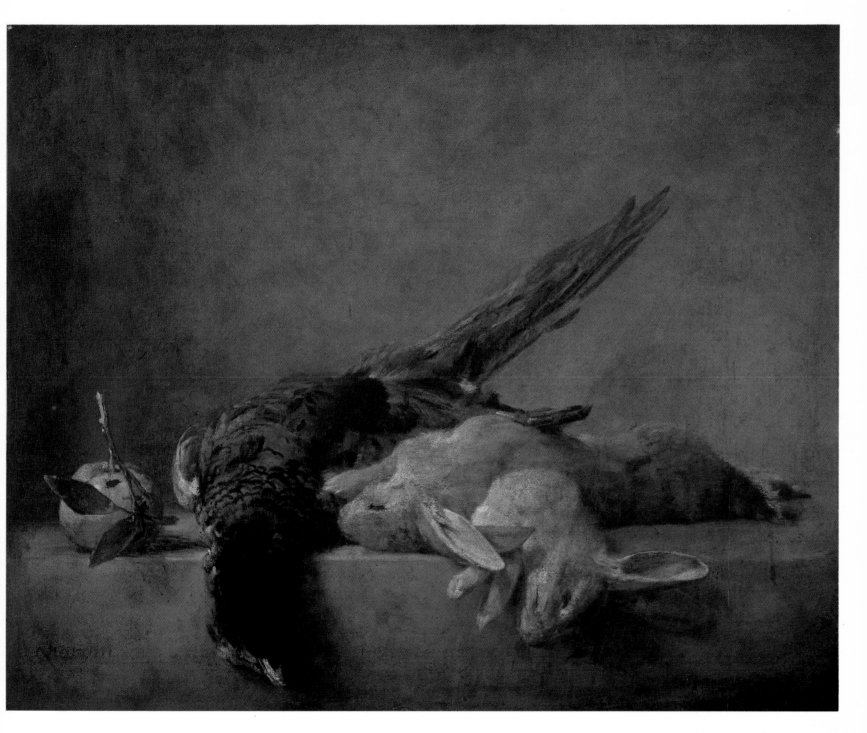

185. *Two rabbits, a pheasant and an orange.*
c. 1759. Oil on canvas, 19½ × 22⅜ in.
(49.5 × 59.5 cm.). Washington, D.C.,
National Gallery of Art, Samuel H. Kress
Collection.

to focus hard, to offer an exact description of a surface. *Two rabbits, a pheasant and an orange* (Plate 185), which has the softer, more diffused lighting found in works executed towards the end of the 1750s, retains the low, horizontal type of composition of his *Dead partridge and a pear*; here, we have a palpable sense of the plump softness of the creatures as they are laid out along the hard stone slab (Plate 184). The heads hanging over the ledge serve to emphasize the dark, empty space above. Such works are silent dramas of light and shade, sometimes accented with a spark of intense colour – but in this picture even the Seville orange with its dark-green leaves does not prepare us for the bright bursts of orange, turquoise and red of the pheasant's plumage, whose vivid notes make even more sombre the soft and subdued tonal unity of the rest of the canvas.

Chardin painted relatively few dead game subjects after his return to still life. By

superseded by fruits, bottles of wine, porcelain, and other attributes of the dinner-table. Among the last are *A pheasant and game-bag* (Plate 186) and its pendant *A hare with onions and a pot of stocks* (Plate 187). The compositional device, with the beasts hanging above a ledge, looks back to his earlier approach to such subjects. But in the case of the hare, the design is disappointingly slack, the artist has attended lazily to the creature's anatomy, and the paint of its nearer flank and underbelly is dragged onto the canvas in an unconvincing and inappropriate rendition of fur. It is as if Chardin had lost interest in this coarse-textured painterly effect. He seems much happier with his hen pheasant, with its plump curved forms and its sleeker

186. *A pheasant and game-bag.* 1760. Oil on canvas, 28⅜ × 22⅞ in. (72 × 58 cm.). Berlin, Staatliche Museen Preussischer Kulturbesitz, Gemäldegalerie. This painting and its companion (Plate 187) originally belonged to Chardin's friend Aignan-Thomas Desfriches (see Plate 16).

187. *A hare with onions and a pot of stocks.*
c. 1760. Oil on canvas, 28¾ × 23⅝ in.
(73 × 60 cm.). The Detroit Institute of Arts.

finish. The pool of light and the more modulated shadows also point to his particular pictorial interests in these years.

We see Chardin re-evaluating and finally rejecting the still life with dead game, which had been one of the prime themes of his early career. With few exceptions he did not return to the kitchen table but, as if issuing from the more refined late figure paintings, he prefers to depict the more sumptuous and opulent settings of the dining-room and the dessert table. As always, his handling is adjusted to suit a given subject. This accounts, for example, for the vastly different touches in the 1748 *Dead partridge and a pear* and the *Orange, silver goblet, bottles and fruit* (Plate

188. *The butler's table.* 1763. Oil on canvas. 15 × 18⅛ in. (38 × 46 cm.). Paris, Musée du Louvre. An autograph replica of the highest quality of the painting in Carcassonne (Plate 192).

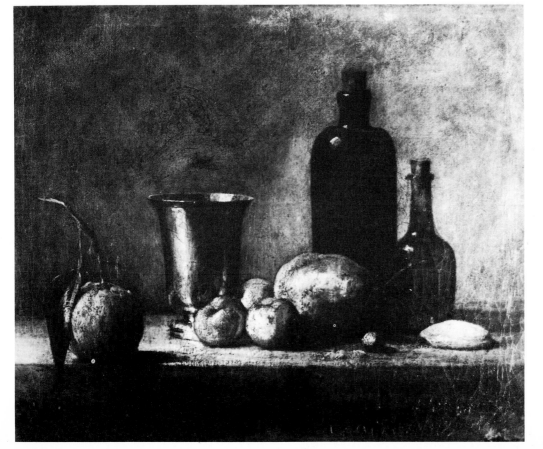

189. *Orange, silver goblet, bottles and fruit.* *c.* 1750. Oil on canvas, 15 × 18⅛ in. (38 × 46 cm.). Private Collection.

189), which most critics agree dates from the early 1750s. In this work, Chardin returns to a favourite theme of the 1720s – the reflections of light and colours in the shiny surfaces of silver and glass. But where the works of the 1720s were versions of the '*genre pittoresque*', with slanting ledges and informal arrangements, the later work seems to belong already to the classicizing trends in French art of the 1750s. Chardin employs a very thick horizontal supporting stone slab, parallel with the picture-plane; and the spectator has a sense of perfect spatial interval between objects, which is complemented by the carefully considered rhythmic rise and fall of their varied silhouettes. He takes a slightly lower viewpoint than in the works of the 1720s, which contributes to the monumental effect. This is above all a painting about light, a cool, strong light coming in from the left to meet the different objects, revealing their colours, textures, gleam and transparency. Chardin orchestrates a variety of orange-reds – the Seville orange, lady-apples, pear, red liquid in the tall green jar, amber liquid in the other – with the dark-green orange-leaf and the dark bottle (a wonderful, glowing, transparent green, this), the yellowish coarse skins of the other fruits, the buff macaroon.

On his return to still life Chardin also developed compositions of greater complexity, to be compared in his earlier work only with such set pieces as the large decorations for Count Rothenburg and his reception works for the Académie. *The kitchen table* (Plate 191) and *The butler's table* (Plate 192), respectively dated 1755 and 1756, have been shown convincingly to be the pair of paintings lent by the collector La Live de Jully to the Salon of 1757. The former seems to be reminiscent

190. *The jar of olives.* 1760. Oil on canvas, 28 × 38⅝ in. (71 × 98 cm.). Paris, Musée du Louvre.

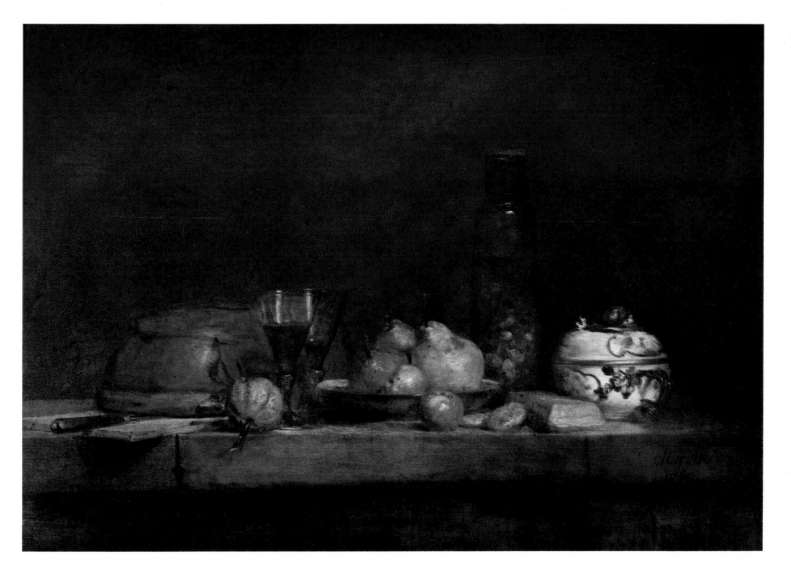

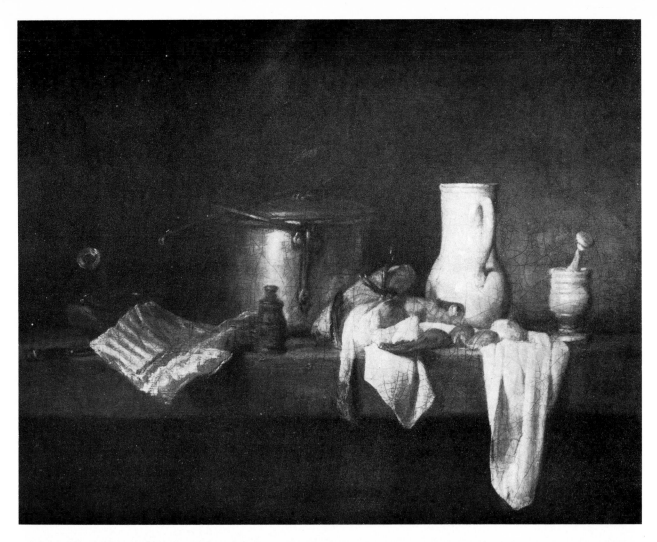

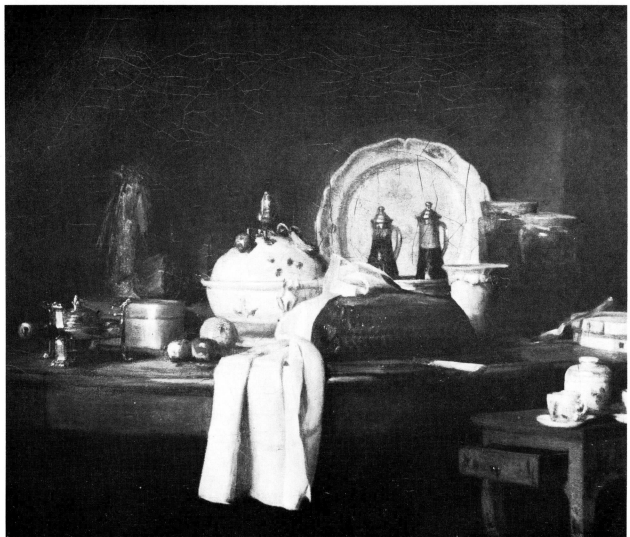

191. *The kitchen table.* 1755. Oil on canvas, 15⅜ × 18½ in. (39 × 47 cm.). Boston, Museum of Fine Arts. This painting and its companion (Plate 192) belonged to the celebrated collector Ange-Laurent La Live de Jully (1725–79) when they were exhibited at the Salon of 1757.

of the still lifes with kitchen utensils Chardin had been painting in the 1720s and 1730s, and includes several of the objects we encountered there: the casserole, the large copper pot, the skimmer, the spice-box, the pestle and mortar. The white pitcher is similar to that on the table in *The convalescent's meal* (Plate 174) of 1747, and altogether the relatively smooth finish, the use of chiaroscuro, and the luminosity of *The kitchen table* have their origins in Chardin's style of the later 1740s, rather than in the textured and impasted approach to this type of subject in his earlier period. *The kitchen table*, with its raw materials and its earthy colours, is perfectly complemented by *The butler's table*, which was executed as a pendant in the following year. The basic foodstuffs of the kitchen have been transformed into the more sophisticated preparations of bottled fruits, a pâté, a box of confectionery, and other fare, while the utensils are the finer ones for serving and more public display: a tureen with elaborate coloured floral decoration, a decorated plate propped at the back, a pair of glass oil and vinegar bottles with silver fittings, an ivory-handled knife, at the left a silver-plated spirit-burner (for warming dishes); Chinese porcelain teacups and a sugar-bowl are displayed on a red lacquer table standing apart at the right. Even the tables are different in form, function and 'meaning' – the kitchen table is a thick, solid, workaday surface, set four-square and parallel with the picture-plane, while the serving-table is curved in shape, creating a more sophisticated spatial effect. We also reproduce in colour the better-known autograph replica of *The butler's table* (Plate 188) in the Louvre, whose history is unknown before the middle of the nineteenth century. If the reader can imagine the colours of *The kitchen table* as related to those of *The convalescent's meal* (Plate 174), so he will appreciate the more positive colours of *The butler's table*, from the bright red of the lacquer table, to the sharp accents of the orange and the red apples, the green, gold, red and blue decorations on the white tureen, the red glow from the burner, the muted blue of the wrapped sugar-loaf behind. There is a subtle play of reflected colour in this work, and the light catches the various shining surfaces, which gleam from the surrounding shadows. The light is now soft, creating an almost hazy atmosphere, which will characterize the ambience of Chardin's still lifes for the rest of this last phase of his career.

Chardin's masterpiece of this type is *The jar of olives* (Plate 190), dated 1760, where on a stone ledge he displays a pâté and a knife on a board, a Seville orange, two glasses of wine, a dish of pears and apples, two macaroons and a cake, a tall glass jar containing olives, and a fancy Meissen soup tureen. The design is less complex than La Live de Jully's two pictures, but the relative simplicity of the forms and their more straightforward presentation lend them a feeling of monumentality and even dignity. *The jar of olives* was exhibited at the Salon of 1763, where it especially attracted the attention of Diderot. On the whole Salon commentators had little to say about Chardin's still lifes, probably because these works had no narrative content – unlike landscapes by Vernet or animal paintings by Oudry, even – but *The jar of olives* inspired one of Diderot's most celebrated passages of writing on this artist:

192. *The butler's table.* 1756. Oil on canvas, 15 × 18⅛ in. (38 × 46 cm.). Carcassonne, Musée des Beaux-Arts. Unlike its companion (Plate 191), whose subject-matter is familiar from Chardin's early works, a number of items make their appearance here for the first time in Chardin's still lifes. For example, from left to right, a silver-plated spirit warmer (1779 inventory), a covered tureen, and a pair of elegant oil and vinegar bottles with silver caps (1779 inventory); the small red lacquer serving-table came from the estate of his first wife, and also appears in a painting of 1735 (Plate 132).

> To look at the paintings of others, it seems that I need different eyes; to look at those of Chardin, I need only to make good use of those nature has given me.
>
> If I were to destine my child for a career in painting, that is the painting I would buy. 'Copy that for me,' I would tell him, 'copy that for me again.' But perhaps nature is no more difficult to copy.
>
> This porcelain vase is of porcelain; these olives are really separated from the eye by the water in which they float; all you have to do is take these biscuits and eat them, open this Seville orange and squeeze it, pick up the glass of wine and drink

it, take these fruits and peel them, put your hand on this pâté and slice it.

Here is one who understands the harmony of colours and reflected light. O Chardin! It is not white, red, or black pigment that you mix on your palette: it is the very substance of objects, it is air and light that you take on the tip of your brush and place on the canvas . . .

This magic defies understanding. It is thick layers of colour applied one on top of the other and beneath which an effect breathes out. At other times, you could say it is a vapour that has been breathed onto the canvas; elsewhere, a delicate foam that has descended upon it. Rubens, Berghem, Greuze, Loutherbourg would explain to you what is involved here better than I; all of them will make your eyes sensitive to the effect. Approach the painting, and everything comes together in a jumble, flattens out, and vanishes; move away, and everything creates itself and reappears.

I have been told that Greuze, walking upstairs to the Salon and noticing the piece by Chardin which I have just described, looked at it and went on, heaving a deep sigh. That praise is briefer and better than mine.

At the same time as he was making these fairly large and ambitious still lifes,

193. *A basket of wild strawberries. c.* 1760. Oil on canvas, 15 × 18⅛ in. (38 × 46 cm.). Private Collection. In his copy of the 1761 Salon *livret*, Gabriel de Saint-Aubin made a tiny drawing of this painting, which is not itemized in the list of works exhibited by Chardin, nor mentioned by contemporary critics.

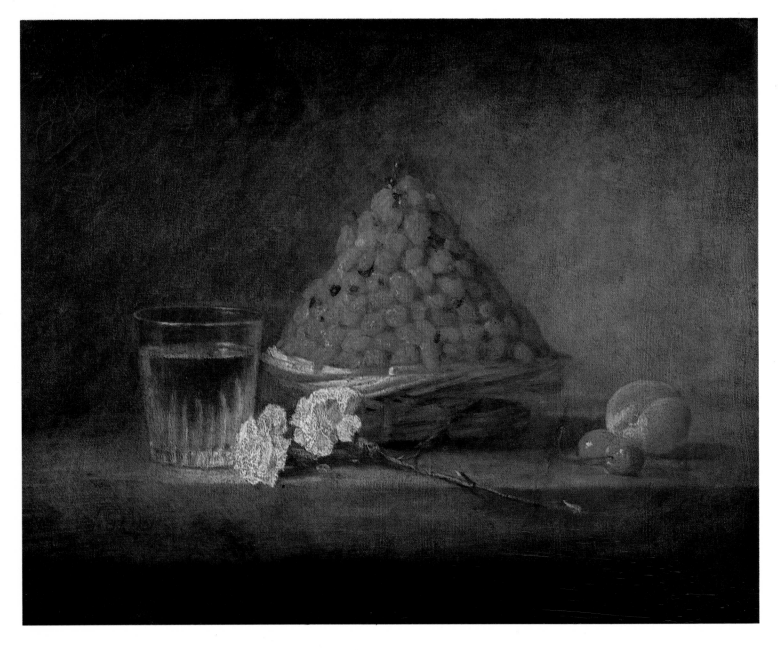

194. *A glass of water and a coffee-pot. c.* 1760.
Oil on canvas, 12¾ × 16⅛ in.
(32.5 × 41 cm.). Pittsburgh, Museum of
Art, Carnegie Institute.

Chardin painted a whole series of quite modestly proportioned works, showing just a few objects or fruits. The pair of works he painted for Abbé Trublet in 1759, which we discussed in Chapter 1 (Plates 7 and 8), are typical of these small still lifes of the late 1750s and the 1760s. He had a special liking for peaches, plums and grapes, which enabled him to explore the most refined effects of sheen, bloom and translucency; against a dull grey-brown background, a gentle light caresses and reveals their forms and textures, which are expressed with a very subtle variety of impastos. Among the muted tones, there will be the gleam of glass, water or wine, modulating the light or bouncing it back in reflections; colours are muted and glowing, enveloped in the soft unity of atmosphere.

A more unusual subject is *A basket of wild strawberries* (Plate 193), exhibited at the Salon of 1761. Here, the pile of tiny red fruits creates a pyramid of bright red towards the centre of the design – a red which makes a subtle contrast with the reds of the two cherries and the peach to the right. These colours, which seem to suffuse the surrounding atmosphere with almost imperceptible vibrations of their warmth, are set off by the cool, silvery colours of the glass of water and the white carnations at the left, where Chardin explores a whole range of whites and greys. The glass is just tinged on either side by a red glow reflected from the strawberries.

In another modest work, *A glass of water and a coffee-pot* (Plate 194), the glass plays the same role as in *A basket of wild strawberries*. But the carnations are replaced

by the whites and greens of three bulbs of garlic, the three fruits by the garlic stalks and leaves, and the red strawberries by the brown earthenware coffee-pot. The tone of the background is lighter than in *A basket of wild strawberries*, to give greater value to the solid, dark form of the coffee-pot. Such works, modest yet with an extraordinary strength in the simplicity of their forms, recall the remarks made in 1757 by Antoine Renou (1731–1806; a painter and later Secretary of the Académie), who extolled Chardin's power as a colourist over Greuze: 'His pictures are silvery and vigorous, all the objects are reflected in one another, and the result is a transparency of colour which enlivens everything touched by his brush.'

Chardin's small still lifes with a few simple objects become more and more sombre, more rich in chiaroscuro, more dense in atmosphere, as he approached the last decade of his life. In *Three pears and a glass of wine* (Plate 195), the rich, ruby colour of the wine in the glass, replacing the silvery transparency of the water in the earlier works we have just discussed, shows Chardin's growing interest in a deeper resonance of colour towards the end of his career. The companion picture, *The silver goblet* (Plate 196), seems almost a conscious rethinking of one of his favourite themes of the later 1720s, such as *Carafe, silver goblet and fruits* (Plate 74), one of his early essays in reflecting fruits in a silver vessel. Even the somewhat self-conscious

195. *Three pears and a glass of wine. c.* 1765. Oil on canvas, 13 × 16⅛ in. (33 × 41 cm.). Paris; Musée du Louvre.

196. *The silver goblet. c.* 1765. Oil on canvas, 13 × 16⅛ in. (33 × 41 cm.). Paris, Musée du Louvre.

perspective effect of the spoon-handle projecting towards the spectator – answered in the pendant by a knife-handle – recalls the relative gaucheness of his early still lifes. But now there is an authority and stability in his design, a sureness of touch as he conjures the bright forms out of the surrounding shadow, which reveal the master of chiaroscuro admired by his contemporaries. As Renou wrote in 1779:

> M. Chardin is perhaps the most gifted painter of our time for colour; his feeling for it was exquisite, and never weakened; it seemed as if he had eyes composed like a prism to separate the different colours of things, and the indescribable passages from light to shade. No one understood better than he the magic of chiaroscuro.

In the late 1750s and the 1760s Chardin also incorporated the elements of the modest, small still lifes into more grandly conceived works, such as *The jar of apricots* (Plate 197) of 1758 and its pendant, *The sliced melon* (Plate 198) of 1760, which are probably a pair of works shown at the Salon of 1761. His favourite basket of peaches appears in the latter, for example, with some greenish plums and a couple of pears. But the composition is dominated by the taller forms of the sliced melon (a cantaloup), the porcelain water-jug with its lid, gilt rim and fittings, and

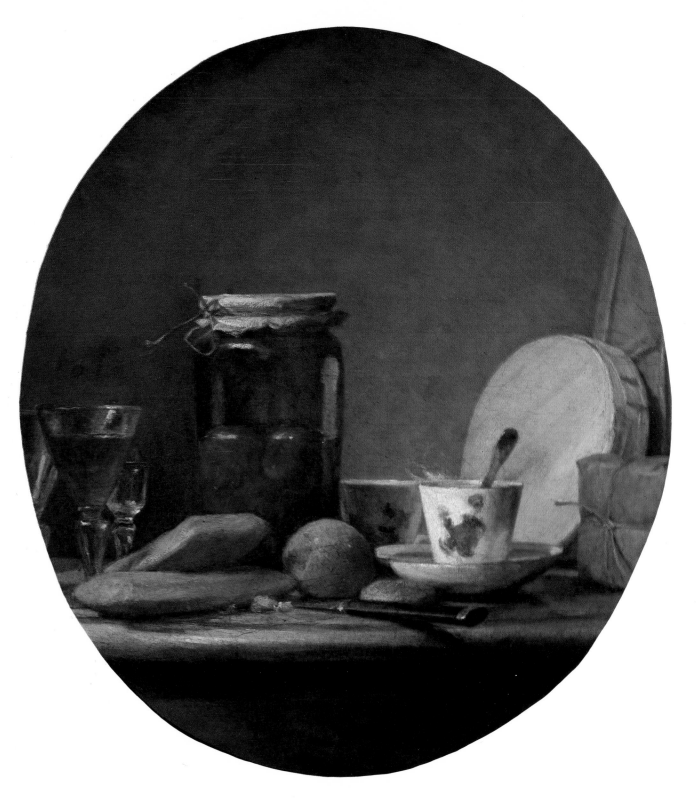

the bottles at the left. Displaying the strongly coloured fleshy inside of the melon is an audacious feature of this painting, making it one of his most assertive images in still life. In this it is matched by *The jar of apricots* not only in the vivid dominating motif of its title, but also in the general sense of large and impressive scale. In both works he has adopted a low and close viewpoint, and in the former the spectator has a sense of his field of vision being cut off at the sides, especially at the right, where he sees only a fraction of the tall blue-wrapped sugar-loaf: this device of the still life seeming to continue beyond the picture-space is an important factor contributing to the special density and monumentality of the design. The oval shape of the canvas, although common enough in decorative painting in eighteenth-century France, is

197. *The jar of apricots*. 1758. Oil on canvas, 22⅜ × 20⅛ in. (57 × 51 cm.). Toronto, Art Gallery of Ontario. When exhibited at the Salon of 1761, this painting and its pendant (Plate 198) were in the collection of Jacques Roettiers (1707–84), goldsmith to Louis XV.

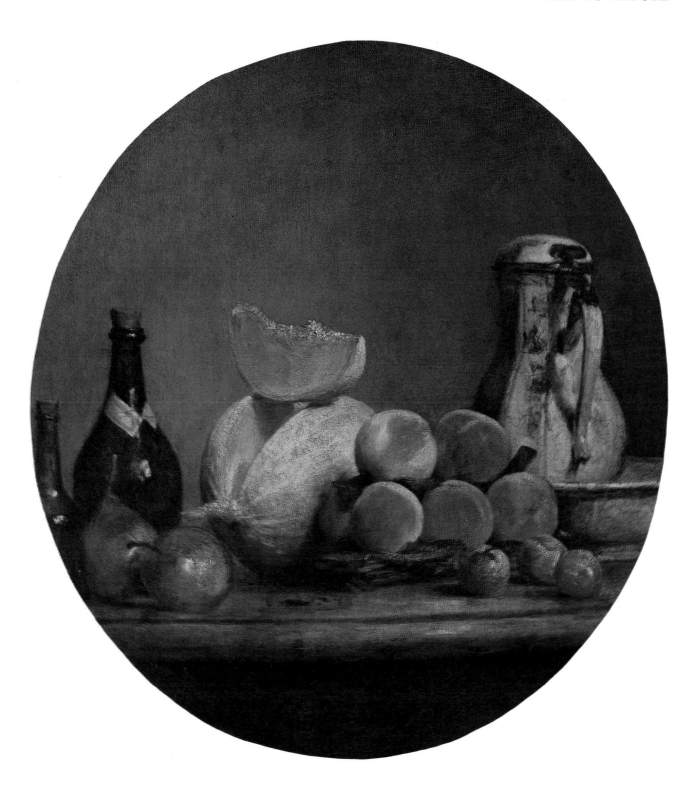

198. *The sliced melon.* 1760. Oil on canvas, 22⅜ × 20½ in. (57 × 52 cm.). Private Collection. The splendid lidded water-jug with silver-gilt fittings appears again in another sumptuous painting of fruits, Plate 200.

rare in Chardin's work, and here adds to the richness of effect, prompting two of his most carefully and tightly organized designs. The curves of the canvas are echoed throughout the two paintings, from the curved shapes of the tables on which the displays are laid, to the complex play of curves among the objects he has selected. The sugar-loaf, the box of confectionery and the jar of fruit, as well as the table, come from *The butler's table* (Plate 192) – but the closer focus in *The jar of apricots* and its companion requires a more lively sense of texture, which is subtly adjusted as we move from one surface to another. Chardin finds perfect equivalents, for example, for the rough skin of the cantaloup and its soft inside, for the hard resistance of a coffee-cup and the glint and shine of glass and bottled fruit, for reflecting, translucent or opaque surfaces, for evanescent steam.

His still-life painting came to its fullness in the early 1760s, when he exhibited the two oval works just discussed at the Salon of 1761, and *The jar of olives* (Plate 190), *Grapes and pomegranates* (Plate 200) and *The brioche* (Plate 201) at the Salon of 1763: what veritable feasts for the eyes of Salon visitors that year! But one or two critics began to express their regret that he had abandoned the invention of figure painting, although he still occasionally sent replicas of earlier works to the Salon and re-exhibited earlier works themselves. For example, C. J. Mathon de la Cour remarked in 1763 that he would have preferred that,

> He would still make his pictures interesting by employing charming figures, as he has done sometimes. Men like to find themselves everywhere; this secret inclination is the secret of sociability. Music which imitates the sound of a bell or the noise of thunder does not please us as much as that which expresses human feeling. Landscapes, fruits, even animals are admirable; but they will never be as interesting as a well-painted head.

This critic of course is expressing the conventional academic preference for figure painting; but most visitors to the Salon of 1763 would have agreed with the author of a piece in a special number of the *Mercure de France* that year, who gave unreserved praise to the still lifes, seeing Chardin as 'the master . . . of the genre he has created, so to speak'.

Grapes and pomegranates is dominated by the lidded porcelain water-jug (which also appears in *The sliced melon*), while the fruits recline in voluptuous curves and bunches along the stone ledge. One of the pomegranates — an unusual and exotic fruit for Chardin — is cut open to reveal the glistening seeds within. The shiny reds and oranges of these fruits are answered by the wine and apples at the right, framing the cooler-toned grapes, jug and pear.

The brioche is a quiet companion, with textured matt surfaces framed by smooth shiny ones, and suffused with softer pinks and browns, from the pink of the decorated tureen at the left, through the peaches, the browns of the brioche, the biscuits, cherries and the rich amber of the liqueur at the right. These warm tones are set off by the green leaves of the sprig of orange stuck triumphantly in the top of the loaf. Each of these pendants has a picturesque rhythm of rise and fall, advance and recess, that is reminiscent of that bolder sense of form Chardin employed in his larger commissioned decorations, and a feeling for chiaroscuro and ambience that recalls some of the greatest masters of the seventeenth century.

With the advantage of hindsight, it is possible to read the large decorative paintings Chardin undertook in the next few years as a logical development of these magnificent cabinet pictures of the early 1760s. On the evidence of the Salons of 1761 and 1763, his patrons could have had every confidence in his ability to complete what were to be the crowning achievements of his career as a still-life painter. It was through the agency of his loyal friend Cochin, Secretary of the Académie and Marigny's chief adviser on artistic matters, that Chardin received an official commission to paint three large overdoors for a drawing-room in the Château de Choisy.

The programme of painted decoration at Choisy, part of a general refurbishment of the royal château in the early 1760s, was organized by the Direction des Bâtiments in another attempt to stimulate serious history painting in the 1760s. Cochin was to devise the programme of these decorations, which were to employ some of the leading history painters of the day — Noël Hallé (1711–81), Louis Lagrenée (1725–1805), Joseph-Marie Vien (1716–1809) and the aged Carle Vanloo (1705–65). With the cessation of the Seven Years War in 1763, Cochin felt it was best to commission for the main gallery of the château works celebrating the

benign and clement deeds of the great victorious rulers of antiquity. He wrote a persuasive memorandum to Marigny to suggest that Chardin be given the task of painting the overdoors of a less important room, and took care to point out that the still lifes would be inexpensive (as compared with landscapes and marines by Joseph Vernet in another room, which cost 1200 livres each, and the history paintings in the main room, which cost 4000 livres apiece):

> I respectfully propose to you that the other [room] be entrusted to M. Chardin. You know how much realism and beauty he imparts to the imitation of things which he undertakes and which he is able to do from nature. We could, then, find a place for his talents by asking him to do two or three of these paintings. In one he would bring together various attributes of the sciences, such as globes, an air pump, microscopes, telescopes, graphometers, etc. In another, he would depict the attributes of the arts: compass, square, ruler, rolls of drawings and prints, palette and brushes, the many and diverse tools of the sculptor. If it were to be in the room needing three paintings, in the third, one might put the attributes of music, the different string and wind instruments.
>
> I believe these paintings would give a good deal of pleasure by that truth that charms everyone and that art of rendering which has resulted in M. Chardin's being considered by artists as the greatest painter in this genre there has ever been. Besides, these paintings would cost only 800 livres apiece.

Of the three paintings proposed by Cochin, executed by Chardin, exhibited at the Salon of 1765, and put in place at Choisy where they remained until the Revolution, only two survive: *The attributes of the arts* (Plate 202) and *The attributes of music* (Plate 203). Both of these works as well as the lost *Attributes of the sciences* can just be seen in the drawing by Saint-Aubin showing the Salon of 1765 (Plate 199): the

199. Detail of Plate 3, showing Chardin's works exhibited at the Salon of 1765. In the middle row, to the left is *The attributes of the arts* (Plate 202), with the lost *Attributes of the sciences* to the right. In the middle of the bottom row is *The attributes of music* (Plate 203).

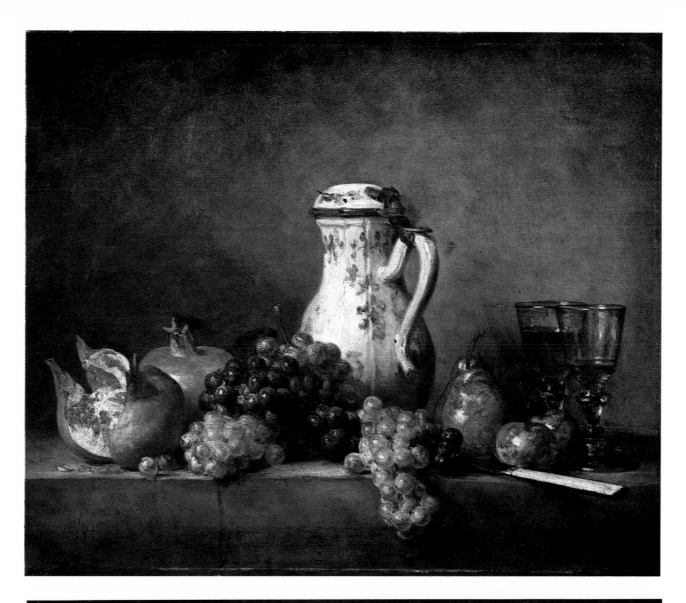

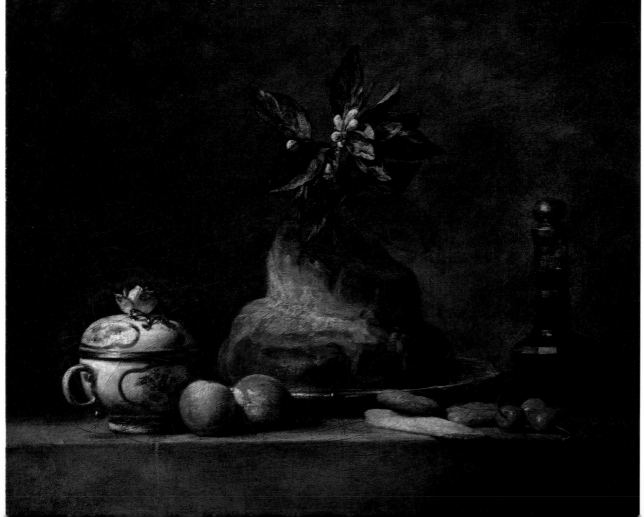

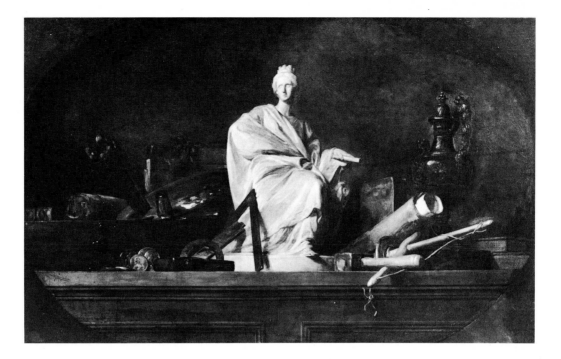

202. *The attributes of the arts.* 1765. Oil on canvas, 35⅞ × 56⅞ in. (91 × 145 cm.). Paris, Musée du Louvre.

200. *Grapes and pomegranates.* 1763. Oil on canvas, 18½ × 20⅜ in. (47 × 57 cm.). Paris, Musée du Louvre. This painting and its pendant (Plate 201) were almost certainly lent by the Comte de Saint-Florentin, a minister of Louis XV, to the Salon of 1763.

201. *The brioche.* 1763. Oil on canvas, 18½ × 22 in. (47 × 56 cm.). Paris, Musée du Louvre. The elaborate Meissen covered bowl is similar to that in Plate 190. They are not specified in any of the inventories, but no doubt belonged to Chardin, and were probably included under the collective indication of 'porcelain'. Their bold, interesting shapes and strong accents of colour are probably what attracted Chardin to them at this period.

two oval works in the centre of the group of eight works by Chardin. To the right of them in the view of the whole Salon (Plate 3) can be seen three of the history paintings for Choisy (two of which are now at Amiens, Musée de Picardie): first Vien's *Marcus Aurelius*, in the centre Vanloo's *Augustus Caesar*, and further to the right Hallé's *The justice of Trajan* (Plate 204). Juxtaposed with such examples of the *grand genre*, Chardin's works reminded at least one academically biased critic that he had chosen the low path of imitating nature, rather than the high road of more ideal conceptions, and there is a grudging note in his praise:

It is always the perfect imitation of nature, an art that captures admirably the transparency of bodies and the softness of feathers. M. Chardin has excelled in this genre. The paintings often create an illusion of reality; although this is not the greatest merit in painting, it is nevertheless very great.

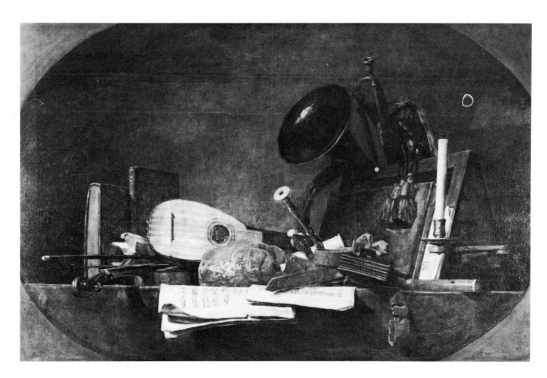

203. *The attributes of music.* 1765. Oil on canvas, 35⅞ × 56⅞ in. (91 × 145 cm.). Paris, Musée du Louvre.

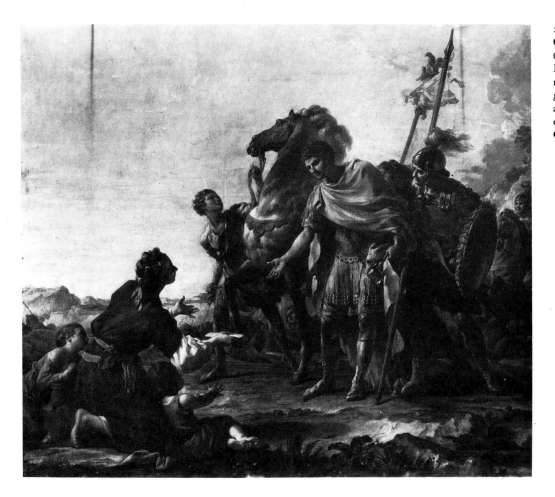

204. Noël Hallé. *The justice of Trajan*. 1765. Oil on canvas, 104¼ × 119 in. (265 × 302 cm.). Marseilles, Musée des Beaux-Arts. This painting is typical of the morally exemplary subject-matter and the grand and noble style which the Académie and the Direction des Bâtiments wished to encourage during the last twenty years of Chardin's life.

But he does not appreciate that the still lifes are done in quite a grand and monumental manner for this class of painting. The *Mercure de France*, however, was prepared to admit that the power and beauty of these works elevated them above petty academic issues of genre:

> We cannot praise enough the transparency, the palpability, if we may so say, the beautiful truth of the objects and the expert skill in the way of grouping them. In a word, when this genre is treated as we have seen it in these pictures, it justifies what we have said before of Monsieur Chardin. The perfection of art places every genre above and beyond the distinction of rank.

For *The attributes of the arts* (Plate 202), Chardin seems to have looked back to his conception of this subject over thirty years earlier for Count Rothenburg (Plate 92). Both versions of this theme can be said to pivot around the pale-coloured solid volume of a piece of sculpture – in the present work, this is no longer an antique, but a reduced plaster model of the allegorical figure of Paris on Bouchardon's monumental fountain in the Rue de Grenelle. Its appearance here is probably a tribute to the sculptor, who had died in 1762, and whose masterpiece the fountain was generally considered to be. While the Choisy overdoor includes many attributes similar to those in the work for Rothenburg, such as the palette and brushes, rolls of paper, and the tools of the sculptor, it is more complex in its allusions, including references to the art of the medallist, the architect, the goldsmith, and so on. Yet for all its complexity, and that of its companion (Plate 203), Chardin has produced a pair of designs remarkable for their organization and clarity. It is his control of space and his understanding of the way the volume of objects displaces air, leaving shapes and passages between them, that are so impressive. The low viewpoint allows the artist to conceal a good proportion of many of the objects, but this in

205. *The attributes of military music*. 1767. Oil on canvas, 44⅛ × 57 in. (112 × 144.5 cm.). Private Collection.

206. *The attributes of civilian music*. 1767. Oil on canvas, 44⅛ × 57 in. (112 × 144.5 cm.). Private Collection.

turn must have created its own formidable problems of space and perspective.

The attributes of music is the more resonant of the two overdoors, with a colour contrast of red and green playing across the quieter tonal range of creams and browns. The ledge is draped in dark red, the court bagpipes have a bright red bag and strap, while the book on the music-stand and the book on the left, both bound in green, have red-edged pages. Chardin has carefully placed and rendered the different curved and angular, soft and hard shapes, and the various materials – woods, metals, leather, velvet, paper, ivory, wax, and so on. Here again he was looking back to a decorative painting made early in his career, Rothenburg's *Musical instruments with a parrot* (Plate 89) – the soft forms of the bagpipes were already employed there, the sheets of music and the music-stand: but how scattered those objects now seem in comparison with the later work, how self-conscious the fancy ewer and the parrot.

At this same time Chardin executed *The attributes of the arts* (Leningrad, Hermitage; see Plate 19 for a replica), commissioned by Catherine II of Russia for the lecture-room at the St Petersburg Academy. The painting was delivered in 1766. Diderot may well have acted as an agent in the transaction of this commission, as he often did between contemporary French artists and the Empress, and in this case he was close to both Chardin and the sculptor Pigalle, whose

207. *A basket of peaches.* 1768. Oil on canvas, 12¾ × 15½ in. (32.5 × 39.5 cm.). Paris, Musée du Louvre. This painting originally had a pendant. *A basket of grapes*, also signed and dated 1768, which was destroyed during World War II. They were almost certainly exhibited at the Salon of 1769.

208

Mercury is a prominent feature of this work, as we have noted in Chapter 1.

The success of the Choisy overdoors in 1765 led to another commission from the Crown. Louis XV decided in 1766 to redecorate the Château de Bellevue, a project also supervised by the Direction des Bâtiments. Again, Cochin was artistic adviser, and kept his old friend's interests in mind when proposing painters to contribute to the scheme. Chardin was requested to produce a pair of overdoors for the Music Room, to represent *The attributes of military music* (Plate 205) and *The attributes of civilian music* (Plate 206). These two works develop the theme of the Choisy *Attributes of music*: and if we recall again the very early pair of pictures celebrating musical instruments executed for Count Rothenburg (Plates 89 and 90), how gauche that earlier pair seems, how grand and monumental the works on royal commission. The richly coloured and embroidered standards in the foreground, and the bold presentation of the brass, pipes and drums which fill more fully the top of the image give *The attributes of military music* an assertive presence, as opposed to the more muted colours, wooden instruments, and shallow silhouettes of the civilian instruments. The grandly conceived overdoors for the châteaux of Choisy and Bellevue reveal Chardin's impressive ability to adjust even the minor genre of still life to suit the scale and the conceptual demands of this less intimate type of painting. He responds with understanding to the requirements of a particular commission and shows at the same time a feeling for the elevated aspirations and more heroic tenor which mark most official art of the 1760s.

But for all his understanding of the heroic mode when it was required of him, Chardin clearly preferred to examine his own quieter responses to a few simple objects, carefully selected by himself. His last dated still life is *A basket of peaches* (Plate 207), painted in 1768, a simple subject, comparable with the two small still lifes of the previous year discussed above. It is an image of reticent, yet great and inexplicable power: a glass of red wine, the peaches arranged on dark-green leaves in a shallow wicker basket, two walnuts, and a knife with its black handle projecting beyond the supporting ledge to the very front of the picture-space, a device retained from his still lifes of forty years before. In *A basket of peaches*, however, he moves in closer to the subject than ever before as if to express a desperate, possessive love of glinting light, of deep translucent red, of full-bodied tactile forms and surfaces conjured from the shadowy air, and of paint itself.

9 The Bold, Assured Hand

When Chardin abandoned the invention of figure subjects in the early 1750s, it would appear to have been a simple matter of having 'painted himself out' in this type of picture. Any doubts he himself may have had about his future as a figure painter would have been confirmed by the uncomplimentary remarks of certain Salon critics we have already noted in these years. He did continue for some time to paint replicas of his earlier successes, but even these, according to Diderot, had lost their old fire. In a replica of *The kitchen-maid* (see Plate 116; the later version under discussion was destroyed in World War II) which Chardin sent to the Salon of 1769, Diderot felt that his manner of painting had become ponderous and uniform – appropriate for the rendering of inanimate objects, but lacking in vitality for the human figure:

> It is marvellously reconciled with the opacity, the mattness, the solidity of inanimate objects; but it jars with the vitality, the delicacy of living things. You can see it here in a dish-warmer, bread and other accessories; judge if it does as much good for the face and arms of this servant, who in addition seems to me rather colossal in proportion and mannered in pose.

In still life, on the other hand, Chardin went from strength to strength in these years, to produce some of the greatest masterpieces in this genre in the history of art.

While in 1753 he exhibited several figure subjects – *The drawing lesson* and *The good education*, the earlier *Alchemist* and *The blind man* – as well as some still lifes, in 1755 he submitted only an imitation of a bronze relief and a single still life. In this year he himself was in charge of hanging the Salon for the first time, and perhaps he deliberately held back his own works. But 1755 was also the year of Jean-Baptiste Greuze's Salon début. Chardin would have known of Greuze's submissions in advance, but no one could have predicted his enormous success. No less than Chardin twenty years before, Greuze capitalized on the perennial interest in Northern art, and his *Sleeping schoolboy* (Plate 208) with its thick, vigorous handling was readily admired as being in the manner of Rembrandt – more readily in 1755, it might be noted, than had Chardin's Rembrandtesque manner in the late 1730s. Nevertheless, the great collector La Live de Jully, who owned this work, warned its author against employing such a manner, 'as if wiped-on', too often, for it was too bold to please at close range! *The Bible-reading* (Plate 209, engraving) pleased much more, not only for its more fluid rendering, but above all for its powerful dramatic concentration, as the humble family gather round in rapt attention (and with some childish distraction) hanging on the old reader's every word. In theme it is not far

208. Jean-Baptiste Greuze. *Sleeping schoolboy.*
c. 1755. Oil on canvas, 24¾ × 20½ in.
(63 × 52 cm.). Montpellier, Musée Fabre.

from Chardin's *The good education*, but its rustic setting must have appeared picturesque and intriguingly remote to any Parisian Salon visitor. The roughly plastered walls, old planks, heavy furniture and homespun clothes gave Greuze an excuse to develop the lively handling that Chardin had lost. And Greuze was better able to manage a complex group of figures, as well as introducing an interesting variety of types, expressions and incident. In its complexity and dramatic unity *The Bible-reading* comes closer to contemporary history painting than anything by Chardin, yet its sources are more immediately in the seventeenth-century genre of Teniers: the design and grouping seem to be based on *The card-players*, engraved by Basan (Plate 210), while in sentiment it is a slightly more elevated version of a family scene engraved by Le Bas in 1753 as *The good father* (Plate 211). There is something more gregarious, more openly emotional about Greuze's approach to genre painting, as opposed to the reticence of Chardin, who hesitates and always seems to hold back emotion and expression. Nor is Chardin as ready to engage our attention with anecdotal detail – such as Greuze's restless and inattentive children reaching for a pencil or playing with a dog. This kind of appealing narrative detail was of course expressly designed to catch the eye of the Salon visitor.

209. *The Bible-reading*. Engraving by Martenasie after the painting (Private Collection) exhibited by Jean-Baptiste Greuze at the Salon of 1755.

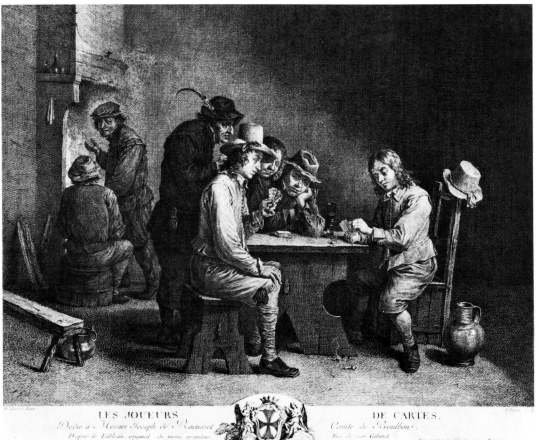

210. *The card-players*. Engraving by F. Basan after a painting by David Teniers.

211. *The good father.* Engraving by J.-P. Le Bas after a painting by David Teniers.

LE BON PERE.

A table entre les pots et les discours joyeux, *Veut enseigner ici ce Pere de famille .*
Qu'est-ce qu'à son gendre, à sa fille *Vous le voyez ; l'art d'estre heureux .*

At the Salon of 1757, as well as some superb still lifes (including Plates 191 and 192), Chardin exhibited a version of his 1738 *Scullery-maid* (See plate 112) borrowed from the Comte de Vence, perhaps intentionally demonstrating, as Cochin was later to express it, that 'there were very few paintings which could sustain themselves next to his'. It seems, as we have already mentioned in Chapter 5, that he wanted to provoke comparisons between his own approach and that of Greuze, especially in such works as the latter's *Lazy Italian* (Plate 124) or his *Scullery-maid* (Plate 118). In an interesting essay on this Salon, Antoine Renou did just that, and gave a judicious assessment of the two painters, whose works had been hung by Chardin on the same wall:

They gain and lose, turn and turn about. Greuze takes each thing he wishes to paint separately; it is true that in each object we find the most satisfying details, but considered as a whole, they do not create harmony, nor show air and light. If we consider colour, M. Chardin is superior. His pictures are silver-toned, vigorous; all the objects are reflected one in another, with the result that a transparence of colour brings to life everything that his brush touches. He has definite effects; we can enter easily the places he represents. M. Greuze is assuredly a colourist: but to give effect and relief he makes too many black tones, where M. Chardin seems to be rid of them all. Considering the two artists from the point of view of genius, M. Greuze seems to have more spirit and a taste which tends towards grand forms; he proves to us that 'The less noble style nevertheless has its own nobility'; but he does not always have the ingenuity of M. Chardin. He is generally more assured in his drawing and has more

expression, which is a considerable advantage. Happy would he be, if he could add the magic of Chardin's tones! For he must still regard him as his master in this part.

For all of Renou's admiration for Chardin's works at the Salon of 1757 (warmly endorsed by him at Chardin's funeral in 1779), he also makes clear the ways in which Greuze came closer to the current academic ideals of figure painting. It is in the full and confident lines of his drawing, his range of expression, and his easy grouping, that Greuze's more conventional training as a figure painter is apparent. We know that he had studied anatomy and from the life, that he also made drawings after antique statuary, and by 1757 had studied the old masters in Italy (his trip to Italy, 1755–7, had been financed by, and in the company of, Abbé Gougenot, whom we have already met as a sympathetic commentator on Chardin's work at the Salon of 1748). In Greuze's works with more than one figure, such as *The broken eggs* (Plate 212), exhibited in 1757, he can happily conceive a whole miniature drama, acted out through gesture, expression and narrative detail. The appeal of such works to the Salon audience is easy to understand – the girl has lost her virginity (symbolized by the broken eggs, as in Boucher's *Pretty kitchen-maid*, Plate 123; but also in a painting known to Greuze by the seventeenth-century

212. Jean-Baptiste Greuze. *The broken eggs*. 1756. Oil on canvas, 28¾ × 37 in. (73 × 94 cm.). New York, The Metropolitan Museum of Art (Bequest of William K. Vanderbilt).

213. Jean-Baptiste Greuze. *The village betrothal*. 1761. Oil on canvas, 36¼ × 46 in. (92 × 117 cm.). Paris, Musée du Louvre.

Dutch artist Willem Mieris); her elderly mother remonstrates with the young man responsible, while he, dissimulating, palms her off with money; a charming detail is the little boy, who tries to piece together a broken egg, his bow and arrows toy versions of Cupid's attributes.

It is tempting to see the larger version of Chardin's *Saying Grace* (Plate 162), extended to accommodate the young servant at the left, and submitted to the Salon of 1761, as an attempt to increase the dramatic interest of this subject. But it is unlikely that he felt himself to be in any serious way challenged by Greuze. They were painters of very different temperaments and abilities. Had Chardin felt willing or able to continue inventing figure subjects through the 1750s and beyond, he would always have found a market; but he simply settled for painting a few replicas of older designs, when it came to the human clay. At the 1761 Salon Greuze stole the show with his full-blown sentimental moral drama of *The village betrothal* (Plate 213). This rustic couple were on their way to join the contented wife of Chardin's *The bird-song organ*, painted exactly ten years before, in the collection of the Marquis de Marigny, who was still awaiting Chardin's pendant. We can guess that the patron and his painters might well have agreed that the work of each artist had its own virtues and characteristics — and, '*Vive la différence!*' The stronger element of narrative, anecdotal detail and openly expressed heartfelt emotion in Greuze was to

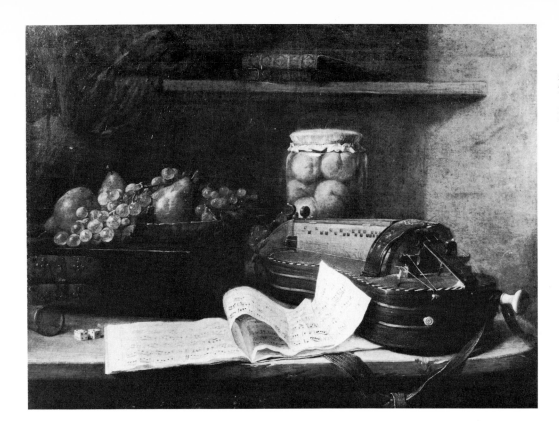

214. Henri-Horace Roland de la Porte. *The hurdy-gurdy. c.* 1760. Oil on canvas, 31¾ × 39¾ in. (80.5 × 101 cm.). Bordeaux, Musée des Beaux-Arts.

have the greater effect in figure painting of all sorts – genre and history – from the 1760s onwards. The fact that Chardin had renounced figure painting for over twenty-five years by the time of his death in 1779 meant, reminiscence apart, that this aspect of his talent was in any case all but forgotten or retained little interest.

If as a figure painter Chardin cannot be said to have had any serious following, his still lifes did encourage several talented painters to work at least superficially in his manner from the 1750s until the end of the century. The most talented of these were Henri-Horace Roland de le Porte (1724–93) and Anne Vallayer-Coster (1744–1818). Diderot rather unkindly described such painters as 'the victims of Chardin'. In a sense, however, Chardin was rather to be their victim. Outside the circle of his more intimate admirers, few spectators or collectors had the critical acumen of a Diderot; one wonders, for example, to what extent a distinguished collector like La Live de Jully, who owned several still lifes by Chardin and by Roland de la Porte, really discriminated between the two painters. It was Roland de la Porte who had been the unfortunate butt of Diderot's acerbic remark in 1763. *The hurdy-gurdy* (Plate 214) must date from around the year of his associateship of the Académie in 1761, and it is clearly inspired by various works of Chardin from about this time: *The jar of apricots* (Plate 197), for example, and the fruits in *The teapot* (Plate 58); while the subject in general recalls the early *Musical instruments with a basket of fruit* (Plate 90) painted for Count Rothenburg. But, in comparison with Chardin, there is a fussy and anecdotal quality about Roland de la Porte's work, and a neat finish that lacks independent painterly vitality. Yet, needless to say, along with most of his work, by the nineteenth century this painting had become a 'Chardin'.

Received into the Académie in 1763, Roland de la Porte exhibited at the Salon that year several works of a decidedly Chardin-like subject-matter, if not execution. *Remains of a country meal* (Plate 215), for example, was greatly admired by one critic for the 'surprising illusion' of the projecting loaf and the (somewhat artfully arranged) piece of string tied round the handle of the pitcher. But even in our photograph his surface is rather smoothly illustrative, the lighting diffused, the design open, and the whole is lacking in that combination of intense observation

and painterly execution we admire in Chardin's work. *The orange-tree* (Plate 216), perhaps his most attractive and best-known work, was in the same Salon; it catches our attention by its nearly *trompe-l'oeil* effects – light on the shiny leaves, the bright strand of brittle straw against the solid curve of the terracotta flower-pot, and a basket of plums – but how we miss the mysterious and ambiguous ambience that surrounds the little basket of plums Chardin had painted for Abbé Trublet in 1759 (Plate 7). In 1766 *The orange-tree* was purchased by the Margravine of Baden-Durlach, to join her four lovely Chardins. But in the inventory of her collection taken in 1784 after her death, it had already joined Chardin's works in attribution, and still within the working life of its true author. This is a specific instance of Chardin falling victim to the still-life painters he inspired. Already in the last decade of his own life, however, Chardin was to fall victim to profounder changes of artistic climate in Paris.

The royal commission for *The bird-song organ* in 1751 – when the artist was fifty-two-years old – was the only mark of official recognition Chardin had received since his presentation to Louis XV in 1740, when he made a gift to the king of *Saying Grace* and *The industrious mother*. Nevertheless, he received quite a good price for *The bird-song organ*, 1500 livres, as opposed to the 1000 livres he was paid for *The drawing lesson* in 1748, for example. Official favour was confirmed, as it were, when he was awarded an annual pension of 500 livres in 1752. In 1755 Chardin became Treasurer of the Académie; in 1757 he and his wife were able to move into grace-and-favour apartments at the Louvre.

If it was a reputation for probity and scrupulous diligence, and perhaps his performance on a committee which reviewed the finances of the Académie in 1754, which gained Chardin the post of Treasurer, it was fully justified. His careful administration of the institution's finances took it from a debt of around 4000 livres to a credit of some 30,000 livres by the time he left office in 1774. It was due to his management that the Académie was able to re-introduce courses in anatomy in 1764; and no doubt he was behind the donation by the Comte de Caylus of funds for a student competition in drawing expressive heads, and behind other schemes

215. Henri-Horace Roland de la Porte. *Remains of a country meal.* 1763. Oil on canvas. 36¼ × 28¾ in. (92 × 73 cm.). Paris, Musée du Louvre.

216. Henri-Horace Roland de la Porte. *The orange-tree.* 1763. Oil on canvas, 23¾ × 19½ in. (60 × 49.5 cm.). Karlsruhe, Staatliche Kunsthalle.

such as his friend Massé's donation of 2000 livres for investment on behalf of the widows and orphans of artists, and another 750 livres annual investment income from the *amateur* Jean de Jullienne.

From 1752 onwards, and especially after 1755, Chardin was to be one of the members most regularly in attendance at the meetings of the Académie, being present between once and twice a month on average. We still tend to have a somewhat romantic conception of artistic life, and forget its institutional procedures in the eighteenth century — for example, the long mornings or afternoons Chardin and his colleagues would have spent sitting in committee, whether to discuss matters of finance or to examine the progress of students. For one who in any case found the invention and execution of figure-pieces a slow and laborious business, might not the intrusion of administrative responsibilities on his precious time have contributed to his abandonment of genre in the early 1750s?

It was owing to the illness of Jean-Baptiste Portail (1695–1759) in 1755 that Chardin was asked to take over the organization of the Salon, a task he assumed on an official basis in 1761. Portail had been charged with the pensionable post of looking after the royal collection at Versailles, a post which subsumed that of organizing the Salons — but Chardin had undertaken this last commitment gratis. It was only thanks to the intervention of his loyal friend Cochin with Marigny in 1763 — suggesting the sum of 500 livres — that Chardin was awarded 200 livres for organizing these exhibitions. As we have seen, Cochin was Marigny's adviser on matters to do with art and artists. Official money for the arts was in short supply, especially during the Seven Years War, so that it was only on the death of Jean Restout in 1768 that Cochin was able to suggest that the history painter's pension of 1200 livres be divided between his widow (600 livres), Dumont le Romain and Chardin (300 livres each). Similarly, on the death of Boucher in 1770, Chardin received another 400 livres a year, thanks to the intervention of Cochin. We have also seen that it was Cochin who won for Chardin the fairly lucrative commissions for decorative paintings at Choisy and Bellevue in the mid-1760s — lucrative except that the Direction des Bâtiments, which was notoriously slow in paying artists, still owed money to Chardin for these commissions and from outstanding pensions in 1779, the year of his death. Cochin actually managed to get the Choisy and Bellevue overdoors revalued from 800 to 1000 livres apiece in 1779, but otherwise his opportunities to further the interests of his old friend ended in 1771, when he was replaced as official adviser by Pierre, who was also Director of the Académie from that year, following the death of Boucher.

Chardin was to repay Cochin's friendly concern in 1777, when, during an apparently tense meeting of the Académie, he protested to Pierre that Cochin had only been given the lowest status in the hierarchy of Councillors of that body. This had been done without due discussion or proper procedures — seemingly a typical example of the authoritarian and unpopular approach of Pierre at the Académie — and Cochin deserved not only more considered attention, but a more honourable position in the academic hierarchy, in recognition of his services. Indeed, Pierre seems to have borne a grudge against his predecessor as artistic adviser, who nearly always put the well-being of the artists he represented before official interests, and whose fundamentally open-minded aesthetic was also generally opposed by the new order. Pierre, moreover, was notoriously snobbish — well-born and enjoying a large personal fortune, he moved in the highest aristocratic circles, and had no time for those lower down the social scale. The element of personal acrimony emerged at the session of the Académie in question, when Pierre made open allusion to Cochin's earlier support of Chardin, and muttered audibly to a neighbour, 'In those days everyone was given pensions.' Chardin subsequently wrote a strongly worded letter

of protest to the Comte d'Angiviller, the new Directeur des Bâtiments, which is how we know of this unhappy episode. But D'Angiviller, as usual, upheld the status quo and sided with his henchman Pierre. It had, of course, been no accident that Pierre and D'Angiviller were joined, in a sort of triumvirate in control of artistic affairs in France, by the classicizing history painter Vien, who had replaced Chardin as organizer of the Salon exhibitions in 1774. Chardin had also resigned his office as Treasurer in 1774, to the sculptor Guillaume Coustou (1716–77).

Pierre and D'Angiviller enjoyed their revenge in the year after Chardin's protest, when Chardin wrote to D'Angiviller to ask for a financial consideration, as he had acted as Treasurer of the Académie for twenty years without reward. D'Angiviller replied – much as he had done to a similar request in 1775, but then at least he had awarded Chardin a token 600 livres – to the effect that the office of Treasurer was one rewarded by honour and the sense of service; and in any case, the Chardins were not badly off. It is true that Chardin and his wife had a comfortable income from investments and property, and in D'Angiviller's office they were known as 'thrifty and even tight-fisted'. Cochin tells us that Chardin's disputes with officialdom in these last years caused him some bitterness; it would indeed be a fair assumption that in several decades of service he must have lost many months' income as a painter. The matter was never settled to his satisfaction, and but for D'Angiviller's tactful editing, insult would have been added to injury, had Chardin received the Director's reply as drafted by Pierre, in a characteristically unpleasant tone:

> If your works prove the care which has earned your reputation in one genre, you should sense that your colleagues are owed the same justice, and you must recognize that in the same occupation your studies have never incurred such high costs, nor such a considerable loss of time, as those of your colleagues who followed the great genres.

Thus the hierarchy of the genres was not just a matter of sterile academic debate. Chardin had not invented a figure-piece for over twenty years – but even had he done so, Pierre's attitude would have been the same. For he made of an old academic doctrine something doctrinaire, by adopting an inflexible attitude which insisted on the overriding importance of the hierarchy of the genres. This rigorous stand on the part of the official academic administration of the day was effectively to put an end to those liberal-minded attitudes, which had been much more tolerant and accepting of a naturalistic aesthetic in the early and middle decades of the century, and was to be another reason for the rapid eclipse of Chardin's reputation after his death.

If the new artistic establishment in the 1770s showed little willingness to support the ageing Chardin, the handful of works he continued to send to the Salon during the last decade of his life was still warmly received by the critics. Age and infirmity took their inevitable toll, so that by the early 1770s – in Chardin's own early seventies – the condition of his eyes no longer permitted him to work with oil paints and their pungent evaporations. But, renewing himself until the end, he turned to drawing in pastel.

Pastel was, above all, a medium for drawing portraits in the eighteenth century, and Cochin points out in his biography that Chardin did not pursue his usual genres in the new technique, but drew life-size studies of heads. For an artist who reputedly so rarely made drawings, it must have been a brave decision so late in life. Yet in addition to the handful of hesitant and sketchy drawings we have already seen him execute early in his career, there is one bold, vigorous and confident drawing, A *wild boar's head* (Plate 217), which might lead us to regret that he did not produce more in this vein. This drawing was listed in the inventory of Tessin's

collections in 1741, so it dates from before then. It is freely executed with black and red chalk heightened with white; in places the artist has rubbed in the shadows with a stump, contrasting with the stronger dark strokes of the black chalk.

Chardin always exhibited his pastels as 'studies of heads', although they were nearly all specific portraits, and were recognized as such by commentators on the Salons. History painters in the eighteenth century not infrequently made drawings, in pastel and in other graphic media, of anonymous heads, as independent studies of form, light and shade, and of 'character'. A fine example of this type of study in pastel is the *Head of an old man* (Plate 219) by Jean-Baptiste Deshays (1729–65), acquired for the royal collection by Cochin at the sale of effects after his premature death. History painters north and south of the Alps had made drawings after such characterful and picturesque aged heads since the sixteenth century, and to some extent Chardin's pastel heads are in this tradition – at least, that is how he seems to have thought of them, exhibiting them as 'studies' rather than as portraits of individuals. It could be suggested that he was attempting to creep up the hierarchy of the genres to the status of portraitist – but perhaps by using the general term 'studies' he was trying to step beyond any easy classification.

The *Self-portrait with spectacles* (Frontispiece) was one of three studies exhibited at the Salon of 1771. The handling of the pastel strokes is tighter than Deshays's loose execution, with more carefully controlled cross-hatching. On the face, for example, Chardin uses a delicately shifting web of groups of short, hatched lines to describe

217. *A wild boar's head.* Before 1741. Black and red chalk heightened with white, 10⅜ × 16 in. (26.4 × 40.6 cm.). Stockholm, Nationalmuseum.

218. *Self-portrait with an eye-shade.* 1775. Pastel, 18⅛ × 15 in. (46 × 38 cm.). Paris, Musée du Louvre, Cabinet des Dessins.

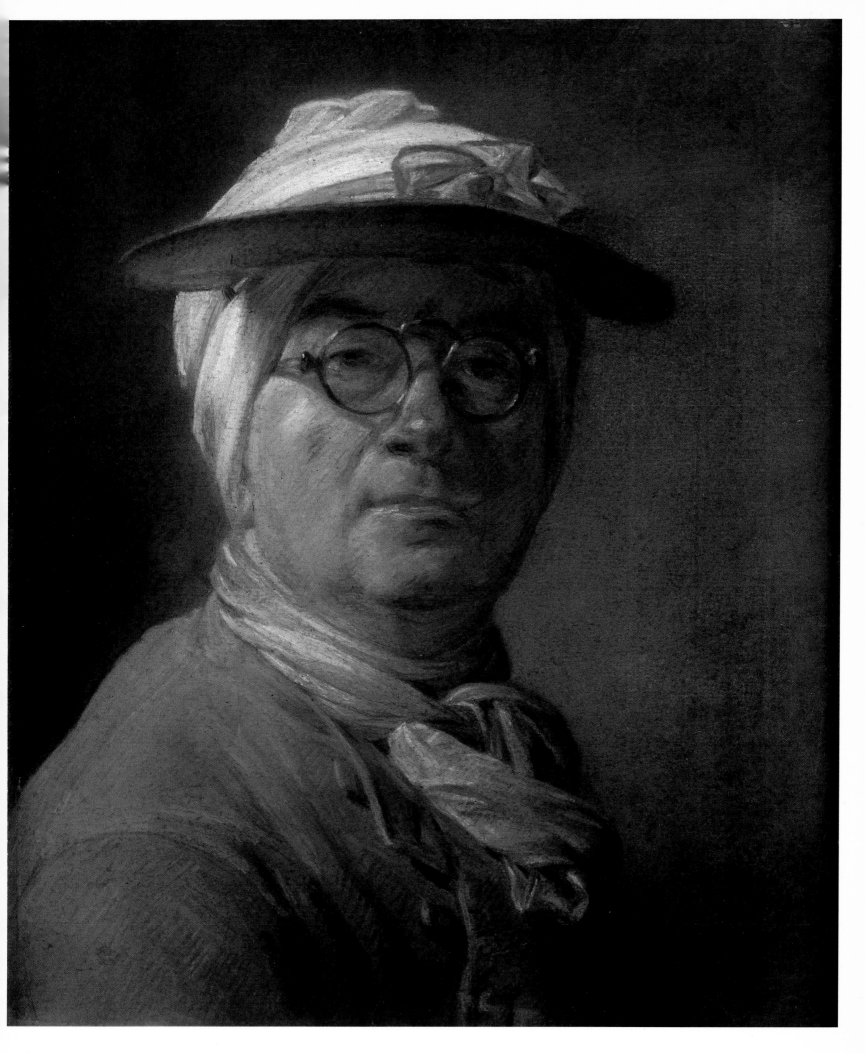

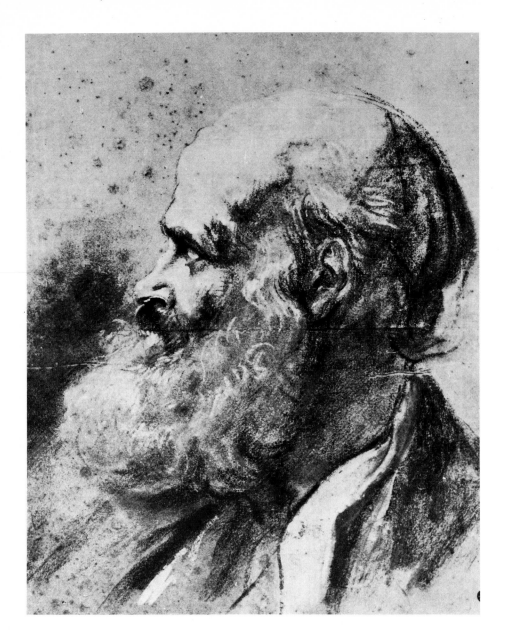

219. Jean-Baptiste Deshays. *Head of an old man. c.* 1760. Pastel, 18⅞ × 15⅜ in. (47.8 × 39 cm.). Paris, Musée du Louvre, Cabinet des Dessins. Deshays died at the age of thirty-six in 1765, which provides a terminus for the dating of this drawing.

exactly the modulations of his soft, ageing flesh from one plane to another; his head is wrapped in a white cloth, tied with a broad band of bright greenish-blue; the scarf around his neck is a soft pink, with a slight pattern of red and blue; the jacket is soft light brown; the background is a grey tinged with blues and greens. The mass of the face, with its gently modulated surface, unfolds between the polarities of the warm tones of jacket and scarf and the cool of the head-gear. The flesh-tones incorporate some of the pinks of the scarf, while in the shadows there are marks of blue coolness. The critics were all sympathetic to this new departure, admiring Chardin's 'broad, expert touch', or 'the same bold, assured hand' as Diderot put it, referring back to the impasto of the master's oils. Chardin has brilliantly adapted his reflective and calculated use of impasto and brushmarks in the oils to the technique of pastel.

The visible hatching of the pastel recalls the approach of Maurice Quentin de La Tour (1704–88), the most famous pastellist of the age, who had made a portrait of Chardin in 1760; when he resigned his post as Treasurer in 1774, Chardin presented the portrait to the Académie (now in the Louvre, Paris; it is not one of La Tour's most impressive works). Chardin's ability to convey a vivid impression of character, surprising from an artist whose figure subjects were always very reticent in respect of facial expression, may owe something to a knowledge of La Tour's

lively studies of expression, preliminary to his more finished pastel portraits. Chardin was also portrayed in pastel by Joseph Ducreux (1735–1802) in 1767 (this portrait is now lost). Both Ducreux and his teacher La Tour made self-portraits – by the 1790s, Ducreux had portrayed his own features in a remarkable variety of expressions and even grimaces, but whether this obsessive self-interest was already finding expression at the time when he knew Chardin is not recorded. Chardin was to record his own features on at least three occasions (excluding replicas), all reproduced here. The simple convenience of having himself as model may explain this choice, but if he was aware of Ducreux's interest in self-portrayal, he must also have been aware of Rembrandt's, the greatest and most celebrated precedent.

It was in this late phase of his career that Chardin paid his first direct homage to the Dutch master, in a pastel copy (Plate 220) of the head and shoulders of Rembrandt's *Old woman in an armchair* of 1654, which is now in Leningrad. Chardin betrays a profound sympathy for the sagging flesh of this aged woman nearing the end of her days, and a thorough understanding of the expressive role of the flickering light and shade of Rembrandt's late chiaroscuro.

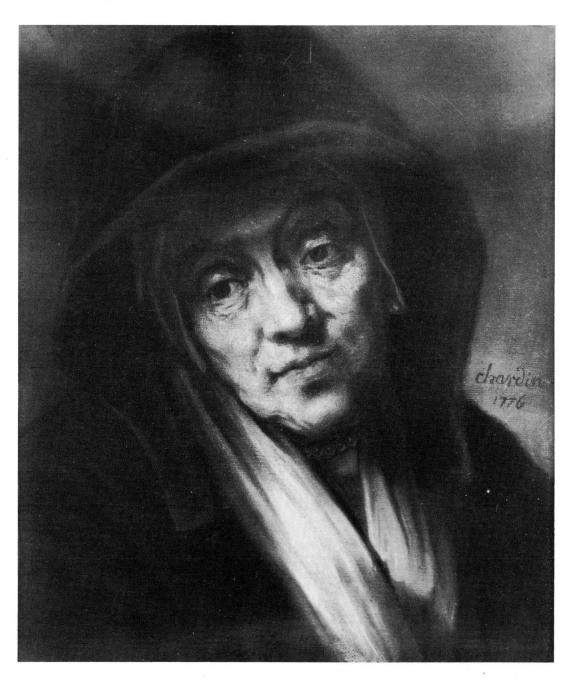

220. *Head of an old woman.* 1776. Pastel, 18½ × 14⅝ in. (46 × 37 cm.). Besançon, Musée des Beaux-Arts. This drawing represents a detail of Rembrandt's *Old woman in an armchair* (Leningrad, Hermitage), acquired in the eighteenth century by Catherine the Great from the collection of the Comte de Baudoin in Paris.

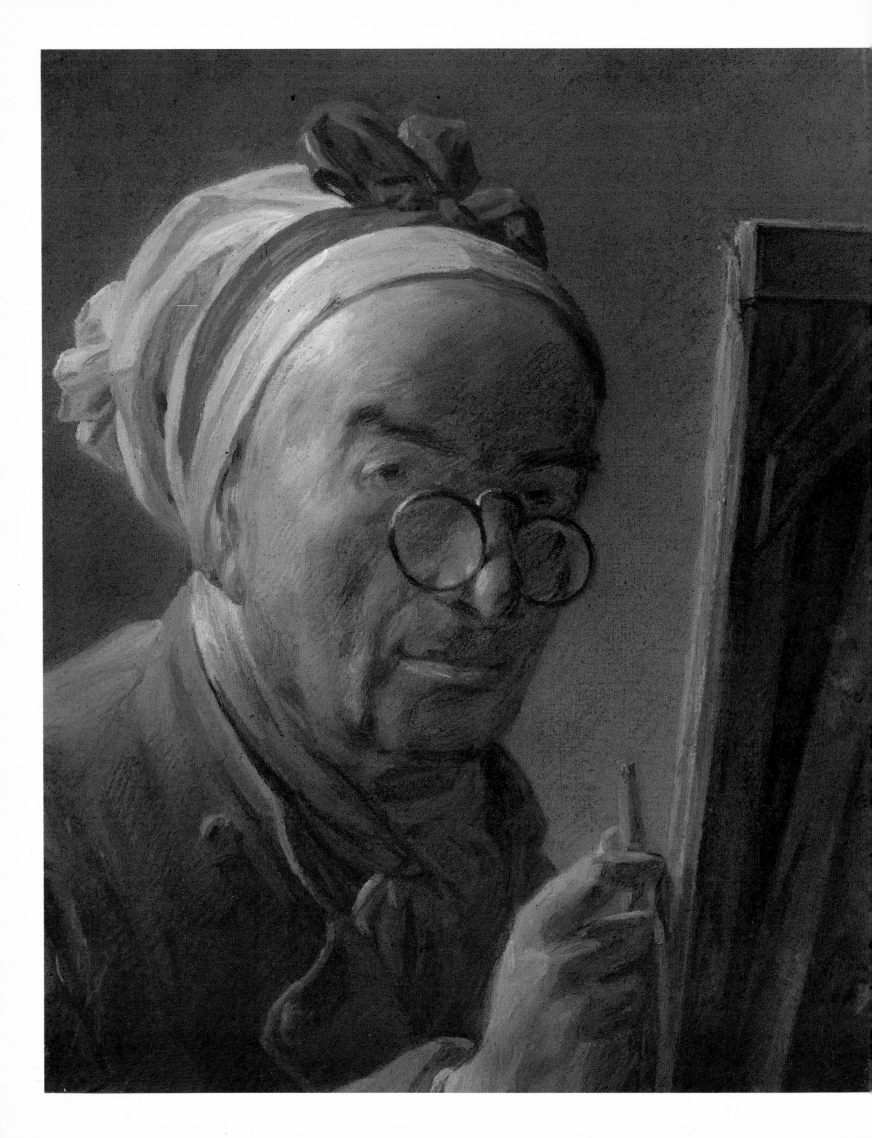